THE CODEX MEXICANUS

The Codex Mexicanus

A Guide to Life in Late Sixteenth-Century New Spain

Lori Boornazian Diel

UNIVERSITY OF TEXAS PRESS ⬧ AUSTIN

The inclusion of color images was supported by the Robert and Mary Jane Sunkel Art History Endowment, Texas Christian University.

Requests for permission to reproduce
material from this work should be sent to:
Permissions
University of Texas Press
P.O. Box 7819
Austin, TX 78713-7819
utpress.utexas.edu/rp-form

The paper used in this book meets the minimum requirements of ANSI/NISO Z39.48-1992 (R1997) (Permanence of Paper). ∞

Library of Congress Cataloging-in-Publication Data

Names: Diel, Lori Boornazian, 1970– author.
Title: The Codex Mexicanus : a guide to life in late sixteenth-century New Spain / Lori Boornazian Diel.
Description: First edition. | Austin : University of Texas Press, 2018. | Includes bibliographical references and index.
Identifiers: LCCN 2017045428
 ISBN 978-1-4773-1673-3 (cloth : alk. paper)
 ISBN 978-1-4773-1674-0 (library e-book)
 ISBN 978-1-4773-1675-7 (non-library e-book)
Subjects: LCSH: Codex Mexicanus. | Manuscripts, Mexican—Mexico—Facsimiles. | Mexico—History—To 1810. | Mexico—History—Spanish colony, 1540–1810. | New Spain—History—16th century. | Aztecs—History—16th century. Indians of Mexico—History—16th century.
Classification: LCC F1219.56.C62525 D54 2018 | DDC 972/.01—dc23
LC record available at https://lccn.loc.gov/2017045428

doi:10.7560/316733

Tables

Figures

Supplement: Color Plates

The complete Codex Mexicanus (pages 1–102) follows page 164

ACKNOWLEDGMENTS

The seed for this project was planted quite some time ago, when I was a graduate student at Tulane University. During seminars focused on Aztec manuscripts, the question of why Christian icons, such as two crucifixes, were included in the annals history of the Codex Mexicanus came up, but was never satisfactorily answered. I stored this puzzle in the back of my mind and turned my attention, instead, to other Aztec pictorial histories, which often led me back again to the Mexicanus and to more questions about the manuscript that I became determined to answer. Support provided by a number of institutions and individuals allowed me the time and resources to immerse myself in the Mexicanus and solve its riddles, including the meaning of those crucifixes.

Special gratitude goes to the Bibliothèque nationale de France and its staff, who kindly provided digital images of the codex and permission to publish it in this book. I am especially grateful to Laurent Hericher, conservateur, chef du service des manuscrits orientaux, for allowing me to examine the original codex on two trips to Paris. These trips were supported by grants awarded by the Texas Christian University (TCU) Research and Creative Activities Fund, which also provided funds to purchase images of the Mexicanus. More images, rights, and reproduction costs, including the publication of the color images of the Mexicanus in this book, were generously supported by TCU's Robert and Mary Jane Sunkel Art History Endowment.

Coming to an understanding of the Mexicanus' contents was not a solitary affair. This book builds on the work of others who have written on the Mexicanus, including Ernst Mengin, Donald Robertson, Joaquín Galarza, Hanns Prem, Federico Navarrete, Gordon Brotherston, Susan Spitler, and María Castañeda de la Paz. Special thanks for their generosity of time and enthusiasm for this project also go to Elizabeth

Boone and Louise Burkhart, who provided valuable insights on the Mexicanus' pictorial catechism; Camilla Townsend, who graciously translated one of the Nahuatl inscriptions in the Mexicanus; and Andy Barnes, whom I often turned to with questions about Aztec calendars and histories. I have also benefitted greatly from the opportunity to present my ideas on the Mexicanus at a number of conferences, including those sponsored by the American Society for Ethnohistory, College Art Association, Latin American Studies Association, and Northeastern Group of Nahuatl Studies, as well as the symposium *Telling Stories: Discourse, Meaning and Performance in Mesoamerican Things*, held at the Moses Mesoamerican Archive and the Peabody Museum, Harvard University. At each of these meetings, I received valuable feedback from audience members. In particular, I wish to thank Anthony Aveni, Davíd Carrasco, James Cordoba, Ana Díaz Álvarez, Bérénice Gaillemin, Patrick Hajovsky, Frances Karttunen, Cecelia F. Klein, Ben Leeming, Leonardo López-Luján, Barbara Mundy, Jerry Offner, Justyna Olko, Susan Schroeder, Fritz Schwaller, John Sullivan, Gordon Whitaker, and Stephanie Wood; all strengthened this project, letting me know when I was on the right path and when I needed to rethink some of my conclusions. My earlier publications of two articles on the Mexicanus also helped with the crafting of this book. The first focused on the Codex Mexicanus' genealogy and was published by *Colonial Latin American Review*, and the second provided an overview of the Mexicanus' goals and contents and was published by *The Americas*. I thank Kris Lane and Ben Vinson III for their editorial stewardship of these articles and the anonymous reviewers who helped me to hone my arguments.

The writing of this book was also generously supported by the Dumbarton Oaks Research Library and Collection and its wonderful staff.

A Summer Fellowship in Pre-Columbian Studies gave me a chance to dig into the historic context of the Mexicanus' creation, while a subsequent Fellowship in Pre-Columbian Studies was instrumental in allowing me to bring this project to a close. I was fortunate to share my times at Dumbarton Oaks with Colin McEwan, Tom Cummins, and Mary Pye along with a great cast of fellows, who all provided valuable feedback and happy memories.

This book has also benefitted from additional support by TCU, which provided a College of Fine Arts Mid-Career Summer Stipend as well as the granting of leave and course reductions. Colleagues at TCU, present and former, as well as graduate students, were another steady source of support. Thanks especially goes to Amy Freund, for reading one of the chapters of this book and offering perceptive comments. I also thank my graduate assistant Candace Carlisle Vilas, whose organizational skills were a great help with securing images and reproduction rights. The University of Texas Press and its staff are owed special appreciation for their efforts and investment with this book. Kerry Webb, Angelica Lopez-Torres, Sonya Manes, and Robert Kimzey efficiently managed the publication process, and an anonymous reviewer provided valuable guidance on it.

And finally, special thanks are owed again to Elizabeth Boone, who awakened my interest in Aztec art many years ago and remains a generous mentor today, encouraging my work on the Mexicanus by continually reminding me that this book needed to be written. Elizabeth read a draft of this book and offered insightful comments and critiques; I hope it meets her exacting standards. Of course, I could never have committed myself fully to this project without the support of my friends and family, especially Tom and McKay.

THE CODEX MEXICANUS

The Codex Mexicanus and Its World of Production

Approximately sixty years after the Spanish invasion and conquest of Mexico, a group of Nahua intellectuals gathered in Mexico City, capital of New Spain, formerly known as Tenochtitlan, capital of the Aztec empire.[1] Their mission was to compile a book filled with information essential to know for life in New Spain. Owned by the Bibliothèque nationale de France, this book, known today as the Codex Mexicanus, is filled with seemingly miscellaneous information, including records concerning the Christian and Aztec calendars, European medical astrology, a genealogy of the Tenochca royal dynasty, and an annals history of preconquest Tenochtitlan and early colonial Mexico City, among other topics. Written in a variety of formats, from the pictorial script of the Aztecs to the alphabetic script of the Spaniards, the book was updated over a long period of time by a number of different contributors. The manuscript is filled with intriguing records; however, it has defied a comprehensive scholarly analysis, most likely due to its disparate contents.[2]

In this study of the Codex Mexicanus, I take a holistic approach to the manuscript. I provide a reading of its contents and explain how they find counterparts in Spanish books called *Reportorios de los tiempos*.[3] Based on the medieval almanac tradition, *Reportorios* contain vast assortments of information related to the issue of time—its passage as well as its influence—as does the Mexicanus. As *Reportorios* were used as guides

to living in early modern Spain, then likewise, the Codex Mexicanus would have provided its native audience a guide to living in colonial New Spain. Moreover, the information included in the Mexicanus was culturally diverse in nature, spanning the Aztec and European worlds, and speaks to the process of identity formation for the book's native owners and contributors. The identity the Codex Mexicanus fashions is one of a Christian New Spain built upon a pagan, but illustrious, Aztec foundation. In this regard, the Mexicanus further mimics the *Reportorio* tradition, as these books communicated a similar identity for Spain—a modern Christian nation built upon its own pagan past, an ancient Roman one. Through the Mexicanus, then, its native contributors communicated both a pride for the Aztec past and an allegiance to the Christian present.

By considering how the parts of the Mexicanus relate to the manuscript as a whole, this book reveals the significance of this often overlooked source. Before now, the only thorough study of the Codex Mexicanus was published by Ernst Mengin in 1952. His was certainly a valiant effort given that Mexican manuscript studies were still in their infancy at the time he worked. Nevertheless, he left gaps in his explication of the work and failed to link the Mexicanus' unwieldy contents into a unified whole. When Donald Robertson (1959, 123) considered the Mexicanus in his pioneering study of Mexican pictorial manuscripts, he seemed to dismiss its significance by describing its contents as "more a compendium or gathering together of seemingly unrelated information than a proper well-ordered manuscript."

Robertson's assessment that the Mexicanus was filled with incongruent material may have influenced subsequent studies of the book, which have typically concentrated on particular sections of the work. The Mexicanus' calendric records have by far been of most interest to a variety of specialists interested in native timekeeping and its relation to intellectual thought in preconquest and early colonial central Mexico.[4] In Joaquín Galarza's (1980) analysis of Aztec writing, he also focused largely on the calendric portions of the codex, but he was more interested in how the Mexicanus' translation of Spanish saints' names into Aztec pictorial script could elucidate the phonetic potential of this writing system. Susan Gillespie's (1986, 100–101) work on Aztec kingship considered the genealogy included in the Mexicanus, as did María Castañeda de la Paz (2013) in her book on the major centers of central Mexico in the pre- and postconquest periods. More recently, two articles have focused specifically on the Mexicanus' genealogy, providing readings of its contents and a consideration of the larger messages it sends (Diel 2015; Castañeda de la Paz 2016). Surprisingly, no studies focused specifically on the Mexicanus' extensive pictorial history have been published, though numerous scholars interested in the preconquest and early colonial Aztec past have used the Mexicanus' history as an important resource.[5]

Filled with significant insights, these analyses of specific sections of the Codex Mexicanus have provided a strong foundation for the present study. In fact, an important point raised by scholars who have considered the calendric information contained in the Mexicanus is that Spanish *Reportorios* must have served as source material for these sections (Prem 1978, 268; Gruzinski 1993, 62–63; Aveni 2012, 47–49). However, other sections of the Mexicanus, such as its genealogy and history, also find counterparts in some *Reportorios*, which suggests that the entire codex was modeled after these Spanish books (Spitler 2005a, 284–285; 2005b, 88). Thus, by focusing on the codex in its entirety and relating it to the *Reportorio* tradition and its

late sixteenth-century context, it becomes clear that the Mexicanus was not a compendium of random information but a carefully curated collection of information that its native compilers must have considered essential to know and remember, a guide to life in New Spain.

An Overview of the Codex Mexicanus

In format, the Codex Mexicanus straddles the European and Aztec worlds. The manuscript is composed of thin sheets of native bark paper that were covered in gesso and then painted upon in the native style. However, its bound nature is typical of European books, making the Mexicanus a true codex, in contrast to Aztec books that were traditionally formatted as long strips of paper stored in a screenfold fashion. Aztec books also tended to be larger and more accessible for public viewing, whereas the Mexicanus is quite small, with each page measuring approximately ten by twenty centimeters. The book could fit in one's pocket, making it a "pocketbook" and suggesting more personal, perhaps even covert, reading.[6] Nonetheless, the book is long, consisting of fifty-one leaves, or 102 pages, packed with a variety of information.

The Codex Mexicanus is best described as a living document, in that it was modified and updated by a number of different painters and scribes who, based on the style and placement of their contributions, must have worked at different times. I suspect an initial group painted the different sections of the book around the same time, and then others updated the completed work with additional imagery. A scribe writing in Nahuatl added some texts to clarify the pictorial imagery, likely soon after the work was produced, while additional scribes contributed supplementary texts, also in Nahuatl, that

added new information altogether. Other texts, in Spanish and French, must have been written by later owners of the manuscript.

Some of the pages in the book were also reused. For example, the column at the left of page 16 is a carryover from the perpetual calendar that begins the codex (see Plates 1–5 and 9), suggesting the reuse of paper here. Moreover, an upside-down European-style sun is revealed on this same page where some of the later gesso coating has flaked away. Also, a narrative scene on page 88 was clearly added to a piece of paper that had originally been intended for the annals history, as the horizontal lines used to delimit the Aztec timeline in the annals portion of the codex are still visible on the page (Plate 45). Other imagery in the codex appears to have been whitewashed, giving the work the effect of a palimpsest. This is most visible on the final pages of the manuscript, where faint traces of imagery are barely visible under a secondary gesso coating (Plates 45–52; see Chapter 2).

The book must have been bound after the pages were painted, as the binding obscures some of the contents of the manuscript. However, exactly when the book was bound and by whom is unknown. As bookbinding was taught to Nahua students at the Colegio de Santa Cruz, Tlatelolco (Gravier 2011, 166), the binding of the Mexicanus could have also been done by a native artisan. However, a French annotation on page 40 that had to have been added to the manuscript by a later owner of the work is also obscured by the book's binding, which may point to it having been bound by one of its later owners (Plate 21). If the book originally had a cover, it has not survived, nor have some of the pages that began and ended the manuscript.

In terms of its writing system, the codex is hybrid in nature, but the majority of its contents are recorded using the Aztec pictorial system of writing, with alphabetic script being used more

sparingly. Aztec writing was essentially a visual system, with imagery rendered in a flat, codified form to communicate information.[7] Although Aztec pictorial script recorded fixed information, there was still an interpretive openness to an image's meaning, as is true of all visual discourse. For an Aztec pictorial record, this meaning was conveyed through an interpreter who could emphasize a particular reading of the imagery or neglect another interpretation, depending on his or her own previous knowledge and the circumstances of the analysis. Indeed, the reading I provide of the Mexicanus in the pages that follow is admittedly a product of my own understanding of the Mexica past, and others may very well see different issues of importance and avenues of interpretation in the codex.

A detail from the Mexicanus genealogy on page 17 of the codex provides an entry point for understanding the Aztec writing system (Figure 1.1). Here, men and women are distinguished by clothing, hair, and pose. The man is shown on the bottom. He is distinguished by a cotton mantle that is tied at the shoulder and covers his arms and folded-up knees, a pose that is typical of men in Aztec pictorials. He is further marked as a ruler by his woven reed throne and crown, which is bound at the back with red leather. In contrast, the figure above is marked as a woman by her shirt and skirt, as well as her kneeling posture. Women wear their hair in a braided and wrapped style such that the ends appear like horns atop their heads. Although figures of the same sex and status appear identical, historical figures are distinguished by names recorded with hieroglyphic compounds. The ruler in Figure 1.1 is identified by a name tag that floats above and behind him and consists of a hand holding three reed sticks, recording his name, Acamapichtli (Handful of Reeds). He is seated in front of another hieroglyphic compound that consists of a stone (*te-tl*) topped by

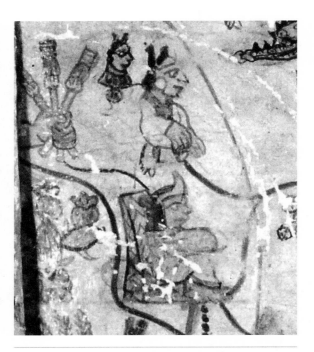

1.1 Detail of the genealogy, Codex Mexicanus, page 17. Courtesy of the Bibliothèque nationale de France.

a nopal cactus (*noch-tli*).[8] This is the place sign for the Mexica capital, Tenochtitlan, Place of the Prickly Pear Cactus.

Subtler information is conveyed through other visual elements, such as composition, color, scale, and links to other elements. On this page, and elsewhere in the book, the reading order extends from left to right, suggesting the progression of time. Accordingly, Acamapichtli is distinguished from his male descendants by his placement to the left, a compositional choice that communicates that he lived earlier in time (Plate 9). Additionally, the dark green lines that extend from Acamapichtli and the woman above join and mark them as husband and wife. They also show that he is the progenitor of the first generation of this family line, and different colored lines are used to distinguish other families. Moreover, Acamapichtli is depicted in a larger scale when compared to the more diminutive figures at the bottom of the page, further establishing his significance.

Because different painters contributed to the Mexicanus, variations in style are seen throughout the work, with some artists exhibiting more European illusionistic devices in their work and others confining themselves to the flat style typical of preconquest Aztec works. In the example from the Mexicanus genealogy explained above, European influence is evident but minimal, best seen in the illusions of modeling and recession into space achieved by the delineation of folds in the mantle ties and the slight three-quarter view of each woman's torso. However, more in keeping with the Aztec visual style, the figures are placed in an empty space with no indication of setting offered, except for the few hieroglyphic compounds that mark different places in a more symbolic fashion.

Because the genealogy and annals history derive largely from Aztec sources, the use of Aztec pictorial writing in these sections is expected.

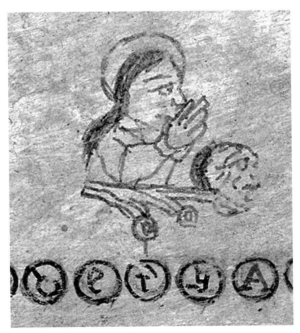

1.2 Detail of the day of the Nativity of Mary, Codex Mexicanus, page 5. Courtesy of the Bibliothèque nationale de France.

However, other contents in the Mexicanus were clearly derived from European alphabetic sources and reveal interesting uses of cross-cultural translation, as is best seen in the monthly calendar in which the alphabetic script of the Spaniards is replaced with the pictorial script of the Aztecs (Plates 1–5). For example, the day of the Nativity of Mary is recorded with an image of a young woman with her hair down and topped by a halo (Figure 1.2). She holds her hands together in prayer and is placed over a stream of water that is drawn in the codified manner typical of Aztec pictorial writings, with wavy lines forming streams and ending in disks and shells. At the end of the stream of water is the wrinkled face of an old man. As the word for water in Nahuatl is *a-tl* and the word for "old" is *huehueh*, together this compound approximates Ave Maria, or *a-hue* Maria (Galarza 1980, 43). The translation of alphabetic text to pictorial image here suggests a perceived equivalency between the two systems of writing. In fact, by successfully translating Spanish concepts into Aztec pictorial script, the Mexicanus contributors revealed the strength of their writing system, which would have also served as a marker of their civility.

The Codex Mexicanus' Contents and Sources

In terms of its contents, detailed in Table 1.1, the Mexicanus also bridges the Aztec and European spheres. The first section of the book deals with calendric matters pertaining to both the native and Christian worlds, including a Christian saints' calendar correlated with Aztec monthly festivals. This section is followed by zodiacal information related to European medical practices, then more calendric information. Next comes a two-page genealogy of the Tenochca ruling house. This is followed by an

extensive annals history of preconquest Tenochtitlan and early colonial Mexico City. Two sections were added to the annals history. One of these additions is an alphabetic text in Nahuatl that extends over ten pages and explains the signs of the European zodiac. The other addition is a catechism that was written in Aztec pictorial script. Succeeding the annals history is a page of biblical imagery, and the book ends with an incomplete Aztec sacred calendar. The information contained in the Mexicanus derives from Aztec pictorial books and Spanish Reportorios, both of which focus on the larger theme of time in both its historical and religious manifestations.

Two common genres of Aztec books were pictorial histories and divinatory codices, and the contents of each of these genres are seen in the Mexicanus.[9] Although no preconquest pictorial histories from Tenochtitlan survive, histories that were recorded after the conquest reveal that those from Tenochtitlan were typically recorded in an annals format, with

Pages 1–8	Monthly Calendar (incomplete)
Page 9	Calendar Wheels
Pages 10–12	Astrological Medical Charts
Pages 13–14	*Tonalpohualli* (partial)
Page 15	Calendrical Calculations
Pages 16–17	Genealogy of the Tenochca Royal Dynasty
Pages 18–87	Annals History of the Aztec Empire (1168–1590)
Pages 23–34	Alphabetic Text on the Zodiac
Pages 52–54	Pictorial Catechism
Page 88	Miraculous Vision
Pages 89–102	*Tonalpohualli* arranged in *Trecenas* (incomplete)

1.1 Contents of the Codex Mexicanus.

important historic events linked to the solar calendar (Boone 1996, 201–205). These events were often chosen to send a message about the superiority of Tenochtitlan and its rulers. Thus, Aztec pictorial histories were designed as political arguments and, as such, could be manipulated to support claims of power and status (Diel 2013). As does the Mexicanus' annals history, many of the extant pictorial histories continue uninterrupted through the Spanish invasion and conquest, though their messages were often modified to better argue for power in a Spanish colonial context. Nahua books of divination, known as *tonalamatl* (day book), were also linked with time, being filled with references to the 260-day sacred calendar, or *tonalpohualli*. The tonalamatl was divided into almanacs that linked the sacred calendar with a wide range of events, such as agricultural activities, religious rituals, marriages, births, travels, etc., and these were read by specialists who could divine their meaning. One of the most common almanacs arranged the tonalpohualli by *trecenas*, a Spanish term used to reference the twenty groups of thirteen days that formed the sacred year. Although an early colonial work, the Codex Borbonicus illustrates these trecenas in what must have been the traditional manner, with the days of the trecena and its religious associations documented via pictorial icons (see Figure 2.11). The Mexicanus ends with an incomplete almanac of the trecenas, but the pictorial information that filled the almanac in the Borbonicus is missing from the Mexicanus, perhaps whitewashed at a later date, as discussed more fully in the next chapter.

The Reportorio tradition in Spain can be traced to the later fifteenth century and was based on a calendar tradition that extended back to the ancient world (Delbrugge 1999, 2). One of the first Reportorios, published by Andrés de Li in 1492, was used to note the passage of time

as well as cultural information. For example, a saints' calendar was included in the Reportorio, as was astrological-medical information, issues important to early modern life that were also included in the Mexicanus. Although the contents of the Reportorios seem miscellaneous, they all deal with the theme of time, and much of this information can be tied to the ancient world, revealing the almanacs' thorough grounding in Roman history (Delbrugge 1999, 21). Li's work was primarily alphabetic, but it contained a number of illustrations derived from woodblocks and engravings. These may have made the Reportorios especially appealing to a native audience accustomed to the visual sphere as a means of communication.

Reportorios were quite popular in Spain; for example, an inventory from 1556 of a Spanish bookstore in Burgos included nineteen Reportorios (Pettas 1995, 141). These were also exported to the New World, appearing in a number of wills and bookstore inventories from sixteenth-century New Spain (Leonard 1992, 201–203; González Sánchez 1999, 214, 219, 226, 246). Li's Reportorio went through a number of reprintings and at least eleven editions and influenced subsequent Reportorios well into the sixteenth century (Delbrugge 1999, 20, 37–38). One such influence was the Reportorio by Gerónimo de Chaves, which was first published in 1534 and republished in numerous later editions. Chaves borrowed from Li's work but also expanded upon it by adding historical information, suggesting an increasing sense that the past was significant to the understanding of the present. Indeed, the first Reportorio to be written and published in the New World, by Enrico Martínez in 1606, was based on the Reportorio tradition of Spain but updated to serve those living in New Spain. Accordingly, Martínez included information on the Aztec calendar and on history that was surely derived from native sources, revealing a sense on the part of this European author that knowledge of the Aztec past was necessary for those living in New Spain, a sentiment clearly shared by the compilers of the Mexicanus. In fact, with its similar contents, the Codex Mexicanus anticipates Martínez's work but for a native audience.

The Codex Mexicanus and Late Sixteenth-Century New Spain

Annotations on page 9 of the codex provide information on the Mexicanus and its context of creation (Plate 5). Written in Nahuatl, a gloss at the top of this page reads, "San Acosti teopixqui ualcallaque sa paollo," or "The friars of Saint Augustine arrived at San Pablo." This note refers to the establishment of the Colegio de San Pablo, which was founded in 1575 by the eminent Augustinian friar, Alonso de la Vera Cruz (Prem 1978, 275; Brotherston 2005, 79). The colegio was located in San Pablo Teopan, which was one of four indigenous neighborhoods in Mexico City. Because references to this colegio are rare in the native annals and the Mexicanus does not reference other barrios, I suspect that the contributors to the Mexicanus may have had an affiliation with this particular barrio and perhaps even this particular school.[10]

In fact, clues on this same page suggest the manuscript was created soon after the colegio was founded. A line connects the notation to a dominical wheel below. This wheel is a chart of the twenty-eight-year cycle created by tracking Sundays in the Christian calendar, and the line ends at a year that is marked as 1575, surely in reference to the establishment of the colegio. This date also serves to correlate the rest of the years of the wheel, which is to be read in a

clockwise direction, as explained more fully in Chapter 2. Accordingly, the cross at the top of the wheel falls between dominical letters corresponding to the years 1578 and 1579, which implies that the Mexicanus was begun at about this time. More calendric notes on Mexicanus page 15 reference the years from 1579 to 1582, and the last historic notice in the annals history was written in for the year 1583. These dates make it likely that the majority of the codex was created and updated during these years (Prem 1978, 283).

In the decades after the conquest, Spanish friars used education as a key tool in the conversion process and established schools for the education of native elites (Kobayashi 1974; Gonzalbo 1990). Fray Pedro de Gante established one of the earliest schools for the education of native children at the Church of San José de los Naturales in Mexico City, and soon after this, the Colegio de Santa Cruz, located in Tlatelolco, neighbor to Mexico City, was founded by Franciscans in 1536 and was specifically dedicated to the education of native children, who were taught to read and write, an endeavor facilitated through the books collected by the library (Mathes 1985; SilverMoon 2007). Although the majority of these books were religious in scope, there is evidence that this library housed almanacs as well as books of a more humanistic nature (Mathes 1996). For example, a 1574 inventory of the library lists a Reportorio by Gerónimo de Chaves (Mathes 1985, 32).

No inventory of the Colegio de San Pablo's library is known today; however, it would not be surprising for it to have contained a Reportorio as well. A humanist scholar known for his defense of the indigenes, Alonso de la Vera Cruz was well regarded for his library, which he shipped from Spain and donated to the colegio. Vera Cruz's collection was considered one of the colony's "finest and most complete libraries"

and was renowned for including "all the latest equipment in such things as maps, globes, and the scientific instruments" (Ennis 1957, 174). The colegio was established to educate friars so that they could work with the Nahuas, who made up the majority of the population of the San Pablo barrio in Mexico City (Rubial García 1989, 124–128). Based on the annotation and the educated nature of the Mexicanus creators, it is logical to assume that they had a connection with this school and perhaps even access to its library as source material for their work.

A page of biblical visions included toward the end of the Mexicanus provides more support for the immersion of the Mexicanus contributors in the religious world of the Augustinians (Plate 45). Page 88 pictures two biblical events linked by a winding road that extends from the upper left hand side of the page to a native convert who stands at the right; the road then doubles back to the lower left. This painting suggests a need on the part of the Mexicanus' patrons and contributors to include a statement on their Christian piety and theological understanding, which they could have gained through an Augustinian education.

The figure at the turn in the road holds his hands together in prayer. His mantle communicates his native identity, but his pants and short hair show that he lives in the Christian world. Twelve eyes, drawn in a schematized manner, extend in front of him and lead to the image at the upper left. Eyes such as this are used in Aztec pictography to suggest sight, while the number 12 has symbolic implications in Christian theology. Here, the eyes must communicate a vision received by the native convert and pictured to the upper left, where Christ stands before a forest and communicates with the devil. Satan's representation is based on European precedents, though he holds stones that are decidedly Aztec in appearance. These are

the icons for stones that appear frequently in Aztec pictorial writings, where they are typically shown as oval shapes with curls at the ends and three striations in the center. For example, a more simplified stone icon also appears on page 44 of the Mexicanus (Plate 23) at the bottom of the hieroglyphic compound for Tenochtitlan. These are not the mimetic depictions of stones one would see in a European print, which points to the event taking place in the New World. This scene references the temptation of Christ, wherein Satan taunted a famished Christ to turn stones into bread.

The biblical tale of Christ's temptation is clearly significant, as is the fact that a native convert received such a miraculous vision. As Jeannette Peterson (2014, 13–16) has explained, the Augustinians emphasized sight in the process of evangelization, with St. Augustine differentiating two kinds of sight. Physical sight is that of non-Christians and is inherently partial and flawed, making them blind to truth. In contrast, spiritual sight is attained by those who have the ability to see the truth of Christianity with their mind. By depicting an indigenous man receiving such a biblical vision, then, the Mexicanus painter communicates that natives had spiritual sight and the capacity to be true Christians.

The vignette at the lower left also relates to the issue of sight. Though in poor condition, the image reveals Christ, identified by his halo and beard, on a road and pointing to two men before him. The first, dressed in tattered clothing, holds a staff in one hand and holds the other hand out to Christ, while a second man, in finer clothing, stands behind the first, leaning over his shoulder and pointing to Christ. Similar iconography in European art typically references an event that happened after Christ's resurrection. Two men were joined by a stranger on the road to Emmaus. They proceeded to walk together and discussed the disappearance of Christ from his tomb.[11] When they arrived at Emmaus, the two men invited the stranger to stay for dinner, and only upon breaking bread did they finally realize it was Christ before them. At this moment, Christ disappeared from their sight.

Christ's disappearance at the moment when the men finally understood, or saw, that it was Christ before them indicates that they now had spiritual sight, much like the native convert who witnesses the temptation of Christ above.[12] The unique linking of these two biblical events in the Mexicanus establishes the Christian identity and theological understanding of the book's patrons, perhaps even witness to such miraculous visions themselves and in command of biblical knowledge. This page also sends a message about New Spain. The appearance of a vision of the temptation of Christ in New Spain, as emphasized by Satan holding stones that are depicted in the iconic Aztec style, marks the colony as a place chosen by God to receive such a miracle.

Further speaking to the Christian identity of the Mexicanus' creators is a series of hieroglyphic compounds added to pages 52–54 (Figure 1.3; Plates 27–28). An explanation of these compounds and their translation is included in Appendix 1. Taking advantage of a blank space in the pictorial history, the painter of this section was clearly referencing the Christian world, as the signs are interspersed with two images of a crucified Christ. Moreover, one of the recurring signs includes a banner inscribed with the word *dios*, or God, and placed over a stone icon (*te-tl*). The reference to the numbers 14 and 7, as well as the repetitious patterning of some of the compounds, points to this being an excerpt from the Articles of Faith, which was one of the prayers that Nahua converts were required to learn.[13]

Catechisms, including the Articles of Faith, were translated into Nahuatl by Franciscan

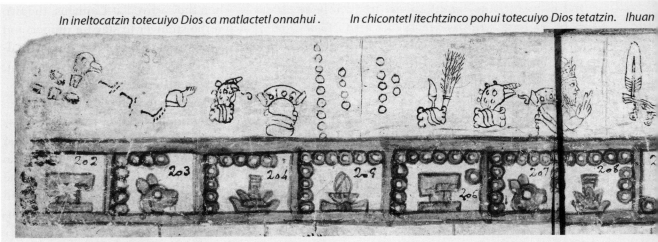

In ineltocatzin totecuiyo Dios ca matlactetl onnahui . In chicontetl itechtzinco pohui totecuiyo Dios tetatzin. Ihuan

Here are his believed things, Our Lord, God, there are 14. Seven, to him pertain, Our Lord, God, the Father. And t

friars, such as Pedro de Gante (1981, 22v-23v) in his *Doctrina christiana en lengua mexicana.* Native writers then took the Nahuatl texts and recorded them using Aztec pictorial script. These are often referred to as "Testerian" manuscripts, after the friar Jacobo de Testera, but Louise Burkhart, Elizabeth Boone, and David Tavárez (2016, 30) have shown that the impetus for the creation of these came more from indigenous communities, as would also be true of the Mexicanus. About a dozen pictorial catechisms are known today, perhaps created as early as the sixteenth century, but the majority were produced through the seventeenth and eighteenth centuries (Burkhart, Boone, and Tavárez 2016, 9). For instance, a pictorial catechism owned by the British Museum (Egerton Ms. 2898) also records the Articles of Faith, but the style is quite different from the Mexicanus (Figure 1.4). The painter of the Mexicanus catechism uses a repertoire of icons that are seen in other sections of the codex and depicts these signs in an assured manner that suggests this section was added close in time to the initial creation of the book and likely by one of the

same artists who contributed other material to the work. Moreover, some of the compounds are obscured by the book's binding, which indicates that this section was recorded before the codex was bound.

The excerpt of the Articles of Faith included in the Mexicanus focuses on an acceptance of God and Jesus Christ. Translated into English, it reads, "Here are His believed things, our Lord, God, there are fourteen. Seven to Him pertain, our Lord, God, the Father. The other seven to him pertain, our Lord, Jesus Christ, a man. First believed thing, it is He, our Lord, Jesus Christ. For our sake . . . " By recording this in the Mexicanus, its patrons made their acceptance of the Christian faith and its main tenets clear. The pictorial catechism would have also provided guidance to others seeking to memorize this prayer; by recording it, it would not be forgotten.

This message about the religiosity of the Mexicanus' creators and owners is especially important given the religious atmosphere of New Spain at the time the book was created. The period from the conquest to the 1560s was

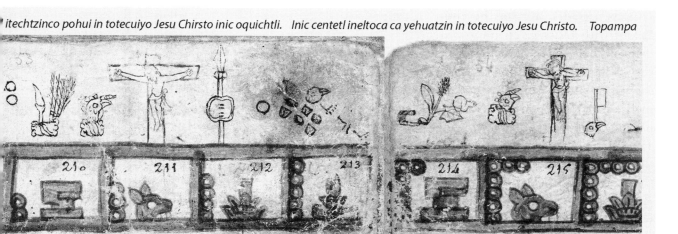

itechtzinco pohui in totecuiyo Jesu Chirsto inic oquichtli. Inic centetl ineltoca ca yehuatzin in totecuiyo Jesu Christo. Topampa

him pertain, Our Lord, Jesus Christ, as a man. First believed thing, it is he, Our Lord Jesus Christ. For our sake…

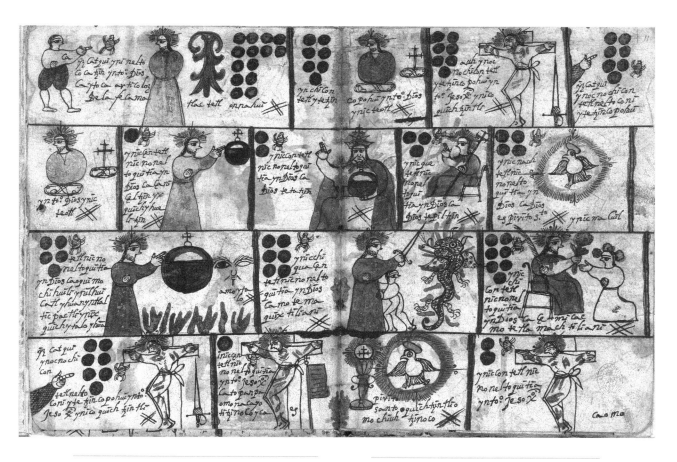

1.3 *Top*: A pictorial catechism in the Codex Mexicanus, pages 52–54. Courtesy of the Bibliothèque nationale de France.

1.4 *Bottom*: Articles of Faith, Egerton Ms. 2898, folio 11. © The Trustees of the British Museum.

seen as a golden age for the church in New Spain, with friars given unprecedented freedoms in their conversion efforts.[14] However, by the 1570s many Spaniards began to question the success of these efforts and were increasingly suspicious of what they saw as lingering paganism among the native converts (Peterson 1993, 171–176). The targeting of the friars for their perceived failures in the evangelization of the natives culminated with the *Ordenanza del Patronazgo* of 1574 (Padden 1956). This order was an attempt to officially limit the powers of the mendicant friars, who had worked closely with the native populations in the decades following the conquest, and to bolster those of the secular clergy. In so doing, the Ordenanza escalated already simmering tensions between the two divisions of the church (Schwaller 1986). In fact, the founder of the Colegio de San Pablo, Alonso de la Vera Cruz, was a particularly outspoken critic of the Ordenanza and the secular clergy (Ennis 1957, 181).

At this same time, debates about the intellectual capacities of the native peoples and their ability to become true Christians were reaching a climax. In Valladolid decades earlier, Juan de Sepúlveda debated Bartolomé de Las Casas about the rationality of the native peoples. Sepúlveda argued that the indigenes were barbarians, a people "in whom you will scarcely find traces of humanity; who not only lack culture but do not even know how to write, who keep no records of their history except certain obscure and vague reminiscences of some things put down in certain pictures" (in Hanke 1994, 85). Las Casas defended the natives: "They are not ignorant, inhuman, or bestial. Rather, long before they had heard the word Spaniard, they had properly organized states, wisely ordered by excellent laws, religion, and custom" (in Hanke 1994, 76). The dispute continued into subsequent decades and was seemingly settled

in Las Casas' favor in 1573, when Philip II promulgated an ordinance that essentially declared the natives rational and called for their "pacification" rather than "conquest" and for peaceful rather than forceful conversion (Hanke 1994, 120–121). Nevertheless, Spaniards remained suspicious of the extent of native conversion and deemed native converts unfit to be ordained as priests.

To what extent the creators of the Mexicanus were aware of the debates surrounding their abilities is unclear, but they were surely cognizant of indigenes being denied the priesthood. Moreover, Alonso de la Vera Cruz was a disciple of Las Casas and inherited his texts arguing for the rationality of the native peoples. Indeed, he wrote his own treatise arguing for the innate intellectual abilities of the native peoples (Hanke 1994, 119). If the Mexicanus' creators were a part of Vera Cruz's world, then it is not difficult to imagine their knowledge of these debates. Indeed, the contents of the Mexicanus provide a sharp rebuke to Spanish skepticism about native abilities, providing a space for its Nahua contributors and owners to assert their intellectual capacities and theological understanding.

Thus, the tense atmosphere of the 1570s must have contributed to a desire on the part of a group of educated Nahuas, perhaps educated in Vera Cruz's recently founded colegio and with access to his library and fearful of losing the guidance of their mendicant teachers, to create this particular book that marked its owners as exemplary Christians and provided its readers a means of worship independent of Spaniards. As Burkhart (1989, 18) has pointed out, by the 1570s, Nahuas were largely left alone to practice their own forms of Christianity. Created around this time, the Christian contents in the Mexicanus would have allowed the book's owners to continue their Christian worship without

interference from Spaniards, while also admonishing any Spaniards who would presume to question their intellectual capacities and Christian faith.

The inclusion of contents related to European medical practices also makes sense given the date of the Mexicanus' creation, a time when health was an overriding concern for the native population. Just a few years before the creation of the Mexicanus, the indigenous peoples had suffered a devastating epidemic. Noted on page 86 (Plate 44) of the annals section of the manuscript, the skull above the years 6 Flint (1576) and 7 House (1577) references the deaths caused by this epidemic, while an alphabetic gloss below reads *cocoliztli* (sickness). The actual cause of this disease is still debated, but it was particularly brutal and marked by fever, intense pain, and bleeding from the orifices. It began around Mexico City and quickly spread from there into the Valley of Mexico. The disease was fatal for natives, whereas Spaniards were minimally affected. Analyses of census data taken in 1570 and 1580 reveal that over 50 percent of the native population died during this outbreak, whose death toll reached its peak in 1576 (Acuña-Soto et al. 2004, 3–4). Although epidemics were common in the years after the conquest, this particular outbreak was one of the most severe and is the most frequently referenced in native sources (Prem 1991, 38). One can only imagine the psychological devastation of witnessing the deaths of so many. The Spanish chronicler Juan de Torquemada provided a particularly poignant description of the loss:

> It was a terrible thing to see the people who died, because the thing was that some were dead, and others about to die, and no one had the health or the strength to be able to cure one or bury another. In the cities and large towns, they opened great ditches, and from morning to night, the ministers did nothing else but carry corpses, dump them in, and cover them with dirt when the sun went down, with none of the solemnity with which the dead are usually buried, because there was not enough time and too many corpses. (Torquemada 1986, 1: 642, translated in Mundy 2015, 203)

The fact that the Mexicanus includes information on European medicine and was made just after this devastating outbreak suggests that the work was created, at least in part, as a reaction to the epidemic and through a desire to gain control, via European medical practices, in the case of future outbreaks. A statement by the mestizo chronicler Diego Muñoz Camargo (in McCaa 1995, 428) supports the perception that the Spaniards would have known the proper remedies to counter the disease: "this last one [1576] was not as great as the first two because although many people died many escaped with the remedies that the Spaniards and the religious people provided."

Surely because of population loss, the 1570s were also a time of transition politically for the native sphere of government in Mexico City, with Mexica nobles losing control over the city's indigenous *cabildo*, or town council. Don Antonio Valeriano, a highly educated nobleman from Azcapotzalco, became judge-governor of Mexico City in 1573 (Castañeda de la Paz 2011, 9). Valeriano's election over what must have been a number of Tenochca nobles with more powerful claims to the governorship than he had was likely tied to general upheavals occurring in New Spain at the time and a desire by competing natives and/or the viceregal government to reduce the influence of the Tenochca royal lineage (Connell 2011, 56). Even before this, during the 1560s, the Spanish cabildo unsuccessfully attempted to have the viceroy

decommission the native cabildo of Mexico City in an attempt to diminish the power of the native ruling sphere (Mundy 2015, 205).

New Spain also saw change at this time economically, as a new system of tribute had been introduced in the previous decade, stirring controversy. Indeed, the last governor of Tenochtitlan to have been descended from the Tenochca royal line, Don Luis de Santa María Cipactzin, was ensnared in the tensions that erupted with the shift in tribute (see Chapter 5). He had attempted to have the Spanish authorities exempt Mexico City from having to pay the new tribute, but he was unsuccessful and his people rebelled against him (Ruiz Medrano 2010, 62). The rebellion is pictured on page 84 (Plate 43) of the annals history. Moreover, in 1575, Philip II declared bankruptcy and increased taxes on the colonies (Ruiz Medrano 2010, 61–62). Not surprisingly, Alonso de la Vera Cruz was also an outspoken critic of the crown's attempts to tax the native peoples (Torre Rangel 1998). These economic changes would have caused further hardships for the Nahuas, especially in the wake of the 1576 epidemic, when they were still expected to maintain tribute payments (Gibson 1964, 391). The Mexicanus includes events related to the new monetary system and taxes in its annals history, pointing to this being another area of concern.

Thus, the Nahuas who lived during the final years of the 1570s witnessed profound changes within the religious, political, and economic spheres and at the same time had to contend with and make sense of devastating health crises. These upheavals also likely explain the tone of suspicion that began to permeate New Spain at this same time, bringing with it a more censorious attitude toward books, which were increasingly feared for the spreading of heretical beliefs. Indices of banned books from the sixteenth century included bibles and books of

hours written in vernacular languages, while a major purge of prohibited books occurred in New Spain in 1572 and targeted the libraries of the mendicant orders (Nesvig 2006).[15] A list of censured books that were confiscated from private citizens as well as monastic libraries includes dozens of books of hours as well as religious works written in Nahuatl, such as the *Doctrina christiana*, written by Juan de Zumárraga, the first bishop of New Spain, and even Nahuatl dictionaries, such as Fray Alonso de Molina's *Vocabulario de lengua mexicana* (Fernández del Castillo 1982, 471–495). In a letter written in 1579, the three orders united to plead to the Santo Oficio de la Inquisición to allow them to use religious works translated into native languages in their evangelization efforts (Fernández del Castillo 1982, 514). Books written by hand were also a cause of concern and accordingly confiscated; for example, one man had a handwritten book on astrology seized (Fernández del Castillo 1982, 483). Even works such as the Florentine Codex, compiled by the Franciscan friar and historian of Nahua culture, Bernardino de Sahagún, were confiscated due to fears, as Martin Nesvig (2013, 174) put it, "that such works would facilitate a spiritual recidivism to the old deities." In the *Real Cédula* of 1577, ordering the confiscation of Sahagún's work, there was an admonition against anyone writing a text in any language that dealt with the superstitions or way of life of the native peoples.[16]

Accordingly, the Codex Mexicanus, with Christian contents translated into native pictorial writing and references to sacred Aztec festivals and Mexica history, would surely have roused suspicion, perhaps even compelling later owners of the Mexicanus to suppress material that could be considered heretical. The very fact that the Codex Mexicanus was made at this time and with these particular contents is simply remarkable. By compiling and safeguarding

a book with such dangerous information, the Mexicanus' creators and owners were chancing punishment and the book's confiscation by Spanish authorities, which reveals the significance this book and its contents must have held for these native intellectuals.

The Codex Mexicanus and the Nahua Intellectual Tradition

The need to navigate a moment of change affecting so many areas of life—medical, religious, political, and economic—must have overridden the atmosphere of distrust that marked late sixteenth-century New Spain and compelled a group of Nahuas to create and consult the Codex Mexicanus. But who were these individuals? Besides a general link with the barrio of San Pablo and its colegio, it is impossible to identify them personally, though they can be classified in a more general manner as *tlamatinime*, the Nahuatl word for "wise men" (*tlamatini*, singular), derived from the root, *mati*, to know something.

According to Sahagún (1950–1982, 11: 29), the tlamatini "possesses writings; he owns books. [He is] tradition, the road; a leader of men . . . a bearer of responsibility, a guide." These same ideas come through in the *Coloquios y doctrina cristiana* compiled by Sahagún (1986) in the mid-sixteenth century from an account by Nahuas of an encounter in 1524 between missionaries and native lords. During this discussion, the native lords explained the role of the tlamatinime: "there are those who guide us; they govern us, they carry us on their backs and instruct us how our gods must be worshiped" (in León-Portilla 1963, 18–19). Also, the domains over which the tlamatinime presided mimic the contents of the Mexicanus; they were historians, priests, calendar specialists, physicians, astrologers, and diviners, but as Boone (2005, 10) writes, "the wise ones were first and foremost owners of books and the wisdom contained therein."

After the conquest, the tlamatinime continued the same intellectual project, though it was shaped by new colonial concerns, maintaining records linked to the Nahua past but adopting new intellectual practices tied to the Europeans. Boone (2014, xi) specifically notes the difficulties of the second half of the sixteenth century and writes that these wise men "carried responsibility both for preserving knowledge of the past and for guiding their people forward through the economic and cultural tumult of the times." Indeed, Boone (2014, x) suggests that the Nahuas who helped Sahagún saw themselves as performing a task similar to the tlamatinime of the preconquest era. The contributors to and users of the Mexicanus also acted as tlamatinime, with the Mexicanus being a container for a wide assortment of information crucial to know in late sixteenth-century New Spain. In fact, an inscription added to the Mexicanus in the eighteenth century relates the book to the tlamatini (see Chapter 6). Moreover, the recurring use of the word "guide" to describe the role of the tlamatinime and their books calls to mind the similar function of the Reportorios and the Mexicanus, which were also considered guides, but for life in Spain and New Spain, respectively.

The Western concept of the "intellectual" has been increasingly used to describe native authors of the colonial period, the Western equivalent to the Nahua tlamatinime (see Spitler 2005a; McDonough 2014; Ramos and Yannakakis 2014). Tristan Platt (2014) has noted how an application of Antonio Gramsci's (1971) concept of the "traditional" intellectual can help us better understand the native intellectual living under the ambiguity of colonial rule. As Platt (2014, 268) writes, these educated individuals

"positioned themselves or were recruited within a new order whose emergence they were able to facilitate, while also constructing, preserving, or refounding their pre-Colombian genealogies." The compilers of the Mexicanus, then, worked as intellectuals caught in an ambivalent tension. They crafted a book that brought the native and European worlds together in order to create a new form of cultural legitimacy based on the two traditions. However, they did so at a time in which their intellectual capacities were being questioned and when their access to knowledge was being threatened. To combat this pressure, the intellectual is often compelled to assert or gain autonomy from the dominant social group (Gramsci 1971, 138), and this is just what the creators of the Codex Mexicanus attempted through the creation of their book. Therefore, the Mexicanus also functioned as colonial discourse, a means by which its compilers and readers attempted to gain control over an unpredictable world.[17]

Gramsci (1971, 166) also links intellectuals with humanistic education, and as explained above, the creators of the Mexicanus were likely educated in such a system. Based on the contents of the Mexicanus, its compilers must have had access to both Spanish and Aztec sources, which may have come through a school such as that established by Vera Cruz. These schools were a place where Nahuas learned the intellectual practices of the Spaniards, but they were also a place where the missionaries learned about the Nahuas (Ramos and Yannakakis 2014, 8). Therefore, it is likely that native books were incorporated into the libraries of the colegios. Moreover, the process of using a library to gather information essential to know would not have differed too strongly from traditional practices, as preconquest tlamatinime also had access to libraries, typically attached to temple complexes and noble palaces, and through the

sources contained therein, they would be able to access important cultural knowledge and communicate this to the people.

By mediating between two worlds and gathering knowledge into book form, the contributors to and readers of the Mexicanus were engaged in an intellectual enterprise geared toward survival in a rapidly changing world. The description by Gabriela Ramos and Yanna Yannakakis (2014, 2) of the efforts of indigenous intellectuals in colonial Latin America nicely echoes the work of the Mexicanus contributors, "In an effort to make colonial life feasible, native people quickly engaged with and adapted to new media, ideas, and practices in order to advance their own interests within the often difficult circumstances of Spanish colonial rule." At the same time that they worked with a New Spanish cultural perspective, native intellectuals also "made use of knowledge rooted in the past as a means of survival" (Ramos and Yannakakis 2014, 2). This dialogue with both Spanish and Nahua cultural traditions is seen throughout the Codex Mexicanus.

María Fernández's (2014, 1) use of the concept of cosmopolitanism is helpful for understanding the multicultural nature of Mexican visual culture from the colonial era, as it "entails juxtapositions, amalgamations, and translations of visual materials from various cultural traditions." Fernández sees this process as linked with the work of intellectuals, and fundamental to identity formation. Hence, the Codex Mexicanus—with its contents carefully culled from native, European, and Christian intellectual traditions and spanning religion, history, and science—is a cosmopolitan work that formulates an identity for its patrons. By taking from Spanish books the information they considered essential to know and coupling it with information from Aztec books necessary to remember, the Mexicanus compilers and readers worked as

tlamatinime in the Aztec sense and intellectuals in the European sense, crafting and interpreting a book that would help them to live autonomously in a world that was growing increasingly unstable.

The Layout of this Book

Although the Codex Mexicanus appears at first glance to be a book of miscellany, the information it records pertains largely to the theme of time, which carries through much of its contents, as it does in the Spanish Reportorios and Aztec books. These contents point to four general thematic areas that structure this book on the Mexicanus: time and religion, health, lineage, and history.

The next chapter, "Time and Religion in the Aztec and Christian Worlds," focuses on the Mexicanus' concern with time and its relation to the sacred, a concern shared by Nahuas and Spaniards alike. In both societies, calendars were closely linked with religious practices and figured prominently in their books. The Mexicanus' calendric records point to a desire for power that must have been motivated by the religious tensions that characterized late sixteenth-century New Spain, as these records would have provided the book's owners religious autonomy.

Chapter 3, "Astrology, Health, and Medicine in New Spain," focuses on another shared belief of the Nahuas and the Spaniards, the connection between the stars and the human body, and consequently, between astrology and medicine. However, the Mexicanus focuses just on European medical astrology drawn from a Reportorio, which points to an area of anxiety for the owners of the book and suggests again that the desire for control, now over foreign pathogens, was another impetus for the creation of the book.

The next two chapters consider the vast historical records included in the Mexicanus. These were largely drawn from Aztec sources, but their inclusion in the Mexicanus is similar to the inclusion of historical records in the later Reportorios and, in a similar manner, speaks to the identity of the book's owners and readers. Chapter 4, "Divine Lineage: A Genealogy of the Tenochca Royal House," focuses on the Mexicanus' two-page genealogy, which I reveal is not a neutral document of a family line, but a carefully constructed argument about the divinity, order, and purity of the Tenochca royal dynasty. Chapter 5, "A History of the Mexica People: From Aztlan to Tenochtitlan to New Spain," examines the Mexicanus' pictorial history, which links events from the ancient Mexica past through the Spanish conquest and imposition of colonial rule to an Aztec timeline. By providing a reading of this pictorial history, I show that it does more than simply identify discrete events in the Aztec past. Like any history painting, it creates a moral narrative, and the outcome here is the ultimate triumph of Christianity over Aztec Tenochtitlan.

In Chapter 6, I reconsider the Mexicanus through these thematic areas and reveal that the Codex Mexicanus was a carefully curated collection of information that its native owners must have felt compelled to maintain. This book, then, provides a glimpse into the issues of importance to native peoples living in a moment of transition under Spanish colonial rule, a time when the religious personnel with whom they had so closely worked were losing their power, when diseases ravaged their populations, and when they were quickly losing political and economic control. The codex must have been seen as a tool by which its owners and creators, quickly becoming disenfranchised, could gain control over a rapidly changing world by maintaining access to knowledge related to the Mexica and Christian spheres. Ultimately, through the

book, its readers would have understood that despite their present depredations, New Spain and its Mexica citizens had an important role to play in the history of Christianity.

Nevertheless, at some point in its history, the Mexicanus became separated from its native owners. In an epilogue, I attempt to trace its journey from Mexico to the Bibliothèque nationale de France, where it remains today.

Time and Religion in the Aztec and Christian Worlds

Nahuas and Spaniards were profoundly concerned with time and its relation to the sacred world. For both societies, calendars were closely linked with religious practices and figured prominently in their books. As Burkhart (1989, 73–74) has noted, there was an affinity between the Aztec and Christian calendars, as each "provided a means of symbolically structuring both the passage of time and the interaction with sacred beings."

Thus, for Nahua Christians, the intertwining of religious observances with the traditional Aztec calendar as well as that of the Spaniards was a point of convergence between the two cultures. Although Gordon Brotherston (2000, 246–248; 2005, 79–94) has argued that the Mexicanus' calendars were an attempt by Nahua intellectuals to prove the superiority of their traditional means of tracking time over those used by Europeans, my reading of the Mexicanus points to its owners and contributors fully embracing Christianity and melding it with traditional beliefs.[1] By recording the dates of both Christian and Aztec sacred days in their book, the Mexicanus' compilers were correlating the Christian religious calendar with the Aztec one, while at the same time crafting a new conception of time. Thus, the Codex Mexicanus presents the two systems held in balance, not in tension, as a hybrid calendar suitable for New Spain.

In this chapter, I tie the interest in recording information related to the Christian and Aztec calendars to a desire for power and autonomy. In her study of medieval *computus* manuscripts used to make complex calendric calculations, Evelyn Edson (1996, 26) linked control of the calendar to power; as she wrote, "he who controls the calendar, controls the timing of many human activities." Moreover, she pointed out that the simultaneous celebration of a holiday such as Easter throughout the world would have signified the unity and ultimate triumph of Christianity, and this could only be achieved through the use of calendric manuscripts that allowed educated religious personnel to accurately calculate holy days no matter their location. Likewise, knowledge of the calendar and access to it would have provided independence for the Mexicanus' owners, enabling them to manage their own sacred activities. The Mexicanus was created at a time when the church in New Spain was going through a controversial transition, with power taken from the mendicants, many of whom had formed close relationships with the native peoples, and given to the secular clergy, without strong links to native populations. In this context, it would have made sense for the Mexicanus' creators to set down calendric records so that they could control religious observances without guidance or interference from Spaniards. The Mexicanus, then, meant religious autonomy for its native owners.[2]

References to native and Christian means of tracking time are sprinkled throughout the Mexicanus. The codex begins with a perpetual calendar that correlates important Christian holy and saints' days with Aztec sacred festivals from the 365-day *xihuitl*, or solar year (pages 1–8). The page after this includes two calendar wheels that link the Christian yearly cycle with its Aztec counterpart, suggesting that they have combined into one (page 9). More calendric information is notated on pages 13 and 14, which record a partial *tonalpohualli* (sacred year) along with some monthly festivals, while calendric calculations of some sort are recorded on page 15. The end of the manuscript (pages 89–102) picks up again with the Aztec tonalpohualli. Here we see one of the most common almanacs of the *tonalamatl*, wherein each page is devoted to one of the *trecenas* of the sacred calendar, but again with monthly ceremonies added. Unfortunately, the pages of this final section are mostly blank, but faint imagery under their gesso coating suggests these contents may have been whitewashed at a later date, perhaps due to fears that Spaniards would view such contents as heretical.

Aztec and Spanish Means of Tracking Time and Religion

For the Nahuas, time was structured around two calendars, one based on a 260-day sacred cycle and the other on a 365-day solar cycle.[3] Called tonalpohualli, or day count, the 260-day calendar consisted of twenty days, expressed with names such as Cipactli (Alligator), Ehecatl (Wind), Calli (House), Cuetzpalin (Lizard), etc., that cycled through coefficients from 1 to 13. Pages 13 and 14 of the Codex Mexicanus record a partial tonalpohualli, beginning at top left with 1 Atl (Water), followed by 2 Itzcuintli (Dog), 3 Ozomatli (Monkey), and so on (Plates 7 and 8). When the coefficient reached 13, the numerical count began again; accordingly, 13 Cipactli (Alligator) was followed by 1 Ehecatl (Wind). The Spaniards referred to each 13-day period as a trecena and conceived these similarly to their own seven-day weeks. Each trecena had sacred qualities, with particular gods having dominion over the trecena as a whole, and other gods holding sway over particular days

and the fates of those born on those days or actions taken on those days. The sacred associations of the tonalpohualli were recorded in tonalamatl; these were multipurpose books filled with calendric almanacs. They were consulted by the *tlamatinime* in order to read the fate of newborn children, predict the outcomes of marriages, and determine the times for planting and harvesting, as well as myriad other activities.

The other calendar, the 365-day xihuitl, or year, ran concurrently with the tonalpohualli but was civil in nature and not used for prognostication. However, in the Aztec world, the civil was tied to the sacred, so the xihuitl still had a religious component, being used to structure sacred rituals on a monthly basis. The xihuitl consisted of eighteen festival periods of twenty days each. Spaniards called these *veintenas* and thought of them as months. The last day of each period was marked by a large public commemoration devoted to a particular god. These ceremonies were also generally linked to the seasons and had agricultural associations. The names of the festivals gave each "month" its name, though some of these names vary in different sources. Five additional days, called *nemontemi*, were added to the end of the cycle to create the 365-day year and were generally considered inauspicious. The Aztec calendar did not have a mechanism by which to deal with the leap year, though the calendar could have been corrected to account for it (Hassig 2001, 81–82). The second section of the Codex Borbonicus, from the early colonial period, contains a section that illustrates the elaborate veintena celebrations that took place in 2 Reed (1507) and points to the significance of these ceremonies for the people of Tenochtitlan (DiCesare 2009, 123–153). As the sixteenth century progressed, more works illustrating and describing these festivals were made for Spanish patrons, who took a particular interest in the monthly festivals.[4]

The European calendar in use at the time of the conquest was the Julian calendar, which was based on the ancient Roman calendar, with a 365-day year divided into twelve months, each with a variable number of days, and with a leap year added every four years in February. The Roman calendar was also divided into weeks of seven days each; the seven-day cycle was independent of the yearly cycle, much as the thirteen-day periods of the tonalpohualli cycled independently of the 365-day xihuitl. The Julian calendar was accepted and formalized as the Christian calendar by the Council of Nicaea in 325 and soon became "completely saturated with the religious observances of the Church" (Delbrugge 1999, 3). The seven-day week, of course, continued into the Christian calendar, with Sundays easily given to the church. However, the moveable feasts, such as Easter, were more difficult to track, and the calculation of the date of Easter became a major concern for the church, as the Council of Nicaea had fixed Easter, in a rather complicated fashion, as the first Sunday after the fourteenth day of the moon after the vernal equinox. The cycle of the moon, then, also needed to be tracked, which led to the creation of a large number of manuscripts in the Medieval period devoted to the issue of time and calendar calculations, called *computus* (Wallis 1990).

By the sixteenth century, almost every day of the year was associated with a particular saint or holy event, and this succession of events or honorary days came to regulate the lives of Christian peoples (Delbrugge 1999, 4). In Spain, Medieval computus manuscripts became codified in the almanacs that were included in the *Reportorios de los tiempos*. The Christian calendar's debt to ancient Rome is evidenced in the *Reportorios* by the continued inclusion of the Roman calendar divisions of Kalends, Nones, and Ides in some of its calendars.[5] Like the stand-alone computus

manuscripts, the Reportorios included information on these saints' and holy days, along with information on other topics related to time, such as agriculture, astrology, and even medicine. Thus, they were multipurpose books, much like the tonalamatl of the Nahuas.

The ordered nature of the Aztec calendar and its links to public celebrations prepared the natives well for the Christian liturgical cycle (Burkhart 1989, 73–74; Lara 2008, 159). The affinity between the Christian and Nahua calendars in terms of their ordering of time and relation to the sacred and mundane worlds made the correlations of the two calendars of immense interest to Nahuas and Spaniards alike. In fact, the references to monthly festivals throughout the calendars included in the Mexicanus speak to an adaptation of the Aztec calendar that occurred after the conquest, when precedence was given to the xihuitl over the tonalpohualli, presumably because the civil calendar fit better with a Christian conception of sacred time. The correlation of the calendars and their relation to sacred days is best seen in the perpetual calendar that begins the Mexicanus and grounds the information that follows in the new hybrid world of the Nahua Christian intellectuals who created the codex and put it to use.

The Perpetual Calendar

The monthly calendar recorded on the first eight pages of the Codex Mexicanus devotes each page to one of the European months, beginning with May. As the first page is in poor condition, it is likely that the calendar was once complete, but the first four pages (January through April) and the work's cover, if there was one, have been lost. In contrast to the Mexicanus' genealogy and the beginning of its annals history, where a variety of colors are used, the dominant color

for the calendar is black, with red used for some details, which links these contents more closely to European books than to Aztec ones, as European books of the era were also printed predominantly in black with red highlights, whereas Aztec pictorial writing relied on color for much of its communicative potential.

As Prem (1978) has shown, the format and contents of the Mexicanus' perpetual calendar were also drawn more from European models than from Aztec ones. Each page of the monthly calendar begins with a column at the left that includes information on the month's name, zodiac sign, and length, written in both alphabetic and pictorial script. More information on each month is written to the right. The days of the month are written with their associated dominical letters, which are enclosed in circles. The dominical cycle begins each January 1 with *a*, which is followed alphabetically by the following six letters (*b–g*), referring to the days of the week. This seven-letter sequence repeats in a standardized fashion throughout the year. In the Mexicanus, these letters are enclosed in circles, with the *A* that begins each weekly cycle capitalized and written in red ink so as to stand out. Calendars such as this are known as perpetual calendars because they are valid in perpetuity and can be used year after year. Another series of letters floats below the dominical letter sequence and records the twenty-seven-day lunar cycle, important for tracking the moveable feasts such as Easter and also used in consultation with the medical astrology portion of the Mexicanus treated in Chapter 3.

Correlated with the calendar on the top register are significant Christian holy days, while on the bottom register are the monthly Aztec feast days, which suggests a visual equivalency between the two systems. Thus, the perpetual calendar tracks both time and religion, correlating the Christian and Aztec calendars and

bringing them together into a new system. Nevertheless, precedence is given to the Christian calendar in terms of structuring time, as the Christian months form the backbone of this section, while the Aztec sacred dates on the lower register serve as its foundation.

With the exception of the Aztec monthly festival references, the contents of the Mexicanus' perpetual calendar were clearly drawn from similar calendars published in Reportorios. For example, the Anonymous Reportorio of 1554 also includes a perpetual calendar (Figure 2.1). A print of each month's zodiac sign and associated labors precedes each month, followed by *KL*, the abbreviation for "month" in Latin, which points to the Roman origins of the monthly calendar. This is followed by a brief text that records the number of days and the hours of the day and night in the month. Then comes the actual calendar. Read from left to right, the calendar lists the days in Roman numerals, followed by a sequence of golden numbers, which are used to show a year's place within the Metonic lunar cycle. Next come the dominical letters for each day, then the saint or holy event associated with each day, and, last, that day's corresponding lunar letter. Beneath the calendar is a longer text that provides more information on each month, focusing largely on the month's agricultural associations and astrological nature.

2.1 September, Anonymous, *Repertorio de los tiempos*, 1554, folios 34v–35r. Universidad de Salamanca (España). Biblioteca General Histórica.

Calendario.

```
xxj    xviij  b  Priuado martyr.
xxij   vj     c  Octaua de nuestra señora.
xxiij         d  ℭ Vigilia.
xxiiij xiij   e  Bartholome apostol.
xxv    iij    f  Luys rey de Francia.
xxvj          g  Seuerino papa.
xxvij  xj     A
xxviij xix    b  Augustin obispo.
xxix          c  Degollacion de sant Juan baptista.
xxx    viij   d  Felix, y Audacto.
xxxj          e
```

ℭN este mes de Agosto es bueno quemar las tierras, o para pan, o para pasto, y echar el estiercol en las tierras de pan. Agora se deuen sembrar los attramuzes, y en auiendo llouido se pueden bien sembrar los nabos para tardios. Puedense muy bien sembrar rauanos, y coles tardias, y deuen se arrancar las cebollas para guardar. En el fin deste mes se coge la simiente delas mielgas y alfalfa. Hazen se en este mes las passeras delos higos, duraznos, priscos, ciruelas. Deuen se assi mesmo aparejar lo nescessario a vendimia. Es bien en este mes buscar agua para hazer pozos, porque donde agora se hallare. Deue se tener por cierto q la aura todo el año. Y es prouecho so sembrar ceuadas y trigos.

ℭLa compañia delas mugeres es dañosa, y el sueño del medio dia es peligroso, entrar en los baños es dañoso, y el mucho comer, no se deue nadie sangrar ni purgar sin extrema necessidad, ni tomar ninguna medicina.

KL Septiembre tiene treynta dias. la luna vente y nueue. El dia tiene doze horas, la noche doze.

Calendario. xxxv.

```
j      xvj    f  Sant Gil abbad.
ij     v      g  Antonio martyr.
iij           A  Doroctea virgen.
iiij   xiij   c  Moyses confessor.
v      ij     d  Victorino martyr.
vj            d  Eugenio obispo y confessor.
vij    x      e  Sant Juan martyr.
viij          f  Natiuidad de nuestra señora.
ix     xviij  g  Gorgonio martyr.
x      vij    A  Nicolas de tolentino.
xj            b  Proto, y Jacinto.
xij    xv     c  Maximiano obispo.
xiij   iiij   d  Maureolo obispo.
xiiij         e  Exaltacion dela Cruz. ℭ Sol en libra.
xv     xij    f  Nicomedis martyr.
xvj    j      g  Eufemia virgen.
xvij          A  Lamberto obispo y martyr.
xviij  ix     b  Victor, y corona.
xix           c
xx     xvij   d
xxj    vj     e  Matheo Apostol.
xxij          f  Mauricio con sus compañeros.
xxiij  xiij   g  Lino papa y martyr.
xxiiij iij    A
xxv           c  Firmiano obispo.
xxvj   xj     c  Cipriano, y Justina.
xxvij  xix    d  Sant Cosmes, y sant Damian martyres.
xxviij        e  Exuperio confessor.
xxix   viij   f  Sant miguel.
xxx           g  Hyeronimo confessor.
```

ℭN la cresciente de Septiembre, es bien començar la sementera. En tierras frias deuen sembrar las aruejas, hauas, attramuzes, es buena la sementera del trigo, siembra se el lino que llaman vayal q no se riega, sembrar los alcaceles tempranos, y en las tierras calientes se siembran dormideras, y enel fin deste mes se ponen los cogollos de clauellinas, los quales

E iij

The contents of the Reportorio calendar are largely repeated in the Mexicanus, which even mimics the Gothic font of the Spanish books, further corroborating that the Mexicanus' contributors were using a European source. Nevertheless, the creators of the Mexicanus' perpetual calendar only chose to include select contents in this section. For example, the Mexicanus does not include information pertaining to the labors, fitting for a book made by and for educated citizens of Mexico City and without the cultural baggage of urban elites in Europe. Nor did the contributors to the Mexicanus include agricultural information derived from the Reportorios in this section, perhaps because the Aztec monthly festivals themselves were largely tied with the agricultural calendar and covered this information sufficiently for a native audience. Moreover, the Mexicanus does not mention the hours in the day and night, which is fitting, as European hours were not imposed in New Spain because they were not seen as necessary for life in the Aztec world (Hassig 2001, 143). Finally, the Mexicanus scribes left out the Roman calendar divisions, replacing these with Aztec references, thereby suggesting that they saw the Aztec calendar as equivalent to the Roman one. The way in which information is communicated has also changed. For example, the majority of information is recorded in the pictorial script of the Aztecs and only limited information is recorded using the alphabetic text of the Spaniards. Also, the contents in the Mexicanus are written in a horizontal fashion with a left-to-right reading order that is also seen in the Mexicanus' genealogy and annals history, whereas the Reportorio calendar organized the days of each month in a vertical composition.

PERPETUAL CALENDAR: ZODIACAL INFORMATION

Unfortunately, the left columns for the first two months (May and June) are in poor condition and impossible to read today, but July on page 3 is fairly clear and serves as a useful example for the pattern that follows in subsequent months (Plate 2). At the top of the column is the word "Leo." Under this is the zodiac sign's pictorial icon of a lion, then the European icon for the moon, a circle enclosing a crescent moon and profile face. As the Romans held that the first day of the month was tied to a new moon, the moon icon came to signify month and repeats for each new month in the Mexicanus. The Latin name of the month, here "Julius" for July, is written alphabetically under this. The pictograph below varies from month to month. These are difficult to read definitively, but I suspect that they may phonetically "spell" the name of the European month using Aztec pictography. For July, the pictograph is a flower, perhaps eliciting the Nahuatl word xoch-itl as an approximation of "Julius." The difficulty the tlacuilo, or scribe, would have encountered in rendering foreign words with Aztec pictorial script is that many of the phonemes used in Spanish have no equivalent in Nahuatl, resulting in scribes using phonetic approximations and substitutions and making their exact readings difficult to trace today. Finally, disks and banners are shown at the bottom of each column; these function as icons for numbers in Aztec pictography. Each disk records the number 1, while the banner is used for 20. As each column has one banner and a variable number of disks from 10 to 11, they must record the number of days in each European month, from 30 to 31. For July, 11 dots float above a partially effaced banner, giving a total of 31 for the number of days in this month. Hence, the information in this column is an

introductory device that communicates the page's association with July, a month with 31 days in it and ruled by Leo.

The remaining months follow this same pattern. For August (page 4), the final letters of the word "virgo" are barely visible, while under this is its pictorial icon of a young woman with long flowing hair (Plate 3). She holds a flower in one hand and perhaps something in her other but the image is unclear, effaced by wear at the edge of the page. In images of Virgo from European zodiacs, the young woman often holds a flowering branch in one hand and a martyr's palm in the other, as she does when Virgo is shown again on page 11 of the Mexicanus (Plate 6). The image of Virgo in the perpetual calendar seems to have been painted by a different artist, as the Virgo in Plate 3 sits rather awkwardly with her knees drawn up in front, a pose typical of seated men in Aztec pictography, whereas Aztec women are shown in a kneeling posture. Clearly copied from a European source, this image of the virgin was not necessarily filtered through a Nahua worldview. The standard moon icon appears below this, but the rest of the column is in poor condition.

The zodiac signs for the next three months are fairly clear (Plates 3 and 4). Scales for Libra mark September, a scorpion associates October with Scorpio, and a bearded centaur shooting an arrow links November with Sagittarius. Each of these columns includes the moon icon and a hieroglyphic compound that all share one component, an animal's head. For September, the animal is paired with a stone (*te-tl*); for October, the animal's head peaks out of a pitcher (*oc-tli*), and for November, it is topped by a woman's head (*cihua-tl*). In Spanish, each of these months ends in *–bre* (*septiembre, octubre,* and *noviembre*), which points to the animal head approximating this syllable, while the additional compound likely records another sound within the month's name, as best seen with the pitcher

(*oc-*) for octubre. Unfortunately, these are difficult to translate completely. Below each of these is an indication of the number of days in each month, some easier to read than others.

The Mexicanus painter, then, took the introductory information from the perpetual calendar of a Reportorio and translated much of it into pictorial form, even when such translations were particularly difficult, such as the European month names. This confirms the native audience for this work. Moreover, the introductory information that was typically included in the Reportorios but was left out of the Mexicanus was the image of the labors, perhaps because these held little significance for urban elites of New Spain, unlike the zodiac signs, which, as explained in the next chapter, were important for the practice of medicine, which is fitting, as a concern with health would have taken precedence at the time the book was created.

PERPETUAL CALENDAR: CHRISTIAN SAINTS' AND HOLY DAYS

Each of the zodiac columns is followed on the right upper register by a Christian saints' calendar, wherein the names of the Christian saints and holy days that were written alphabetically in the Reportorios were translated into a pictorial system of writing and in a variety of ways, suggesting that multiple painters contributed to this section. At times, they used hieroglyphic script to phonetically "spell" the name of a saint or holy event, but more frequently, they identified saints via their attributes, typically combining the attribute with an image of the saint and more rarely using the attribute alone. Sometimes they even combined hieroglyphs and attributes.

In his analysis of the phonetic potential of the Aztec system of writing, Joaquín Galarza (1980) devoted attention to this section of the Mexicanus and had a number of perceptive insights.

For example, Galarza (1980, 42) noted that a recurring sign used to identify many of the saints' days throughout the Mexicanus' calendar is an icon of a brick wall, which must have functioned as a sign for *xam-itl*, or "adobe wall" in Nahuatl. In possessed form, *xam-itl* becomes *xan*. As the Nahuatl language did not use the *s*- sound, *x* (pronounced *sh* in English) would have served as a useful approximation; hence, *xan* equaled *san*, or saint. To identify the particular saint, the Mexicanus painters combined the *xan* sign either with an image of the saint and his or her attribute(s) or with a hieroglyphic compound that approximated the name of the saint.

As the Reportorio calendars list saints' names via alphabetic text and not imagery, the Mexicanus painters must have also had access to images of saints and their attributes, either transmitted as single prints, in books (see Figure 2.2), or in church murals, and they adapted these into their pictorial script. When hieroglyphic compounds were used to "spell" saints' names, this was likely because the painter had no visual models upon which to draw. Thus, the Mexicanus contributors used all the tools in their arsenal to communicate information using a visual system. Moreover, they must have sought outside representations for this project, evidence of a creative vocabulary and mastery of Christian symbolism, as it would have been far easier to simply copy the alphabetic text of the Reportorio.

Below, I provide a reading of the months and their Christian holy days. For the most part, these visual records are easy to read when cross-referenced against the calendars included in the Reportorios. This cross-referencing also reveals key insights into the Nahua practice of Christianity. As I show, the inclusion of particular holy days in the Mexicanus points to a liturgical calendar linked more to New Spain than to Spain.

May

The first page, for May, is in poor condition, but an image of a cross is visible toward the beginning of the month (Plate 1). Although the exact date to which it was linked is not clear, the reference most likely was to May 3 as the day of the Invention of the Cross. May 15 is called out as another Christian holy day in the Mexicanus via a badly damaged icon that seems to be a spade, which is used in Spanish art to reference St. Isidore, the patron saint of farmers, whose feast day was indeed on May 15.[6]

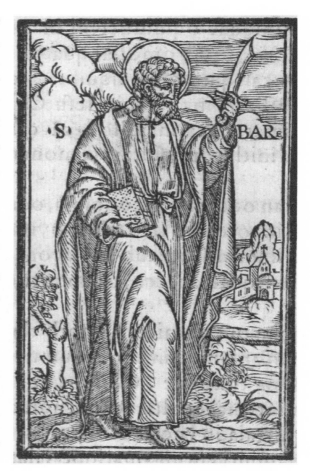

2.2 St. Bartholomew, Bernardino de Sahagún, *Psalmodia christiana y sermonario de los santos del año*. Nettie Lee Benson Latin American Collection, the University of Texas at Austin.

June

June begins with the phrase *quatollotepore* written vertically in a Gothic font modeled after text in European books (Plate 2). This word references the Latin phrase *quattuor tempora*, or *quatro temporas* in Spanish, and is an interesting transliteration, as it suggests that the scribe was not simply copying an alphabetic text directly but instead hearing the words spoken and phonetically writing them down. Known as "Ember Days" in English, these days fall on the Wednesday, Friday, and Saturday of a particular week in each of the four seasons and were days set aside for fasting and prayer. Here, the phrase refers to the second set of Ember Days that fall the week after Pentecost. As Pentecost is a moveable feast, this set of Ember Days would not have been fixed in the Christian calendar. Their placement in June supports a correlation of 1579 with the painting of this calendar, as the Ember Days fell in early June in that year, whereas those for the year just before and after fell in May.

A pictorial icon of a fish appears three times in June and also in August, September, and December. These mark days of vigil, which were days of abstinence for Christians, meaning they could not consume meat from mammals or fowl, but they could eat fish. Accordingly, these days came to be known as fish days. In the Reportorio saints' calendars, these days are simply marked as days of *vigilia*, as seen in the Anonymous Reportorio on September 20 (see Figure 2.1).[7]

June also contains three important saints' days. Each of these days is recorded with an image of a haloed man wearing long, robe-like garments and seated on the adobe wall, or xan sign, marking each man as a saint. Each is further identified by his attribute. Above June 11, St. Barnaby gestures with one hand toward

a book held in his other; the book must reference the Gospel of St. Matthew, which is one of his attributes. June 24 is the day of St. John the Baptist, who is shown pointing to three of his attributes, all held in one hand: a lamb, a book, and a cross. Although cut off by the book's binding, the partial image above June 29 must reference St. Peter, as this was his holy day and the visible key his attribute. St. Peter shared his day with St. Paul, who may have originally been included in the Mexicanus, but the book's binding makes it impossible to see today.

July

The Mexicanus includes four holy days for July (Plate 2). The first falls on July 2 and is the day of Visitation, Mary's visit with Elizabeth, or Isabel in Spanish. This day is recorded via an image of a young, haloed woman with long flowing hair. She is shown in profile and holds her hands together in a gesture of prayer. This will be a standard means of depicting Mary in the Mexicanus calendar, but here it is combined with a hieroglyphic compound that includes an eye (*ix-tli*) plus the sign for water (*a-tl*). These approximate the first two syllables for "Isabel," or *ix-a*, and together the compound communicates that this is the day of Mary *and* Isabel for the Visitation.

July 22 brings the feast day of Mary Magdalene, which is recorded with a haloed saint whose long hair marks her as female. Only her torso is shown above the standardized xan sign, and she is shown in a more narrative representation with tears falling from her eyes and into a chalice she holds in her extended hands. The tears are shown in the Aztec fashion, as small streams of water ending in disks. This image evokes the story of Mary Magdalene washing the feet of Jesus with her tears and then anointing them. In prints of Mary Magdalene, the vessel that held the ointment is often included

as her attribute, but the actual tears with which she washed his feet are not typically indicated. In contrast, in this inventive rendering of the event, the Mexicanus artist combines the elements of the story, filling the vessel with the tears instead of the ointment.

The day of St. James Major is linked to July 25. Known to Spaniards as Matamoros, or Moor-killer, St. James is also shown in a more narrative fashion, as a warrior on a rearing horse, but without the Moorish victim. He was the saint most frequently evoked during the conquest and accordingly became a patron of the conquistadors. The popularity of St. James in New Spain paired with the more narrative representation here suggests the painter's familiarity with his image, which would have been commonly displayed during celebrations of his day.

Although the holy day at the end of July is a bit effaced, the long hair and xan sign mark this as a female saint, and her association with July 26 shows this was the feast day of St. Anne. An image that appears to be a profile face floats in front of Anne's praying figure, but it is difficult to make out completely. Because Anne is listed in the Reportorios as "Anne, Mother of Our Lady," the smaller face could have been intended as a reference to Mary, but due to the damage of the page, this is impossible to confirm. Throughout the saints' calendar, long hair is used to mark figures as female. However, in Aztec pictography, long hair worn down is a visual referent for a young, unmarried woman, whereas older, married women wear their hair in a wrapped and braided style. Accordingly, on this page, the images of the Virgin Mary, Mary Magdalene, and St. Anne are effectively equalized as female based on European visual conventions.

August

The month of August is packed with holy days, with the first falling on August 5 and recorded with a hieroglyphic compound placed on top of the xan icon (Plate 3). Galarza (1980, 46) reads the rest of the compound as bird (*toto-tl*) and arrow (*mi-tl*), for *xan-to to-mi*, an approximation of Santo Domingo, or St. Dominic. St. Dominic was the founder and patron saint of the Dominican order, which had special prominence in New Spain, being the second order to arrive in central Mexico (after the Franciscans) and evangelize the native peoples. However, the phonetic rendering of the saint's name in the Mexicanus suggests that the painter was unfamiliar with attributes associated with the saint. In fact, I suspect that the image of a bishop's bust above August 6 was added to clarify that the earlier compound did indeed reference the bishop, as a faint line connects this image with the hieroglyphic compound. Moreover, while some calendars list August 5 as the day of St. Dominic, others list it as the day of Santa María de la Nieve. Thus, the bishop's miter would have secured the identification of this day as that of St. Dominic rather than Santa María de la Nieve. Although another line links the image of the bishop with August 6, this is typically listed as the holy day of Transfiguration, and it would have made little sense to communicate this day with a bishop icon.

Five more feast days complete August. For August 10, the day of St. Lawrence is recorded only via his attribute, the gridiron of his martyrdom, which is included in numerous images of the saint. August 13 is the feast day of St. Hippolytus, though the associated compound in the Mexicanus is difficult to reconcile with this name. Here the xan sign is combined with a stone (*te-tl*) and the head of a young, beardless man wearing a tight-fitting cap with a halo marking his divinity. August 15 is marked as the day of the Assumption of the Virgin, the principal feast of Mary. This is shown in a narrative fashion with a small cloud filled with stars and scrolls at the bottom. Two feet emerge from a long skirt and are shown disappearing into the

cloud, signifying her elevation into heaven. The day of St. Bartholomew (August 24) is pictured without the ubiquitous xan sign, though the saint does have a halo. He is shown holding a book and a large knife, as tradition holds that he was martyred by being skinned alive. A number of prints from the sixteenth century, such as the one published in Sahagún's *Psalmodia*, show the saint holding both the book and a knife in a similar style (Figure 2.2). The pictograph for St. Augustine, shown above his feast day of August 28, is a bit difficult to understand. The xan sign marks this as a saint's day, and the image of a mitered man must reference St. Augustine, who was also a bishop. However, the purpose of the additional sign, which looks like a jar (*co-mitl*), is unclear.

September

September contains a number of holy days (Plate 3). The first falls on September 8 and is another day devoted to the cult of Mary, her nativity. Again, Mary is shown in profile as a young woman, with halo, long hair, and hands held in prayer. Here, she is placed over a stream of water (*a-tl*) that ends with the wrinkled face of an old man (*hue-hue*), approximating Ave Maria, or *a-hue* Maria (Galarza 1980, 43). A week later, the Feast of the Holy Cross is shown on September 14. Reading from bottom to top, the first sign is the brick wall for xan, then an iconic stone for *te-tl*. This compound, then, approximates the word *xan-te*, for Santa, which is then paired with an elaborate cross to indicate the day of Santa Cruz. Immediately following this is an alphabetic text, *quatollotepore*, referencing the third set of Ember Days, which fall directly after the day of Santa Cruz. Less than a week later, a fish marks a day of vigil.

The final three holy days in September are devoted to four saints. September 21 is the day devoted to St. Matthew, whose torso is shown on top of the xan sign. He holds a book in one hand,

an allusion to the writing of his gospel. In his other hand, he holds a long instrument, perhaps a writer's stylus or a sword, both of which are his attributes. On September 27, the shared feast day of Sts. Cosme and Damian is combined into one hieroglyphic compound, with the xan sign as a base (Galarza 1980, 46). For Cosme, the scribe uses a jar (*co-mitl*) and maguey (*me-tl*), for *co-me*, and for Damian, the stone sign (te-tl) with something unclear above. The final feast day falls on September 29 and is devoted to St. Michael the Archangel. Although much of the paint has flaked off here, St. Michael's typical representation as a winged warrior wielding some type of weapon can just barely be made out.

October

Two anomalous historical notices are included in the perpetual calendar, and the first of these falls in October (Plate 4). Linked to October 4th is an image of descending footprints, communicating arrival, and a man's head. The hat and beard mark this man as a Spaniard, and since the new viceroy, Lorenzo Suárez de Mendoza, arrived in New Spain on this date in 1580, this image must record his arrival. The addition of this news further supports my dating of the Mexicanus, as it points to the event being added to the book soon after the actual arrival happened. Indeed, the image seems to have been added after the saint shown for the same day, as it is squeezed to the left of the saint. Almost an exact duplicate of this image is shown in the annals history on page 86, again recording the arrival of the viceroy (Plate 44). The Mexicanus, then, was a living document, updated over time.

The viceroy's arrival happened on the day devoted to St. Francis (San Francisco), which is also linked to October 4. Placed on top of the xan sign, St. Francis is identified by his beardless face and friar's garments. However, a hieroglyphic compound was also included,

presumably to clarify the friar's exact identity with a phonetic rendering of his name. The compound consists of a banner (*pan-tli*), shells (*cill-in*), and a jar (co-mitl) for *pan-cil-co*, an approximation of Francisco, which must have been a difficult name for the Mexicanus scribe, as the *f*, *r*, and *s* phonemes were not used in the Nahuatl language (Galarza 1980, 46). Interestingly, the three saints associated with the mendicant orders in charge of evangelization efforts in New Spain (Saint Francis, Saint Dominic, and Saint Augustine) are all shown with hieroglyphic elements, suggesting that the painter of these days was unfamiliar with their attributes or desired to stress the pronunciation of their names.

Completing October are three days of vigil and two more saints' days. Each saint is shown as a bearded man with a halo and placed on top of the xan sign. For St. Luke, whose feast day falls on October 18, a book, stylus, and inkwell act as his attributes and reference the writing of his gospel book. October 28 was a double holy day, being devoted to Saints Simon and Judas. However, in the Mexicanus, only one saint is shown, and he holds an axe, which is the typical attribute of St. Judas.

November

The first day of November was All Saints' Day, or *Todos Santos* in Spanish (Plate 4). In the Mexicanus, this day is written phonetically. In Nahuatl, plurals are formed by adding a suffix of −*me*. Hence, if someone were to take the Spanish word *santo* and make it plural in Nahuatl, it would become *santo-me*. In the Mexicanus, the xan sign is combined with a bird glyph (for *to-to-tl*) and maguey sign (for *me-tl*). Together, these signs approximate *xan-to-me*, or *santome* for all the saints (Galarza 1980, 45). This is followed by the Day of the Dead for November 2, now written symbolically, with a funerary

bundle laid flat in the Christian fashion and topped by a candle with an extinguished flame, a Christian symbol of death (Galarza 1980, 40).

Another historic notice was added to this month, but its meaning is not entirely clear. Toward the beginning of the month, another image of a Spanish man's head floats above the timeline, but without the footprints suggesting arrival and not linked to a specific day. This must record another historic event, perhaps one that happened in early November 1580 or perhaps the date of the arrival of Hernán Cortés in Tenochtitlan on November 8, 1519, as the head floats above this day. However, the exact meaning of this addition is unclear, as it is untethered to the calendar and it includes no identifying characteristics for the figure beyond his Spanish identity.

Three more saints' days complete November. November 11 is marked as the day of St. Martin, which is communicated with a representation of a bearded man wearing a bishop's miter and placed atop the xan sign. St. Martin was also known as the Bishop of Tours, hence the image of a bishop to signify his day. The feast of St. Catherine is recorded for November 25. Placed on top of the xan sign, a profile face with long hair identifies this as the day of a female saint, and her attribute of a wheel, referencing her martyrdom, specifically marks this as her day. November 30 was the day of St. Andrew, as indicated with an x-shaped cross above the xan sign and below the remnants of a bust of a saint. The St. Andrew's cross is his attribute, as he asked not to be crucified on the traditional cross because he was unworthy of emulating Christ.

December

December was the busiest of months in the liturgical year (Plate 5). It included two days of vigil and two holy days devoted to Mary's cult. The first, on December 8, is the day of her

conception. Again, Mary is pictured as a young woman, pious and divine, while under her, a hieroglyphic compound approximates the word *concepción*. The painter uses the familiar jar sign for *co-* with an image of shells on either side (*cil-li*), perhaps for *co-cil* as an abbreviation of *concepción* (Galarza 1980, 43). The second, on December 18, is the Expectation of the Virgin's Delivery, also known as the day of Santa María de la O. The Mexicanus painter references this day with the now-codified icon of Mary, but with a glyphic compound that, according to Galarza (1980, 45), phonetically approximates the Latin *expectatio* and includes a bean (*e-tl*), an eye (*ix-tli*), a stone (*te-tl*), a face (*xayaca-tl*), and shells (*cil-li*).

The feast day of St. Lucy fell a few days earlier, on December 13. The Mexicanus scribe recorded this by coupling the xan sign with a stone (*te-tl*) above, for *xan-te*, or Santa. The female saint on top holds a plate with two eyes on it, the attribute of St. Lucy, whose eyes were torn from their sockets. St. Lucy is one of only two saints to be shown in the Mexicanus in a three-quarter view rather than a profile view, which suggests the image was based on a print. Below St. Lucy, the Ember Days are again noted.

The feast day of St. Thomas is indicated for Dec. 21. His name is written in a completely phonetic fashion and includes the xan sign, the head of a bird (*to-to-tl*), and a hand (*ma-itl*) for San To-ma (Galarza 1980, 46). A few days later, on Dec. 25, the Nativity is shown with a baby in an oval made of parallel lines. The next day, that of St. Stephen, is recorded with the head of a young man wearing a crown of stones, referencing his martyrdom via stoning. However, Galarza (1980, 37–38) points out that the stones, circling his head may also reference the name Stephen, which means "crown" in Greek. If correct, then the painter has come up with a unique way of indicating both the saint's martyrdom and the etymology of his name. The day of St. John is indicated for December 27. He is shown beardless to reference his youth, and he holds his attribute of a chalice. His image includes a halo but excludes the xan sign. A line that extends from December 28 suggests that another saint's day was included here, but the image is no longer visible. Most likely this was the feast day of Santos Inocentos. The head that floats at the top of the page may have referenced this day or another holy day that fell on December 29, the day of St. Thomas of Canterbury, but this is inconclusive due to the poor condition of the manuscript.

THE PERPETUAL CALENDAR AND HOLY DAYS

Although almost every day of the liturgical year could be associated with a saint or holy event, Christians were only obligated to observe a limited number of these days. In the Reportorios, these days are typically called out with a cross or rosette, marking them as days of *santissima sacramento*. For example, the Anonymous Reportorio includes a number of saints' days in September but only includes a rosette at September 8 for the Nativity of Mary, September 21 for St. Matthew, and September 29 for St. Michael (see Figure 2.1). Most of these same days were included in a list that detailed the religious obligations of Spaniards living in the New World; this list (henceforth called the *Arzobispado* list) was published and distributed by the church in New Spain (*Constituciones del Arzobispado* 1556, 10v). The obligations for indigenous converts, however, were not as strenuous. In a Papal Bull of 1537, the new converts were given special dispensation because of their poverty and only had to recognize a limited number of holy days and only the shared saints'

day of Sts. Peter and Paul. Nevertheless, the saints' and holy days included in the Mexicanus adhere to the larger number of sacred days Spaniards were obligated to worship and not to the abbreviated list of the natives. This points to the ambitions of the Mexicanus contributors and their desire to lay claim to the same power and status as Spanish Christians.

The friars working with elite converts must have also promoted their full worship, as books published in New Spain for the indoctrination of the Nahuas also included the complete roster of saints and holy days and not the abbreviated list. For example, Fray Pedro de Gante's *Doctrina christiana en lengua mexicana* includes a perpetual calendar with special holy days highlighted in red; the page for September highlights the same holy days listed in the Mexicanus (Figure 2.3). Fray Juan de la Anunciación's *Sermonario en lengua mexicana* (1577), dedicated to Fray Alonso de la Vera Cruz, also includes a calendar with holy days marked with a rosette (Figure 2.4). By including a full roster of holy days that exceeded the religious obligations imposed by the church, the Mexicanus identifies its patrons and contributors as exemplary Christians, able to worship just as their mendicant teachers did.

A comparison of the sacred calendars published in Spain and New Spain with the Mexicanus reveals the emergence of a distinctively New Spanish liturgical cycle. The days that were highlighted as being of santissima sacramento are largely consistent in the published sources, and these, for the most part, are the same holy days recorded in the Mexicanus. However, the Mexicanus includes some holy days that were not considered days of santissima sacramento. One of these additions speaks to a burgeoning form of Christianity for New Spain that would become a key part of Mexico's national identity, the celebration of All Saints' Day and All Souls' Day. All Saints' Day is consistently highlighted

as a day of santissima sacramento in the sources published in both Spain and New Spain and is included in the Arzobispado list as a holy day that all Spaniards were obligated to observe. However, All Souls' Day was not highlighted in the published sources. As seen in the *Sermonario* (Figure 2.4), All Saints' Day (Fiesta de todos santos) at November 1 is marked with a rosette, but All Souls' Day (*Conmemoración de difuntos*) at November 2 is not. Nor was All Souls' Day included in the Arzobispado list, which suggests that this holy feast was not one that the church hierarchy stressed.

2.3 September, Pedro de Gante, *Doctrina christiana en lengua mexicana* (1553). Nettie Lee Benson Latin American Collection, the University of Texas at Austin.

NOVIEMBRE.

1 ✳ Fiesta de todos sanctos.
2 Commemoracion de difunctos.
3 Sant Hilarion obispo.
4 Sant Vital y Agricola
5 Sant Zacharia.
6 Sant Leonardo confessor, teopixqui sant Augustin.
7 Sant Prosdecimo obispo.
8 Quatro coronados.
9 Dedicacion Basilicæ saluatoris.
10 Sant Triphon y sus compañeros.
11 Sant Martin obispo.
12 Sant Martin papa.
13 Sant Bricio obispo.
14 Sant Iuan limosnero.
15 Sant Felix obispo.
16 Sant Euchario obispo.
17 Sant Aniano obispo.
18 Dedicaciõ dela yglesia de s. Pedro
19 Sancta Ysabel biuda ciua, teopixqui sant Francisco.
20 Sant Stephano confessor.
21 Sant Mauro martyr.
22 Sancta Cecilia virgen.
23 Sant Clemente papa.
24 Sant Grisogono martyr.
25 ✳ Sancta Cathalina virgen.
26 Sant Pedro Alexandrino.
27 Sant Iacobo.
28 Sant Prospero obispo.
29 Sant Saturnino. Vigilia.
30 ✳ Sant Andres apostol.

DIZIEMBRE.

1 Sant Albino martyr.
2 Sancta Bibiana virgen.
3 Sancta Candida virgen.
4 Sancta Barbara virgen.
5 Sant Sabba abad.
6 Sant Nicolas obispo.
7 Sant Ambrosio doctor.
8 ✳ Conception de la virgen.
9 Sant Siro obispo.
10 Sant Melchiadis papa.
11 Sant Damaso papa.
12 Sant Pablo obispo.
13 Sancta Lucia virgen. y s. Iodoco hijo del rey de Yngalaterra, teopixqui sant Augustin.
14 Sant Nicasio obispo.
15 Octaua de la conception.
16 ✳ Fiesta de la expectacion.
17 Sant Graciano obispo.
18 Sancta Antonilla virgen.
19 Sant Clemente presbytero.
20 Sant Iulio. Vigilia.
21 ✳ Sancto Thomas apostol.
22 Sancta Theodosia virgen.
23 Sant Seruulo confessor.
34 Sant Luciano. Vigilia.
25 ✳ Natiuidad de nro redẽptor.
26 ✳ Sant Esteuan martyr.
27 ✳ Sant Iuan Euangelista.
28 ✳ Los Innocentes, y sant Euticio, teopixqui sant Augustin.
29 Sancto Thomas canturiensis.
30 Sant Sabino obispo.
31 Sant Siluestre papa.

2.4 November and December, Fray Juan de la Anunciación, *Sermonario en lengua mexicana* (1577). Nettie Lee Benson Latin American Collection, the University of Texas at Austin.

Today in Mexico, these days are linked with Day of the Dead celebrations and commemorated with images associated with death, such as *calaveras*, or skulls. Similar skull icons also appear in the preconquest art of the Aztecs to signify death. Two Aztec monthly festivals were also devoted to the dead. In fact, an insert in Diego Muñoz Camargo's *Historia de Tlaxcala* records these monthly feasts using a skull and crossed bones (Figure 2.5). These similarities have led some to link contemporary Day of the Dead celebrations to pre-Hispanic beliefs, but Stanley Brandes (1998, 185) cautions against too readily accepting this link. Indeed, the painter of the Mexicanus records All Souls' Day with an image of a simple, shrouded corpse topped by a candle, while the Aztec monthly festivals related to death are signified also with shrouded figures, rather than skulls, as explained in the discussion that follows on the Aztec monthly feasts. Nevertheless, the inclusion of All Souls' Day in the Mexicanus suggests that the native peoples were particularly drawn to this day, perhaps because of similarities with their own monthly festivals. Additionally, it may have had a special resonance for the creators of the Mexicanus due to the fact that it was created so soon after the major epidemic of 1576, a time when the dead were surely on the minds of the living.

Another saint's day included in the Mexicanus points to an association of the codex with Mexico City. The day of St. Hippolytus (August 13) is not marked as particularly important in the Reportorios published in Spain, but it is highlighted as a significant day in the sources published in New Spain. According to the Arzobispado list, the day of St. Hippolytus was only to be observed in Mexico City. He was made the patron saint of the capital because Tenochtitlan fell to the Spaniards on his day in 1521. Thus, the historic event of the conquest, especially as a Christian victory over a pagan religion,

became an essential part of the Christian calendar of New Spain (Trexler 1987, 582). Its inclusion here points to a Christian identity tied to New Spain rather than one tied to Spain. It also suggests that the contributors to the Mexicanus identified themselves with the Christian triumph of the conquerors.

A few additional saints' days included in the Mexicanus are not highlighted in the published sources nor are they included in the Arzobispado list. Perhaps the contributors to the Mexicanus chose to include some of these because they were specially promoted in New Spain. For instance, St. Isidore (August 15) may have been given prominence by Spanish friars working with native converts because of his Spanish heritage. The inclusion of the day of St. Martin (November 11) is not as easy to explain, but may have again stemmed from Spanish friars emphasizing his worship, as St. Martin was the bishop of Tours, an important stop on the Spanish pilgrimage route of Santiago de Compostela. Alternatively, St. Isidore's association with farmers and St. Martin's with soldiers may also have made them attractive to the mendicants and their native converts, as these two occupations were important to the economic well-being of the former Aztec empire and also of New Spain.

I suspect that other saints' days were added to the Mexicanus calendar because of the particular interests of its contributors. For example, the inclusion of the shared holy day of Sts. Cosme and Damian (September 27) on page 5 is unusual in that this day is not called out as a day of santissima sacramento in the published sources (see Figures 2.1 and 2.3). Moreover, this day seems to have been added after the other saints on the same page were recorded, as the hieroglyphic compound that records their names was added in at the top of the page. The use here of a hieroglyphic compound also suggests that the painter was unfamiliar with

images of these saints and their attributes, perhaps because their worship was not emphasized in New Spain. Nevertheless, Sts. Cosme and Damian were the patron saints of medical doctors, and the Mexicanus exhibits a clear interest in medicine (see Chapter 3). Moreover, the Mexicanus was created soon after epidemics

had ravaged the native populations; thus, a concern with health may have inspired the book's creators to include this shared saints' day as an important day of worship.

The final unusual holy day inclusion is that of St. Lucy, whose day is not typically promoted in the published sources. The Anunciación

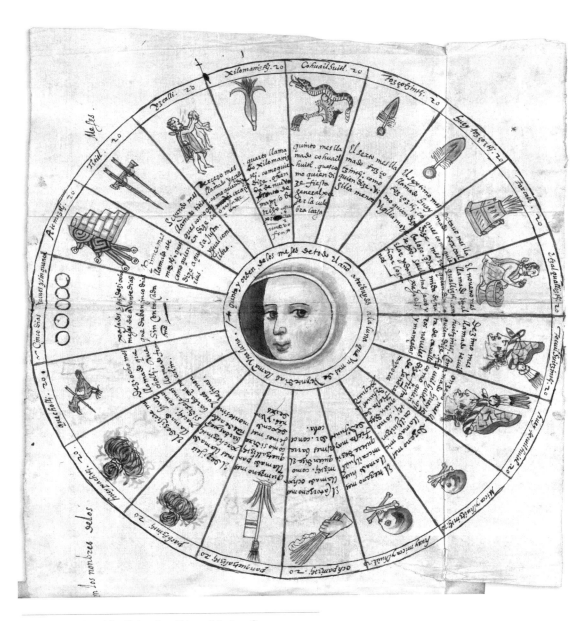

2.5 Aztec Monthly Calendar, Diego Muñoz Camargo, *Historia de Tlaxcala* (Ms. Hunter 242), verso of insert between folios 177 and 178. University of Glasgow Library, Special Collections.

calendar includes St. Lucy's day at December 13 but does not mark it with a cross (see Figure 2.4). Only the Anonymous Reportorio (1554) marks her day as one of *santissima sacramento*. My sense is that St. Lucy was included in the Mexicanus because her day helped to anchor the final set of Ember Days, which fall on the Wednesday, Friday, and Saturday following her day, hence the *quatollotempore* phrase floating on the register below her representation. Thus, it was necessary to know her day in order to know when these Ember Days fall.

In fact, the inclusion of the Ember Days in the Mexicanus calendar distinguishes its perpetual calendar from the ones included in the Reportorios, which typically include information on the Ember Days in a text separated from the perpetual calendars. In the Reportorio by Andrés de Li, the explanation for the *Quatro temporas* comes almost ten pages after the calendar ends, whereas in the Chaves Reportorio published in 1576, it is found a few pages earlier. This suggests again a sense of selectivity and creativity on the part of the Mexicanus' contributors. That is, the contributors here were not simply copying a Spanish source; instead, they were extracting information from that source and putting it together in an efficient, original, and purposeful manner, so that all of the necessary information pertaining to the liturgical year appeared in one place.

The emphasis given to the cult of Mary in the Mexicanus also merits some attention. In four of her five days, she is consistently shown as a young woman with long hair. A halo marks her divinity, and she holds her hands together in prayer to signify her piety. She is never shown on the xan sign, and she is typically paired with a hieroglyphic compound that communicates and distinguishes the exact holy day in her cycle,

be it Visitation (July 3), Nativity (September 8), Conception (December 8), or Expectation (December 18). The only one shown in a more narrative fashion is the day of her Assumption (August 15). These holy days in Mary's cult are mostly emphasized in the published sources, but one of these, the day of Expectation (December 18), is inconsistent, being included in some calendars but not others. The inclusion of even minor days related to the cycle of Mary reveals her significance for the native population and worship in New Spain. And yet, the one day particularly tied to the worship of Mary in Mexico today, December 12 for the day of the Virgin of Guadalupe, is not included, suggesting that this particular Marian devotion did not concern the contributors to the Mexicanus.

Spitler's (2005b, 187–192) study of native intellectuals and their interest in European timekeeping drew her to consider the calendric portions of the Mexicanus. She viewed the Mexicanus' calendric records as a native intellectual enterprise, a type of reverse ethnology. That is, just as the Spaniards were interested in learning about native means of tracking time and its relation to the sacred, so too were native intellectuals interested in understanding the Spanish calendar and its link to Christianity. While Spitler's insights are certainly correct, I would add that the Christian calendar was not just an intellectual marvel for the Mexicanus' owners for the simple reason that it was not a foreign calendar. It was their calendar, as they too were Christians. More than a mere intellectual exercise, information related to the Christian calendar was recorded by these native intellectuals because it was necessary to know. Of course, the Mexicanus contributors were also Nahuas, hence the inclusion of native sacred days on the register just below.

PERPETUAL CALENDAR: AZTEC MONTHLY FEASTS

The pictorial texts recorded on the lower register, though difficult to read in their entirety, are also linked to the perpetual calendar, but now by a thick line that is sometimes black but more often red. The first clear lines appear on page 2 under the days that would have corresponded to June 4 and 24, respectively. As these lines fall every twenty days and connect with icons and dates written in the Aztec system of writing, these must record the Aztec monthly feasts, which occurred every twenty days. The interconnected Aztec calendars are a mathematically elegant system. Because the monthly commemorations that form the 365-day xihuitl fall on the last day of each twenty-day month, in a given year, the feasts always fall on one of four days from the 260-day sacred calendar. These days are Rabbit, Reed, Flint, and House, and they are also known as the year-bearer days because the end of each year also falls on one of these days and gives each year its name. For example, in the year 9 Reed, or 1579 in the Julian calendar, the monthly festivals would have occurred on Reed days. In 1580, or 10 Flint, they would have fallen on Flint days; in 1581, or 11 House, on House days; and in 1582, or 12 Rabbit, on Rabbit days. Three of these signs—Reed, Flint, and House—are visible on the lower register along with a numerical coefficient. Unfortunately, much of the lower register is difficult to read, but for those day signs that are legible, they too are spaced twenty days apart. Therefore, the dates on the lower register must have marked the days in the 260-day calendar on which the monthly celebrations fell in a given year. Because the day signs that appear here are Reed, Flint, and House, they may have been added over a three-year span of time. In fact, for each thick red line that marks a monthly

	Monthly Festival	Christian Calendar Date	*Tonalpohualli* Date
Page 1	Toxcatl	May 15	(9 Flint)
Page 2	Etzalcualiztli	June 4	(3 Flint)
Page 2	Tecuilhuitontli	June 24	10 Flint
Page 3	Hueytecuilhuitontli	July 14	4 Flint
Page 4	Miccailhuitontli	August 3	11 Flint
Page 4	Hueymiccailhuitontli	August 23	5 Flint
Page 5	Ochpaniztli	September 12	12 Flint
Page 6	Pachtli	October 2	6 Flint
Page 6	Hueypachtli (aka Tepeilhuitl)	October 22	13 Flint
Page 7	Quecholli	November 11	7 Flint
Page 8	Panquetzaliztli	December 1	(1 Flint)
Page 8	Atemoztli	December 21	(8 Flint)

2.1 Monthly festivals and their date correlations in the Codex Mexicanus perpetual calendar, pages 1–8.

feast on the Mexicanus calendar, there is a faint black line linking the following day in the calendar to the lower register. Perhaps the black lines reflect an original attempt to correlate the monthly festivals with the Christian calendar, but after a leap year, a contributor noticed that the festivals shifted a day earlier and updated the calendar to bring it back into sync.

Accompanying these dates are pictorial icons that must reference the names of the monthly festivals. Although these too are in poor condition, some sections are legible enough to allow a complete correlation of the monthly festivals in the Mexicanus (see Table 2.1). The first monthly feast day is recorded for May 15 with a thick line leading from this date to the lower register, but its imagery is impossible to read today (Plate 1). However, based on the correlations that follow, this must have marked the feast day that ended the month of Toxcatl.[8] Twenty days later, another thick line links June 4 to now effaced imagery on the lower register (Plate 2). This must have originally recorded the feast that closed the next month of Etzalcualiztli.

The imagery for the next monthly festival is clearer. Twenty days later, June 24 is marked with a red line leading to the lower register. Here, the painter recorded a day sign of 10 Flint and below this an icon of a turquoise diadem with hair underneath. The diadem is a signifier of Mexica lords and must record this month's celebration, known as Tecuilhuitontli, or the "Feast of the Lords." In a work written in 1579 by Fray Diego Durán (1971, 368), *Historia de las Indias*, he includes a calendar of the monthly feasts with associated illustrations, and a diadem is used to mark this same month. In the Muñoz Camargo calendar included in his *Historia de Tlaxcala*, the painter records this month with a visual of a lord wearing both a Mexica

diadem and a twisted red-and-white headband, the headgear for Tlaxcalteca rulers (Figure 2.5). Thus, the diadem in the Mexicanus elicits a portion of the month's name, and the associated 10 Flint sign must refer to the day from the 260-day sacred calendar on which this festival fell in a particular year. If this festival fell on 10 Flint in one year, the next festival would fall twenty days later, which brings 4 Flint or July 14, and indeed, a red line from this date does lead to the lower register (Plate 2). However, this next monthly festival, which would have corresponded to the celebration of Hueytecuilhuitontli (Great Feast of the Lords), is completely effaced in the Mexicanus.

Imagery over the next few monthly festivals is easier to read, but not all of it is explicable. Twenty days forward from July 14 brings the reader to August 3 in the Christian calendar and 11 Flint in the tonalpohualli (Plate 3). Hence, the Mexicanus painter includes another red line leading from August 3 to the lower register and linked to an image of a funerary bundle lying horizontally in the Christian fashion. This marks the feast of Miccailhuitontli, "Small Feast of the Dead," with the funerary bundle referencing the name of the monthly festival. Although the original Flint sign is now effaced, 11 dots are visible and correspond to the appropriate day coefficient. However, the significance of the additional notations here is not entirely clear. An image of a House sign is visible to the right of the funerary bundle and may reference an attempt in another year to correlate the festival with its associated day in the sacred calendar, though there is no clear coefficient here. More pictorial icons are included to the right of the House sign, and a line seems to link this compound to August 6. The imagery is partially effaced but includes what appears to be a snake curled

2.6 *Facing:* Ochpaniztli, Diego Durán, *Historia de las Indias*, folio 337r. Courtesy of the Biblioteca Nacional de España.

Al maguey biendole tan prouechosso y
~~cosa celestial~~ y assi le rreuerenciauan, y ten
al bino. que del cumo del. se haze temianle mi
mas nimeros. por dios debajo deste non bre
ometochtli, que quiere dezir. dos. conejos y
si como nosotros. bedamos. la comunion a los
niños que. aun. no tienen. el tendimiento para
saber. lo que rreçiuen. assi estas. naciones be
dauan. el bino. a los. mocos y mocas y no se lo
conssentian beber. ni aun. a los. y a son biud
como no fuesse prençipal. por. la reuerencia deste
mal dicho bino. que no se lo les. seruia. de biui
da. y de enbeodarsse. con el. pero tan bien. lo ne
verençiauan. como. a dios. y lo tenian por cossa.
Diuina biendo el efeto que tenia y fuercade en bri
agar.

¶ Este mal dicho brebaje. hera particular ofrenda.
de los dioses. y assi algunos / sacrifieios que
yo. he allado yo fiendas remas de allar comidas

y plumas. y copal y otras materias. y sugetes de huesos
y tres teçillos de barro. y cuente que las. he hallado
cantarillos. muy pequemitos. de pulque juntamen
te, temor tengo. que soy endia / segun la afiçion le
muestran y se tienen y segun se mueren por el, quen
asa. alguna. supersticion. en ello por que beo que ya
no queda. biejo. ni moço. ni muger. ni ombre. ni niño)
ni. niña. que ya no lo beba. y a los. niños de teta
rreçien. naçidos. mojan las. madres. el dedo en
el pulque. quando. se allan. en alguna. borrachera
y se lo dan. a chupar. y dize que haze aquello por
que. nose destete. con el desseo. de bello beber
y si alguno. o alguna. se quiere abstener de
no lo beber. dicen le. los biejos y biejas, que
criara. Ha la garganta. carrasspera y llagae
y mil ynbinciones. satanicas para que beoan abe
bello. y assi los señores. se bomtan. y lo tiemen grandeza
el estar borrachos. y los mocos por gentileza

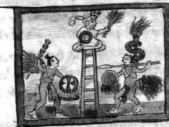

¶ El un deçimo mes de
llano que estos naturales çele
brauan tenia ueinte dias
llamauase el prime,
ro dia ochpaniztl
y quiere dezir dia de barrer, en el qual,
dia çelebrauan la solene fiesta de
toçi que era la madre de los,
dioses y coracon de la tierra
aui' aun saçrifiçio,
es pañoso de en
pala dos,

into an S-shape and a series of footprints that fan out, suggesting a journey or exodus of some sort. Twenty days later, at August 23, another funerary bundle marks the next monthly festival, known as Hueymiccailhuitontli, or the "Great Feast of the Dead." As shown in the Mexicanus, this would have fallen on 5 Flint. Another House sign is placed just to the right of this, perhaps again marking the day of this festival in the following year. Diego Durán (1971, 370, 371) also includes funerary bundles to illustrate these last two months, while the Muñoz Camargo insert uses skulls and crossed bones for these months (see Figure 2.5).

Twenty more days later, the reader arrives at 12 Flint, or September 12 (Plate 3). A drawing here of a grass broom records the feast known as Ochpaniztli, or the "Sweeping of the Way." In Diego Durán's (Figure 2.6) illustration of this festival, he shows a goddess holding a similar grass broom, while a hand holding a grass broom marks this same festival in the Muñoz Camargo insert (see Figure 2.5). Another house sign is located just next to this, perhaps again referencing the day on which this festival fell in the following year.

Continuing forward twenty more days brings October 2, where a thick red line leads to the lower register (Plate 4). Unfortunately, the associated record is difficult to read, though it may depict Spanish moss, which is used to illustrate the feast of Pachtli in the Muñoz Camargo insert (see Figure 2.5) as well as Durán's (1971, 373) illustration. This would have fallen on 6 Flint. Later in the month, another thick red line leads from October 22 to the lower register, where a slightly clearer depiction of Spanish moss marks the next monthly feast of Hueypachtli (also known as Tepeilhuitl). Interestingly, the scribe now uses Roman numerals to provide coefficients for the Aztec day signs; thus, *xiii* next to a Flint sign gives the Aztec day 13 Flint,

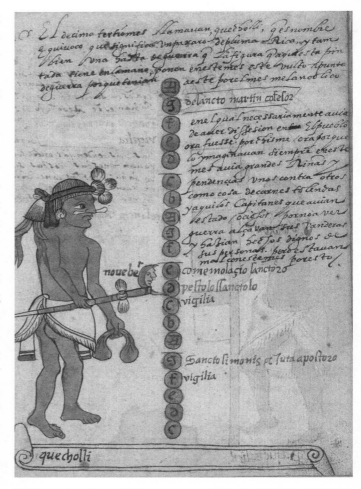

2.7 Quecholli, Juan de Tovar, Tovar Calendar, folio 154r. Courtesy of the John Carter Brown Library of Brown University.

which falls next in the sequence. Just above the moss is a fragment of a House sign, and to the right of this is another Aztec date sign, 13 Reed, perhaps referencing the days upon which this festival fell in previous years.

November contains another monthly festival, but this is preceded by a confusing image on the lower register (Plate 4). The illustration does not fall at a twenty-day interval and is therefore unlikely to reference a monthly feast. The image includes descending footprints and what looks like a face wearing a distinctive headpiece and mask that are reminiscent of Quetzalcoatl in his

manifestation as the wind god Ehecatl. Why such an appearance would be recorded here is unclear. Returning to the monthly festivals, at November 11 a thick red line leads to a date of 7 Flint, with the coefficient written again with Roman numerals. An associated pictogram is in poor condition but includes the head of a man wearing a distinctive headband. This must reference that month's festival of Quecholli, as the Tovar Calendar pictures this same month with an image of a man wearing a similar head-piece and likely referring to Camaxtli-Mixcoatl, a god of war and hunting (Figure 2.7). Durán (1971, 375) includes an image of a deer hunter to illustrate this month, while the Muñoz Camargo insert uses a hunted duck (see Figure 2.5). In the Mexicanus, a Reed sign plus a coefficient of at least five dots is added just after the man's head, again likely recording an attempt to correlate the months in a different year. The next monthly festival, Panquetzaliztli, would have fallen on December 1 (1 Flint), but the imagery here is impossible to read (Plate 5). Twenty more days later, a thick red line leads to December 21, but only disks plus a Reed glyph are visible. This would correspond to the Aztec month for Atemoztli.

THE VEINTENAS

Although it may seem counterintuitive, by correlating the Aztec monthly festivals with the Christian calendar, the lower register of the perpetual calendar links the Codex Mexicanus more with the colonial world than the preconquest one. As Betty Ann Brown (1977, 9) has noted, many of the Spanish chroniclers took an interest in the monthly calendar and gave little attention to the tonalpohualli, most likely because the monthly calendar fit better with their cultural expectations about the monthly divisions of time and its structuring of sacred events. Indeed, when compared

with the number of pictorial manuscripts that reference the tonalpohualli, there are relatively few that detail the monthly festivals, and the majority of these sources were largely created at the behest of Spaniards who surely steered the native informants toward topics of interest to Spaniards. In contrast, the preconquest sources that deal with the calendar focus largely on the 260-day tonalpohualli, which led Brown (1977, 10–11) to conclude that the tonalpohualli took precedence in the lives of the natives who lived before the conquest (see also Boone 2007, 17). Moreover, those colonial sources that explain the Aztec months exhibit a great deal of variation in terms of the iconography for illustrating the months and their associated rituals, which suggests that conventions for representing these months may not have been universally codified prior to the conquest (Kubler and Gibson 1951, 52).

As the monthly festivals were more public celebrations convened by the rulers of Tenochtitlan, these were more likely associated with the city. Since the Mexicanus was created in Mexico City decades after the conquest and by a group of native intellectuals immersed in the Spanish world, its interest in the monthly festivals makes sense. Indeed, in this regard, the Mexicanus is similar to other sources from this same time period that also attempted to correlate the Aztec xihuitl with the Christian year. Nevertheless, the Mexicanus includes the least amount of information on the monthly festivals. Whereas the sources created for Spaniards, such as the Tovar Calendar, include information on the months and the gods and rituals with which they were associated, the Mexicanus simply includes the names of the months and their correlations. Thus, the Mexicanus' records are fairly neutral and do little in the way of communicating pagan information, perhaps because its readers were already familiar with this information. Alternatively, they may have feared Spanish reprisals for

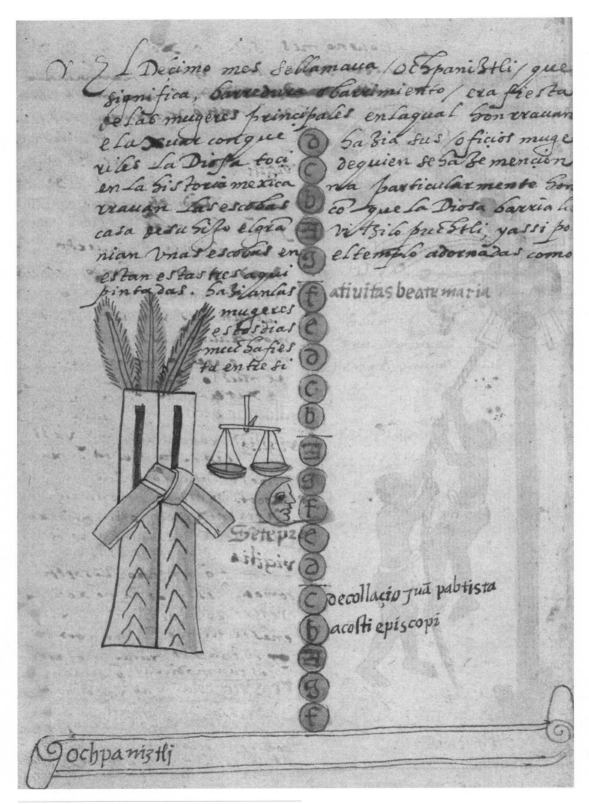

El Décimo mes se llamaua, / Ochpanistli / que
significa, barredura o barrimiento / era fiesta
de las mugeres principales enlaqual honrrauan
e la ~~deesa~~ congre había sus oficios muge
viles La Diosa toci dequien se haze mencion
en la historia mexica rra particularmente hon
rrauan las escobas co que la Diosa barria la
casa pues susto elgia vitzilopuztli, yassi po
nian unas escobas en el templo adornadas como
estan estas tres aqui
pintadas. hazianlas atiuitas beate maria
mugeres
estos dias
media fies
ta entre si

Setepe
alipia

Decollacio Juā pabtista
acosti episcopi

Ochpaniztli

2.8 Ochpaniztli, Juan de Tovar, Tovar Calendar, folio
151v. Courtesy of the John Carter Brown Library of
Brown University.

having such information in their book, regardless of its neutral tone. Indeed, the poor condition of the lower register stands in contrast to the relatively intact upper register, which suggests that the contents associated with the Aztec sacred calendar may have been purposefully effaced so as to escape Spanish censure, as is also seen in the final section of the Mexicanus, which also focuses on the Aztec sacred calendar and reveals more evidence of "whitewashing."

Probably most similar in format and contents to the Mexicanus is the Tovar Calendar, which was bound at the end of the Spanish friar Juan de Tovar's *Relación de la Origen* and is owned today by the John Carter Brown Library (see Figures 2.7 and 2.8). The Tovar Calendar was created as a part of the correspondence between Tovar and another friar, José de Acosta, in which a main topic was the Aztec past. Each page of this calendar is devoted to one of the months of the Aztec year, and information on the month is communicated with images that were likely painted by a native artist and a descriptive text written in Spanish, presumably by Tovar.

As in the Mexicanus, the painter of the Tovar Calendar records the name of the Aztec monthly feast with a pictorial sign. For example, the feast of Ochpaniztli is recorded with a broom similar to that seen in the Mexicanus (Figure 2.8). Also similar to the Mexicanus, the days of the month are correlated with the Christian calendar via dominical letters, but now they are written vertically and read from bottom to top. The Tovar Calendar also includes associated zodiac signs for the months along with saints' and holy days. As Ochpaniztli fell in September, the painter includes a set of scales to reference Libra, while holy days, such as that of Mary's Nativity, are written in alphabetic script. The new month of September is communicated with a personified moon similar to the Mexicanus. The descriptive text in the Tovar Calendar is written in Spanish and describes rituals associated with the month, which points to this calendar as being created to educate Acosta about the native festival system. In contrast, in the Mexicanus, readers are told when to celebrate these events because they must have already known how.

2.9 Ochpaniztli, Bernardino de Sahagún, Florentine Codex, book 2, folio 8r. Florence, the Biblioteca Medicea Laurenziana, ms. Med. Palat. 219, f. 62r. Reproduced with permission of MiBACT. Further reproduction by any means is prohibited.

A calendar focusing on the Aztec monthly feasts included in the Florentine Codex also serves as a useful comparison with the Mexicanus (Figure 2.9). The columns in the Florentine Codex calendar visually mimic the layout of the Reportorios, and the *KL* sign that begins each Aztec month references the Roman Kalends, or months, just as it does in a Reportorio (see Figure 2.1) and in Pedro de Gante's *Doctrina christiana* (see Figure 2.3).[9] Each page of the Florentine Codex calendar is devoted to one of the Aztec months with information about that month's festivities squeezed into a central column. At the left of the column are Arabic numbers for the twenty days in each month, followed by the associated dominical letter, which repeats to the right of the column of text. At the far right, the last column of numbers indicates the numerical days from the Christian calendar correlated with the Aztec one. In this calendar, the Aztec structuring of time and its sacred connotations were transformed to fit a visual pattern brought from Spain via the Reportorios.

Scholars from the sixteenth century to the present have been interested in correlating the Spanish and Aztec calendars, and these sources would appear to provide a means of doing so. However, one runs into vexing inconsistencies when attempting to bring these calendars into sync. As George Kubler and Charles Gibson (1951, 53) long ago concluded, no one correlation "can reconcile all the conflicting sixteenth-century equation points." Indeed, trying to correlate the Mexicanus' monthly calendar with other sources is an exceedingly frustrating task.[10] The monthly feasts in the Florentine Codex happened three days earlier than those recorded in the Mexicanus, while those recorded in the calendars by Tovar and Durán occurred one and four days later, respectively. For example, the Ochpaniztli festival took place on September 9 according to the Florentine Codex, September 12 according to the Mexicanus, September 13 based on the Tovar Calendar, and September 16 according to Durán. As the Aztec calendar did not correct for the leap year, the dates for each Aztec festival moved one day earlier in the Christian calendar every four years (Caso 1971; Milbrath 2013, 25). Using the correlation proposed by Alfonso Caso, in 1519 the Ochpaniztli festival occurred on the Christian date of September 21, then in 1520, which was a leap year, it occurred on September 20. After 11 leap years, it would have fallen on September 9, as recorded in the Florentine Codex, which if correct would place the correlations tracked in Sahagún's calendar sometime between 1564 and 1567. When Durán set his calendar down, in 1579, Ochpaniztli should have fallen on September 6, but he had it ten days later, perhaps because he was following an earlier source. In 1582, the Gregorian Calendar Reforms cut ten days from the calendar, which would suggest that the Tovar Calendar was recorded sometime between 1588 and 1591.[11] However, in their study of the Tovar Calendar, Kubler and Gibson (1951, 11) argued that it was most likely recorded around 1586.

While I suspect that the majority of information in the Mexicanus was added between 1579 and 1581, this dating for the work is impossible to reconcile with the correlations included on the Mexicanus' perpetual calendar. The Mexicanus' record of the Ochpaniztli festival is a good example of the dating discrepancies in this section. Using the Caso correlation, the only years in which the Ochpaniztli festival could have fallen on September 12 in the Christian calendar were between 1552 and 1555 and, because of the Gregorian Calendar Reforms, again between 1592 and 1595. These dates seem too early and too late for the creation of this work. Moreover, even if one were to accept one of these correlations, the tonalpohualli

dates still do not match. That is, using the Caso correlation, the Ochpaniztli festival could not have fallen on the tonalpohualli date of 12 Flint in either of these years. The years 1552 and 1592 are the ones in which the Ochpaniztli festival fell on a Flint date, but for 1552 it fell on 5 Flint and in 1592 on 6 Flint. The only Christian years in which the Ochpaniztli festival fell on the tonalpohualli date of 12 Flint were 1520 (September 20) and 1572 (September 7). If the earlier date were the one referenced in the Mexicanus, then it would suggest that the contributor here was actually setting down the correlations between the monthly festivals and tonalpohualli that were true at the time the Christian and Aztec calendars collided, just after the Spanish arrival, and presumably for their historical impact.

Although the correlation of the monthly festivals with the Christian calendar cannot be dated accurately, the inclusion of this information does suggest an interest in maintaining knowledge of the Aztec rituals and aligning these with Christian sacred days. Moreover, the composition of the perpetual calendar points to an equivalency between the two systems and a sense that they are now in sync. Indeed, the coming together of the Christian and Aztec traditions is also emphasized on the page that follows the perpetual calendar.

The Calendar Wheels

While the Mexicanus' perpetual calendar correlates the days of the Aztec and Christian years, page 9 correlates Aztec and Christian yearly cycles (Plate 5). In the center of the page is a dominical wheel inside of which St. Peter is shown holding his gospel book and key, effectively marking the wheel as Catholic time. This wheel is a visualization of a twenty-eight-year

dominical cycle based on the letters seen in the perpetual calendar on the preceding pages. The letter of the calendar date on which the first Sunday of the year falls in a given year is known as that year's dominical letter, and these cycle through a standardized sequence that repeats every twenty-eight years and are charted by dominical wheels like the one seen here (see Figure 2.10), which is meant to be read in a clockwise direction. Accordingly, if Sunday fell on dominical letter *c* in a given year, then the next year, it would fall on dominical letter *b*, then *a*, and so on. The double columns reference leap years, in which Sunday fell on one dominical letter and then moved to another after February 29.

The dominical wheel is evocative of Aztec time reckoning, which also had a cyclical nature, as is suggested by the correlation of the dominical wheel with an Aztec calendar wheel to the right. The last day of each Aztec solar year always falls on one of four signs in the 260-day sacred cycle: Rabbit, Reed, Flint, or House. The day on which the year ends gives that year its name. Since the day signs cycle through coefficients from 1 to 13, the cycle repeats every fifty-two years. Thus, 1 Rabbit begins the count, and the next year is 2 Reed, then 3 Flint, 4 House, 5 Rabbit . . . 13 Rabbit, 1 Reed, and so on. The Mexicanus wheel begins with 1 Rabbit at the left and is read in a counterclockwise direction. The twelve dots mark the twelve years after 1 Rabbit, which leads to 1 Reed, shown at the bottom; twelve more years bring 1 Flint, and another twelve years bring 1 House, and back again to 1 Rabbit. The creators of the Mexicanus, then, must have seen a cyclical equivalency between their calendar and that of the Christians.

Because the dominical wheel is accurate in perpetuity, it can be used to track multiple twenty-eight-year cycles. However, a notation at one date allows a more accurate correlation. At

the upper left of the dominical wheel, the letter *b* is linked to 1575. This was the year of the founding of the Colegio de San Pablo, which was referenced in the Nahuatl annotation that floats above and was discussed in Chapter 1. The first Sunday of 1575 did indeed fall on dominical letter *b*. Tracking the wheel forward, the cross at the top falls between the years 1578 and 1579, further corroborating a creation date for the codex around these years. Tracking the years back to the intersection of the two calendars, the Aztec year 1 Rabbit is equated with dominical letter *c*, or 1557. In reality, this correlation is slightly off, as 1 Rabbit should have been linked with 1558, but the proximity of these dates leads me to believe that there was an intention to correlate the two calendars here.[12] Setting the wheels in motion, the dominical wheel would move in a counterclockwise direction, while the Aztec wheel would move in a clockwise direction.

Additionally, an alphabetic annotation on this same page suggests a perception on the part of the writer that the creator of the wheels was not just correlating the two calendrical sequences but was creating a new, interlocked system. The text in Nahuatl, *nuahpohualli xihuitl* (eighty years), gives the number arrived at when joining the fifty-two-year Aztec cycle with the twenty-eight-year Christian dominical cycle. Such a combined sequence further points to the idea that New Spain was built upon both Aztec and Christian time.

The source for the Mexicanus' dominical wheel is not clear. Chaves' *Reportorio* (1576, 126r) includes a textual description of the dominical letter cycle, while the Anonymous *Reportorio* (27v) includes a twenty-eight-year dominical chart, but it is enclosed in rectangular columns that do not emphasize the cyclical nature of the years as effectively as the Mexicanus. Circular dominical wheels are known in

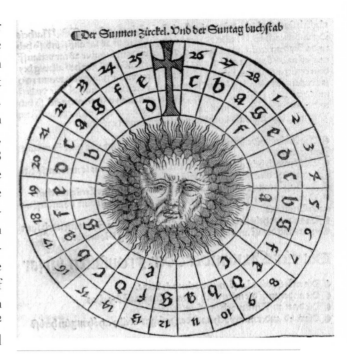

2.10 Dominical wheel, Regiomontanus, *Kalendar*. Bayerische Staatsbibliothek München, Res/4 Eph.astr. 99 r, fol. 20r (E4 r).

European sources, such as calendar books and prints. For example, an early sixteenth-century calendar book by the German mathematician and astronomer Regiomontanus (1512) contains a dominical wheel similar to that seen in the Mexicanus (Figure 2.10). Regiomontanus' book was highly popular in sixteenth-century Europe, with at least a dozen translations published in Latin and Italian, so perhaps this or a similar book or print was another source for the Mexicanus painters. Indeed, the Gothic font used by the Mexicanus painter for the dominical letters, as contrasted with the cursive script used by the Nahuatl annotator, suggests the creator of the wheel copied a European source. However, Regiomontanus' wheel includes a personified sun in the center rather than the image of St. Peter, which may be another sign of the creativity of the Mexicanus contributors, as I have yet to find a similar dominical wheel

with St. Peter in the center. In this case, the painter likely modeled his image after one of the many images of St. Peter that circulated in New Spain via print or book. Known as the rock of the church, St. Peter's inclusion in the Mexicanus marks its dominical wheel as Christian time and distinguishes it from the pagan time of the Aztec wheel.

Just as the perpetual calendar did, the composition of this page privileges the Christian calendar through its central placement. However, the color choices convey a sense of compositional balance between the two calendars. In the dominical wheel, black ink is used for the letters and image of St. Peter and red ink for the circle and time divisions. Black and red are commonly used in European books, and these colors link the image with the Christian world. In contrast, the Aztec icons and years are painted blue and outlined in black, linking them more to the Aztec world. The icon for "year" in Aztec pictography is typically a turquoise disk because the Nahuatl word *xihuitl* means both "year" and "turquoise." A faint red circle inside the Aztec calendar wheel creates visual balance with the dominical wheel. Thus, the color choices link both calendars to their different cultures while also tying them together.

The pictographs at the left of the page are difficult to decipher completely. One has to turn the orientation of the page 90 degrees to the left to read this section, which implies that its contents are distinct from the calendar wheels. Nonetheless, the imagery includes the turquoise mosaic disks that reference years in Aztec pictography and points to an association, though not entirely clear, with the calendar wheels. Each of the four turquoise disks is topped by a feather, used in Aztec pictorial writing to signify 400. Accordingly, the image references 1,600 years. Additional turquoise disks to the right are smaller and in a plain blue, but the poor condition of this section makes it difficult to interpret. Remnants of banners are just barely visible and were likely originally attached to each one. In Aztec pictorial writings, banners signify 20; therefore, we see another numerical reference here.

Unfortunately, the series of circles drawn under the blue disks fall at the binding of the page, making them difficult to comprehend as well. The disks, surely referencing numbers, are separated into two by a red line. Although the total amounts originally indicated are unclear, I suspect that these two sets of numbers also referenced the calendar wheels. Reading from bottom to top, the sequence on the left is 5-5-5-3-5. If one more set of five were indicated under the binding, then we would have a total number of twenty-eight disks, which corresponds to the years of a dominical cycle. The sequence on the right ends with 5-5-2, totaling twelve. If pictograms indicating the number forty, such as two banners, were included at the binding, then this would have originally recorded the fifty-two years of the Aztec cycle. A pictogram next to this sequence is read by Prem (1978, 275) as *domingo,* as it includes a bird's head (*toto-tl*), an arrow (*mi-tl*), and a jar (*co-mitl*), for *to-mi-co,* a nice approximation of Domingo, or "Sunday" in Spanish. Since the dominical wheel is essentially a sequence of Sundays, I think it likely that Prem's reading of this glyph is correct, which would further corroborate the idea that these numbers are referencing the yearly cycles via Aztec pictorial script.

Anthony Aveni (2012, 4) maintains that there was a shift in how time was represented in the native world after the conquest. He argues that before the conquest, native peoples conceptualized time as square or quadrangular in form; for example, the trecena almanacs in the Codex Borbonicus are formatted in a square grid (Figure 2.11). After the conquest, this perception

of time shifted to a more European view, with time now conceived as circular in nature.[13] To be sure, links between wheels and time were known in the Aztec world, as suggested by the well-known Calendar Stone in the Museo Nacional de Antropología, Mexico City, but this monumental sculpture was not a calendar in the traditional sense. It shows the twenty day-signs of the Aztec calendar in one of its rings, suggesting a cyclical conception for the calendar, but in the tonalamatl, calendars were typically presented in a rectangular format. If Aveni's argument is correct, then the Aztec calendar wheel seen in the Mexicanus would have been another attempt to make native time fit a European conception.

Indeed, when Spanish chroniclers attempted to explain the Aztec calendar, they often reverted to images of calendar wheels, as did other native artists (Cummins 1995).[14] Spitler (2005a, 285)

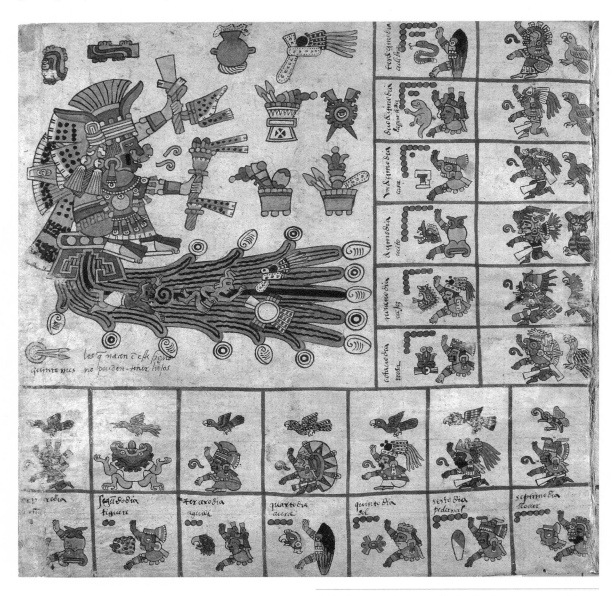

2.11 *Trecena* almanac, Codex Borbonicus, page 13.
Source: Bibliothèque de l'Assemblée nationale.

sees these wheels as hybrid documents, bearing "the marks of two strains of influence so knotted that it becomes extremely difficult to extract an 'original' or 'authentic' calendar, one free of the effects of the give-and-take of translation." Ultimately, the Mexicanus calendar wheels together reveal the colonial worldview of the book's creators, but the unique imagery here also points to the creativity of the native artist, who joins these two conceptions of time into a connected system. While the calendar wheels and perpetual calendar are anchored by Christian time, other calendric references in the Mexicanus focus on the Aztec sacred calendar and its links to the monthly festivals.

Tonalpohualli

A two-page sequence in the Mexicanus, written on the front and back of a single sheet of paper on pages 13 and 14, records a portion of days from the Aztec 260-day sacred calendar with references to some of the Aztec monthly feasts (Plates 7 and 8). The tonalpohualli traditionally begins with the day 1 Cipactli, but the sequence in the Mexicanus begins with 1 Atl, which falls toward the end of the 260-day sequence, being the first day of the seventeenth trecena. The last day is 2 Xochitl (Flower), of the seventh trecena. This is an incomplete rendering of the 260-day calendar, as each page includes sixty-six days filled into a grid of six rows and eleven columns, giving only 132 days out of the 260-day calendar. The reading order is from left to right, and the Aztec day signs that were traditionally written pictorially are now written alphabetically, while the numbers are written with Arabic numerals.

Additional information on the monthly festivals is also provided at each of the Reed days. As discussed above, in each given year, the monthly festivals fall on a day with the same

sign, so in a Reed year, all of the monthly feasts would have fallen on Reed days. Therefore, this tonalpohualli also includes the days from the 260-day sequence on which monthly festivals fell in a particular year. Unlike the dates given on the Mexicanus' perpetual calendar, the monthly dates here do make sense when using the Caso correlation. The first monthly feast noted in the Mexicanus tonalpohualli is Miccailhuitontli, which fell on 5 Reed and is noted in the fifth column of the first row on page 13 (Plate 7). Using the Caso correlation, in 1579, the festival of Miccailhuitontli did indeed fall on 5 Reed, or July 28 in the Christian calendar.[15] The next monthly festival, Hueymiccailhuitontli, occurred on 12 Reed, as marked in the third row and column. In that same year, the Ochpaniztli festival happened on 6 Reed, Pachtli on 13 Reed, Hueypachtli on 7 Reed, and Quecholli on 1 Reed. All of these dates are correlated with the correct monthly festivals on these pages of the Mexicanus, suggesting that they were set down in 1579. One of the Mexicanus contributors, then, used these pages to track the monthly feasts, squeezing them into the tonalpohualli boxes after the days had been written. However, these dates do not match the dates of the monthly festivals noted in the perpetual calendar on Mexicanus pages 1–8.

In fact, pages 13 and 14 have a different feel than the rest of the Mexicanus. The gesso coating on these pages has a gray tint that does not match the lighter gesso used on the rest of the book. In fact, a number of faint dots for Aztec coefficients can be seen under the gesso coating, which suggests these pages were reused or their imagery modified. Nevertheless, the final iteration of this page reveals an interest again in the monthly festivals and provides evidence that these native intellectuals continued to track these sacred days well after the arrival of the Spaniards and Christianity.

Calendric Calculations

Mexicanus page 15, which comes just after the incomplete day count, appears more like a workbook of calendrical calculations, as if one or more of the contributors were trying to work out numerical year correlations between the Aztec and Spanish systems and perhaps calculate moveable feasts in these years (Plate 8). Turning the book ninety degrees to the right (the orientation of my reading below), a grid organizes the page, with vertical columns of equal width and horizontal rows of variable heights. Four Christian years—1579, 1580, 1581, 1582—are written in the horizontal rows of this grid, though the final year is partially obscured by wear at the bottom edge of the page. These dates yet again associate the Mexicanus' creation with this time span.

The icons above the first two Christian years, 1579 and 1580, reflect an attempt to also write these years in the Aztec pictorial writing system, wherein feathers are equal to 400, banners to 20, and disks to 1. Accordingly, for the 1579 row, the first column includes one feather (400) with five banners (100) above, giving a total of 500. The same feather plus five banners repeats in the next column, giving a total of 1,000 above the 1 (thousand) of 1579. The same feather-plus-five-banners compound repeats again above the 5 (hundreds) column of 1579, giving another 500 years. The column above the 7 (tens) of 1579 includes three banners, for 60, plus ten disks, for a total of 70, which matches the tens column in the Christian year. The column above the 9 (ones) of 1579 appears empty, though faint remains of disks are barely visible, suggesting that nine disks were originally here but were later effaced. The same pattern repeats for 1580 but with a mistake. The columns above the 1 and 5 of 1580 include three of the feather-plus-

five-banners compounds, for a total calculation of 1,500 years. However, the column above the tens position of 1,580 only includes 3 banners and 10 disks, for a total of 70 rather than 80. The next column is blank, presumably for zero, which the scribe correctly indicated. Toward the bottom of the page, 1581 and 1582 were written with empty spaces left above for more Aztec pictographs, though none were added.

The cells to the right of these year dates contain more information related to each of these years, though the meaning of these contents is not entirely clear. The sixth column associates the years 1579, 1580, and 1581 with the numbers 16, 17, and 18, respectively (the 1582 row is too effaced to read). The first two numbers (16 and 17) are written with both Aztec numbers and Roman numerals, while the last is just written in Roman numerals. Prem (1978, 278–279) speculated that these numbers may somehow be related to the lunar count or to golden numbers, but the golden numbers of these years are 3, 4, and 5, respectively. The next column references the appropriate dominical letters for each year, with 1579 being dominical letter *d*. The next year, 1580, was a leap year and therefore known by two dominical letters, *cb*, while 1581 corresponded to dominical letter *a*. A remnant of the *g* for 1582 is just barely visible at the edge of the page.

The final two columns contain information recorded in a combination of pictorial and alphabetic script. Beginning with the second-to-last column, the first group of icons is associated with the 1579 row. Reading from top to bottom, these include an unclear image at the binding of the page, an animal icon, and Roman numerals *xv*, for 15. The next sequence is associated with 1580 and includes a similar animal icon, Roman numerals *xxxi* for 31, and an alphabetic notation reading, *enelo*, which likely approximates *enero* (January). Nahuatl lacks the *r* phoneme, and *l*

is a typical substitute for this sound in Nahuatl writings. The alphabetic reference to a European month here suggests that the animal icons in this column may refer to this same month. If the animal is read as a dog, then it may have been intended to elicit the Spanish word *perro* to approximate *enero*, which would be an interesting use of Spanish phonics in Nahuatl pictorial script. If correct, the first date would be January 15, 1579, and the second date would be January 31, 1580. Appearing in this same column but now closer to 1581 is another Roman numeral, *xii*, and *fefellelo*, which likely approximates *febrero*, or February, as Nahuatl also lacks the *b* phoneme; this would make the final date February 12, 1582.

Reading the final column from the top of the page to bottom, another unclear image was originally included at the binding of the page. Below this is a drawing of a hand (*ma-itl*), which I suspect was intended to approximate another European month, this time *marzo*, or March. Unfortunately, the number that was written under this is now difficult to read. Placed closer to 1580 is a compound of a banner and seven disks, for 27, which is repeated in Roman numerals (*xxvii*) below. Under this is an alphabetic notation reading *fêlelo*, which is likely an alternative spelling of *febrero* (February), giving a date of February 27, 1580. Below this, and closer to 1582, are the Roman numeral *viii* and *fêlelo*, for February 8, 1582. More annotations are just barely visible at the bottom of the page associated with 1582, but these are largely effaced today.

The dates listed, then, are as follows:

1579: January 15 and March ?
1580: January 31 and February 27
1581: February 12 and February 8

Unfortunately, the meaning of these dates is not clear. Prem's (1978, 278–279) suggestion that they may have referenced moveable feast days seems logical; however, the two he offered, Septuagesima and Ash Wednesday, are not an exact match with the dates listed here.[16] Of course, the scribe himself may have been mistaken in his calculations, and the poor and incomplete condition of this page also hampers a definitive reading of its contents. Nonetheless, it is clear that the Christian calendar in these four years was the concern of this page's creator.

Tonalamatl in *Trecenas*

The Mexicanus ends with an incomplete almanac on pages 89 through 102 (Plates 45–52). Each of these pages is devoted to one of the trecenas, or thirteen-day periods, of the sacred Aztec calendar (Robertson 1954). The day count begins on the proper date, which is 1 Cipactli, but it ends early, at the fourteenth trecena, with the final six pages of trecenas that likely ended the original manuscript now lost. This section is formatted with the thirteen days of each trecena written in boxes that extend down the left edge of the paper and across its lower border. The rest of the page that would have been filled with information pertaining to the period and its associated gods and rituals is now mostly blank, with only traces of imagery barely visible under the gesso coating and some alphabetic texts added on top.

The days of the trecenas do remain and are written in Nahuatl in black ink, while the coefficients are written with Roman numerals in red ink. These seem to have been written by different hands; the numbers are written in a larger script that is different in style from the day names, and in places, the numbers intrude

upon the alphabetic text, suggesting that the numbers were written first and the day names added later. However, remnants of dots are visible under some of the day signs, making me suspect that these were originally written in a pictorial form and then changed to alphabetic text at some later point. In fact, inspection of the original codex makes it clear that an additional coating of gesso was added to these cells, with the darker gesso visible inside the date boxes and slightly raised over the lighter gesso visible in the spaces between each box.[17]

Some remnants of painted images do remain in the trecena section, but for the imagery that can just barely be read, their exact meanings are elusive. Clearly, the paper used for this section was repurposed, as the parallel lines used to record the timeline in the annals section are visible under the gesso coating, and some of the ghost-like imagery may have originally related to historic records. However, the placement of other images tends to fall near one of the four year-bearer dates of the tonalpohualli, which suggests that signs related to the monthly festivals of the xihuitl were added here as well. For example, Robertson (1954, 220–221) noted that many of the Rabbit (written *tochitli*) days bear traces of erased images. As these fall every twenty days, they likely once referenced the monthly festivals. If true, this would distinguish this section from the traditional trecena almanacs, which do not reference the monthly festivals. For comparison, see the trecena almanac from the Codex Borbonicus in Figure 2.11.

That the monthly festivals were on the minds of the Mexicanus contributors is clear when we consider some of the imagery and alphabetic texts that were added to this section on Reed dates. These link particular days from the Aztec sacred calendar to the monthly festivals.[18] Table 2.2 provides a chart of these days and their associated trecenas. For example, on page 93 (Plate

	Trecena Name	Monthly Festival	Monthly Festival Date	Caso Correlation
Page 89, Trecena 1	1 Cipactli	(Tititl)		
Page 90, Trecena 2	1 Ocelotl			
Page 91, Trecena 3	1 Mazatl	(Izcalli)	(7 Reed)	
Page 92, Trecena 4	1 Xochitl			
Page 93, Trecena 5	1 Acatl	Xilomaniztli	1 Reed	February 18, 1579
Page 94, Trecena 6	1 Mizquitl	Tlacaxipehualiztli	8 Reed	March 10, 1579
Page 95, Trecena 7	1 Quiahuitl			
Page 96, Trecena 8	1 Malinalli	Tozoztontli	2 Reed	March 30, 1579
Page 97, Trecena 9	1 Coatl	Hueytozoztli	9 Reed	April 19, 1579
Page 98, Trecena 10	1 Tecpatl			
Page 99, Trecena 11	1 Ozomatli	Toxcatl	3 Reed	May 9, 1579
Page 100, Trecena 12	1 Cuetzpalli	Etzalcualiztli	10 Reed	May 29, 1579
Page 101, Trecena 13	1 Ollin			
Page 102, Trecena 14	1 Itzcuintli	(Tecuilhuitontli)	(4 Reed)	

2.2 *Trecenas* in the Codex Mexicanus and their associated monthly festivals, pages 89–102.

47) there is an image of a hand clutching what are probably unripe corn ears (*xilo-tl*), likely referencing the feast called Xilomaniztli (Kubler and Gibson 1951, 70–71). The Muñoz Camargo insert also pictures this month with a corn plant (see Figure 2.5). While the sign in the Mexicanus is linked by a black line to the day 2 Jaguar, a red line links it to the previous day, 1 Reed, which makes more sense, as the feast days fell on year-bearer days, and the other feast days are also linked with Reed days. Following this, on page 94, an alphabetic text calls out the subsequent feast of Tlacaxipehualiztli and links it to the day 8 Reed, which fell twenty days later (Plate 48). Under the gloss, there is a faint trace of what appears to be a flayed skin, which would communicate the main ceremony associated with this month, the flaying of a captive to propitiate the month's patron god, Xipe Totec (Díaz Álvarez 2011, 337). Twenty days later, on page 96 (Plate 49), 2 Reed is linked with the next monthly festival, Tozoztontli. There is also a small stream of water under the text, which may have clarified that this monthly festival was associated with water, fitting as it was in honor of the Tlaloque, or gods associated with clouds and rain (Caso 1971, 341). On page 97 (Plate 49), the next monthly festival, Hueytozoztli, is written in above 9 Reed; on page 99 (Plate 50), Toxcatl is written next to 3 Reed; and on page 100 (Plate 51), Etzalcualiztli is written at 10 Reed. Using the Caso correlation, these dates all correlate with these associated monthly feasts in the year 1579, adding further support to the manuscript being created around this time. As the erased images are associated with Rabbit days and the alphabetic texts with Reed days, a later contributor may have erased the images of the monthly festivals that were current in the previous Rabbit year of 1578 and corrected the correlations with alphabetic texts that linked the different celebrations to the Reed days that were current in 1579.

Additional whitewashed images are visible on other pages near year-bearer dates. For example, on page 91 (Plate 46), an arrow piercing a stone is visible under the gesso coating and linked to the day 12 Flint. On page 93 (Plate 47), a faint trace of another arrow piercing something is linked to 6 Flint. On page 94 (Plate 47), an image of a House sign with an upright banner underneath is shown above the date 13 Flint. Another arrow is visible above the day 10 Rabbit on page 95 (Plate 48), and here it appears to strike a bird (Robertson 1954, 221). This may have referenced the monthly festival of Quecholli, as the Muñoz Camargo insert also indicates this month with an image of a pierced bird. Perhaps yet another arrow was shown above 7 Flint on page 96 (Plate 48), and a now faint diagonal arrow was drawn on page 97 (Plate 49) near the 4 Rabbit sign. As these dates are all associated with the days on which the monthly festivals fell, the images may have been logograms for the monthly festivals. Moreover, many of the House days have a line attached, suggesting they too were correlated with monthly festivals.

More palimpsests are visible in this section as well, but these are not necessarily linked with days on which monthly festivals would have fallen. One of the clearest of these is found on page 97 (Plate 49), where a fringed shield floats toward the top of the page and the outline of a funerary bundle is faintly visible underneath. On page 98 (Plate 50), a drawing of a turquoise diadem is linked to 1 Flint. Other images seem more like graffiti added to the manuscript at later times. Some clear examples of this are found on pages 97 (Plate 49) and 100 (Plate 51). I suspect these speak to more random markings added to the book over the years.

In a traditional tonalamatl, additional information pertaining to the sacred features of each trecena would have been included in the sections that now contain only notations and residual imagery and erasures in the Mexicanus. For

example, the Codex Borbonicus, made soon after the conquest, has a composition similar to the Mexicanus', but here the information pertaining to the gods and rites associated with each trecena remains intact (see Figure 2.11). In the Mexicanus, the remains under the gesso coating suggest that the original contents were whitewashed at some point in the manuscript's history, perhaps because of fears that such information would be deemed suspect by Spanish authorities. In fact, toward the end of the sixteenth century, Spanish officials were becoming increasingly suspicious of the native converts and fearful of persisting heretical beliefs, as evidenced by the whitewashing of monastic murals that were believed to contain native content (Peterson 1993, 171, 174). We may see a similar whitewashing here.

Nonetheless, the references to the monthly feasts suggests these were gaining prominence in the minds of the Nahuas, perhaps because they were not seen in as threatening a light. That is, the 365-day xihuitl with its attendant festivals was edging out the sacred 260-day calendar that had figured so prominently in the lives of the Nahua peoples before the conquest. Indeed, in this trecena almanac, the days of the sacred calendar have effectively been purged of the sacred associations seen in the Borbonicus almanac. This shift may be explained by Brown's points about the similarities between the xihuitl and the Christian year and also by the attention Spaniards gave the xihuitl over the tonalpohualli. Having internalized this privileging of one calendar over the other, the contributors to the Mexicanus may have adjusted its contents to better reflect the calendars of colonial New Spain.

Conclusions

Calendars are far from neutral timekeeping devices; they are tied to culture. As Elisheva Carlebach (2011, 2) writes in her study of the Jewish calendar in early modern Europe, "No calendar serves as an objective instrument for marking the passage of time, just as no map represents an unfiltered view of the natural landscape. Both incorporate political agendas, and often religious worldviews, into their representation." This statement certainly applies to the calendars included in the Codex Mexicanus. These calendars convey information on how the contributors to the book embraced the Christian calendar while meshing it with the Aztec one. This combination consequently speaks to how the contributors reacted to Spanish religious and political hegemony, while at the same time developing their own identities as Nahua Christians of New Spain.

Ross Hassig (2001, 137–138) has asserted that the Spanish invasion set the stage for a conflict between the Christian and Nahua calendars, with the Spaniards spreading the Christian calendar as a way of combating the heathenism of the Nahuas, which was intimately tied to the ritual cycle of their calendar. Hassig (2001, 162) points out that the Spaniards feared a conflation of the two calendars, as evidenced by the Dominican friar's, Durán's (1971, 71), complaint that the natives pretended to celebrate Christian holy days but often "insert, mix, and celebrate those of their gods when they fall on the same day. And they introduce their ancient rites in our ceremonies." While Durán's statement may be true, the Spaniards themselves played a role in this conflation. Although the Spaniards condemned Aztec religious practices, they were clearly interested in the organization

and chronology of the Aztec calendars, going so far as to attempt to make the native calendar correspond to Christian chronology (Baudot 1995, 425, 427). They did so by eliciting information on the monthly festivals from native informants. Accordingly, the 365-day solar calendar came to supplant the importance of the 260-day sacred calendar for the native converts. The emphasis in the Mexicanus on the monthly rituals, along with their correlation with the Christian calendar, reveals its contributors' place in the colonial world and their intentions to bring these two systems of time into balance, not into battle.

In her dissertation on visual representations of the calendar in preconquest and colonial Aztec works, Ana Díaz Álvarez (2011) argues that the sixteenth century saw the creation of a new calendar that served both natives and Spaniards; she describes this calendar as *indígena novohispano*. For the natives, the adoption of the Christian calendar allowed them to assimilate more fully into colonial life, whereas for the Spaniards, it allowed them to colonize native timekeeping practices (Díaz Álvarez 2011, 13). The references to Christian means of keeping time and the tracking of Catholic holy days in the Mexicanus reflect the dominance of the Christian calendar in New Spain and the natives' acceptance of Christianity. At the same time, the correlations of the Aztec monthly feasts with the Christian calendar (pages 1–8) and the inclusion of multiple references to the tonalpohualli (pages 13–14 and 89–102) speak to the continued importance of the native calendar for the Nahuas. Nevertheless, though the tonalpohualli was referenced in the Mexicanus, it was stripped of its sacred associations and effectively neutralized. For example, on pages 13–14, the grid pertains neither to 13 nor 20, sacred numbers in the Aztec system, and the addition of monthly festivals on the pages

devoted to the tonalpohualli reveals that the emphasis shifted to the solar calendar, which better fit a Christian conception of time. This concern with the xihuitl suggests that the Spaniards were successful in colonizing the native calendar, but for the creators of the Mexicanus, the conflict described by Hassig did not result in the destruction of the native calendar but its adaptation and incorporation into a New Spanish one.

Indeed, the Christian calendar that begins the Mexicanus speaks to a distinctively New Spanish form of Catholicism. While the majority of holy days are consistent with those worshipped in Spain, the additions of some days that speak specifically to New Spain, such as the day of St. Hippolytus and All Souls' Day, point to the emergence of a distinctive Christian identity for the colony. Although Díaz Álvarez (2011, 23) argues that the analogy between the Christian calendar and the xihuitl allowed the church a mechanism of control through which it could monopolize liturgical time in New Spain, the inclusion of additional saints' days that must have had special resonance for the book's creators suggests that the native intellectuals behind the Mexicanus were seeking to control, if not shape, liturgical time for themselves.

The calendric information recorded in the Codex Mexicanus is evidence of a newly hybridized calendar, one that takes Christian time as its framework and Aztec time as its foundation. In this regard, the calendars of the Mexicanus are evocative of Spain's own calendar, which had its foundation in the pagan Roman past. Just as the Reportorios acknowledged Spain's debt to Rome in its calendars, the Mexicanus acknowledges the continued importance of the Aztec calendar for colonial New Spain. In fact, by referencing both Christian and Aztec means of

keeping time, the Codex Mexicanus anticipates the Reportorio published by Enrico Martínez in the early seventeenth century and meant to serve those living in New Spain. Accordingly, he added a section in his book that detailed the Aztec calendric system, suggesting that he too believed that knowledge of Aztec means of keeping time was necessary to know for life in New Spain. In general, the Reportorios communicate Spain's identity as a modern Christian nation built upon a pagan, but illustrious, Roman past. The Mexicanus and Martínez's Reportorio send a similar message for New Spain. It too was a modern Christian nation built upon its own illustrious past, an Aztec one.

Just as the Roman calendar speaks to the ingenuity and civility of the ancient Romans, the inclusion of references to the Aztec calendar in the Mexicanus points to the civility of the Mexica. Thomas Cummins (1995, 158–169) has argued that there was an association between calendars and notions of truth in early colonial New Spain. As he shows, many of the Spanish chroniclers who wrote histories of the Aztec empire referenced the native calendar as proof of their historical validity, with the calendar establishing the Aztec past as history rather than mythology. For example, in their correspondence about the Aztec past, Acosta asked Tovar how he knew that Aztec histories were truthful. In response, Tovar included the calendar discussed earlier in this chapter, suggesting, as Cummins (1995, 164) has argued, that the Aztec calendar was the "temporal structure upon which Mexican history is authenticated." The inclusion of the Christian calendar and its correlation with the Aztec one at the outset of the Mexicanus, then, establish that what is to follow is truthful, built upon an accurate conception of time that reflects the civility of the Aztec past. Ultimately, the existence of the Aztec calendar and its similarities with that of Rome and Spain are evidence of the intellect of the native peoples and the achievements of their past, while the new hybrid calendar seen in the Mexicanus points to the place of its contributors in the Christian present.

Astrology, Health, and Medicine in New Spain

In early modern Europe, medicine was linked with astrology, as the stars were believed to influence the body. Accordingly, one had to have knowledge of astrology in order to know when to perform medical procedures such as bleeding and purging. By the fifteenth century in Spain, one could find this type of information in the *Reportorios de los tiempos*. The Nahuas had their own beliefs about the body and its link with the stars as well

as the sacred calendar, and they too recorded this information in their books. Thus, it is not surprising that the contributors to the Mexicanus would include contents related to medical astrology in a three-page section of the codex (pages 10–12). However, the information recorded in this particular section comes exclusively from European, rather than native, sources.

In this chapter, I explain these rather esoteric contents and show that their presence in the Mexicanus is understandable given the

epidemics that arrived in the New World along with the Europeans. Many of these outbreaks were unheard of in the preconquest past and particularly devastating for native peoples with no immunity to Old World contagions. Indeed, I suspect that the deadly epidemic that occurred just before the Mexicanus was created compelled one of the book's contributors to include this particular information in the Mexicanus. That the material contained in this section is derived from European sources underscores the

fact that it was the diseases introduced by the Spaniards that concerned the creators of the codex. It is likely that native peoples believed Spaniards would have more knowledge of necessary treatments, as they had more experience with these diseases. Indeed, the poor condition of these pages today suggests their frequent consultation in the past. Health, then, was another area over which the Mexicanus' owners and readers must have desired control.

Although the presence of astrological material in a book owned by and geared toward a native population seems remarkable, especially given the censorious attitude of later sixteenth-century New Spain, medical astrology was largely accepted in Spain and New Spain. Indeed, records pertaining to European medical astrology were likely seen as safer than references to native medical practices, which were viewed with suspicion by Spaniards. Accordingly, missing from the Mexicanus are Nahua beliefs about the sacred calendar's effects on health. Although Nahua knowledge of the medicinal properties of plants garnered the interest of numerous Spaniards in the years after the conquest and even came to serve as a sign of the civility of the Nahua peoples, native medical *practices* were viewed in a more negative light, being seen as rituals linked with paganism and superstition; hence the exclusion of such material from the Mexicanus.

Likely working at a later date, another contributor to the Mexicanus added a lengthy alphabetic text also related to astrology. Written in Nahuatl but drawn from a Spanish source, the text was added to a blank expanse within the annals section of the manuscript and explains the twelve signs of the zodiac and the characteristics of people born under the different signs (pages 24–34; Plates 13–18). A number of Spaniards correlated European astrological beliefs with Aztec beliefs that the stars and the sacred calendar also had influence over human affairs; the divinatory manuscripts are filled with such information. However, the Spaniards viewed these native beliefs as superstitions and actively rooted them out. That someone took the time to translate European zodiacal material into Nahuatl and add it to the Mexicanus points to traditional beliefs about astrology being slowly replaced with European ones. Thus, this text continues the theme of the link between people and the stars and also continues to show the Nahua interest in European cultural ideas. Nevertheless, in the eyes of the Spaniards, not all astrology was equal. The Spaniards accepted that the stars could influence the physical parts of man along with weather, navigation, and animals. However, the belief that stars could influence human affairs was seen as superstitious and therefore unacceptable and dangerous to record in a native book (Espantoso-Foley 1964, 7–8).

Medicine in the European and Nahua Worlds

In Europe, the practice of medical astrology can be traced to the medieval and classical past. As Hilary M. Carey (2003, 481) wrote, "Citing Hippocrates, medieval authors argued that whoever called himself a doctor, yet knew no astrology, was like a blind man." At first the church was suspicious of astrological beliefs, but eventually the study of astrology was assimilated to Christianity and its medical associations largely accepted as scientific fact (Bober 1948, 5; Clark 1979, 108; Weckmann 1992, 559). Indeed, Isidore, the archbishop of Seville who lived during the seventh century, included treatises on astrology and its links with medicine in his well-known work *Etymologiae*, in which he wrote that the ideal physician "ought to know astronomy, by

which he should study the motions of the stars and the changes of the seasons, for as a certain physician said, our bodies are also changed with their courses" (in Sharpe 1964, 64). In the following century, the Venerable Bede, an English monk, used *Etymologiae* as a source for his work *De temporibus* (*On Time*), which is best known because of its introduction of his principles of *computus*, the complex calculation of the date of Easter, which was largely based on astrology. Bede's work also included references to the humors and their relations to the seasons (Clark 1979, 130). Bede set a pattern for the production of computus manuscripts, many of which came to include texts pertaining to medical astrology, such as those that related the zodiac to the body for purposes of ascertaining proper times for bleeding and purging.

By the thirteenth century, the link between medicine and astrology was firmly established in Europe, with some universities even holding chairs of medicine and astrology (Carey 2004, 346–348). At this same time, accounts on medical astrology came to be recorded in a variety of books, including the aforementioned computus manuscripts, as well as calendars, almanacs, books of hours, and more personal manuscripts such as "folded almanacs" that were used to record calendric, astrological, and medical information and used largely by medical practitioners in England and France (Carey 2003). The practice of astrological medicine must also have been popular in Spain, as information on medical astrology was recorded in Reportorios as early as the fifteenth century, and by 1570, there was even a petition in Spain that all medical students learn astrology (Espantoso-Foley 1964, 6).

Although the Inquisition later forbade the practice of astrology and some Inquisition trials were related to astrological practitioners, this was not because astrology was viewed as a heretical practice by the church but instead because the accused were believed to be communicating with negative astral influences (Cañizares-Esguerra 1999, 50). Writing in the sixteenth century, the noted theologian and mathematician Pedro Ciruelo distinguished between true and false astrology, claiming that true astrology, also known as natural astrology, focused on the influence of the heavenly bodies on weather, animals, and the physical parts of man, whereas false astrology, known as judicial astrology, dealt with the influence of the stars on human affairs, or superstitions (ctd. in Espantoso-Foley 1964, 7–8). Accordingly, when Pope Sixtus V issued a Bull in 1586 that prohibited the practice of astrology, it was divinatory astrology that was targeted, whereas natural astrology and the publication of books related to natural astrology and its association with medicine, as well as agriculture and navigation, were still permitted (Avalos 2007, 81). Hence, the Inquisition in Spain did not systematically persecute astrologers unless they practiced judicial astrology, and even those cases were relatively rare (Avalos 2007, 100).

The Nahuas who lived before and after the conquest also practiced astrology, observing the stars and consulting their books for divination and healing. The *tlamatinime*, or wise men, were sometimes described as astronomers, based on "their responsibility as calendar priests and soothsayers who tracked the cycles of time and interpreted their meaning" (Boone 2007, 23). Doctors, called *ticitl* in Nahuatl, were included in the general category of tlamatinime and were important members of Nahua society. Sahagún (1950–1982, 11: 30) included information on doctors in his work, explaining that "the physician [is] a curer of people, a restorer, a provider of health." The twenty-eighth chapter of book 10 includes information on a variety of illnesses and their treatments, and Sahagún

(1950–1982, 11: 163) ended this chapter by naming the eight native doctors who served as his informants, suggesting the respect he held for them. Doctors would have used divinatory codices for their work, as these include records to be used in diagnosing and curing various illnesses in accord with the calendar and the stars (Boone 2007, 26–27).

Elite individuals also had knowledge of the stars. For example, when discussing the education of elite Aztec boys, Diego Durán (1971, 293) included astrology among the "arts" that they were expected to learn. He also compared the Aztec day signs with the European zodiac, writing "some signs were held to be good, others evil, and others indifferent, just as our almanacs record the signs of the zodiac, where we are told that some influences are good, others bad, and others indifferent regarding the sowing of crops and even the health of our bodies" (Durán 1971, 396). Religion and astrology were also linked, as an image in the Codex Mendoza (62v–63r) records the nighttime duties of the priests by picturing one observing the stars. The associated texts explain that some priests were occupied at night, using the stars for timekeeping or to learn the correct times for services and duties. Thus, the link of the stars and human activities and health was an idea shared by Europeans and Nahuas alike.

Another shared area of interest for the Spaniards and the Nahuas was on the medicinal properties of plants, with the Spaniards being particularly fascinated by the medicinal plants of the New World. For example, a book known as the Codex de la Cruz Badiano was commissioned by Francisco de Mendoza, the son of the former viceroy Mendoza, and is filled with illustrations and texts detailing the healing properties of native plants. Intended as a gift for Charles V, this book was compiled in the

mid-sixteenth century at the Colegio de Santa Cruz Tlatelolco by Nahua authors, but it was a bicultural product, laced with native and European ways (Gimmel 2008). In format, the book is similar to European herbals, with its contents separated into chapters according to disease and associated body part, and its creators must have had European books available to them as source material and model, likely through the Colegio's library (Gimmel 2008, 171, 177). Likewise, the encyclopedic work on native culture compiled by Sahagún (1950–1982, 12: 129–220) included information on medicinal plants of the New World. This information was presented in a manner similar to the Codex de la Cruz Badiano, suggesting that Sahagún's informants too had access to and knowledge of European sources, but the contents of both were clearly drawn from native culture.

Nevertheless, though Sahagún was interested in native knowledge about the medicinal properties of New World plants, he did not exhibit complete acceptance of native medical procedures. He followed the distinction between true and false astrology explained above, seeing European medical astrology as the true one and the medical astrology of the natives as one built upon falsehoods. Accordingly, in his discussion of the Aztec physicians' practice, Sahagún (1950–1982, 11: 30) does not mention the divinatory manuals or astrology. Moreover, when he describes the native day count and its association with divination in another section, he contrasts it to the natural astrology common among Europeans, describing the Nahua system as "an artifice made by the devil himself" (Sahagún 1950-1982, 6: 145). The creators of the Codex de la Cruz Badiano also neglected to tie the use of medicinal plants to the tracking of the stars or to ritual. Thus, Spaniards were interested in native medicine and saw it as a

legitimate practice, as long as it was shorn of its "superstitious" and ritualistic associations, which I suspect partly explains the lack of references to native medicine in the Mexicanus.

Indeed, to find information on native medical practices tied with rituals associated with healing one must turn to a group of codices that are often described as "cultural encyclopedias." For example, the Codex Tudela and the Codex Magliabechiano contain information on divining illnesses and the offerings necessary to cure particular illnesses (Nuttall 1903, 65v-66r; Boone 2007, 27). However, these were created at the behest of friars with the intent of allowing them to recognize these practices so that they could be stopped. Indeed, in 1629, Hernando Ruiz de Alarcón (1984) published a treatise in which he denounced the "heathen" practices of the native peoples, and he included curing practices among these. Thus, the emphasis on European medicine in the Mexicanus, rather than native medical practices, makes sense, as the Spaniards would have promoted their own practices over the so-called heathen ones of the Nahuas.

Medical Astrology in the Codex Mexicanus

Information on medical astrology is found in a three-page section of the Codex Mexicanus that could be used on its own or in conjunction with information taken from the perpetual calendar that begins the book and immediately precedes this section (Plates 6 and 7). The first page of this section is devoted to a chart of the lunar cycle, which is associated with the astrological signs and the Metonic cycle. This page is used to determine a day's suitability, or lack thereof, for bleeding and purging. The second page repeats the astrological information of the first

but additionally relates each zodiac sign to one of the four elements. This still relates to medicine, as the elements were believed to affect one's humors, which also affected one's health. Although in poor condition, enough remains of the final page of this section to associate it with a common genre in European manuscripts. Known as a Zodiac Man, the illustration associates parts of the body with the zodiac signs, again with the idea that the astrological signs influence the body and healing.

Two of these pages, the lunar chart and the zodiac man, were clearly copied from European sources, most likely those included in a Reportorio, as supported in more detail below. Two medical books were published in Mexico City in the sixteenth century, but neither contains charts similar to those included in the Reportorios, which suggests that the Mexicanus creators were looking to an almanac rather than one of these medical books.[1] The information on page 11 pertaining to the zodiac signs and the elements does not have a pictorial match with the Reportorios but repeats material that is found in alphabetic texts within them. In the Reportorios, material pertaining to medicine is more thorough, spread over a number of pages and filled with lengthy alphabetic explanations, whereas the Mexicanus painter took this information and condensed it into a succinct visual form. As in the perpetual calendar, the painter must be addressing this information to a native audience used to the visual sphere as a means of communicating information.

LUNAR CHART

A table that would have been used to determine the position of the moon in the zodiac on any given day is recorded on page 10 (Plate 6), the first page of the medical-astrological section (Prem 1978, 275). This information was at the

core of astrological medicine (Carey 2004, 352). Composed with a vertical rather than horizontal orientation, the table includes a column at the left filled with the signs of the zodiac, communicated in their iconic pictorial forms beginning with Aries at the top. Each sign is associated with either two or three rows, giving a total of twenty-eight rows in the chart. Each sign is also shown with a disk colored red, black, white, half-red/half-black, or half-red/half-white; the colors of the disks are consistent for each sign. That is, each of the three rows associated with Aries includes a circle that is half red and half black, while the two rows devoted to Taurus are each fully black and those devoted to Gemini are fully red. At the top of the chart are the nineteen golden numbers, written in Roman numerals, based on the Metonic cycle.[2] Each calendar year has an associated golden number, which is calculated by dividing the given year by 19, then taking the remainder and adding 1. Filling the 532 cells of the chart is a repeating twenty-seven lunar letter sequence that begins at the top left and fills the columns vertically.[3] This same lunar letter sequence also appears on the Mexicanus' perpetual calendar, which was used in consultation with this chart. For example, page 5 associates September 1 with the lunar letter *a*. Using the year 1580 as an example, one would calculate its golden number by dividing 1580 by 19 and then taking the remainder and adding 1, which gives golden number 4. Finding *iiii* in the golden number row and tracing that column down to lunar letter *a* and following that row to the left brings the reader to Cancer. Using this chart, then, one would learn that in 1580, on September 1, the moon was in Cancer.

This information relates to the practice of medicine. The Anonymous Reportorio of 1554 includes a golden number chart similar to that included in the Mexicanus that also follows immediately after a monthly saints' calendar

(Figure 3.1). The main difference, however, is that the Mexicanus records the signs of the zodiac with pictorial icons rather than alphabetic text, and it also includes the circles of red, black, and white. The next page in the Reportorio clarifies the meaning of these disks and makes clear the association of the lunar chart with medicine. In the Reportorio, the golden number chart is succeeded by another that correlates the moon being in one of these signs on a particular day as a time that is good, bad, or indifferent for purging and bleeding (Figure 3.1). When comparing this chart with the Mexicanus' association of zodiac signs with circles on the golden number chart, it becomes clear that the circles act as a shorthand device to record similar information on a particular day's suitability, or lack thereof, for these same medical practices.[4] For example, all of the signs that are bad for both purging and bleeding in the Reportorio of 1554 are also marked as fully black in the Mexicanus. If black is associated with bad, red with indifferent, and white with good, the Mexicanus disks are an almost exact match with this almanac. The only disjunctions are with Aquarius and Libra, but this is not surprising, as the various Reportorios with bleeding and purging charts are not consistent as to their good, bad, or indifferent natures. Hence, this contributor to the Mexicanus may have followed the Anonymous Reportorio of 1554 and made a mistake or may have copied his information from a different Reportorio.

A medical practitioner, then, would consult a chart like this to determine the position of the moon on a given day. With this information in hand, he or she could determine whether a particular day was good, bad, or indifferent for the bleeding or purging of a sick patient. Returning to September 1, 1580, for example, as the moon was in Cancer on this day, it would have been good for purging and neutral for bleeding. The contributors to the Mexicanus may have been

particularly interested in purging and bleeding because these related to preconquest practices, such as bloodletting as a means of restoring balance to the body (López Austin 1988, 380–381).

The inclusion of a lunar table, called *tabula signorum seu minutionum*—along with an index of days that are good, bad, or indifferent for bleeding and purging—is typical of Spanish sources and distinguishes them from French and English calendars (Bober 1948, 20). Therefore, the source for the Mexicanus contributor was surely a Spanish one and most likely a Reportorio, as supported also by the following pages. The Mexicanus scribe, then, has taken information that was communicated in an alphabetic format in a Reportorio and translated it into a pictorial system, using colors to indicate favorability, or lack thereof, for these medical practices and indicating the zodiac signs with their pictorial icons rather than alphabetic text. Moreover, he has combined information from different pages of the Reportorio into a coherent whole, a system he follows on the next page of the Mexicanus, which continues the medical focus.

ZODIAC CHART

Page 11 (Plate 6) of the Mexicanus includes a chart of the zodiac signs with the same circle/color combinations indicating each sign's favorability, or lack thereof, with bleeding and

3.1 Lunar and zodiacal charts used for medical astrology, Anonymous, *Repertorio de los tiempos*, folios 39r–39v. Universidad de Salamanca (España). Biblioteca General Histórica.

purging.[5] The signs and the circles associated with each match the signs and circle/color combinations on the previous page. The additional information provided pertains to each sign's association with one of the four elements. Beginning at the top left, Aquarius is associated with wind, Pisces with water, Aries with fire, and Taurus with earth. Then the cycle of elements repeats, with Gemini associated with wind, Cancer with water, Leo with fire, Virgo with earth, Libra with wind, Scorpio with water, Sagittarius with fire, and Capricorn with earth.

The association of the zodiac signs on this page with the same sequence of disks indicating good, bad, and indifferent times for bleeding and purging shows that this page also relates to medicine, as is also supported by the references to the four elements, as these were also linked with the practice of medicine. Dating to the practice of Hippocrates, each of the four elements was believed to have an associated quality. Fire was associated with heat, air with cold, earth with dryness, and water with moistness. These elements came to be associated with the bodily humors, which were linked with the four fluids that were believed to circulate through the body: blood, phlegm, yellow bile, and black bile. According to Hippocratic medicine, for one to be in proper health, one needed a proper balance of the humors (Foster 1987, 359). Humoral medicine spread throughout eastern and western Europe and eventually became integrated into medieval Christian medicine (Foster 1987, 361). Isidore of Seville even included a text in *Etymologies* relating the humors to the body and the elements; as he wrote, "Just as there are four elements, so also there are four humors, and each humor imitates its own proper element: blood the air; yellow bile fire; black bile earth; and phlegm water" (in Sharpe 1964, 56). This medical theory remained dominant in Europe through the sixteenth century, and as Foster

(1987, 361–362) points out, humoral medicine came to the New World as a sophisticated system related to the educated classes and especially clergy and physicians. It was taught at the Colegio de Santa Cruz Tlatelolco by the 1530s, and knowledge on humoral medicine would have spread to the masses through a network of physicians and clergy.

It also likely spread through books such as the Reportorios. Although the Reportorios have no charts similar to the one included in the Mexicanus, they do include material on the zodiac signs and their medical associations. For example, more thorough information on the zodiac signs and their associations with the different elements is provided in a section of the anonymous Reportorio of 1554 that preceded its lunar charts (Figure 3.2). Here, each sign is shown in pictorial form with a short paragraph that gives a history of the sign and explains the temperaments of those born under each sign. As seen on this same page, this section ends with a brief chart that relates each sign to one of the four elements. As it is likely that the Mexicanus was modeled after a Reportorio, the Mexicanus painter must have greatly condensed the textual information found in such a book and translated it into pictorial form, as was done with the lunar table.

Apart from the medical implications of this section, it is informative to consider the visual renderings of the zodiac signs as well as the icons for the elements. Clearly, the Mexicanus painter was looking to a European source for his representation of the zodiac signs. In Europe, these signs were fairly standardized (Hourihane 2007). The icons used in the Mexicanus largely follow these conventions. For Aquarius, the Mexicanus shows a typical representation of a man standing in a lake and pouring water from a vase held in each hand. Water in this representation is depicted in a more perceptual manner

and not with the icon for water that is used elsewhere in the Mexicanus. Pisces is shown with two fish placed horizontally and facing in opposite directions. Aries is a ram, Taurus a bull, and Gemini shown with a pair of entwined twins. The sign for Cancer is not entirely clear but appears to be a fish seen from above. A male lion with a distinctive mane records Leo. For Virgo, a single woman is shown, and she holds a palm in one hand and a flower in the other, as is typical in European representations of Virgo.

3.2 Description of Pisces followed by a chart of the zodiac signs and their associated elements, Anonymous, *Repertorio de los tiempos*, folio 26v. Universidad de Salamanca (España). Biblioteca General Histórica.

Scales are shown for Libra. In Europe, Scorpio was one of the least consistently depicted signs, presumably because European artists had little experience with scorpions (Clark 1979, 340), but it is shown in a fairly accurate manner in the Mexicanus. Seen from above, it has the distinctive curled tail and eight legs, though the artist includes pincers on four of these rather than just the first two. Sagittarius is shown as a centaur shooting an arrow from a bow. Finally, Capricorn is shown with a distinctive curled tail, though the rest of the goat's body is in poor condition. When comparing these drawings with the signs of the zodiac printed in the various Reportorios, there are general similarities but no exact matches to point to a specific source being used by the Mexicanus painter, perhaps because he had multiple sources for reference.

The depiction of the elements is also distinctive, as these are shown in a manner that reflects both European and native iconography. For example, the personified icon for wind is clearly based on that used in Europe, the image of a face blowing out a gust of air. In three of the representations, the face is shown in profile, but in the fourth it is shown in a three-quarter view, again indicating that the painter was not slavishly copying one source. The image of water is atypical of both European and native imagery. Here water is shown coming down from a conical emblem, perhaps representing rain. This is surprising, as the icon for water in Aztec pictography is perhaps one of the most standardized and is drawn in this iconic form in other sections of the Mexicanus. Fire, too, is standardized in Aztec pictography, but again the Mexicanus contributor eschewed the native practice and depicted fire as the flames that are more typical in European imagery. The pictorial icons for water and fire were ubiquitous in preconquest art, especially because the metaphor of water and fire (*atl-tlachinolli*) signified war in Aztec art

and rhetoric.[6] By contrast, the representation of earth in the Mexicanus is more typical of Aztec pictography. Earth is typically shown as a rectangular patch with U-shaped elements and dots, and this same icon is used in the Mexicanus. However, the element above the patches of earth is not entirely clear. The triangular object may reference a plow or digging stick, while the round piece above this may suggest a seed, though it also resembles a ball of copal.

Ultimately, the association of the zodiac signs with the elements, along with the inclusion of the disks related to bleeding and purging, suggests that this page also related to medicine and specifically the medical humors, and that the source for this information, again, was likely a Reportorio. Although translated into pictorial form, the majority of images seen on this page are more typical of European iconography, which again points to the European sphere as the focus. However, there is an element of innovation here, as this page is not an exact match with a Reportorio and even includes a native pictorial icon, suggesting the painter has taken information from a European source but creatively presented it in a pictorial manner understandable to an audience of indigenes.

ZODIAC MAN

Continuing with the medical theme is the image on the next page, which is commonly known as a Zodiac Man and again reveals the interrelated nature of medicine and astrology in the early modern world (Plate 7). Unfortunately, this page is in extremely poor condition, which I suspect is more a result of its frequent usage than a deliberate whitewashing at a later date. Fortunately, enough remains of the image to trace its similarity to a general form known as the Zodiac Man, also called *Figura de amistad* and *homo signorum*.

Based on the belief that the stars exert an influence on the body, such illustrations associate parts of the human body with the signs of the zodiac (Clark 1979, 284–287). A typical Zodiac Man shows a nude male figure, with his legs apart and arms extended (Figure 3.3). The signs of the zodiac may be imposed on the body itself or arranged to the side of the figure, with lines linking each zodiac sign, and sometimes planets, to a particular body part. The latter format is seen in the Mexicanus. Zodiac Man illustrations were often accompanied by a text that explained the parts of the body governed by each zodiac sign and described the medical procedures, such as bleeding, applicable to the various body parts and dependent on the position of the moon in the zodiac (Clark 1979, 270). Accordingly, illustrations of the Zodiac Man are often used in conjunction with lunar tables, such as the one on page 10 of the Mexicanus. Images of the Zodiac Man began to appear in Europe in the thirteenth century, and in subsequent centuries, they became ubiquitous in a wide variety of manuscripts, typically being included in medical astrological texts but also in calendars and books of hours, and later, with the advent of printing, they began appearing in books such as the *Reportorios de los tiempos*. The popularity of astrological and medical works, especially medical calendars and almanacs, made the Zodiac Man a common image in early modern Europe (Clark 1979, 356, 370).

The Zodiac Man included in the Mexicanus is similar to a print included in some Reportorios, such as the Anonymous Reportorio of 1554, which suggests the Mexicanus painter used the print as a model (Figure 3.3). For example, the illustrations in both the Mexicanus and the Anonymous Reportorio show the Zodiac Man in frontal view and with his head turned to the viewer's right. Although the Mexicanus Zodiac Man is in poor condition, the lines that

connect the body parts to the right and left are still visible in red and largely match up with the lines included in the Reportorio image. In the Reportorio, these lines lead to zodiac signs on the right and the planets, sun, and moon on the left. Unfortunately, in the Mexicanus, the elements to which these lines lead are now largely illegible; however, the barest trace of the scales for Libra is visible toward the middle of the right side of the page, with a faint red line linking this sign to the Zodiac Man's thigh, as is also seen in the Reportorio image. In the Reportorio, the Zodiac Man's head is linked to the ram for Aries at the top right of the page, and likewise in the Mexicanus, a red line from the Zodiac Man's head leads to a curved horn that must have been a part of the sign for Aries. The signs at the left are even more difficult to read today; however, the lines that are still visible again largely match up with those in the Reportorio print. For example, in the Reportorio, a line leads from the head of the Zodiac Man all the way down to a moon by his foot, and a similar red line is seen in the Mexicanus leading from the head of the Zodiac Man down to the figure's hand, where the line becomes effaced but presumably continued to the foot. I suspect that the disks that are visible along the margins where the zodiac signs and planets should be are remnants from an earlier use of this paper.

More compelling evidence for the similarity between the Mexicanus and the Reportorio print is found at the center of the figure. First, both works include another, smaller figure between the Zodiac Man's legs. Although the image in the Mexicanus is partially effaced, he stands with his left arm in a gesture similar to the figure in the Reportorio. Another shared feature between the two Zodiac Man illustrations is their chests, which have been opened to reveal internal organs that are labeled with text. In the Reportorio image, the organs at the top are the heart (*corazón*) and lung (*pulmón*). In the Mexicanus, an image of an oval-shaped heart, highlighted in red, is barely visible, while to the left of this, the word *pulimon* can be made out in reference to lungs. Under the heart, both the Reportorio and the Mexicanus include texts that read *estómago* (stomach), and at the bottom, both record another notation for *tripa*, or guts.

Though the Reportorio includes a number of additional texts identifying the different temperaments of man and naming the different zodiac

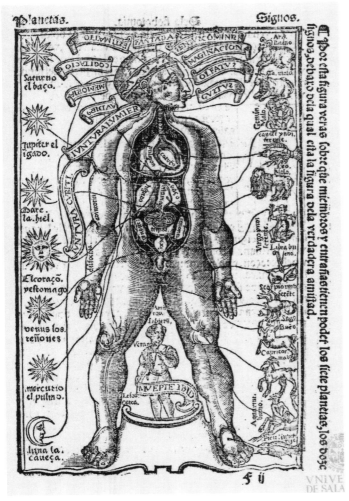

3.3 *Zodiac Man*, Anonymous, *Repertorio de los tiempos*, folio 42r. Universidad de Salamanca (España). Biblioteca General Histórica.

signs and planets, along with a description of good, bad, or indifferent, these texts are not included in the Mexicanus. Nevertheless, there are enough similarities between the two images to suggest that the painter of this image copied the Zodiac Man from this same print, either having seen it in the Reportorio of 1554 or elsewhere, as it was published in other Reportorios at this same time. Moreover, the Zodiac Man in the Reportorios typically followed soon after the golden number and purging and bleeding charts. The Mexicanus contributor must have been particularly drawn, then, to the medical information contained within the larger almanacs.

Specifically, the painter of the Zodiac Man may have been drawn to this European image because of a predisposition to the visual sphere as a means of recording knowledge and also because the Nahuas too linked the body with time. In this regard, the Zodiac Man is the one page in this medical-astrological section most similar to native beliefs. Indeed, native books also included diagrams that linked the day signs with body parts (Viesca, Aranda, and Ramos 1998; Nowotny 2005, 227–228; Boone 2007, 107–113). The preconquest books included a number of diagrams related to supernaturals and deer skins, but not humans. The only one to picture a human was included in a postconquest source, the Codex Vaticanus A (Figure 3.4). According to an explanation of the image by the friar who commissioned the work, Pedro de los Ríos, this corporeal almanac pertained to healing, in that "a cure could be developed according to the day and time an ailment began" (Boone 2007, 110). Boone (2007, 112–113) notes that friars working in central Mexico may have been particularly drawn to these almanacs because they superficially resembled the Zodiac Man with which they were familiar. Nevertheless, the native almanacs work in a different manner, with the Aztec day signs taking meaning from the body parts, whereas the body parts

in the Zodiac Man derive their meaning from the zodiac. Although the image in the Vaticanus A was likely influenced by a European model, the linking of day signs with corporeal almanacs related to supernaturals and animal skins in some preconquest sources suggests that the connection between the body and time was also a part of the native belief system (Viesca, Aranda, and Ramos 1998, 150; Boone 2007, 112).[7] Nonetheless, the image in the Mexicanus is thoroughly based on a European source, but

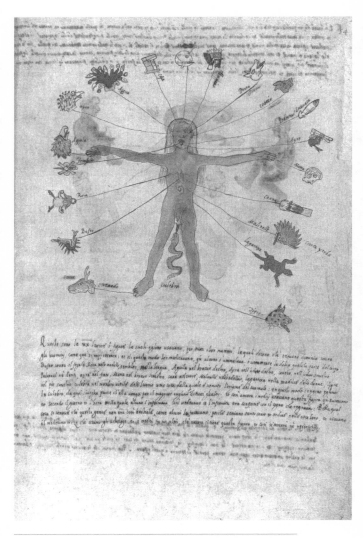

3.4 Diagram of the human body and associated day signs, Codex Vaticanus A, folio 54r. Courtesy of the Biblioteca Apostolica Vaticana.

one that must have been of interest to a native audience interested in the medical practices of the Spaniards.

ASTROLOGY AND HEALTH

This three-page section of the Codex Mexicanus points to a sense of anxiety about health on the part of its native compilers, which was surely linked with the epidemics afflicting the native population throughout the sixteenth century. The Spanish invasion did not just bring a new people, religion, and political system to the native peoples, but it also introduced the natives to pathogens never before experienced and to which they had no immunity, such as smallpox, typhus, and hemorrhagic fever.

Indeed, the Mexicanus' annals history makes the prevalence of disease a recurring feature of colonial life. The first reference to a European disease is found just one year after the arrival of the Spaniards, with a smallpox victim shown above the year 2 Reed (1520) on page 77 (Plate 39). Another outbreak is noted twelve years later, in 1 Flint (1532), with an image of a person covered in pustules and a shroud (Plate 40). An associated alphabetic gloss mentions a *huey zahuatl*, the Nahuatl term used to describe smallpox, and that there was much death (*ic micohuai*). Another epidemic occurred from 1545 to 1548. The exact illness is still undetermined, though a team of scientists recently recovered salmonella in burials associated with the outbreak (Vågene et al., 2017). Spaniards commented on the large number of indigenes who died from what must have been a devastating disease, marked by bleeding from the orifices (Prem 1991, 31). On page 81 of the Mexicanus, above the year 1 House (1545), a prone man is shown with blood coming from his mouth and indicating the start of the epidemic (Plate 41). The majority of events recorded throughout the annals history are typically depicted with black ink, but here the painter shows the blood in red, highlighting the devastation of this disease. Yet another outbreak occurred in 1563–1564, marked in the Mexicanus by another prone figure covered in pockmarks and placed under the year 7 Flint (1564) but linked with a line to the previous year as well, communicating the extent of the outbreak (Plate 43). This one may have been measles (Prem 1991, 37–38). A decade later, the epidemic of 1576–1577 is recorded with a skull above the years 6 Reed and 7 House, while below, an alphabetic text records a *cocoliztli*, or sickness (Plate 44). The most striking symptom of this disease was bleeding from the orifices, but the Mexicanus painter focuses just on the deaths it caused. Of all the epidemics the native peoples had suffered in the first century of Spanish rule, this was the most devastating and the one most frequently mentioned in contemporaneous accounts (Prem 1991, 38). With the Mexicanus being created so soon after this latest epidemic, it is understandable that the issue of health, or lack thereof, was a key source of anxiety for the owners of the book.

The devastation wrought by these epidemics was unprecedented, as were the sicknesses themselves before the arrival of the Spaniards. Accordingly, the Nahua peoples must have felt that their traditional medicine was no match. Moreover, the Spaniards were more resistant to these diseases because of their built-up immunities. The Nahuas could not have known this and would have likely thought that the Spaniards did not suffer as much because their European medical practices were able to combat the illnesses. Indeed, writing in 1582, the Texcocan chronicler, Juan de Pomar, suggested, "as all these illnesses are known by the Spaniards, they have cured and treated according to their rule and opinion, applying the medicines and ordinary treatments which are still used at the present time" (in Cook 1998, 102). A letter sent by Viceroy Don Martín Enríquez to Philip II in

1576 specifically stated that the principal remedy for the latest epidemic should be bleeding, and the viceroy indicated that he had called on friars, priests, doctors, and barbers to share this remedy with the native peoples (*Cartas de Indias* 1877, 331). With such an educational push led by the Spaniards themselves, it makes sense that the contributors to the Mexicanus would have included material on European medical practices in their book.

Leading this educational charge would have been the religious personnel who came into daily contact with the native peoples. As George Foster (1987, 361–362) has shown, the religious orders played a major role in transferring their medical beliefs, especially about humoral medicine, to New Spain, and medical concepts were even taught to native students at the Colegio de Tlatelolco by the late 1530s. In the case of the contributors to the Mexicanus, knowledge about medical astrology may have come, directly or indirectly, from Alonso de la Vera Cruz, who clearly had an interest in the stars, as the earliest reference to astronomy in a book in the New World is found in his 1557 publication, *Physica Speculatio* (Trabulse 1983, 57). Moreover, his library at the Colegio de San Pablo was decorated with astronomical instruments and models (Weckmann 1992, 560). Thus, the references to medical astrology in the Mexicanus may further link the creation of the book with the intellectual world of the Augustinians and the Colegio de San Pablo.

Moreover, just as the link between astrology and health was largely accepted in Spain, so too was it accepted in New Spain, even being used to explain the health crises that devastated central Mexico. For example, Sahagún attributed the epidemics to "evil astral influences" (in Cañizares-Esguerra 1999, 44–45), and in a medical book published in the sixteenth century by Alonzo López de Hinojosos (1977, 153) in Mexico City, he too linked the recurring outbreaks of diseases in Mexico to the conjunctions of the stars.

The Zodiac Signs

A later annotator added in a lengthy text pertaining to the zodiac under the year count in a blank portion of the annals section of pages 24–34 of the Mexicanus (Plates 13–18). The style of writing here is different from the Nahuatl annotations found elsewhere in the manuscript, and the blocky penmanship points to this being the work of a scribe writing in the seventeenth century. It is also more fitting of one with less experience writing. This is evidenced by the lack of ligatures (connected letters). The only one used in this section is *tl*. In other Nahuatl texts in the Mexicanus, *ch* and *tz* also appear as ligatures, as do the endings *–mi* and *–ui*. Moreover, the scribe did not use a consistent orthography, which makes a transcription and translation of this text difficult. This difficulty is compounded by the poor condition of this section, as much of the text is worn away at the papers' edges. A transcription of the text, though necessarily incomplete, is offered in Appendix 2.

Despite these roadblocks to offering a translation of this section, the names of the zodiac signs do stand out, as does the phrasing at the beginning of each new sign's description. For example, the text begins, "aqui ypa tlacati yn itoca Aqualliyos . . . " (Someone who is born during that time, its name is Aquarius). The remaining signs all begin with similar introductory texts. For clarity in the original, each section is separated by a triangle. In the excerpts below, I reconstruct effaced letters or words, while Appendix 2 offers a more literal transcription:

- *Ynic otetli yn itoca pizis yn aqui ypa tlacati yehuatli*

And the second sign, its name is Pisces, and someone who is born during that time, he . . .

- *Ynic uetetli yn itoca Ariyes yn aqui ypa tlacati yehuatli*

And the third sign, its name is Aries, and someone who is born during that time, he . . .

- *Ynic nauhtetli yn itoca taolloes yn aqui ypa tlacati yehuatli*

And the fourth sign, its name is Taurus, and someone who is born during that time, he . . .

- *Ynic macuiltetli yn itoca geminis yn aqui nima tlacati yehuatli*

And the fifth sign, its name is Gemini, and someone who is born then, he . . .

- *Ynic chiquacentetli yn itoca cancer yn aqui ypa tlacati yehuatli*

And the sixth sign, its name is Cancer, and someone who is born during that time, he . . .

- *Ynic chicometetli yn itoca lleonis yn aqui ypa tlacati yehuatli*

And the seventh sign, its name is Leo and someone who is born during that time, he . . .

- *Ynic chicuetetli yn itoca virco yn ichipochtli yn ipa tlacati yn aço cihuatl*

And the eighth sign, its name is Virgo, young woman, and someone who is born then, perhaps a woman . . .

- *Ynic chicuinauhtetli yn itoca libra pexo yniqui ypa tlacatetl yehuatli*

And the ninth sign, its name is Libra, weight (scales), and someone who is born during that time, he . . .

- *Ynic matlactetli yn itoca scorpio yn aqui ypa tlacati yehuatli*

And the tenth sign, its name is Scorpio . . . and someone who is born during that time, he . . .

- *Ynic matlactlocetetli satoceallios yn itoca yn aqui ypa tlacati yehuatli*

And the eleventh sign, its name is Sagittarius and someone who is born during that time, he . . .

- *xii. yn itoca capricornos y tetçone yn aqui yn ipa tlacati yehuatli*

Twelve, its name is Capricorn, goat, and someone who is born during that time, he . . .

The information that follows the introductory sentence explains the temperaments and proclivities of those born under each sign. For example, one born under Taurus is likely to be a farmer (*tlalchiuhqui*) and strong (*chicahua*), but not arrogant (*amo ceca mopohuani*). These texts are surely derived from a Spanish source and then translated into Nahuatl, adding another level of complexity to the translation, as many of the ideas and objects in Spanish may not have been a part of Nahuatl language or thought. For example, under Sagittarius, the word *tlacamaçatl* is used and means "person deer." This term must describe a centaur, the pictorial sign for Sagittarius and a concept that would not have existed in Nahuatl. Some other signs are also described. For example, Virgo includes the word *ichpochtli*, or "young woman"; Libra includes the Spanish word *pexo*, for "weight" or "scales," and Capricorn is called *tetçone*, which means "bearded one" and was the name the Nahuas used for goats.

Although this information may have been drawn from a Reportorio, none offers a direct match with the texts in the Mexicanus. For example, the Anonymous Reportorio (1554, 25v) begins the description for Sagittarius by

describing its sign as *"un monstruoso animal que es medio hombre delante y medio caballo detrás, llamado por los antiguos Centurio"* (a monstrous animal that is half man in the front and half horse in the back), whereas the Mexicanus scribe ends the description of Sagittarius by describing its sign simply as a *tlacamaçatl* (person-deer). Moreover, the Reportorios provide fuller information on the signs, including the months and planets with which they were associated, and they do not typically list occupations, as the Mexicanus does (see Figure 3.2). And finally, when explaining the zodiac signs, the Reportorios begin with Aries, but in the Mexicanus, the scribe begins with Aquarius, which follows the start of the Christian calendar, as Aquarius falls in January, and it also follows the presentation of the zodiac on page 11 of the Mexicanus. As this section was likely added later, the scribe may not have had access to the same sources as the earlier contributors to the Mexicanus.

Just as the Christian saints' calendar provided the native peoples a way of tracking time comparable to traditional ways, the zodiac signs and their influence over human affairs were surely seen as another divinatory mechanism comparable to preconquest beliefs. Before the conquest, when a child was born, parents consulted wise men, who used their pictorial books to determine the fate of that child based on the sacred calendar (Boone 2007, 29). Analogous to preconquest traditions, then, the European zodiac would have been another perceived equivalency between the two worlds and between the Reportorios and Aztec divinatory books. Nevertheless, while the section on medical astrology was unlikely to raise the suspicions of the church, this alphabetic text could be seen as emblematic of the false astrology that was targeted by the Inquisition. Moreover, the concern with such practices had increased by the seventeenth century, when it is likely that this

section was added. Therefore, its very inclusion speaks to the perceived necessity of having such information, in spite of its danger. This section further evidences the Nahua audience for the book as a whole and suggests that it was intentionally kept from Spanish view.

Conclusions

The Mexicanus' inclusion of material related to European astrology makes sense, as such contents were included in the Reportorios, and the Mexicanus as a whole was modeled after this genre. However, the choice to include information related to the stars' link with health and divination also reveals a process by which European concepts began to replace native ones as the sixteenth century progressed. Just as the calendrical references in the Mexicanus revealed an adaptation wherein the monthly calendar related to the 365-day xihuitl began to take precedence over the 260-day sacred calendar (see Chapter 2), the European zodiac seems to have been gaining primacy in the minds of the native peoples. The preconquest tonalamatl linked the sacred calendar with issues of health and fate, and likewise, the Reportorios linked the European zodiac with these same domains. Thus, the astrological contents in the Mexicanus, though drawn from European sources, were likely of interest to native intellectuals and selected for inclusion in the Mexicanus because they were similar to native traditions.

The contributors to the Mexicanus were not unique among native intellectuals in taking an interest in European astrology. For instance, descriptions of the zodiac signs and their relations to agriculture, astrology, and medicine were taken from a Reportorio, translated into Nahuatl, and added to a 1553 edition of Fray Pedro de Gante's *Doctrina christiana en lengua*

mexicana; the style of writing suggests this was done in the second half of the sixteenth century (López Austin 1973). Created in the mid-seventeenth century, another manuscript in the collection of the Bibliothèque nationale de France, Fonds Mexicain 381, includes a description of the signs of the zodiac, while the rest of the manuscript is filled with Christian prayers translated into Nahuatl (Tavárez 2011, 133–139).[8] Like the descriptions in the Mexicanus, these are not direct translations from Spanish to Nahuatl of contents in a Reportorio, though they do reveal general similarities with this material. Additionally, a Nahuatl manuscript in the Tropenmuseum in Amsterdam, written in 1758 but perhaps copied from an earlier source, contains information comparable to the Codex Mexicanus, including images and texts on medical astrology and the zodiac signs that were derived too from a Reportorio (Wichmann and Heijnen 2008). Farther afield in the Maya region and compiled during the eighteenth and nineteenth centuries, the series of works known collectively as the Books of Chilam Balam, too, contain material related to European astrology drawn from the Reportorios, especially the Books of Kaua and Ixil (Bricker and Miram 2002; Caso Barrera 2011; George-Hirons 2015).

Thus, a number of native intellectuals shared an interest in European astrology and acquired knowledge on the topic through Reportorios. The information related to medical practices was surely included because of the concern with health and the diseases introduced by the Spaniards. Moreover, this information was related to natural astrology and would have been deemed acceptable in the colonial world. In contrast, the information related to the zodiac and its influence over human affairs was related to "false" astrology and would have been riskier to include in native books. Indeed, a papal Bull issued in 1586 expressly prohibited the practice of divinatory astrology, which makes the inclusion of this material in the Mexicanus all the more remarkable, especially considering it was likely added after the prohibition was circulated. That a later contributor added such contents and in spite of the risk of Spanish condemnation reveals the perceived necessity of having access to such information. As the author of the zodiacal information inserted into the Gante *Doctrina* wrote, "Muchas cosas no se ponen aquí que no aprovechan a los indios" (many things were not included here that do not benefit the Indians) (López Austin 1973, 292). That is, the zodiacal information was recorded in these sources because it was believed to benefit the lives of the native peoples, giving them a sense of control over health and fate, domains that were once linked with the Aztec sacred calendar in the tonalamatl but were now associated with European astrology and recorded in the Reportorios.

Divine Lineage

A Genealogy of the Tenochca Royal House

Spanning just two pages of the codex (pages 16–17), the Mexicanus' genealogy is one of the few pictorial genealogies of the Mexica royal house known and is by far the most extensive (Plate 9).[1] The genealogy records an intricate but organized web of familial connections, imposing structure on the royal house as its generations multiplied over time. Much like any genealogy, this one is an edited record of the past, with certain family members chosen and highlighted to send a message important to the times in which the genealogy was created. Few scholars besides myself (Diel 2015) and María Castañeda de la Paz (2013, 2016) have considered this genealogy in detail; working independently and not always concurring on our readings of some of the genealogy's place and name signs, we do both find that ultimately the Mexicanus communicates the high status of the Mexica ruling line.

As argued in the reading that follows, the Mexicanus genealogy communicates the divinity of Tenochtitlan's rulers by linking them with the sacred past and suggesting that its dynastic line was directly descended from the gods. The genealogy also renders the ruling dynasty of Tenochtitlan in a highly ordered manner, which further suggests a cosmic underpinning to the royal family and points to concepts of sacred kingship being important for the legitimization

of rule. Finally, the genealogy sends a unique message regarding the purity of the Tenochca bloodline. On one level, this focus relates to Spanish discourse on *limpieza de sangre*, or blood purity, that was gaining traction in late sixteenth-century New Spain, particularly as a means of promoting the status of one's bloodline. On another level, I suspect that this focus also relates to a desire on the part of the Mexicanus' contributors to promote the Tenochca royal lineage above all others. Painted just after descendants of the Mexica noble line had lost control of Mexico City's native government, the Mexicanus genealogy pictures the Tenochca dynasty as a closed bloodline that essentially rebukes outsiders who may lay claim to Mexica privileges but could not match the divinity, order, and integrity of its bloodline.

Genealogies in the Nahua and Spanish Worlds

Both the Aztec and Spanish empires kept records on royal genealogies, seeing them as linked with the functioning of the state and hereditary rule. In fact, it is difficult to tease out the amount of European influence in the Nahua genealogies created after the conquest, because genealogies had such similar functions in the Aztec and Spanish worlds. In her study of European family trees, Elizabeth Klapisch-Zuber's (1991, 107) description of European genealogies could apply equally well to Nahua ones; as she writes, in these, "what counts most is the ability to prove the antiquity and continuity of one's line, beginning with the remotest ancestor possible." This is certainly true of the Mexicanus genealogy, which traces the Mexica dynastic line to the divine past and stresses its continuity from then into the colonial period.

Although no preconquest Aztec genealogies survive, they must have been recorded before the conquest (Olko 2007). For example, Sahagún (1950–1982, 6: 250) describes the work of a genealogist in his encyclopedia on Aztec culture, using the expression *teco, teuipana*, which Arthur Anderson and Charles Dibble translated as "he linketh people; he placeth people in order." As Delia Cosentino (2002, 120) explains, "The expression reflects the idea that for the Nahua, the genealogy was in effect a group of people 'strung' together, and thus, a physical network of related individuals." This idea is also expressed by the Nahuatl term *tlacamecayotl*, or rope of kinship. These kinship ties, or strings, are clearly evident in the Mexicanus' visualization of the Tenochca family line, as well as other genealogies from the colonial era.

The closest pictorial genealogy in style and content to the Mexicanus genealogy is the *Fragmento de genealogía de los príncipes mexicanos* (Figure 4.1). Following Sahagún's description, the genealogy links people together and places them in order. Painted on a single piece of European paper in the mid-sixteenth century, the genealogy is recorded primarily in visual form, with alphabetic annotations supplementing the pictorial imagery. Read in a descending order, the *Fragmento* begins with the Mexica rulers Itzcoatl and Moteuczoma I; then their respective children, Tezozomoc and Atotoztli, are below them and linked by a dotted line in a marriage statement. Below them, and linked together by a horizontal red line, are their three children and subsequent rulers of Tenochtitlan: Tizoc, Axayacatl, and Ahuitzotl. However, only the descendants of Tizoc are pictured and are clearly given precedence. For example, Tizoc's son, Tezcapopocatzin, is shown just below his father and linked to him with a vertical line. He has the throne and crown of a ruler, even though

he never held that position. His son, Don Diego (Tehuetzquititzin), is linked by a line just below and shown in a similar manner, though he actually did serve as governor of Tenochtitlan.[2]

Some other pictorials also provide statements on tlacamecayotl. For example, the Codex Cozcatzin provides a brief genealogical statement on Moteuczoma II, showing him linked by a line with two of his children, his daughter Doña Isabel and his son Don Pedro (see Figure 4.11). Another genealogy, known as the Circular Genealogy of Nezahualcoyotl (Figure 4.2), records one family's descent from the Mexica ruler Itzcoatl and the Texcocan ruler Nezahualcoyotl. It also uses lines to show connections between family members, but the main focus is on the family line presented in a circular manner, with the generations echoing out into successive rings, much like the generations on the second page of the Mexicanus genealogy. Unfortunately, with no known preconquest examples, it is impossible to know whether the circular composition was typical of Aztec genealogies, but the consistent use of lines to connect family members in each of these examples suggests this was a preconquest convention.

In Europe, family lines and genealogies were conceptualized as trees; however, it wasn't until the fifteenth century that genealogies took on the canonical structure of the family tree. Before this, when genealogies took pictorial form, they were often composed in a vertical fashion, with a top-to-bottom reading order taking precedence until the sixteenth century, when the opposite reading order based on the structure of a tree became popular, likely inspired by images of the biblical Tree of Jesse (Klapisch-Zuber 1991, 122–123).[3] In these later genealogies, the founding ancestor was typically placed at the roots or trunk of the tree and his descendants occupied the ascending branches (Klapisch-Zuber 1991, 105).

Beginning in the mid-sixteenth century, Reportorios began to include more historical information on Spain and its history, which included kings' lists. Although not formatted as genealogical trees, the kings' lists do imply genealogical relationships, as descent was typically from father to son. For example, the Reportorio

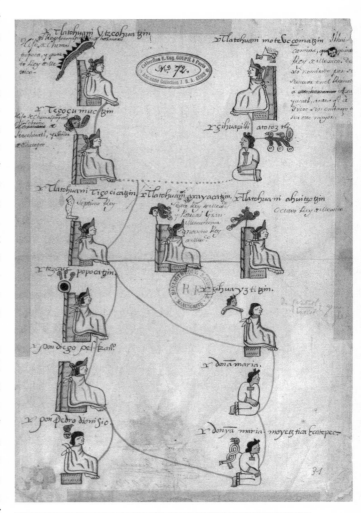

4.1 *Above*: Royal Mexica genealogy, Fragmento de genealogía de los príncipes mexicanos. Courtesy of the Bibliothèque nationale de France.

4.2 *Facing*: Genealogy of descendants of Itzcoatl and Nezahualcoyotl, Circular Genealogy of Nezahualcoyotl. Nettie Lee Benson Latin American Collection, the University of Texas at Austin.

by Chaves (1576, 82r-83r) includes a kings' list for Spain that begins in the ancient past with the founder of Iberia, Tubal, and ends with King Philip. This same list is included in other Reportorios, such as one published by Bernardo Pérez de Vargas (1563, 288–289).

In early modern Spain, genealogies had another important characteristic: being linked to a growing discourse on blood purity, or limpieza de sangre. Beginning in the fifteenth century and continuing into the eighteenth century, limpieza de sangre was necessitated for most political and religious positions, and purity was proven through genealogies (Martínez 2008, 43–44). A concern with blood purity clearly impacted the Spanish colonization of the New World. In her study of the transferal of limpieza de sangre to the New World, María Elena Martínez (2008, 16) links it specifically with the evangelization project:

> That religion was integral to Spanish colonialism was due in large measure to its importance in sixteenth-century Spain itself, where Catholicism was the only religion allowed, where the church and state had developed an extraordinarily strong relationship, and where the twin notions of "Old Christian blood" and genealogical purity had emerged as powerful cultural principles and exclusionary weapons. Religion, lineage, and blood would in turn be used to organize the Spanish colonial world.

As Martínez (2008, 5) points out, the argument that native peoples were "unsullied by Judaism and Islam and had willingly accepted Christianity, made it possible for some of the descendants of pre-Hispanic dynasties to successfully claim the status of limpieza de sangre." The result was that a discourse of purity and lineage became a strategy for native nobles interested in proving their high status and acceptance of Christianity (Martínez 2008, 19–20). Such a discourse becomes clear in the reading and analysis of the Mexicanus genealogy that follows.

Claims of Divinity in the Codex Mexicanus Genealogy

The first page of the Mexicanus genealogy concerns the migratory Mexica ancestors and their divine origins. The genealogy begins in the distant past, with four figures—two male-female pairs—commencing the genealogy at the left (Figure 4.3, Plate 9).[4] Each is placed within cells of a larger rectangular grid. The central cell is marked with a place sign that is difficult to interpret definitively. It consists of a hill sign topped with spiky branches that may reference reeds. Based on its placement at the beginning of the genealogy and its association with reeds, this place sign could refer to Aztlan, the original Mexica homeland. In the annals history, Aztlan is also shown as a place of reeds and the location from which the Mexica ancestors had departed as they began their search for a new homeland, which eventually led them to Tenochtitlan, where they settled and built an empire. However, the place sign here is different from the sign for Aztlan used at the beginning of the Mexicanus' annals history (Plate 10). Moreover, it includes a banner sign for *pan-tli* affixed to the hill sign. Alternatively, Castañeda de la Paz (2016, 131–132) identifies the place as Tlacopan. In this case the banner would reference the *–pan* suffix for "on the surface of" and the spiky branches would be rods, or *tlaco-tl*. However, the place sign for Tlacopan that appears on pages 40 and 59 (Plates 21 and 30) of the Mexicanus annals history is also different, making it difficult to unequivocally identify this place apart from its role as a place of origin.

Malinalco

Copil

Tlatelolco

Epcoatl

Xicomoyahual

Chalchiuhnenetzin (?)

Cuauhtlequetzqui

Tenzacatetl

Huitzilopochtli (?)

Chapultepec

Aztlan (?)

Xicomoyahual

Acacihtli

Malinalxochitl

Chimalpopoca

4.3 Page 1 of genealogy with important figures labeled, Codex Mexicanus, page 16. Courtesy of the Bibliothèque nationale de France.

The identity of the man seated before this sign is also problematic. He is identified with a name tag of a full-sized bird. His mantle, crown, and woven reed throne, called a *tepotzicpalli*, designate him as a ruler. However, I suspect that he represents Huitzilopochtli, the patron god of the Mexica people. Huitzilopochtli is typically identified as a hummingbird, but in the annals portion of the Mexicanus, he also appears as an eagle (Plate 10; see Chapter 5). The figure seated below him also points to his identity as Huitzilopochtli. Occupying her own cell and shown in a kneeling posture, she is identified with a name tag of a white and red conical cap that often marks a figure named Copil in Aztec pictorial histories. Here, I believe it identifies the woman as Copil's mother, Malinalxochitl, who was the sister of Huitzilopochtli. Contextually, it would make sense for this primary pair to represent, in human form, the original leaders of the Mexica migration, Huitzilopochtli and his sister Malinalxochitl, who also played a significant role in the migration. No lines link this male-female pair, pointing to a sibling relationship rather than that of husband and wife, or father and daughter.[5] The strongest support for the woman being Malinalxochitl is her "Copil" name tag, which repeats on a male figure seated at the top of the same column, surely referencing her son. A yellow line links him to a hill sign topped by a twisted rope, recording a place called Malinalco (Place of Twisted Grass). A woman seated below Copil is linked to the same Malinalco place sign by another yellow line, and her name glyph is a bee surrounded by dots for Xicomoyahual (She Who Becomes a Bee).

The relationship amongst these figures comes into better focus upon consulting alphabetic accounts of the Mexica migration. According to numerous sources, the Mexica began their migration compelled by their patron deity Huitzilopochtli and accompanied by his sister Malinalxochitl.[6] The Spanish chronicler Fray Diego Durán (1994, 31–33) gives a detailed

account of how the Mexica migrants were troubled by Malinalxochitl, whom he describes as "wicked, possessed of evil arts and cunning." The migrants abandoned her, and she went on to found Malinalco, where she gave birth to her son Copil. She later told her son of Huitzilopochtli's offenses against her, and Copil "promised to seek out his uncle and with his arts and cunning destroy him and all his followers." Having learned that Huitzilopochtli and his followers had arrived at Chapultepec, Copil provoked other towns to rise up with him against the migrants. Copil and his allies traveled to Chapultepec, where they attacked the Mexica. However, in the melee, a high-ranking Mexica priest named Cuauhtlequetzqui captured and killed Copil. According to the Nahua annalist Chimalpahin Cuauhtlehuanitzin (1998, 1: 161), Copil had brought his daughter, Xicomoyahual, with him to Chapultepec, and upon his defeat, he offered her to Cuauhtlequetzqui, who took her as his wife.

These events must be reflected in the Mexicanus genealogy. Footprints below Xicomoyahual at Malinalco suggest travel and lead the viewer to the Grasshopper Hill place sign for Chapultepec, in front of which is a second representation of Copil's daughter.[7] A man is seated above her, and his Eagle-Leg name glyph identifies him as Cuauhtlequetzqui, a name that is difficult to translate fully but contains the words for eagle (*cuauh-tli*) and leg (*quez-tli*). A yellow line from Xicomoyahual joins a red line from Cuauhtlequetzqui, confirming their union. These same events are referenced in the annals portion of the manuscript (Plate 20). On the top register above the year 1 House (1285), one man grabs another by the hair. Although the victor is unnamed, the victim is identified by the "conical cap" name tag as well as an alphabetic annotation as Copil. Underneath, Xicomoyahual and Cuauhtlequetzqui are linked again in a marriage statement.

The placement of Copil and Xicomoyahual at the beginning of the genealogy suggests their importance, which is underscored by the fact that Xicomoyahual is one of only two figures in the genealogy marked with footprints and whose image repeats. Moreover, according to this genealogy, most of Tenochtitlan's future rulers will be able to trace their descent to this family, which is made clear at Xicomoyahual's second representation, where a yellow line from her merges with the red line of her husband. The change of Xicomoyahual's line from yellow to red suggests the precedence of a new patriline, and the colors of all subsequent family lines in the Mexicanus genealogy, too, will be organized based on the male line. In fact, Doris Heyden (in Durán 1994, 31–32) maintained that the Malinalxochitl versus Huitzilopochtli legend symbolically referenced a clash between two factions of Mexica migrants, one a matrilineal group associated with Malinalxochitl and the other a patrilineal group tied to Huitzilopochtli. Heyden concluded that Huitzilopochtli's success ensured the patrilineal basis of Mexica rule, which may also be suggested by the Mexicanus genealogy, where all subsequent connective lines mark families along the patriline, confirming its dominance. This dominance is also suggested by the acquisition of Copil's daughter and her incorporation into the Huitzilopochtli faction of migrants.

The red line from Cuauhtlequetzqui leads to a man identified with a name glyph of a stone (*te-tl*) and a lip labret (*tente-tl*) for Tenzacatetl, which implies that he is their descendant. The Tira de Tepechpan also records a son being born of Cuauhtlequetzqui and Xicomoyahual at Chapultepec, though it identifies him as Coatzontli, or Snake Beard (Figure 4.4). According to Chimalpahin Cuauhtlehuanitzin (1997 2: 81), Coatzontli had a son named Tenzacatetl, who would go on to found Tenochtitlan. The Tira de Tepechpan concurs, showing Tenzacatetl also

as one of Tenochtitlan's founders (Figure 4.5). The Mexicanus genealogy shows the Tenochtitlan place sign just in front of Tenzacatetl on the next page, suggesting his association with Tenochtitlan's foundation here as well. A reconciliation of these different accounts suggests that Tenzacatetl is the grandchild, via his father Coatzontli, of Xicomoyahual and Cuauhtlequetzqui. Accordingly, the Mexicanus painter has collapsed time and omitted the Coatzontli generation, thereby highlighting the founder's descent from Xicomoyahual. In so doing, he communicates Tenzacatetl's descent via his mother from the Mexica gods, Malinalxochitl and Huitzilopochtli. He must therefore be semidivine. Although Copil is often identified as an enemy of the Mexica, I believe it is his divinity that takes precedence in this story. Indeed, it was only because of his evil acts that Xicomoyahual entered the Mexica lineage, imbuing it with a divine foundation.

This divinity can be traced to future rulers of Tenochtitlan through Tenzacatetl's daughter. A red line extends from his foot down to the right and ends at a woman on the next page, signaling that she is his offspring (Plate 9). This falls at the binding of the page and is difficult to see in reproductions but visible when viewed in person. The woman is identified with a name tag of grass (*zaca-tl*), teeth (*tlan-tli*), and preciousness (*chalchihuitl*), perhaps reading Chaltlanzacatl. A thick green line from her joins another thick green line from Acamapichtli (Handful of Reeds) above, recording their marriage. Placed just in front of the Tenochtitlan place sign, Acamapichtli is shown with the accoutrements of a proper *tlatoani*, a turquoise diadem and *tepotzicpalli*, communicating the establishment of the city's royal dynasty.[8] The joined lines from Acamapichtli and his wife end at Huitzilihuitl (Hummingbird Feather), marking the second ruler of Tenochtitlan as their son. Huitzilihuitl's mother, then, links him with the ancient and divine past, as seen in the family tree in Figure 4.6. Moreover, with the exception of Itzcoatl, all future rulers of Tenochtitlan will be able to trace their lineage through Huitzilihuitl to this woman and through her to Xicomoyahual, Malinalxochitl, and Huitzilopochtli. Thus, they are all semidivine.

4.4 Cuauhtlequetzqui, Xicomoyahual, and their son Coatzontli, Tira de Tepechpan, page 2. Courtesy of the Bibliothèque nationale de France.

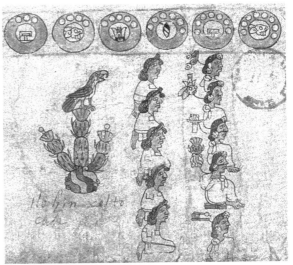

4.5 Foundation of Tenochtitlan, Tira de Tepechpan, page 5. Courtesy of the Bibliothèque nationale de France.

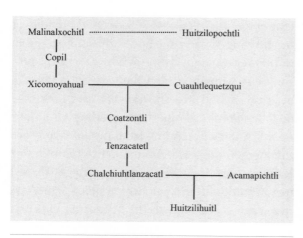

Malinalxochitl ···················· Huitzilopochtli
 |
 Copil
 |
Xicomoyahual ——————— Cuauhtlequetzqui
 |
 Coatzontli
 |
 Tenzacatetl
 |
Chalchiuhtlanzacatl ——————— Acamapichtli
 |
 Huitzilihuitl

4.6 Family tree for Huitzilihuitl according to the Codex Mexicanus.

Acamapichtli appears on the same axis line as Huitzilopochtli generations earlier, suggesting his generative role (Plate 9). Moreover, both are shown in an autochthonous manner, in that their own parents are not shown. The lack of an ancestry statement for Acamapichtli makes sense given how unclear his parentage is in the sources. Susan Gillespie (1989, 26–42) has attempted to reconcile the various traditions. As she points out, in the rare instances in which Acamapichtli's parentage is mentioned, he is most often said to have been the son of a Culhua princess and a Mexica father. More recently, Castañeda de la Paz (2013, 64) has argued that the various traditions on Acamapichtli's parentage can be divided along two lines, with Mexica sources identifying him as a Culhua-Tolteca and Acolhua sources as a Chichimeca-Tepaneca. Pedro Carrasco (1984, 57) suggests that the uncertainty evident in the literature would have "helped to mark clearly the beginning of a new dynastic line and to make it difficult for any other dynasty to claim a well-established right to the rulership." This is certainly true in the Mexicanus, where Acamapichtli's appearance begins the dynastic line with apparently no need to record his ancestry. Indeed, I suspect

that Acamapichtli's wife's ancestry is emphasized instead because she establishes the ruling dynasty's divinity.

Just as the exact identity of Acamapichtli's parents is difficult to pin down in the sources, the same is true of his principal wife. The sources cite one woman most frequently, Ilancueitl of Culhuacan, but her role is ambiguous. Many chroniclers point out that she was not the mother of Acamapichtli's children and therefore not the major progenitor of the Mexica ruling line. Durán (1994, 52) explains that Ilancueitl was barren, so the principal lords of Tenochtitlan decided that each would offer a daughter to the tlatoani. These women would be considered secondary wives, and from them "sons and heirs would be born." He continues that a man named Acacihtli (Reed Hare) was the first to offer his daughter. The sign of a reed (*aca-tl*) and a hare (*cih-tli*) that floats under Tenzacatetl on page 16 must record his name (see Figure 4.3). A man with the same name sign is included in the Tira de Tepechpan image of Tenochtitlan's foundation (see Figure 4.5) as well as the Codex Mendoza (see Figure 5.2). Acacihtli was followed by Tenzacatetl and other town founders.[9] Although many sons were subsequently born, it was the fourth-born who became the next ruler. This was Huitzilihuitl, who Durán also notes was the grandson of Cuauhtlequetzqui. Both Durán and the Mexicanus genealogy, then, highlight Huitzilihuitl's ancestral links to the divine past.

The omission of Ilancueitl from the Mexicanus genealogy is telling, as she and her Culhua lineage are highlighted in other sources. Indeed, the Mexica of Tenochtitlan were seen as so linked with Culhuacan that they were often called the Culhua-Mexica (see Carrasco 1999). Throughout his letters, Hernán Cortés (1986) simply refers to the Mexica as the Culhua. Culhuacan is typically associated with the esteemed Toltecs, and the marriage of a Toltec

noblewoman to the Mexica ruler added Toltec prestige and legitimacy to the Mexica ruling line (Gillespie 1989, 57). Indeed, though women are infrequently included in Aztec histories, when they do appear, one of their key roles is to act as a "Toltec ennobler"; that is, they provide Toltec blood to the dynastic line (Gillespie 1989, 39; Diel 2005a, 84–86). Accordingly, the Codex Telleriano-Remensis annals history, which typically makes no mention of wives, includes Ilancueitl (Old Woman Skirt) along with her Culhuacan (Curved Hill) place sign (Figure 4.7).

4·7 Acamapichtli and his Culhua wife, Ilancueitl, Codex Telleriano-Remensis, folio 29v. Courtesy of the Bibliothèque nationale de France.

The codex, then, stresses the Toltec connections of this wife and implies that she was the mother of the next Mexica ruler, Huitzilihuitl. The message is that the dynasty's legitimacy was traced to its fusion of Toltec and Mexica bloodlines (Quiñones Keber 1995, 212–214).

In contrast, the Mexicanus presents an alternative tradition that omits Toltec connections from the Mexica dynasty. Presumably these Toltec connections mattered little for the painter of the genealogy, who instead stressed the divinity of the Tenochca royal house by showing that Acamapichtli's principal wife and the mother of Tenochtitlan's second ruler was a descendant of the original Mexica migrants, who themselves were descended from the gods. With their divine connections, the Mexica ruling lineage would have been held above all others. Moreover, the genealogy stresses ethnic purity by visualizing the start of Tenochtitlan's ruling dynasty as purely Mexica, not Culhua-Mexica. This focus on purity continues in the second half of the genealogy on page 17, but first the genealogy takes some tangents by including some noninheriting descendants of Acamapichtli and Huitzilihuitl.

Additional information on the family line of Acamapichtli is included toward the bottom of the Mexicanus, but unfortunately, much of this area is in poor condition, making it difficult to interpret fully. A light blue line from Acamapichtli passes through Huitzilihuitl's mother and then leads to a series of hieroglyphic compounds at the left (Plate 9). The first compound is challenging to read, as its falls at the binding of the book and the bottom of the page. A line from here leads above toward what appears to be the face of a woman, which is then linked to the Acacihtli sign, perhaps in reference to the daughter he also provided to Acamapichtli. Another blue line at the bottom of the page leads to two more hieroglyphic compounds on page 16.

The first consists of a warrior's head (*yao-tl*), and the second is a hand (*ma-itl*) over a house (*cal-li*) sign. These may reflect more founders who provided daughters to Acamapichtli, though the name tags do not match the names of these founders listed in other sources.

Another line from Acamapichtli, this time a red dotted one, leads to more hieroglyphic compounds below on page 17 (Figure 4.8). The line splits in two, with the one on the right linked to a compound of a star (*citlal-in*) and a snake (*coa-tl*) which in turn is associated with a head below, suggesting this is a name tag. According to Chimalpahin Cuauhtlehuanitzin (1998 1: 227), Acamapichtli had a son named Citlalcoatl. Hence, the Mexicanus must record this same son. The other line extends to a compound of a shield and club (for war, *yaoyo-tl*) coupled with a woman's head (*cihua-tl*), for Yaocihuatl, who the Mexicanus records was another son of Acamapichtli.[10]

Descendants of Huitzilihuitl are also included in the Mexicanus genealogy. A dark-green dotted line extends from him (below and to the right) to three men who wear their hair in topknots that distinguish warriors in Aztec pictorials. These men must be his children, and each is identified with a name tag. Because the bottom of the page is in such poor condition, the name of the first son at the right is difficult to read. The second son is identified with a name tag of an upright drum (*huehue-tl*) with what appears to be grass on top (*zaca-tl*). According to Durán (1994, 81) and Chimalpahin Cuauhtlehuanitzin (1998, 1: 241), Huitzilihuitl had a son named Huehuezaca, which matches the Mexicanus name sign. The name tag for the third son is a red shape that I suspect represents a liver (*el-li*), in reference to another son of Huitzilihuitl named Tlacaelel, who was known as a strong military leader and who acted as *cihuacoatl*, or second in command to the Mexica ruler.[11]

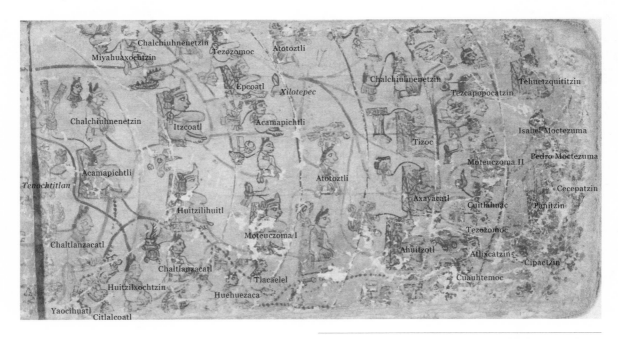

4.8 Page 2 of genealogy with important figures labeled, Codex Mexicanus, page 17. Courtesy of the Bibliothèque nationale de France.

Durán (1994, 202) includes Tlacaelel and Hue-huezaca in a list of "bold men" and notes, "It was because of them that Mexico-Tenochtitlan was exalted, feared, and revered, and the name Aztec respected and obeyed. These men initiated warring as a means of rising in Aztec society."

Another dark-green dotted line leads from Huehuezaca. It breaks in two, with the lower dotted line leading to the head of a woman who may be identified with a water (*a-tl*) name tag, though some tears in the paper here make this difficult to see. A green dotted line from her, in turn, leads to the head of a man placed to the left of the curved hill sign of Culhuacan. He is identified with a name tag, though it is difficult to read. The man faces to the left, toward the woman, which suggests that she was sent to Culhuacan to marry him. If so, this marriage would establish the supremacy of Tenochtitlan over Culhuacan, as it was typical for higher-ranking rulers to offer their daughters in marriage to subordinate rulers; such marriages established loyalty between the two rulers while also publicly marking the lesser ruler's subordinate rank.[12] According to the Mexicanus annals history, Tenochtitlan defeated Culhuacan in 11 Reed (1347), hence the marriage (Plate 25). The secondary dotted line from Huehuezaca curves above the head of the woman and around her name tag.[13] It then extends to the right and appears to end at a hieroglyphic compound that includes a house (*cal-li*) sign, though much of the imagery here has flaked away and is hard to decipher.

These additions at the bottom of the page serve to flesh out some of the descendants of Acamapichtli and Huitzilihuitl, especially those who were said to have been strong warriors and integral to the buildup of Tenochtitlan's military power. However, the painter of the genealogy was forced to squeeze these family members in at the bottom of the page because the two main branches of the royal lineage created by Acamapichtli's two wives and their sons clearly took precedence.

Cosmic Order in the Codex Mexicanus Genealogy

With the start of the Mexica dynasty and its divinity established, the Mexicanus genealogy goes on to record the subsequent rulers of Tenochtitlan, and it does so in a highly structured manner that I believe also comments on the sacred nature of the Mexica rulers by linking them with cosmic order (see Figure 4.8, Plate 9). Table 4.1 lists the Mexica rulers included here, along with their reign dates according to the Mexicanus' annals history.

Mexica Tlatoque	Years of Rule
Acamapichtli	1376–1396
Huitzilihuitl	1396–1417
Chimalpopoca	1417–1428
Itzcoatl	1428–1441
Moteuczoma I	1441–1470
Axayacatl	1470–1483
Tizoc	1483–1486
Ahuitzotl	1486–1502
Moteuczoma II	1502–1520
Cuauhtemoc	1520–1526
Don Diego Panitzin	1538–1541
Don Diego Tehuetzquititzin	1541–1554
Don Cristóbal Cecepatzin	1557–1562
Don Luis Cipactzin	1563–1565

4.1 Tenochca rulers in the Codex Mexicanus genealogy, along with their reign dates as recorded in the Mexicanus annals history.

The familial branch created by Acamapichtli and his second wife resulted in the birth of their son, Itzcoatl (Obsidian Serpent). Returning to Durán (1994, 53), he notes that Acamapichtli also took a beautiful slave as his wife. She was called Chalchiuhnenetzin (Precious Greenstone Doll), and together they had a son named Itzcoatl. As the generations echo out, so too does her name, reappearing on two future generations, that of her granddaughter and great-granddaughter, evidencing her significance, surely based on the achievements of her son, who despite his illegitimate birth and lack of a pedigreed mother, became so renowned for his bravery and military powers that he eventually became Tenochtitlan's fourth tlatoani. In the Mexicanus, Itzcoatl's mother is shown just above Acamapichtli, and the two are joined by a thick green line, just as he was linked to his other wife (Huitzilihuitl's mother) below. The green lines suggest equality between the two sons through their shared father and despite the different status levels of their mothers, whom the Mexicanus representation effectively equalizes.

Itzcoatl did not follow Huitzilihuitl directly to the throne; his reign came after that of Chimalpopoca (Smoking Shield), who is typically described as a child of Huitzilihuitl but also sometimes as his brother. A figure on the previous page may represent Chimalpopoca, but he is shown untethered and presumably without family, added in at the bottom of the page, seemingly an afterthought (see Figure 4.3). Chimalpopoca may have been excluded from the linked genealogy for a few reasons. First, Chimalpopoca's mother was said to have been a Tepanec princess (Carrasco 1984, 59), and the Mexicanus genealogist only includes Mexica noblewomen in its dynastic line. Moreover, the Tepanecs of Azcapotzalco were the leading power in central Mexico in the early fifteenth century until a coalition led by Itzcoatl conquered them in

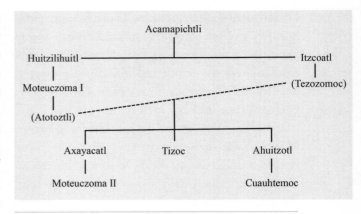

4.9 Tenochca family tree according to the Codex Mexicanus.

1428. Some colonial sources state that after this defeat, it was decided that the descendants of Chimalpopoca were demoted to commoner status because of his cowardice and links to the enemy Tepanecs through his mother (Carrasco 1984, 60; *Anales de Cuauhtitlan* 2011, 139). Accordingly, he would not merit inclusion in the dynastic line.

Finally, there is an elegant structure to the Mexica lineage that the Mexicanus genealogist stresses by showing two branches of leading families emanating from Acamapichtli and later coming together again through a key marriage. This is explained further below but can be seen charted in the diagram of the family tree at Figure 4.9. Susan Gillespie (1989) has convincingly argued that this ordering of the Mexica dynastic sequence reflects concepts of sacred kingship. As Mexica cosmology insists on order, the Mexicanus genealogy visualizes the dynastic line as an orderly and balanced construction, and the inclusion of Chimalpopoca in his rightful place would have marred this elegant construction.

The balanced structure of the Tenochca dynastic line is further supported by the inclusion of the wives of both Itzcoatl and Huitzilihuitl. A faint gray line from Huitzilihuitl joins one from his wife, named Huitzilxochtzin

(Hummingbird Flower), who is shown below and behind him. The line breaks away toward a daughter, who carries the same Precious-Teeth-Grass name tag as her grandmother.[14] The joined line from Huitzilihuitl and his wife ends at their son and future ruler of Tenochtitlan, Moteuczoma I (Angry Lord). Itzcoatl's wife, Miyahuaxochtzin (Corn Tassel Flower), is shown seated above and behind her husband. A red line links husband and wife and ends at their five children. The lineage of these two wives is recorded with a thick black line that leads from each wife back in time to the previous page where the lines join and end at a couple associated with the sandy-hill place glyph for Tlatelolco, marking the couple as their parents and the two wives as sisters.[15] Visually, this black line stands out in the manuscript and calls attention to these two women and their shared homeland and ancestry.

Tenochtitlan and Tlatelolco shared an island within Lake Texcoco, and each city was independently founded by Mexica migrants. Therefore, the taking of these early royal wives from Tlatelolco kept the Tenochca ruling lineage ethnically intact and purely Mexica. Later in time, the two cities became rivals, and Tenochtitlan conquered Tlatelolco and established control over the city, as recorded in the annals history (see Chapter 5). However, after the Spanish conquest, Tlatelolco became an independent city yet again. The inclusion of these two wives, then, links the colonial descendants of the Tenochca dynastic line to Tlatelolco and may reflect a desire on the part of the Mexica of Tenochtitlan to reclaim that city. Indeed, the message that Tenochtitlan's royal family was ultimately linked to Tlatelolco through the wives of both Itzcoatl and Huitzilihuitl is unique to the Codex Mexicanus; the identities of these wives are inconsistent in other sources. Only one known source claims a Tlatelolca wife and

for just one of these rulers, Itzcoatl; not surprisingly, that source is the *Anales de Tlatelolco* (2004, 87).

This ruler of Tlatelolco, and father-in-law of the two Tenochca rulers, is a spotty figure in Aztec history. The *Anales de Tlatelolco* (2004, 87) calls him Epcoatl (Conch Serpent), while the mestizo historian Fernando de Alva Ixtlilxochitl (1997, 1: 305, 402, 409) calls him both Epcoatl and Mixcoatl (Serpent Cloud). Epcoatl (Conch Serpent) may better relate to the name sign in the Mexicanus, which shows a face coming out of a scrolled element that may be a conch. This ruler appears twice in the Codex Xolotl (1996, maps 2 and 4), but with only one descendant shown, which Douglas (2010, 108) interprets as a sign of his line's fledgling status. However, Alva Ixtlilxochitl identifies his brothers as Acamapichtli and Tezozomoc, making the three siblings the rulers of Tlatelolco, Tenochtitlan, and Azcapotzalco, respectively. Interestingly, the Mexicanus shows three sons for Itzcoatl, and they too are named Tezozomoc, Epcoatl, and Acamapichtli, which suggests commemoration and mimicry of their grandfather's generation. Moreover, if Epcoatl and Acamapichtli were brothers, then the wives of Huitzilihuitl and Itzcoatl were also their cousins, a marriage pattern that will be followed by later Mexica rulers and one that secures the integrity of the dynastic line by excluding wives from other territories and ethnicities and thereby avoiding a wife with split loyalties (see Carrasco 1984, 56–63).

The shared Tlatelolca nationality of the wives of the half-brothers further equalizes the two branches of the Tenochca royal family created by Acamapichtli's two wives, but these branches are distinguished by the colors of the lines that extend from them. Itzcoatl and his wife are linked by red lines that extend to their children and then to all of their subsequent descendants. Red is a significant color choice,

as it is associated with blood and therefore life. For example, the first page of the Codex Fejervary-Mayer symbolically depicts the cosmos and links red with the east, place of sunrise. Thus, the use of this color for Itzcoatl's family line (and Cuautlequetzqui's earlier one) points to its dominance. The significance of Itzcoatl is also communicated by his placement toward the top of the page. In the Fejervary-Mayer cosmogram, east is also shown at the top, further reiterating its importance.

In contrast, a light gray color is associated with Huitzilihuitl's family line and extends to his son and subsequent ruler of Tenochtitlan, Moteuczoma I. Another gray line then links Moteuczoma I to two women who I suspect are his daughters. The first is seated in front of him and identified with a name tag that may be a dog's head. Moreover, a turquoise diadem floats below her, but a tear at the page makes it difficult to determine its intended meaning. Another gray line leads to a woman who is identified as Atotoztli (Water-Bird). As Moteuczoma's line ends with daughters, we see the end of Huitzilihuitl's patriline.

Nevertheless, Atotoztli does play a key role in perpetuating the dynastic line. She stands out for her central placement in the genealogy, being shown on the same faint horizontal ground-line as Acamapichtli, thus suggesting her generative role (Gillespie 1989, 98–106). Moreover, she is shown twice, the only figure besides the earlier Xicomoyahual (see Figure 4.3) to be shown twice in the genealogy, which again suggests her essential role. This is further marked by the fact that she and her sister are the only members of this generation included in the Mexicanus. Another faint gray line from Atotoztli is marked with footprints and leads to her second representation, now facing toward the earlier generation shown to the left. She is placed across from Itzcoatl's son Tezozomoc (Smoking Stone), a composition that refers to their marriage.

Although this marriage is mentioned by many other sources, they fail to address why Tezozomoc himself was never made an official ruler of Tenochtitlan.[16]

A different son of Itzcoatl is shown as a ruler in the Mexicanus; this is Epcoatl, who was sent to rule Xilotepec (Place of Young Corn), a Mexica-affiliated town in a strategic location to the north. The place is shown with a hill sign topped by a flint knife with a diagonal line inside. However, I suspect that what appears to be a flint knife was meant to be a corn plant, with the artist failing to include its distinctive tassels; a pictogram of this same place is included in the Codex Mendoza (8r), with a tasseled corn plant that is also marked with a diagonal line. Epcoatl's arrival in Xilotepec is highlighted in the Códice de Huichapan (2001, 26) and is also mentioned in the *Crónica Mexicáyotl* (1997, 133). He died an unnatural death by falling off a scaffolding, which may also be communicated in the Mexicanus annals history (Plate 32). In the genealogy, Epcoatl provides a nice visual counterpoint to Moteuczoma, his cousin, because the composition highlights the fact that both Huitzilihuitl and Itzcoatl had children who were rulers, further leveling the branches. Nevertheless, Moteuczoma is clearly more important, as he is shown larger and with his own descendants.

The union of Atotoztli and Tezozomoc is significant because they will be parents to the next three rulers of Tenochtitlan. In order of their reigns, their sons are Axayacatl (Water Face), Tizoc (Chalk Leg), and Ahuitzotl (Water Rat). Axayacatl is shown in the middle of the three brothers, Tizoc above, and Ahuitzotl at the bottom. An additional son of Tezozomoc and Atotoztli, named after his great-grandfather Huitzilihuitl, is shown toward the top but with no descendants, while a daughter, named Chalchiuhnenetzin (Precious Greenstone Doll) after her great-grandmother, is also included,

with red lines linking her to two daughters.[17] As Carrasco (1984, 63) has shown, the principal wives of the subsequent Tenochca rulers were from the dynasty itself; they were not outsiders. Therefore, no spouses for future generations are shown in the genealogy, perhaps because as Mexica queens, their identities were unremarkable. As in the Aztec histories, when a royal marriage met traditional expectations, it was unnecessary to promote it (Diel 2007, 270). All subsequent descendants are linked by red lines, suggesting that Itzcoatl's descent line has taken precedence and that all subsequent generations are equalized through their shared lineage.

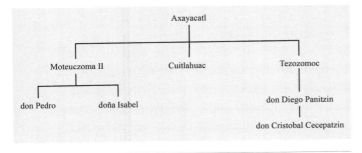

4.10 Axayacatl's descendants according to the Codex Mexicanus.

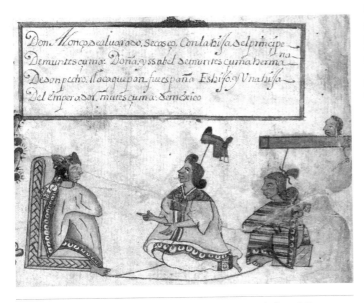

4.11 Moteuczoma II and his children, Doña Isabel and Don Pedro, Codex Cozcatzin, detail of folio 1v. Courtesy of the Bibliothèque nationale de France.

From Axayacatl, red lines lead to three of his sons (see Figure 4.10 for Axayacatl's family tree). The first one at the top is the Tenochca ruler Moteuczoma II. He is distinguished from the other members of his crowded generation by being shown in full, seated on the woven reed throne and wearing the diadem of rulership. Two lines lead from Moteuczoma II, one ending at the head of a man with a name glyph that matches that of his son, Don Pedro, in the Codex Cozcatzin, and the other ending with a woman's head that must reference his daughter, later known by her Spanish name, Isabel, who is also included in the Cozcatzin (Figure 4.11). Red lines extend from the siblings, suggesting the continuity of the family, though it is impossible to read whom they originally recorded. The second son of Axayacatl, Cuitlahuac (Excrement), appears below Moteuczoma II. It is generally agreed that Cuitlahuac ruled Tenochtitlan after the death of Moteuczoma II in 1520 for just eighty days before dying of smallpox, but the Mexicanus genealogy shows him with a simple image of a head with hair worn in a topknot. The painter of the genealogy, then, saw him as a warrior, not a ruler. A line from Cuitlahuac is visible, suggesting he had a child, though it is impossible to read the name sign to which it must have been attached, as this part of the page is highly damaged. The third son of Axayacatl, named Tezozomoc after his grandfather, is also marked as a warrior and linked to his own son. Although in poor condition, the son's turquoise diadem and woven reed throne indicate that he was a ruler, and his banner (*pan-tli*) name tag identifies him as the colonial governor, Don Diego Panitzin, who ruled Tenochtitlan, now Mexico City, from 1538 to 1541. A faint trace of a red line leads forward from Panitzin to the trace of another figure, likely referencing the reign of his son Don Cristóbal de Guzmán Cecepatzin, who ruled from 1557 to 1562.

From Tizoc (above Axayacatl) at the top, four red lines lead to four of his sons, indicated with simple head signs and name glyphs but distinguished in some ways by hair styling and facial features. One of these is Tezcapopocatzin (Smoking Mirror), who is pictured also in the Fragmento de genealogía de los príncipes mexicanos (see Figure 4.1). The painter of the Mexicanus genealogy shows him in a larger scale but not distinguished as a ruler. He is linked by a line to his son, Don Diego Tehuetzquititzin, whose full representation, throne, and diadem identify him as a ruler, as he succeeded Panitzin as governor, ruling from 1541 to 1554. Another red line from Tehuetzquititzin suggests that his family line continued, but no lines extend from Tizoc's other children.

From Ahuitzotl (below Axayacatl) at the bottom, the traces of two more red lines lead to two more sons. Although in poor condition, the son at the bottom must be Cuauhtemoc (Descending Eagle), Moteuczoma's successor and cousin, as traces of his woven reed throne are visible, as is his turquoise diadem. His brother, a warrior, is identified as Atlixcatzin (Water Eye). A man with this same name is also mentioned as a son of Ahuitzotl in the Información de 1548–1553 (Martínez Baracs 2006, 140–144). In the Mexicanus genealogy, he is also shown as a father of another colonial-era ruler by the red line that extends from him to another figure. Although in poor condition, the figure's full-body depiction can just barely be made out, suggesting this was another ruler, most likely the colonial-era governor Don Luis Santa María Cipactzin, who ruled from 1563 to 1565. He was the last of the Tenochca rulers to be descended from the royal bloodline (Gibson 1964, 169). Chimalpahin Cuauhtlehuanitzin (1998 2: 225) identifies the governor as a grandson of Ahuitzotl, as shown here. He also stresses that upon his death, rule over Tenochtitlan was no longer in the hands of the dynastic line. As Chimalpahin Cuauhtlehuanitzin (2006, 139) wrote, "with him it came to an end that descendants of the Mexica and Tenochca rulers should rule in Tenochtitlan any more; at that time their governing as rulers was cut off forever."

Limpieza de Sangre and the Mexica Royal Lineage

The Mexicanus sends a unique message about the purity of the Tenochca bloodline that must relate to the late sixteenth-century context in which it was set down. By this time, a discourse on native purity had emerged. Adapted from Spanish discourse on limpieza de sangre, or blood purity, for the Nahuas, it came to be based on lineage and associated with rights and privileges (Martínez 2008, 105). The only outside wives included in the Mexicanus genealogy are from Tlatelolco and therefore of Mexica blood, if not members themselves of the same royal lineage. Thus, the Mexicanus genealogy stresses the closed and pure Mexica nature of the bloodline to set its colonial-era descendants apart from all others.

Moreover, its message about the purity and integrity of the Mexica royal bloodline would have resonated in the tense religious atmosphere of late sixteenth-century New Spain. When Spanish discourse on blood purity was merged with colonial policy, the result was that "the native people's acceptance of the Catholic faith made them into a spiritually favored and unsullied population while their voluntary subjection to the Castilian monarch earned them rights similar to those enjoyed by natives of Spanish kingdoms" (Martínez 2008, 92). When considered in the light of the contents of the Mexicanus that communicate the Mexica acceptance of Christianity and Spanish

sovereignty, the Mexicanus genealogy's image of a pure Tenochca bloodline further enhances the prestige of the descendants of this bloodline.

Native aristocratic concern with blood and its link to rule was reinforced also by the Spanish colonial system. The issue of blood purity came to impact the native political sphere, with Spanish authorities distinguishing natives who were *principales de linaje y sangre* (nobles by virtue of lineage and blood) from natives who were *principales de gobierno* (nobles by virtue of office), and a key means of proving one's blood nobility was the presentation of genealogical information (Martínez 2008, 95, 109). Beginning in the late sixteenth century, some contenders for government positions were denied because of their mixed race (Martínez 2008, 115–116; Connell 2011, 121–125). This discourse on blood purity had become institutionalized by the late seventeenth century, when a Spanish royal decree stated that descendants of noble natives deserved the same rights and privileges as Spanish hidalgos (Villella 2011, 641). Accordingly, by the eighteenth century, there was a tradition of native elites claiming that the blood purity of their noble ancestors was the equal in quality to the nobility of Spain (Villella 2011, 635).

Long before the institutionalization of this discourse, the Mexicanus genealogist presented a unique view of the Mexica dynastic lineage, one that stressed its purity in such a way as to suggest that he was familiar at an early stage with this discourse and its usefulness in the religious and political spheres. Not only was the Tenochca lineage who lived during the later sixteenth century purely native, it was a step above, being purely Mexica, a distinction Spaniards may not have recognized but that must have mattered to the creator of the genealogy. Thus, the genealogy was a way for Mexica elites to set themselves apart from other native

groups and bolster the family line's prestige through this Spanish discourse. In fact, Rodrigo Martínez Baracs (2006, 136) showed that Juan Cano used a similar strategy to argue for privileges for his wife, Isabel Moteuczoma. In early texts related to Isabel's lineage, her mother was described as a noblewoman from Tlacopan, but later her mother was identified as a daughter of the Mexica ruler Ahuitzotl, thereby making Isabel pure Mexica nobility and presumably more worthy of privileges.

At a time when ethnic divisions were breaking down and the Tenochca dynastic line no longer controlled the native government of Mexico City, the Mexicanus' emphasis on the antiquity and purity of the bloodline would have essentially rebuked other ethnic groups laying claim to Mexica status and privileges. Indeed, the genealogy ends with fraying paper at the right, but the continuance of red lines indicates that the royal lineage continued, with its final descendants having children and grandchildren.

Nevertheless, after Cipactzin's death, there was an interregnum followed by the election of Don Francisco Jiménez, a nonnobleman, as judge of the Mexico City *cabildo*. He ruled until 1573, when Don Antonio Valeriano was elected judge-governor, and continued in this position until 1599. Thus, he was ruler of Mexico City's native sphere through the years in which the Codex Mexicanus was created, but the Mexicanus annalist distinguishes Valeriano from Tenochtitlan's earlier rulers. In the Mexicanus' pictorial history, earlier noble rulers were associated with reed thrones, whereas Jiménez holds a *vara*, or staff of justice, at his inauguration in 10 Reed (1567; Plate 43), as does Valeriano at his accession in 3 House (1573; Plate 44). The varas mark these men simply as judges, rather than noble governors. According to the Mexicanus, then, these men were principales de gobierno, not principales de linaje y sangre.

Indeed, the genealogy underscores the continuity of the royal lineage and its links to the native ruling sphere by showing the Mexica noblemen who ruled as colonial governors seated on the same woven reed thrones as their preconquest predecessors.

In actuality, Valeriano likely was a nobleman (Castañeda de la Paz 2011, 9–10). However, being born in Azcapotzalco, he was not a Tenochca nobleman.[18] Valeriano's election over what must have been a number of Tenochca nobles with more powerful claims to the governorship than he had was likely tied to general upheavals occurring in New Spain at the time and a desire by competing natives and/or the viceregal government to reduce the influence of the Tenochca royal lineage (Connell 2011, 56). That the Codex Mexicanus was made at this same time and with a focus on the Mexica dynastic line suggests that it was made, at least in part, in reaction to a perceived loss of power on the part of some members of the Mexica nobility and to bolster their position in colonial society. One of the strategies by which they did so was an emphasis on the purity and integrity of the family line.

Conclusions

The Mexicanus genealogy stands out from other pictorial genealogies for a few reasons. Other genealogies of the Tenochca royal house take a shallow view of the lineage with an emphasis on particular branches of the family. For instance, most other known genealogies from Mexico City focus on Moteuczoma II's descendants. Moreover, when these sources include family trees, they are often presented in a descending order, like the Fragmento mentioned earlier (see Figure 4.1), but many begin with Moteuczoma II, as if descent from him were enough to establish royal credentials in the colonial era.[19] In contrast, the Mexicanus takes the most extensive view of the royal house, tracing the lineage into the distant past. Additionally, with all colonial descendants in the Mexicanus genealogy being connected with red lines to the same ancestors, no one family takes precedence. This sense of equality amongst the latest descendants is also suggested by the horizontal orientation of the Mexicanus genealogy, whereas the vast majority of native pictorial genealogies are arranged vertically, with ancestors placed at the top and their descendants below, a literal visualization of direct descent (Cosentino 2002, 124–125).[20]

While the genealogies that focus on the descendants of Tizoc and Moteuczoma II emphasize their royal pedigrees, their main intentions were to prove their families' ties to land.[21] Again, this stands in contrast to the Mexicanus, which includes just a few place signs but without clear claims on these places. In fact, though pictorial genealogies of the Tenochca royal house are rare, there is a fairly large corpus of colonial-era genealogies from greater central Mexico, and these too were typically created in the context of local land disputes (Cosentino 2007; Olko 2007, 2012). Many of these native genealogies were created in the Tlaxcala-Puebla region, and they tend to merge genealogical information with maps, so much so that Cosentino (2002) referred to these genealogies as "landscapes of lineage." Their ultimate function was to secure a particular family's ties to land.

Without clear ties to land or an emphasis on a particular family line, the intentions behind the Mexicanus genealogy must be found in the larger goals of the codex, one of which was to show New Spain as the equal of Spain, and accordingly the Mexica dynastic line as the equal of the Hapsburg line. In this regard, the inclusion of a genealogy in the Mexicanus may have been seen as a parallel to the Spanish kings' lists that were

included in the Reportorios. These typically link Spain's kings to the pagan past. For example, the Chaves Reportorio (1576, 82r–83r) traces the line of Spain's rulers from Philip II back through the ancient Roman past. Likewise, the Mexicanus genealogy relates the colonial rulers of Mexico City's native sphere to the ancient Aztec past. Even though their ancestors were linked with the divine, the model of Spain revealed that a pagan past was not an impediment to a Christian present. The Mexica past may have been a time of paganism, but it was also a time in which the seeds of a new Christian nation were planted, just as was true of Spain's own Roman past. These seeds then flowered through the colonial-era descendants of the Mexica ruling house, whose purity enabled them to embrace Christianity. Nevertheless, they must have remained proud of their Mexica heritage and wished to preserve its memory and bolster its prestige in light of the religious and political transformations upending New Spain and its own dynastic line in the 1570s and 1580s.

This was done by emphasizing the purity of the bloodline and linking it with the divine via its ancestors and its cosmic structure. In so doing, the Mexicanus genealogy sets Mexica nobles above all others, a strong statement given that non-Tenochca nobles had acceded to the upper echelons of power over the native cabildo at the time the genealogy was created.

Since no other native groups could claim as high a status as the Mexica, the Mexicanus genealogy's focus on the integrity of the Tenochca dynastic line, its ancient origins, and orderly nature, coupled with the larger codex's message on its embrace of Christianity, would have distinguished the Mexica royal house from other noble bloodlines in colonial Mexico and would have spoken to the high prestige of this family line in a colonial context. As a part of a larger codex that reconciles Mexica history with a Christian worldview and reveals its owners' embrace of Christianity, the genealogy further suggests that the pagan Mexica past was a legitimate foundation for the Christian present.

A History of the Mexica People

*From Aztlan to Tenochtitlan
to New Spain*

Formatted as a year-count annals, the Mexicanus' extensive historical record begins with the Mexica migration, follows through the foundation of Tenochtitlan and growth of the Aztec empire, and concludes with the transition to colonial rule and creation of New Spain. As a pictorial record, the imagery in the Mexicanus is open to interpretation and is meant to elicit a fuller oral account that I attempt to replicate with my reading of the history that follows. Such an account is enabled by reading the iconography of the pictorial imagery on its own terms and also by comparing its imagery to other pictorial histories and alphabetic accounts on the history of Tenochtitlan and New Spain.

While the information recorded here is useful for understanding the Aztec past, it must be approached through the context of the late sixteenth century in which it was written. As Burkhart (1989, 6) has noted, "The Nahuas reinterpreted their own culture and their own past in the light of their new experiences and pressures; their own image of the 'ancient Aztec' was in part a colonial artifact." With this idea in mind, I provide a reading of the Mexicanus' annals through a focus on its three "chapters"— migration, imperial, and colonial—and then I discuss each section in relation to the colonial context in which the material was written. In conclusion, I consider the entire history as one

overarching account. While on one level the Mexicanus annals history seems to record discrete events in Mexico City's past, on another level, and when considered in its totality, it also creates a narrative about the creation of Aztec Tenochtitlan and its transition into Christian New Spain. The underlying message is that the Mexica ancestors were destined to find and found Tenochtitlan, grow it into an imperial power, and facilitate its transformation into Christian New Spain.

Historical Traditions in the Aztec and Spanish Worlds

The Aztec conception of history differs from the idealized Western view that sees history as a "true" account of the past. By contrast, Aztec histories were more obvious political constructions, with past events reinterpreted and reconfigured to fit contemporary circumstances (Diel 2013). Moreover, as Camilla Townsend (2009) has argued, for the Nahuas, Aztec historical truth was compiled by consulting multiple perspectives. Thus, the past for Aztec historians was flexible, amendable to modification and interpretation, which was particularly enhanced by their pictorial system of writing that guided an oral recitation. That is, the pictorial imagery recorded fixed information, but it had to be brought to life through an interpreter who could bring his or her own knowledge of Aztec history and other sources to the task. The interpreter, in turn, could highlight particular records or neglect others depending on the circumstances of his or her reading. Indeed, the brevity and lack of specificity inherent in the pictorial writing system, as opposed to an alphabetic system, allowed an interpretive openness.

Many Spaniards denied the Aztec peoples a historiographical tradition because the Spaniards linked history with writing and did not accept Aztec pictorial script as a true writing system. In turn, these Spaniards could argue that the Aztec peoples lacked civility because they lacked writing and history. As Boone (2000, 4) writes, "European intellectuals and men of letters understood writing to have reached its evolutionary pinnacle in the alphabet, and they believed (alphabetic) writing to have been a major factor in what they saw as the political and social supremacy of the West: writing was a complement and agent of advanced civilization." The Spanish jurist Juan de Sepúlveda took this view, using the natives' perceived lack of writing as proof that they lacked civilization and could be legally enslaved (Hanke 1994, 85).[1]

In contrast, those who worked among the Nahuas debated the nature of Aztec writing and notions of history and, by extension, civility. Fray Toribio Motolinía (1951, 74–75) took a more liberal view than Sepúlveda. When listing types of Aztec books, he noted that the ones that recorded history were indeed truthful. In fact, it was through a link with the calendar that Motolinía supported the truthfulness of Aztec historical accounts (Cummins 1995, 161–162). Thus, it was Aztec notions of time, so clearly emphasized in the Mexicanus, that gave their accounts historical validity from a Spanish perspective. Indeed, an epistolary exchange between José de Acosta and Juan de Tovar questioned how the Aztecs could have histories without having writing; the conclusion was that though the Aztec system by which historical knowledge was recorded may have been different from European alphabetic writing, there was indeed a system whereby this information was remembered and linked with time (Cummins 1995, 164). Thus, the annals format itself validated the Mexicanus' historical record despite its being written via pictorial script. On one level, then, the inclusion of a history in the Mexicanus served to confirm the civility of the Mexica peoples and to show that New Spain

was a place with a long historical tradition and one that influenced its current condition.

On another level, if the Mexicanus as a whole was based on the *Reportorio* tradition, it also made sense for it to include a historical account. For example, the Chaves Reportorio (1576, 60r–64r) includes an annals history, composed in sections that follow the ages, from the biblical past to the time of Julius Caesar of Rome and including information on the rulers of Spain and the Holy Roman empire up until his own day. Moreover, the Reportorio written by Enrico Martínez ([1606] 1981, 106–119) in New Spain includes historical information as well, but now expanded to encompass Mexica history and its calendar, which points to tacit acknowledgment that knowledge of the Mexica past was necessary for an understanding of contemporary New Spain. Thus, a concern with history was another area of shared interest for Nahuas and Spaniards alike and an important component of their sense of identity. For Nahua Christians of New Spain, memory of the historical past was necessary to understanding their place in the present.

The *Xiuhpohualli*, or Year-Count Annals

The Mexicanus' history is formatted as a preconquest-style *xiuhpohualli*, or a continuous year-count annals (Nicholson 1971). In such works, a continuous timeline, based on the Aztec year count, forms the backbone of the history. The years of the Aztec calendar—Rabbit, Reed, Flint, and House—unfold in sequence, cycling through coefficients from 1 to 13 and then repeating. In the Mexicanus, each of these years is shown in a rectangular cartouche, with the forms painted blue and outlined in red. The timeline begins on page 18 with the year 1 Flint (1168). The donut-like disk stands for 1,

and the flint year sign is rendered in its iconic pictorial form. The next years are 2 House, 3 Rabbit, 4 Reed, 5 Flint, and so on, all shown in standardized forms that repeat throughout the manuscript.

The consistency of the timeline and the uniform style of the years' pictorial icons suggest the timeline, from page 18 through 85, was the work of one hand. The ordering of the years' coefficients is also constant throughout these pages, with the painter placing 1 at the lower left corner and then sequentially placing more numbers up the left frame, then from left to right at the top border, and finally down the right. Moreover, the painter reliably included six years per page, with just a few exceptions, one being the start of the annals history on page 18 (Plate 10), where half the page was reserved for a vignette that sets up the coming migration. Also, on page 80 (Plate 41), only five years are shown. There is another shift at page 86 (Plate 44), where ten year signs are squeezed onto the page. This was likely the work of a different artist, as the year coefficients are arranged in a different manner on this page. Yet another contributor attempted to continue the annals history by adding an additional page (87), but he made no attempt to make it feel like the rest of the annals (Plate 44). There is no color here, and the year signs are written in an abbreviated and less skilled manner, with their year coefficients written with Arabic numbers. Moreover, only one historical notice is recorded and in alphabetic text, creating a disjunction with the pictorial history.

Though the Codex Mexicanus is a bound book in the European tradition, the painter who laid out the original timeline was surely aware of the preconquest format. Preconquest annals were typically made of a long strip of bark paper that was folded accordion-style. Placing the timeline at the exact same height on each page, the Mexicanus painter gives the illusion that

the year count was indeed unbroken, with some imagery even continuing from the front to the back of a page, further suggesting the continuity of a year-count annals in the preconquest manner (Navarrete 2000, 32).

Also following preconquest tradition, historic events in the Mexicanus are communicated via conventionalized signs that are typical of Aztec pictorial script. For example, footprints indicate travel, and a shield placed over an obsidian club communicates war. Places are recorded with hieroglyphic compounds that function in a more phonetic manner. The migration account witnesses the Mexica move continually from one location to another; thus, there is no fixed setting, and a multitude of place-name signs fill this section. However, upon the foundation of Tenochtitlan, the location is assumed to be the capital city unless otherwise noted. The same is true upon the Spanish arrival and the capital's transition into Mexico City. A sense of time and chronology is provided by linking events to the timeline, which gives a sense of order to the history. Moreover, the cyclical nature of the Aztec calendar, in which the same dates repeat every fifty-two years, suggests an underlying cyclical patterning and a sense of history as prophecy that will be emphasized in the Mexicanus account.

Although the timeline seems to have been set down by one person, the historic events were set down by multiple hands. I suspect one was the primary historian and the majority of events in the Mexicanus were painted by this person. However, another painter added a few historical notices to the migration account. On page 20 (Plate 11), the less skillful style of this artist stands in contrast to the more assured hand of the primary painter. The imperial history has greater cohesion style-wise, which makes me suspect it was recorded by one or more painter working in a consistent style. As Barbara Mundy (2012, 35) has pointed out, Aztec manuscripts were typically painted by multiple people who deliberately worked with a uniform style so as not to create a work with visual disruptions. By contrast, the colonial account exhibits more inconsistencies style-wise, which may have resulted from a need to expand the pictorial repertoire of Aztec script to include material related to the Spanish world; hence this section is more experimental in style. Be that as it may, with the exception of the additions to the migration account, I shy away from identifying specific contributors because this is an inherently difficult task given the poor condition of the Mexicanus and the abbreviated nature of much of its imagery.

Adding to the visual complexity of the annals history, a number of people added notations to the manuscript throughout its history. Many of these additions correlate the Aztec years with their Christian counterparts. For example, at the start of the history, 1168 is written under the year 1 Flint (Plate 10), and more year correlations sporadically appear throughout the annals history. Some of these correlations were written in a light ink similar to that used for the Nahuatl annotations, which points to their being added at an early date and likely by the same annotator. However, the writing style and ink saturation for other correlations vary, which suggests a number of different people adding these (and not always correctly!). Based on the sharp black ink of one set of correlations, I suspect these were added by one of the later owners of the manuscript (see Plates 37–39), and based on the shared writing style and dark ink it is likely that this same contributor was responsible for adding another year count to the Aztec one. Beginning on page 18 at 1 Flint, this person kept a running count of the years passed since the start of the timeline. Hence, an Arabic number 1 appears at the upper right corner of the 1 Flint cartouche, then a 2 at 2 House, and so on, until 3 House

(1521), where 354 was included at the upper right corner of that year's cartouche (Plate 39). This person was clearly interested in tracking the length of time elapsed since the beginning and "end" of Mexica history. Of course, as the continuous year count shows, though the history of the Mexica people certainly changed in 1521, it by no means ended.

Yet more contributors added notations in Aztec pictorial script concerning time and its measurement. One set tracks every twenty years from the start of the annals history in 1168. Accordingly, a small banner, the Aztec icon for twenty, was added at 7 Reed (1187) in black ink (Plate 11). Then every twenty years after this, an additional black banner was added. Thus, two banners, now rather faint, are added at 1 Reed (1207), three at 8 Reed (1227), and so on. The placement of some of these points to their being added after the pictorial history was recorded. For instance, on page 61 (Plate 31), at 13 Reed, or 260 years after the departure from Aztlan, historic events fill the space, forcing this contributor to add the thirteen banners for 260 years at the bottom of the page and to the left, with a line linking these banners to the time-line. In some portions of the manuscript, either this or another contributor added single coefficients to the banners. For example, on page 31 (Plate 16), four banners were linked to 2 Reed to record the eighty years since the migrants began their journey. However, an additional ten dots were added in and linked by a line to the migrant shown two pages later (Plate 17) above 12 House, or ninety years since the migrants began their journey. Additional calculations such as this were added throughout the manuscript with lines linking them forward in time. Unfortunately, these often make the annals quite busy and visually confusing.

Adding to this untidy effect, yet more banners were added in different colors. One set consists of green banners that track the years since the Mexica had arrived at Chicomoztoc, an important stop on their migration route (Plate 12). The first green banner appears on page 26 (Plate 14) above the year 7 House, and an associated annotation reads, "20 ans depuis quinehuayan chicomoztoc" (Twenty years after Quinehuayan Chicomoztoc). Obviously, this text was added by one of the later French owners of the manuscript, and I suspect the green banner was as well. More green banners and French glosses reappear at twenty-year intervals throughout the manuscript, but they stop in 1513, just before the conquest. Other banners were drawn in red; these track the years that had passed since the founding of Tenochtitlan in 2 House (1325), shown on page 44 (Plate 23). Thus, on page 47 (Plate 24), one red flag appears at 8 Flint (1344), and then on page 51 (Plate 26), two red banners are tethered to 2 Flint (1364), and so on throughout the rest of the history. Yet another series of flags, now in a black outline, track back, in twenty-year increments, to the tying of the years in 2 Reed (1247), shown on page 31 (Plate 16). The first of these is seen on page 34 (Plate 18) above 8 Rabbit (1266), but who added these is not clear.

Alphabetic annotations were also added intermittently to the annals history. These were mostly written in Nahuatl, but one was in Spanish (at Chicomoztoc on Plate 12) and others are notes in French that point out similarities between the Mexicanus and other native manuscripts (for an example, see page 40 on Plate 21). While the Spanish and French annotations were likely added by later owners of the manuscript, I suspect the Nahuatl notations were added closer in time to the creation of the book and by a native interpreter seeking to clarify some of the Mexicanus' contents. In the reading of the pictorial history that follows, I strip away the distractions created by these later additions

and focus on the pictorial history itself, along with the few Nahuatl notations that must have been added closer to the work's creation.

The Mexica Migration: From Aztlan to Tenochtitlan

Various traditions about the Mexica migration circulated in the sixteenth century, and all shared a similar message.[2] In these accounts, the Mexica were guided by their patron god, Huitzilopochtli, and overcame adversity in order to transform into a strong people destined to found Tenochtitlan and grow it into an imperial capital (Boone 1991). The Mexicanus' migration account follows these same general contours. At the same time, its story of the migration emphasizes particular themes that associate the Mexica with both the classical and biblical pasts. In this regard, I suspect that the message of the migration was expanded and rethought based on the circumstances of the migrants' descendants as Christian Nahuas living in late sixteenth-century New Spain.

Although a product of the sixteenth century, the Mexicanus' migration account still reveals its contributors' thorough grounding in the Aztec pictorial system of writing and knowledge of Mexica history. As Federico Navarrete (2000, 31) has pointed out, the deliberate and systematic way in which native artists recorded the migration by integrating time and space into a coherent visual narrative shows that these accounts were based on a highly developed tradition. The Mexicanus' migration account makes use of this developed system, most likely because its painters had access to other visual accounts upon which they based their records. In fact, the sophisticated nature of the place signs used throughout the migration account suggests they too were based on preconquest forms, and there are very few alphabetic notations added to clarify imagery. Instead, the imagery itself does the heavy lifting in terms of communicating information.

In this regard, the Mexicanus' story of the migration is visualized in a highly structured manner that leads readers forward in time and from place to place. For the most part, the migration account is placed on the upper register, but sometimes, for more complicated events, action spreads to the lower register. Typically, the name of the place where the migrants stayed is recorded with a place sign that acts visually or phonetically to elicit the place-name. This sign is usually placed above the timeline and is associated with a red line that joins the timeline at two points, the first establishing the year of arrival and the second that of departure. At the beginning of the migration account, profile heads, all male and signifying the migrants, are shown on top of or within the place sign, suggesting the notion of a settlement of a multitude of people. The convention of showing this, with the heads in front shown in full and those behind layered and only shown in partial view, is a Renaissance device, revealing knowledge of European artistic forms (Escalante Gonzalbo 2010, 166–167). Thus, the story of the migration is told using a succinct visual system that tells viewers where, when, and for how long the migrants settled. Most stops are uneventful, but when important events do happen, the painter conveys this narrative action as well and sometimes deviates from the conventional system.

Departure from each place and movement to a new location are also recorded in a standardized manner with a migrant who leads the way. The migrant, always a man, is dressed in animal-skin clothing, shown as a cloak with black hatching to indicate the texture of fur and sometimes colored brown, with a white loincloth included underneath. The coarse clothing

indicates that these Mexica were not yet settled peoples and had not yet taken on the trappings of civilization, such as woven cotton clothes. The migrant also carries a white bundle and a walking stick that is sometimes painted green. The year in which the migrants depart each location is recorded by another red line that typically links the foot of the migrant with the timeline, and the journey forward is suggested by footprints that extend from him to the right, moving the reader and the migrants forward in time and space. The footprints typically end at the next place sign, though beginning on page 27, just one or two footprints convey movement. A slight shift in the rendering of the migration account occurs a few pages later. Whereas color was used in the earlier pages to clarify the imagery from pages 18–29, it was no longer used in the later section, where actions, instead, were recorded in simple black ink. Also, rather than being shown in profile heads to indicate settlement, the settlers are now shown in full and seated in front of associated place signs. They now wear simple white cloaks, though the migrant who leads his people forward continues to wear his coarse animal-skin mantle.

Religious references in the migration are subtle. For example, the primary migrant's white bundle presumably includes the cult image of the Mexica patron god Huitzilopochtli.[3] In Sahagún's (1950–1982 11: 191) account of the migration, he describes these bundles: "Thereupon departed those who carried the god on their backs; they carried him wrapped—wrapped in a bundle. It is said that their god went advising them." The Nahuatl term for these migratory leaders was *teomama*, which literally means "god carrier." Thus, the Mexicanus migrant as a leader and holder of the bundle was a teomama, a god carrier. As noted more fully below, Huitzilopochtli also appears in the migration account, where he is shown in his avian form

guiding the migrants, but he disappears long before they arrive at Tenochtitlan.

Accounts of the migration of the Mexica people are told in many Aztec pictorial histories, as well as chronicles written in alphabetic script by native, mestizo, and Spanish historians. Table 5.1 provides a list of the migration stops recorded in the Mexicanus and how they compare with these other sources. As the table makes clear, the stops included in the Mexicanus are included in other sources, but none is an exact match. The other sources also include stops not recorded in the Mexicanus, and the order of the stops varies in the sources as well. Indeed, no two sources are exactly the same, but taken together they provide useful comparisons with the Mexicanus and aid in the decipherment of its pictorial signs.

In terms of the pictorial histories, the Codices Aubin (1981), Azcatitlan (1995), and Boturini (1964) tell a similar version of the migration, but they vary in terms of style, format, and some details. The Boturini is the most preconquest in style and format; it focuses just on the migration and is recorded purely in pictorial script with just a few alphabetic annotations (see Figure 5.1). The Codex Azcatitlan also relies on the visual sphere to convey much of the migration story, but annotations are used more frequently and the style of representation has clearly been influenced by European illusionistic techniques. The Codex Aubin relies the most on alphabetic writing but does contain some pictorial references. Like the Mexicanus, each of these sources ties the events of the migration to the Aztec year count. By contrast, the Mapa Sigüenza is formatted as a cartographic history. It focuses just on the Mexica migration and has relatively little overlap with the Mexicanus. The Codex Telleriano-Remensis (1995) and its cognate, the Vaticanus A (1964), exhibit even fewer similarities with the Mexicanus.

Codex Mexicanus	Codex Aubin	Codex Azcatitlan	Codex Boturini	Mapa Sigüenza	C. Telleriano-Remensis/Vat. A	Cronica Mexiana, Chimalpahin	Cronica Mexicayotl	Hist. de Mexicanos por sus pinturas	Anales de Tlatelolco	Anales de Cuauhtitlan
Aztlan	*	*	*	*		*	*	*	*	*
Teoculhuacan	*	*	*	*		*	*	*	*	
Tepemaxalco		*								
Chicomoztoc (1)	*	*		*		*	*	*	*	
Coatlicamac	*	*	*			*	*	*	*	
Matlahuacallan						*		*	*	
Ocozacapan						*		*	*	
Chicomoztoc (2)	*	*		*		*	*	*	*	
Coatepec		*			*	*	*	*		*
Chimalco						*		*	*	
Xicoc								*		
Tollan	*	*	*			*	*	*	*	*
Atlitlalacyan	*		*	*		*	*	*	*	
Atotonilco	*					*		*	*	
Atenco							*			
Apazco	*	*	*	*		*		*	*	
Tzompanco	*	*	*	*	*	*	*	*	*	*
Huixachtitlan	*	*	*		*	*	*	*		
Ecatepec	*	*	*		*	*	*	*		*
Tolpetlac	*	*	*		*	*	*		*	*
Chimalpan				*		*		*		
Tecuicuilco						*				
Coatitlan	*		*			*		*	*	*
Popotlan	*		*				*			*
Tecpayocan	*	*	*		*	*	*	*	*	*
Tepeyacac						*				*
Tepetzinco		*				*			*	
Pantitlan	*	*	*	*		*			*	*
Chapultepec	*	*	*	*	*	*	*	*	*	*
Contitlan/Culhuacan	*	*	*	*	*	*	*	*	*	*

5.1 A comparison of the migration stops in the Codex Mexicanus
with other pictorial and alphabetic sources.

The migration account is also recorded in a number of alphabetic chronicles. For example, an early Spanish account, known as the *Historia de los mexicanos por sus pinturas* (1965), includes many of the same places as the Mexicanus.[4] Writing in the later sixteenth and early seventeenth centuries, a native chronicler from Chalco, Chimalpahin Cuauhtlehuanitzin, wrote a number of historical accounts that include sections on the Mexica migration, but his *Crónica Mexicana*, or "History or Chronicle with Its Calendar of the Mexican Years" is the source with the most similarities to the Mexicanus (Chimalpahin Cuauhtlehuanitzin 1997, 1: 178–219).[5] Another Nahuatl account, known as the *Crónica Mexicayotl* (1997), also contains valuable information on the migration.[6] Two additional sources, the *Anales de Tlatelolco* (2004) and the *Anales de Cuauhtitlan* (2011), provide a perspective on the migration from the point of view of two non-Tenochca cities, Tlatelolco and Cuauhtitlan. Fuller accounts by the Spanish friar Durán (1994) and the chronicler Cristóbal del Castillo (1991) are also useful for explicating some of the imagery in the Mexicanus.[7] After noting the similarities amongst these sources, one cannot help but wonder whether the authors of these accounts consulted each other as source material and whether and how such materials would have circulated.

In the pages that follow, I provide a reading of the Mexicanus' migration account, identifying the different stops on their migratory route and, where applicable, the important events that happened at particular locations and times. A consideration of the migration account in a more holistic sense gives the Mexicanus' account coherence and elucidates its messages. On one level, the Mexicanus reveals the larger significance the Mexica migration must have held for the Mexica imperial state before the Spanish arrival, and on another level, it shows how the migration continued to resonate long after the conquest, especially for the descendants of the Mexica migrants who were now living in completely different circumstances, as Nahua Christians in late sixteenth-century New Spain.

AZTLAN: I FLINT (1168)

The Mexicanus' history begins on page 18 with Mexica migrants departing from their homeland, the island of Aztlan, but the year count itself does not begin until the migrants have crossed from Aztlan to the mainland (Plate 10). A tall reed plant, painted green and shown with a flower cluster at the top, frames the scene at the far left. Below the reed plant, a stream of water is shown in the conventionalized manner typical of Aztec pictorial script, a wavy stream that ends in shells and disks. Together, the reed (*aca-tl*) and water (*a-tl*) act as the place sign for Aztlan, but the painter adds an additional phonetic element. A set of white teeth and red gums (*tlan-tli*) are placed between the water and reed to phonetically signal the final part of the place name. The reference to reeds and water also works to evoke the marshy island of Aztlan. Moreover, by showing the original home of the Mexica people as a "place of reeds," known as *tollan* in Nahuatl, the painter elevates its prestige. The word *tollan* was used to designate sacred cities throughout Mesoamerica; therefore, the Mexicanus informs viewers that Aztlan was also a sacred city, a tollan.

Floating to the right of the reed plant is an image of a house, shown in a standard geometric form, similar to the one used to designate House years in the timeline but embellished with a red T-shape, indicating post and lintel construction, and a tall thatched roof painted yellow. Imagery at the door to the house includes a profile face with a speech scroll and a stream of eagle-down

balls. The latter are depicted in Aztec pictorial script as small circular shapes with parallel lines at the bottom. These typically signify sacrifice. Put together, this is no simple house but one that issues a call for sacrifice, the heart of Aztec religion. The presence of a temple at Aztlan also reveals that these Mexica lived as a settled community.

The stream of water used for the place sign performs double duty, as it also supports a group of migrants and propels them forward. A face, presumably a personification of wind drawn from European tradition, is also included and frames the migrants on the left with a line that comes from its mouth. Anther line from its neck creates a path forward for the migrants, a mass of men and women, all dressed in coarse, animal-skin clothing that marks their nonsedentary status. The men wear mantles tied at the front, while the women wear tops and skirts and have their hair styled in the braided and wrapped manner typical of Aztec women. Some carry bundles, and the men carry walking sticks made of craggy pieces of wood. The figures look toward the upper right, and one actively points his hand, directing both migrants' and viewers' attention to a bird perched in a tree in front of the timeline.

Representing Huitzilopochtli as his avian avatar, the body of the bird faces to the right but its head turns back to the left and issues speech scrolls that signal his command to his people to come forward, up onto the timeline in order to commence historical time (Boone 1994, 67). To do so, the migrants must cross another stream of water, now shown with a wavy blue line and without the Aztec symbolic elements. The line above the water shows the migrants the way, linking their watery path to the timeline above and to another migrant, who leads the journey. This migrant stands on the sign for the year 1 Flint (1168). Like Huitzilopochtli, he faces to the right but turns his head back toward his people. He raises his left hand, beckoning his people to join him.

The time and place of the migration convey its sacred significance. In the Mexicanus, the migration and time itself begin in a year called 1 Flint, a recurring date that will become a touchstone in Mexica history; events important to the Mexica state will happen in 1 Flint years, giving them sacred undertones (Umberger 1981). The migration is also linked to a sacred space. In most accounts of the Mexica migration, the first stop is a place called Teoculhuacan, the Sacred Place of Ancestors. This place is likely referenced by the hill sign shown behind Huitzilopochtli. The hatching on the hill is typical of place signs in the Mexicanus; however, the top of the place sign no longer remains but could well have had a curl at its top to mark it as Teoculhuacan. Typically, Aztlan is shown as an island city with Teoculhuacan across the shore, suggesting the two are symbolically linked (Boone 2000, 214). Indeed, the Codices Aubin, Azcatitlan, and Boturini (see Figure 5.1), as well as the Mapa Sigüenza, all show Teoculhuacan as the first stop after the Mexica left Aztlan in 1 Flint. Moreover, it is rare to see other groups who arrived in the Valley of Mexico associate themselves with Teoculhuacan, suggesting this was a Mexica tradition, as was the departure from Aztlan itself.[8]

TEPEMAXALCO: 2 HOUSE (1169)–4 REED (1171)

In the very next year, 2 House (1169), the migrants make their second stop, which is indicated with a divided hill sign that is filled with the heads of the migrants. The Codex Azcatitlan (3v) has the migrants arrive in this same year at a place also shown as a divided hill, which an alphabetic annotation calls Tepemaxalco, or "Place at the Fork in the Hills." However, the

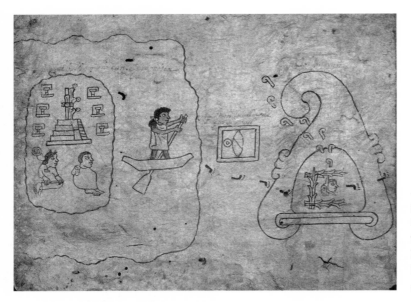

5.1. Start of the Mexica migration, Codex Boturini, page 1. SECRETARIA DE CULTURA.-INAH.-MEX. Reproduction authorized by the Instituto Nacional de Antropología e Historia.

Mexicanus place sign also includes teeth (*tlantli*), but this sound does not figure in this place-name, making this identification not entirely secure.[9] A red line extends from 2 House (1169) to 4 Reed (1171) on the next page, where a migrant carrying a walking stick continues the journey (page 19, Plate 10). Although the figure is not colored, the style of the drawing as well as the detail of his clothing, a coarse cloak with a loincloth underneath, suggest this too was drawn by the primary artist.

CHICOMOZTOC PART 1: 5 FLINT (1172)–13 FLINT (1180)

Footprints from the departing migrant at 4 Reed (1171) lead to the far right, where a place sign begins and continues on to the other side of the page (pages 19–20, Plates 10 and 11). A red line marks the years that the migrants must have stayed in this next place; it begins at 5 Flint (1172) and ends at 13 Flint (1180).

The imagery here deviates from what will become the standardized means of depicting migration. For one, there is an eagle above the timeline at 5 Flint (1172). This may reference

Huitzilopochtli again, in which case he continues to lead the migrants. In his account of the migration, Cristóbal del Castillo (1991, 135) wrote that after the migrants left Aztlan, Huitzilopochtli transformed into an eagle and continued to guide his people in this form. Footprints from the departing migrant extend under the eagle and lead to another migrant shown above the year 7 Rabbit. Although this migrant is shown in the standard manner with a coarse mantle, loincloth, bundle, and walking stick, he is also identified with a tag that is in poor condition but with some dots visible and similar to a place-name sign affixed to another figure just to the right. This figure carries the sandy-hill sign for Tlatelolco, which suggests that the following events concern the Mexica who would go on to found Tlatelolco rather than the ones who would eventually settle at Tenochtitlan.

The place that straddles pages 19 and 20 likely references Chicomoztoc, or Seven Cave Place, a typical stop for central Mexican migrants. Chicomoztoc is typically shown as a cave with seven crevices, and the image in the Mexicanus is similar, visualized as a green cave-like opening with seven niches inside. A man

stands before the place sign on page 19. He is simply dressed in a loincloth and his legs are akimbo, suggesting action, but unfortunately the top part of his body has flaked away, making it difficult to see what he was once doing. Because the sandy-hill place sign marks this man as a representative of the Tlatelolca peoples, the Mexicanus may be communicating that the Mexica tribes had split apart early in the migration, with the faction that would found Tlatelolco arriving at this time at Chicomoztoc, separate from the Tenochca-Mexica, who the Mexicanus shows arrive at Chicomoztoc later. Although now quite faint, images were once included in the cave sign. On page 19, a trace of what may have originally been a loincloth (*maxtlatl*) is barely visible, and on page 20, the outline of a box may have originally represented a baby's basket. If read correctly, these icons would indicate the birth of an important person at Chicomoztoc, or birth in general at the site.[10]

A different contributor added a few figures to the right of the Chicomoztoc sign on page 20.[11] The first figure is linked to the year 11 Rabbit. The skirt identifies her as a woman, and she holds a bundle that marks her as a migrant. However, she faces and gestures left toward the Chicomoztoc sign, whereas the vast majority of figures in the Mexicanus face to the right, reflecting progress forward in time and space. If the item in the cave is indeed a baby basket, then the secondary contributor may have intended to link this woman with childbirth. Reading to the right, this same contributor added another figure that mimics the migrant painted above 13 Flint by the primary artist. The latter migrant is more skillfully rendered and colored, and he wears the standard garments and carries the same accoutrements as the earlier migrants, though his hands are reversed. He holds his walking stick in his right hand and gestures forward with his left hand, whereas the other migrants hold

their right hands close to their bodies and their walking sticks in their left hands. The forward left hand gives this migrant a greater sense of leadership, as if he has been forced to compel his people forward and away from Chicomoztoc. This migrant appears to be communicating with another figure, who is seated before him, but this is misleading, as this figure's crude style and lack of color reveal that it was the work again of the secondary painter and, as such, likely added at a later date. The primary painter's migrant stands on the red line that enters the timeline at 13 Flint, while his other foot is linked to another red line that exits the timeline and, along with the associated footprints, communicates a journey to the next place.

COATLICAMAC: 1 HOUSE (1181)–3 REED (1183)

MATLAHUACALLAN: 4 FLINT (1184)–6 RABBIT (1186)

OCOZACAPAN: 7 REED (1187)–11 REED (1191)

The next few stops are uneventful. From 1 House (1181) to 3 Reed (1183), the migrants stayed at Coatlicamac, or the "Place of the Snake's Mouth" (Plate 11). This place is identified by an image of a coiled snake (*coa-tl*) with a large open maw (*camac-tli*), inside of which are a number of heads referencing the migrants. Coatlicamac is a standard early stop in accounts of the migration. In 3 Reed (1183), the migrants resumed their journey and a year later arrived at a "net" place (Plate 11). This likely records a place called Matlahuacallan, as it contains the root *matla-tl*, or net, and many of the alphabetic accounts mention that the migrants stopped here after Coatlicamac. These same accounts have the migrants at a place called Ocozacapan next, as does the

Mexicanus, where the standardized migrant reappears above 6 Rabbit (1186) and guides his people to a place identified with a woven grass box (Plate 12). This must be Ocozacapan, which includes the roots for pine (*oco-tli*) and grass (*zaca-tl*). They stayed here from 7 Reed (1187) to 11 Reed (1191), when the teomama appears in motion once again.

CHICOMOZTOC PART 2: 12 FLINT (1192)–7 FLINT (1200)

The next stop is clearly significant in this and other accounts of the Mexica migration. In the Mexicanus, imagery related to this stop extends over the binding of pages 22 and 23 and above and below the timeline (Plate 12). Notice for this stop also deviates from other migratory stops because it begins with the footprints of the migrant above 11 Reed (1191) leading into the timeline at 12 Flint (1192). In this same year, an image of a hummingbird also descends into the timeline. The hummingbird must reference Huitzilopochtli, who leads his people down into Chicomoztoc, or Seven Cave Place, pictured on the lower register. Although readers may presume that Huitzilopochtli has been guiding the migrants all along and will continue to do so, he is no longer pictured in the Mexicanus after this stop.

Chicomoztoc is again shown as a semicircle in green with seven indentations or niches. When the Tlatelolca earlier arrived at Chicomoztoc, the place and event were presented wholly on the upper register, but the Tenochca stop is shown on the lower register, giving a sense of descent into the earth and the underworld, fitting as many accounts of the stay at Chicomoztoc speak of emergence from this place. The image of the Tenochca stop at Chicomoztoc is also more visually complex. The interior of the cave is brown, for the earth, and at its middle

are the roots of a tree that emerges through the timeline above with a mass of leaves. The tree furthers the sense that Chicomoztoc is a sacred place that bridges the upper and underworlds, the earthly and divine spheres. A horizontal element, outlined in red and with a scroll at its end, pierces the cave, but its exact meaning is unclear.

On the upper register and extending from page 22 to 23, a series of seven place signs/ethnic identifiers are recorded, and each is linked by a red line to one of the notches inside the cave below. Reading from left to right, the hieroglyphic compounds stand for the following peoples: Xochimilca (Flower Field), Matlatzinca (Fishing Net Rump), Acolhua (Arm Water), Cuitlahua (Excrement Water), Tepaneca (Stone Banner), Huexotla (Willow Tree), and Chalca (Preciousness). These are the peoples who had left Chicomoztoc before the Mexica. Two annotators took an interest in these peoples. Writing in Spanish, the first annotation reads, "De este lugar nombrado Chicomoztoc, o siete cuevas, salieron las 8 naciones Tecpanecas, Cuitlahuaques, el año ce Tochtli y pues ataron el siglo en el ome acatl" (From this place named Chicomoztoc, or seven caves, the 8 nations left, the Tepanecs, the Cuilahua; the year 1 Rabbit and then they tied the century in the [year] 2 Reed). I suspect this annotation was added by one of the former owners of the work, José Antonio Pichardo, as the writing here matches that in his notes. The second annotation is in Nahuatl, "quinehuayan chicomostoc oncan quisque yn chicue calpolltin tepaneca colhuaque" (From Quinehuayan Chicomoztoc, they emerged, eight *calpulli*, the Tepaneca, the Culhua). This annotator refers to Chicomoztoc by its full name, Quinehuayan Chicomostoc, and he and Pichardo must have considered the Mexica themselves as the eighth calpulli, or ethnic group.

It is surely no coincidence that the binding of the year ceremony that marks a new fifty-two-year cycle happened soon after the arrival at Chicomoztoc. The tying of the years is referenced in the Pichardo annotation and is tracked in the Mexicanus and many other annals histories, with each new cycle designated at the year 2 Reed. In the Mexicanus, it is shown on the lower register with a schematic tie that will repeat at every 2 Reed year until the last ceremony before the Spanish arrival in 1507. This was a very important and fearful time for the Mexica peoples, who conducted ceremonies that included the binding of a bundle of fifty-two reeds to symbolize the end of the previous cycle and important sacrificial rituals undertaken to ensure the start of a new cycle. The implication is that the Mexica first oversaw the ceremony at the sacred Chicomoztoc.

Two lines lead from the lower Chicomoztoc sign to the timeline on page 23. The upper line was likely added by the secondary painter, as it leads to 5 Rabbit (1198), and a vignette on the upper register is drawn in the more rudimentary style typical of this contributor. Two men are shown in front of the Coatepec (Snake Hill) place sign and point to strange happenings in the sky. These include a long shape in the sky, suggestive of a descending snake, and two round shapes, one with a star inside and overlapping another with a sun. Coatepec is typically included in Mexica migration accounts as the birthplace of Huitzilopochtli, but the imagery here suggests a story in the Codex Azcatitlan (5v–6r) which notes that the sun had not risen for four days as the migrants journeyed to Coatepec, and upon their arrival there, a fire serpent shot down from the sky above (Graulich 1995, 66). Thus, the secondary contributor seems to be referring to this same story with the addition of a Fire Serpent and a starry sky eclipsing the sun.

The lower line leads into the 7 Flint cartouche. This, in turn, is linked to an image on the upper register of a migrant on the move, indicating that the Mexica had stayed at Chicomoztoc from 12 Flint (1192) to 7 Flint (1200), at least according to the primary painter.

CHIMALCO: 8 HOUSE (1201)–13 RABBIT (1206)

XICOC: 1 REED (1207)–9 REED (1215)

TOLLAN: 10 FLINT (1216)–12 RABBIT (1218)

ATLITLALACYAN: 13 REED (1219)–1 FLINT (1220)

ATOTONILCO: 2 HOUSE (1221)

ATENCO: 3 RABBIT (1222)–7 RABBIT (1226)

APAZCO: 8 REED (1227)–10 HOUSE (1229)

Footprints from the migrant lead to the next stop, the first of a few that are largely uneventful. Identified with a shield (*chimal-li*) with a jar (*co-mitl*) superimposed, the first stop was at Chimalco on page 24 (Plate 13). According to the red line linked to the timeline, the migrants must have arrived there in 8 House (1201) and remained until 13 Rabbit (1206), when the migrants hit the road again. This lead migrant is subtly different in that he now carries a smooth walking stick rather than the craggy one used earlier.[12] Perhaps this communicates that the migrants are slowly taking on more signs of civilized status. They arrive the next year, 1 Reed (1207), at a place recorded with a bumblebee (*xico-tl*) superimposed on a jar (*co-mitl*) for Xicoc, shown on page 25 above the sign for 4 Rabbit (Plate 13).

There are some additional elements at this migration stop. First, a very faint migrant is shown above 6 Flint. The small stature and crude draftsmanship of this figure point to its being drawn by the secondary artist. More images are shown in a faint ink on the next page, but the more skilled handling of line here suggests these were added by a different contributor (Plate 14). The first image is of a wall with circles and parapets, which is the typical place sign for Tenayuca, but here it is upside down; perhaps it is a fugitive representation from an earlier use of the paper. Next to this is an image that is right-side up and more fitting of the migration account. This image is of heads hiding in grass and presumably being drenched by the rain clouds shown above. The lack of color here, along with the more simplified style of representation, point to this being an addition made by the secondary painter. A similar image of heads hiding in reed plants reappears on this same page a few years later, but without the clouds.

The migrant takes off again in 9 Reed (1215), and his footprints end at a place sign of reeds, which identifies the place as Tollan, or Tula (Plate 14). The heads of the migrants appear hidden inside the reeds, and they remained there from 10 Flint (1216) to 12 Rabbit (1218). They next arrived in 13 Reed (1219) at a place identified with a compound of water (a-tl) over a field sign (tlal-li), for Atlitlalacyan, where they remained until the next year. Oddly, a red line with a snake on it arches above the departing migrant at 1 Flint. The significance of this may be explained by Chimalpahin Cuauhtlehuanitzin (1997 2: 25), who writes of the migrants' stop at Atlitlalacyan, "There they shot a very thick snake with arrows; it was a Chichimeca who shot it."

At this point in the history, the stops become more frequent, though not always more eventful.

Still on the same page, in 2 House (1221), the migrants stayed at a place identified with a jar raised on feet and with water spilling out of it. This must be Atotonilco, or "Place Where the Water Boils." The migrants left in this same year and arrived in the next year at a place identified with a compound of water (a-tl) on top of a stone (te-tl) ideogram, presumably for Atenco.[13] The migrants stayed there from 3 Rabbit (1222) until 7 Rabbit (1226), when they set out again. Shown on page 28 (Plate 15), their next stop was a place called Apazco, or "Place of the Basin," accordingly recorded in the Mexicanus with a basin (ahpaz-tli) filled with water. The Mexica remained there from 8 Reed (1227) until 10 House (1229), when the familiar migrant returns to once again move his people forward.

TZOMPANCO: 11 RABBIT (1230)–4 FLINT (1236)

The migrants arrived in 11 Rabbit (1230) at a place called Tzompanco, or "Place of the Skull Rack," shown on page 29 (Plate 15). The place sign for Tzompanco consists of a platform topped by a rack holding one skull (tzom-tli) with a banner (pan-tli) above. Replacing the heads that had heretofore marked migration stops, a group of full-bodied migrants are seated to the right of the place-name sign. They wear white mantles, though the migrant who leads the journey continues to wear animal skin.

An interesting vignette is added to this stop. A line from the migrants leads to a kneeling woman who gestures in communication with a man seated before her. This man gestures back to the woman, but he is shown in a more European figural style, with his face in profile view but his body in a three-quarter view. Moreover, his legs are exposed and not hidden under his mantle, which is also unusual. Four items are arrayed below the two: a tripod vessel, a jar, an

unknown object, and perhaps a basket or a piece of cloth. A line extends from the man to a house that is embellished on its roof with the eagle-down balls that signify sacrifice. The door of the house reveals a profile face and a sun, which may mark this as a temple, perhaps devoted to a sun god. A line from the house extends to another seated man, shown in profile view with a speech scroll issuing from his mouth and marking him as a leader who issues orders. Indeed, this man must be historically important, as he carries a name tag of a dog (*itzcuin-tli*) and a bundle of grass (*zaca-tl*).[14]

This vignette is difficult to interpret on its own, and other pictorial migration accounts provide no help, as they note the stop at Tzompanco but with no additional details. However, the alphabetic sources do recount interesting, though contradictory, events at Tzompanco, and these elucidate some of the imagery in the Mexicanus.[15] One version of the story notes that the leader of Tzompanco treated the Mexica settlers well, giving them food and drink and even offering his daughter to marry one of the migrants.[16] The vessels in the Mexicanus, then, may reference the food and drink supplied by Tzompanco's leader, and the woman would be the Tzompanco ruler's daughter, who is shown with her new Mexica husband. A slightly different version of the story explains that the Mexica had settled near Tzompanco without its ruler's knowledge. His son had noticed their arrival and went undercover amongst the migrants to learn their intentions and ended up marrying a Mexica woman. In this regard, the woman's link with the other Mexica migrants in the Mexicanus depiction would point to her membership in that group. Although these two versions are contradictory, they do agree in one important regard. Both state that the marriage resulted in the births of three children: two daughters, named Chimallaxochtzin and Tozpanxochitzin,

and a son, Huehue Huitzilihuitl. Each of these three children will appear later in the Mexicanus' migration account. This may also explain the house sign, as the offspring of this couple establish a new lineage, or "house," of Mexica nobles.

Yet another version of events at Tzompanco is less detailed but links the Mexica to an important structure, the *tzompantli* that would be placed in a prominent position at the future Tenochtitlan. This version notes that the Mexica fought the locals at Tzompanco and captured and sacrificed an enemy warrior. They then erected a tzompantli so that they could display his skull. The well-known image of the foundation of Tenochtitlan in the Codex Mendoza includes a skull rack, suggesting that its erection was one of the first orders of business upon the foundation of the city and a key aspect of Mexica identity (see Figure 5.2).

HUIXACHTITLAN: 5 HOUSE (1237)

ECATEPEC: 5 HOUSE (1237)–6 RABBIT (1238)

The Mexica migrants resumed their journey in 4 Flint (1236), but a cacophony of information follows on page 30 (Plate 16) and points to chaotic events. Toward the top of the page, at 5 House (1237), a faded hieroglyphic construction of a house with a face and eagle-down balls coming out of the door is reminiscent of the temples shown previously at Aztlan and Tzompanco, but its meaning at this juncture is unclear.

Meanwhile, footprints from 5 House lead to a drawing of a tree, after which they split in two directions.[17] The tree references Huixachtitlan, the Place of the Huixache Tree. From the tree sign, the upper set of footprints leads to a woman's head. She is identified with a name tag of a flower (*xoch-itl*) and water (a-tl). Another

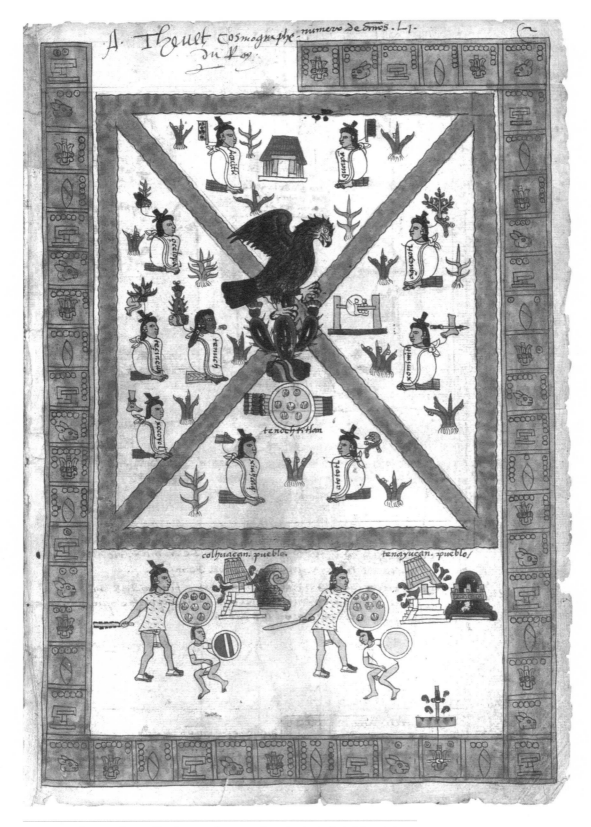

5.2. Foundation of Tenochtitlan, Codex Mendoza (MS. Arch Selden A1), fol. 2r. Courtesy of the Bodleian Libraries, the University of Oxford.

footprint from her leads to a fish, perhaps suggesting Michoacán, "Place of Fishermen." The "Historia de los mexicanos por sus pinturas" (1965, 45) may explain this vignette, as it recounts that soon after leaving Tzompanco, some Chichimecs captured a Mexica woman and took her to Michoacán. All future inhabitants of Michoacán then claimed descent from this woman.[18]

The lower set of footprints leads to the place sign for Ecatepec, which is shown as a hill sign with the face of Ehecatl, the wind god, above. Two Mexica migrants sit in front of the place sign, suggesting their settlement there, but it must have been brief, as footprints from them lead to more place signs angled upward to the right. The footprints first lead to a sign of reeds (*tula*) on top of a woven mat (*petla-tl*), reading Tolpetlac. According to Chimalpahin Cuauhtlehuanitzin (1997 2: 27), the migrants went there after Ecatepec but spent "only one hurried year," which explains why it is not shown with migrants in the Mexicanus. More footprints after Tolpetlac lead to a place sign of a shield (*chimal-li*) and a banner (*pan-tli*), for Chimalpan (On Top of the Shield), and then to a painted (*cuihcuiltic*) stone (*te-tl*) sign for Tecuicuilco (Place of the Painted Stone). The footprints then double back to the timeline at 7 Reed.[19]

Putting this together, after Tzompanco, the migrants journeyed to Huixachtlan and from there split into two groups, one perhaps led by a woman and headed to Michoacán, while the others went to Ecatepec, Tolpetlac, Chimalpan, and Tecuicuilco before returning to Ecatepec in the next year and quickly setting off again, though the standard image of a migrant indicating the new journey forward is not included here.

COATITLAN: 7 REED (1239)–10 RABBIT (1242)

POPOTLAN: 11 REED (1243)–12 FLINT (1244)

TECPAYOCAN: 13 HOUSE (1245)–6 REED (1251)

TEPEYACAC: 7 FLINT (1252)–10 REED (1255)

TEPETZINCO: 11 FLINT (1256)

PANTITLAN: 11 FLINT (1256)–12 HOUSE (1257)

The Mexica migrants proceeded to settle in a number of places but without remaining at any for long. A faint line picks up again on page 30 at 7 Reed (1239) and leads to a group of migrants settled at their next destination, Coatitlan (Place of Snakes).[20] They remained until 10 Rabbit (1242), whereupon the teomama leads his people forward once again, now to a place on the next page called Popotlan (Place of the Popotl Plant), where they stayed from 11 Reed (1243) until 12 Flint (1244). The next stop for the migrants was a place identified on the same page (above the 2 Reed sign) with a flint knife (*tecpa-tl*) over a stone (*te-tl*) in reference to Tecpayocan, where the migrants remained from 13 House (1245) to 6 Reed (1251). During this time, the Mexica bound their years, as the standardized binding is shown also above 2 Reed (1247). To the right of the binding and also linked to the year 2 Reed is the pictorial icon for Xochimilco (Flower Milpa). The ink used to depict this sign is lighter than that for the place sign below, which may point to its being added by a later painter. Moreover, the four banners

that were added to mark the eighty years that had passed since the start of the migration have an additional eleven disks added and a line that extends from them forward in time to end at 13 Rabbit (1258) on page 33 (Plate 17). This calls attention to the year the Mexica arrived at Chapultepec, which would be a key stop along their migratory journey (see below).

In 6 Reed (1251), the migrants took off again and settled the next year in a place identified with a hill sign (*tepe-tl*) that has a nose (*yaca-tl*) attached at its right, for Tepeyacac (Plate 17).[21] On the next page, in 10 Reed (1255), footprints and a red line lead up to a place identified as Tepetzinco by a hill (tepe-tl) and rump (*tzin-tli*) sign (Plate 17). The place sign floats higher above the timeline than is usual, and migrants are not included next to the place sign, suggesting that they simply passed through it. And finally, the migrants arrived at Pantitlan (Place of Banners), which is marked with an oversized banner (*pan-tli*), in 11 Flint (1256) and left again in the very next year.

CHAPULTEPEC: 13 RABBIT (1258)–1 RABBIT (1298)

The next stop, at Chapultepec (Grasshopper Hill), is the longest and one of the most significant for the Mexica migrants. Their stay is indicated by a red line from 13 Rabbit (1258) on page 33 (Plate 17) that extends over page 34 and stops at the Chapultepec place sign, a grasshopper on a hill, on page 35 (Plate 18).[22] The red line then continues forward in time, over pages 36 and 37, which are free of imagery (except for a large signature by Eugene Goupil, a previous owner of the work), and finally comes to an end on page 38 (Plate 20), where images and events proliferate.

The action begins at 1 House (1285), where a man on the upper register grabs another by the

hair. Both men wear simple loincloths, but the man on the left also carries a bundle that marks him as one of the Mexica god carriers. The other figure is identified by the conical cap name tag seen earlier in the Mexicanus' genealogy to identify Copil, the nephew of Huitzilopochtli. An alphabetic annotation confirms this identification. As explained in Chapter 4, Copil had journeyed to Chapultepec to defeat his uncle and avenge his mother, but a Mexica priest defeated Copil, as is shown in the annals. On the lower register, the priest is identified by his Eagle-Leg name tag as Cuauhtlequetzqui, and the woman with whom he is linked in a marriage statement is identified as Xicomoyahual, whom the Mexicanus genealogy identified as Copil's daughter (page 16). The ideogram that floats in front of the newly married couple includes a stone icon merged with a face that wears a prominent lip plug. This likely references the offspring of Cuauhtlequetzqui and Xicomoyahual, who was identified in the genealogy section as Tenzacatetl (Stone Lip-Plug).

Although the migrants had successfully defeated Copil, they fled Chapultepec one year later, in 2 Rabbit (1286), as communicated by the image of a migrant with footprints leading him to a series of place signs that extends from page 38 to 39 (Plate 20) and must indicate the places to which the Mexica fled. The list of place-names here largely matches a list provided by Chimalpahin Cuauhtlehuanitzin (1997, 1: 203) and the *Crónica Mexicáyotl* (1997, 89):

Acuezcomac: Water (a-tl) + Jar (*co-mitl*)
Huehuetlan: Standing Drum (*huehue-tl*)
Atlixyocan: Water (a-tl) + Eye (*ix-tli*)
Teoculhuacan: Stone (te-tl) + Curved hill (*culhuacan*)
Tepetocan: Hill (tepe-tl) + Bird (*toto-tl*)
Huitzilac: Hummingbird (*huitz-il*) + Feather (*ihui-tl*) + Water (a-tl)

Culhuacan: Curved Hill (culhuacan)
Huixachtlan: Huixachtl Plant (*huixach-tl*)
+ teeth (*tlan-tli*)
Cahualtepec (Cihuatepec): Woman
(*cihua-tl*) + Hill (tepe-tl)
Tetlacuixomac: Two (*ome*) + Stones (te-tl)
Matepec: Hand (*ma-itl*) + Hill (tepe-tl)
Tlapitzahuayan: Teeth (tlan-tli) + Thin
(*pitzahuac*) + Water (a-tl)

The group of heads at the last place sign indicates that the Mexica had finally settled here. The *Crónica Mexicáyotl* (1997, 89–91) explains what happened next:

The year Eleven Reed, 1295: At this time, in Quecholli in the month count of the ancient ones, when the Mexica kept going forth into the grasslands, the people of Chalco regarded them as an evil portent [because of] the head leather that the Mexica put on. They chased them from there; they stoned them. Once again [the Mexica] went to Chapultepec. At that time Huehue Huitzilihuitl had become ruler of Mexico.

The Mexicanus painter distinguishes two warriors just after this string of place signs on page 39. The warrior to the right is identified with the place sign for Chalco and wears a simple loincloth. He holds a bag in one hand and a stone in the other. His opponent must be a Mexica warrior. If Chimalpahin Cuauhtlehuanitzin were looking at the Mexicanus image, then the headband worn by this warrior could be the head leather he described, while the warrior's double bag could have been interpreted by Chimalpahin Cuauhtlehuanitzin as a stone sling. However, the Mexica warrior also wears eagle-down balls in his hair and a lip plug, while his arms and legs are striped and he holds a spear.[23] These,

together with the headband and double bag, are distinctive features of Camaxtli-Mixcoatl, a god of war and hunting who was celebrated during the monthly festival of Quecholli. For example, in the Tovar Calendar, Camaxtli-Mixcoatl is pictured as the patron of the month of Quecholli and looks quite similar to the Mexicanus warrior (see Figure 2.7). The Tovar representation only lacks the striped arms and legs, which figure prominently in other representations of the war god, such as those included in the Codex Telleriano-Remensis (4v) and Codex Borgia (25). Chimalpahin Cuauhtlehuanitzin links the battle to the month of Quecholli, which suggests that the battle may have been linked with these festivities. Footprints from the Mexica warrior lead to the left, suggesting a retreat back to Chapultepec and accordingly a defeat. In this case, even though the footprints appear to lead back into time, they are meant to be read as leading back into *place*.

Upon their return to Chapultepec, the Mexica continued to raise the ire of other groups. War soon broke out once again, and their leader, Huehue Huitzilihuitl, was captured.[24] His sacrifice is shown on the next page, where a man identified with a hummingbird-feather name tag is splayed on his back over the curved hill place sign of Culhuacan (Plate 21). A crevice in his chest marks the extraction of his heart. This is shown above 13 House (1297), but a line links the sacrifice to the Chapultepec place sign that appears over the next year, 1 Rabbit (1298). The place sign for Xochimilco also floats above Huitzilihuitl's death and is next to an ideogram that includes a woman's head along with a name tag of a Shield (*chimal-li*), Water (a-tl), and a Flower (*xoch-itl*) name sign. This must reference Huitzilihuitl's sister, Chimallaxochtzin, who knowledgeable readers might recall was born at Tzompanco. A line from her joins an image of another woman, now identified with a name

tag that includes a stone (te-tl) and what might be sand (xal-li); presumably, this is another sister of Huitzilihuitl. Two place signs float above this woman. The first includes a bundle of sticks (tlaco-tl) under a banner (pan-tli) for Tlacopan, and the second is the Ant Heap place sign for Azcapotzalco. Yet another woman's head is linked to 3 Flint (1300). She is identified as Huitzilihuitl's other sister, Tozpanxochitzin, with her name glyph that includes a banner (pan-tli) and a flower (xoch-itl). Two additional place signs flank her; the first references Tenayuca and the second, Xaltocan (Sand Spider).

In sum, the pictorial representations on pages 38–40 communicate that after the battle with the Chalca, the Mexica had regrouped at Chapultepec, where they were led by Huehue Huitzilihuitl. While there, war broke out again and the Mexica leader was captured and taken to Culhuacan for sacrifice. His sisters were captured as well and taken to the other territories listed. The campaign against the Mexica at this time was presumably led by Culhuacan but also included Xochimilco, Tlacopan, Azcapotzalco, Tenayuca, and Xaltocan. The latter communities were all associated with the Tepanec peoples, who were the leading power in the Valley of Mexico at the time. However, the Mexica will eventually avenge this campaign against them, as each of these territories will appear as Mexica conquests in the Mexicanus' imperial history.

The aftermath of these events is shown on the lower register of the same page. Just below 13 House (1297) and 1 Rabbit (1298), a marshy place is shown. It is filled with the heads of men and women, referencing the Mexica who had fled to Acocolco after Huitzilihuitl's defeat, as some of the Mexica are described as having hidden in the waters of Acocolco (*Anales de Tlatelolco* 2004, 63). Eventually, they begged the ruler of Culhuacan to grant them access to another piece of land, so he first relocated them to Tizapan. This is shown in the Mexicanus

under 2 Reed (1299) with the curved hill sign for Culhuacan above a place sign of a white (tiza-tl) hill and water (a-tl) for Tizapan. While there, they must have tied their years, as indicated with the tied knot attached to the same year. The Mexica soon moved to another place under the control of Culhuacan. This place is called Contitlan and is shown to the right of Culhuacan and indicated by a sign of jars (co-mitl) with heads above indicating another settlement for the migrants. While alphabetic histories give a rather gruesome account of emerging tensions between the Culhua and the Mexica that eventually forced the Mexica to flee once again and find their homeland, the Mexicanus is silent on these events.

ACOLHUACAN: 5 RABBIT (1302)

A small vignette added to the lower register at the binding of pages 40 and 41, under 5 Rabbit (1302) and 6 Reed (1303), references a group of men at Acolhuacan, "Place of Curved Water," which references the region associated with Texcoco, future ally of Tenochtitlan. The heads of two rulers, identified by their diadems, are shown. Strangely, these men are not named, whereas the three lower-status men without crowns are. One carries a name tag reading Quaquautli (Stick), another is named Huitzilin (Hummingbird), and the last is Coanacochtli (Snake Collar). The Acolhua chronicler Fernando de Alva Ixtlilxochitl (1997, 1: 420, 531) mentions men named Coanacochtzin and Huetzin, who rebelled against Topiltzin, a Toltec ruler to whom the Acolhua traced their ancestry. However, it is unclear whether the Mexicanus painter refers to the same men and event, as they would have lived much earlier in time. A line from 5 Rabbit circles the men and extends forward in time to 10 Flint (1320) on page 43 (Plate 22), just a few years before the foundation of Tenochtitlan.

TENOCHTITLAN: 2 HOUSE (1325)

After the eventful migration account, the Mexicanus' rendering of Tenochtitlan's foundation is relatively anticlimactic. Shown on page 44 (Plate 23), the foundation happens in 2 House (1325) and is marked by a simple hieroglyphic compound for Tenochtitlan, a rock (te-tl) topped by a nopal cactus (*noch-tli*). Preceding the sign for Tenochtitlan is a list of named men who are each linked with a house sign; these must be the city's founders. The ink used for these men is lighter and not as fine as that used for the sign of Tenochtitlan. Moreover, the faces and name tags are drawn in a rather crude style that makes me suspect that yet another painter added them in, perhaps wishing to give a greater sense of import to the foundation scene.

Each man at Tenochtitlan's founding is referenced with a simple head linked to a house, perhaps to reference the leaders of the various calpulli of Tenochtitlan. Translated as "great house," the term *calpulli* refers to the social units, or clans, that organized Aztec cities. The man closest to the Tenochtitlan sign must be the most important, and indeed this is Tenoch, shown as the leader of the founders in the well-known foundation page in the Codex Mendoza (Figure 5.2). He is also included in the Tira de Tepechpan image of the foundation (Figure 4.5) In both sources, he is identified with a name tag of a nopal cactus and a stone that mimics, in miniature, the sign for Tenochtitlan. The other founders in the Mexicanus largely match the list provided in the Codex Mendoza. Reading back from the sign for Tenochtitlan, the men are identified as Quiahuitzin (Rain), Ahuexotzin (Tree Water), Ocelopantzin (Jaguar Banner), Xiuhcactzin (Sandal), Xomimitzin (Arrow Leg), Cuapantzin (Fringed Banner), and the last sign is effaced.[25] There are seven house glyphs but eight men, with Xiuhcactzin squeezed in and sharing Ocelopantzin's house sign.

Moreover, thirteen more male heads, each with a name tag but without a house sign, are shown on the previous page (Plate 22), but their relation to the foundation is unclear. Each man is linked individually to the timeline rather than to the foundation on the next page, and the men's names do not consistently match those of the founders in other sources, nor are these names generally known from Aztec histories. Continuing to read these from right to left, from the foundation of Tenochtitlan back into time, the name signs are Stone Wall (?), Coatl (Serpent), Xochtlan (Flower Teeth), Cecepatzin (Two Beans), Tliltapayaxin (Black Salamander), Tlacatl (Person), Matlatl (Net), Ohpantli (Banner Road), Atotoztli (Water Bird), Michin (Fish), Ce (Disk or One), Tototl (Bird), and Ahuacalli (Baby Basket Water).

Additional images precede the foundation scene on the lower register, but these are difficult to interpret. First, two male heads float toward the bottom of page 42 (Plate 22), under the year 3 House (1313). This same year sign is linked by a faint green line to a series of 12 disks below 2 House (1325), the year of Tenochtitlan's foundation (Plate 23). The twelve disks likely indicate the twelve years that separated the appearance of the two men's heads and the foundation of Tenochtitlan, though this does not clarify the significance of these men or what must have happened in the year 3 House (1313). Additional imagery is included on page 43 (Plate 22) on the lower register and linked to the years 8 Rabbit (1318) through 10 Flint (1320). Unfortunately, these are quite difficult to read.

Clearer imagery appears on the lower register of page 44 (Plate 23), though the meaning of this imagery remains uncertain. Under 11 House (1321) is a hieroglyphic compound that includes an incense bag (*xiquipil-li*) with a bird (or turkey) and a stone (te-tl). In the Codex Mendoza, the incense bag is either used in a

literal fashion, for *xiquipilli*, or in a symbolic fashion as the sign for 8,000. To the right of this, and linked to the year 1 Flint (1324), is a stepped wall. If these icons relate to the foundation, they could reference offerings made for the foundation and perhaps also the acquisition of building materials for the future city; however, this interpretation is far from certain. Also of unclear meaning are the disks, ten hollow and eight solid, that float about the foundation scene. Such disks usually call for the reader to move forward or backward in time. A line leads from these to a sign of eight banners on the next page above 4 Reed (1327) and marking the 160 years since the departure from Aztlan; thus, I suspect that the number sequence above 1325 must somehow have referenced the 158 years since this same departure.

MIGRATION DISCUSSION

On one level, this story of the Mexica migration is based on the account from the preconquest past that served to legitimize Mexica rule before the Spanish arrival.[26] At the same time, the people who recorded this particular version of the migration account did so as Nahua Christians living in late sixteenth-century New Spain. By considering the migration story through multiple lenses, it becomes clear that through their migration, the Mexica became a chosen people, destined to found Tenochtitlan and grow it into an imperial power, capital of the Aztec world, and later destined to accept Christianity and transform Tenochtitlan into Mexico City, a Christian power in the New World.

In a general sense, the Mexica migration story has sacred undertones that legitimize the status of Tenochtitlan as an imperial power and the Mexica as imperial leaders; the Mexicanus adheres to this tradition. The Mexicanus emphasizes the start of the migration in 1 Flint

(1168) by showing that time itself begins on that date, and as will be seen in the imperial history, events important to the Mexica will continue to happen in 1 Flint years, marking their cosmic validity. Moreover, the migration ends upon the foundation of Tenochtitlan in 2 House (1325). Not coincidentally, 2 House follows 1 Flint in the Aztec solar calendar; thus, there is a sense of sacred balance to the general story of the migration (Umberger 1981). Of course, the Mexica were also compelled to begin their migration by their god, Huitzilopochtli, giving a divine undertone to the migration itself.

Particular places stand out in the Mexicanus migration account, and these same places tend to be emphasized in other migration accounts as well. For example, the first scene of the migration hews closely to Mexica tradition, with the departure from Aztlan and arrival at Teoculhuacan being distinctive of the Mexica. Indeed, the representation of the start of the migration in the Mexicanus has many similarities with the illustration in the Codex Boturini, including the references to 1 Flint, Teoculhuacan, and Huitzilopochtli (see Figure 5.1). Other groups in central Mexico also claimed to have migrated to the Valley of Mexico, but they did not claim Aztlan as their homeland. Thus, Aztlan gives a sense of identity to the Mexica ethnic group, setting them apart from the other groups occupying the valley.

At the same time, the Mexica migration borrows from the migration traditions of these other groups, many of whom claimed that their ancestors had emerged from Chicomoztoc. Accordingly, many Mexica migration stories, including the Mexicanus, include Chicomoztoc as a stop for the Mexica migrants. In the pictorials, Chicomoztoc is typically visualized as a cave, and as Doris Heyden (1981) has shown, caves were considered sacred spaces throughout Mesoamerican history. Accordingly, Mexica

historians must have felt a need to apply the symbolic import of this place to their own past, hence the inclusion of Chicomoztoc in their migration legend. Moreover, if Aztlan is the homeland that makes the Mexica distinct from all other groups in the Valley of Mexico, then the stop at Chicomoztoc gives them a common ancestral humanity, as shown by the Mexicanus' inclusion of the ethnic groups that had preceded the Mexica at Chicomoztoc.

Moreover, the Mexicanus includes a distinctive event at Chicomoztoc, at least for the Tenochca-Mexica, as it is here that the hummingbird avatar of Huitzilopochtli descends into the sacred cave and is not seen again. The implication may be that Huitzilopochtli remains behind and claims this sacred space for the Mexica. The Mexicanus' account of the migration also stands out from the others by showing two stops at Chicomoztoc. On a political level, this explains the division of Tlatelolco and Tenochtitlan, and the rivalry between the cities will be a recurring theme in the imperial history. On a religious level, the distinct depictions of the two stops at Chicomoztoc emphasize the sacred aspect of the Tenochca-Mexica stop there, endowing them specifically with cosmic associations.

After Chicomoztoc, the migration in the Mexicanus is relatively uneventful until their arrival at Tzompanco, which falls at about the midway point in the migration account and is the only midpoint stop to be included in each of the migration accounts listed in Table 5.1. Thus, this stop must have played an important role in helping to form Mexica identity. On one level, this identity is linked to the establishment of sacrifice and the skull rack, which subtly foretells the future power of the Mexica people. On another level, the stay at Tzompanco was significant because it provided the Mexica a chance to form a marriage alliance with another, more established territory and lineage, and from that alliance, the future ruler Huehue Huitzilihuitl was born (Castañeda de la Paz 2006, 82–83). Nevertheless, the Mexicanus makes it clear that Huehue Huitzilihuitl did not survive the migration, and with his death and that of his sisters, his lineage would have ended. In this regard, the migration story speaks to the Mexicanus' genealogy, which instead emphasizes the divinity of the Mexica dynasty through a different set of ancestors linked with Copil and, through him, Huitzilopochtli.

A dialogue between the Mexicanus' history and genealogy is also seen with events at Chapultepec. As Boone (1991, 138) noted, in the pictorials, the stop at Chapultepec (Grasshopper Hill) is a pivotal point, with the accounts now stressing the trials of the Mexica migrants. Events at Chapultepec are covered more thoroughly than any other migration story in the pictorial annals in general and the Codex Mexicanus specifically (Boone 2000, 219). The first event, the defeat of Copil, communicates the power of the Mexica over their rivals, as Copil and his mother in general symbolize enemies of the Mexica peoples. Nonetheless, when read in dialogue with the Mexicanus' genealogy, this story also serves to emphasize the divinity of the Mexica bloodline, as the annals history also records the marriage between Copil's daughter and the Mexica priest. From them, future Mexica rulers will be born. Indeed, one might suppose that this bloodline will replace the one that would be extinguished upon Huehue Huitzilihuitl's death. The capture and sacrifice of Huehue Huitzilihuitl and his sisters is the second major event at Chapultepec. The Mexicanus' rendition of these events emphasizes the many groups who allied to fight the Mexica. It is surely no coincidence that the Mexicanus' imperial history will note the conquests of each of these territories in turn. Thus, this event legitimizes

the future conquest state of the Mexica peoples and makes their eventual rise to power all the more impressive.

There are many stops in the migration where nothing happens, but these places must have been included for a reason. If readers are meant to assume that some Mexica stayed behind at each stop and married with the local people, then the inclusion of these places would link the Mexica with a vast territory. Ties to land remained important in the colonial era, especially for members of the nobility who were competing with Spaniards and other native nobles for access to lands. Thus, histories became an important means of establishing ties to lands, and in this regard, someone could read the Mexicanus' migration account in a more legal sense as a list of places connected with the future Tenochca state. However, not all of the places can be definitively identified on a map, nor do many of these come up in sixteenth-century documentation that would support the idea that these were merely contested lands to which the Mexica of the late sixteenth century were attempting to stake a claim. Thus, Boone (1991) sees these stops along the migration as a ritual circuit, and she has likened the migration story to a play or drama. When human actors bring this ritual circuit to life through performance, they become transformed "from a small nomadic band to a people appropriate as rulers of Mesoamerica" (Boone 1991, 122). In this regard, there is a sense that the migration marks the Mexica as a chosen people. As Boone (1991, 148) puts it, the Mexica migration is a rite of passage, in that it activates the elevation of status of the Mexica and separates them from their earlier condition, by endowing them "with the spiritual and mental fitness for rule."

Such a transformation via movement in space also carries biblical undertones, and others have noted that the general contours of the Mexica migration account are reminiscent of the Book of Exodus (Davies 1980, 9; Christensen 1996; Escalante Gonzalbo 2010, 174). Just as the Mexica were compelled by their god, Huitzilopochtli, to leave Aztlan and travel through a number of places in search of a new homeland, the Israelites were compelled by God to leave Egypt and travel through a number of places before finding their promised land. The similarities between the Mexica and the Israelites did not escape the notice of the Spanish friars. For example, Durán (1994, 7) wrote,

> Among the narrations of these people that tell of their coming to possess and inhabit this territory, I often find great differences among the old people who tell these tales regarding the events, toils, and afflictions that took place during their journey. Yet, when they narrate this story, some one way and some another, their different accounts seem to describe that long, tedious road traveled by the children of Israel who went from Egypt to the promised land, told so vividly that I could cite passages from Exodus or Leviticus to show the resemblance.[27]

Although Durán sees the similarities in all the tales of migration, the Mexica may have taken this a step further through an emphasis on Huitzilopochtli. In the next paragraph, Durán goes on to describe "a great man" who sounds similar to Huitzilopochtli leading the migration (Christensen 1996, 452). His description reads, "he gathered the multitude of his followers and persuaded them to flee from that persecution to a land where they could live in peace. Having made himself leader of these people, he went to the seashore and moved the waters with a rod that he carried in his hand. Then the sea opened up and he and his followers went through" (Durán 1994, 7). Durán's description

is evocative of the start of the migration in the Mexicanus, including the holding of a rod by the male migrant about to cross the sea, which of course is much like the parting of the Red Sea by Moses. Thus, the similarities between the migration and exodus must have been a tradition that had emerged during the sixteenth century and one that became particularly emphasized amongst the Mexica and internalized by the primary painter of the Mexicanus' migration account.

Alexander F. Christensen's (1996) observation that the story of the migration told by Cristóbal del Castillo in his *Historia de la venida de los mexicanos* (ca. 1600; 1991) was reworked to accentuate parallels between the Mexica migration and story of exodus in the Old Testament is also applicable to the Mexicanus. Christensen (1996, 455) notes that del Castillo's tale of the migration equates the Mexica with the Lost Tribes of Israel, and in so doing, del Castillo elevates the Mexica above even the Spaniards. As Christensen (1996, 455–456) puts it, this move "justifies the Mexica's heathenism just as the Catholic Church is willing to accept that the Jews were virtuous, and even praiseworthy, without being Christians, because they lived before God had offered them a new revelation, so the pre-Spanish Indians do not have to be condemned for their lack of faith. One cannot hold their former paganism against the new converts any more than one can hold it against the Jews of the Old Testament." The same message could certainly be seen in the migration account in the Mexicanus. Thus, by the late sixteenth century, this account would have served a new function, legitimizing the pagan past of the Mexica people.

As Pablo Escalante Gonzalbo (2010, 171–173) has pointed out, the Mexicanus' visualization of the departure from Aztlan is also reminiscent of Christian tradition. For example,

some of the Mexicanus migrants carry walking sticks made of thick branches filled with spurs, but this inclusion of walking sticks is unique to the Mexicanus; for example, the Boturini representation does not include such an accessory (see Figure 5.1). As noted above, the walking sticks are evocative of Moses' rod, but Escalante Gonzalbo understands them via a Christian model. He compares the recurring image of the Mexicanus migrant to St. Christopher, patron saint of travelers who carried the Christ Child over a river. In European prints, St. Christopher uses a walking stick, and a mural painted in the Church of San Francisco in Tlatelolco shows St. Christopher using a stick made of a craggy piece of wood similar to that seen in the Mexicanus. Additionally, the water the Mexica migrants cross is evocative of the river that St. Christopher crossed with the Christ Child. Thus, as Escalante Gonzalbo observes, the journey of the Mexica migrants, who were initially propelled by water rendered in Aztec iconic script but then made to cross a river painted in a more European manner, can be likened to the journey of the Christ Child and St. Christopher. Moreover, the migrant's bundle also marks him as a teomama, or god carrier, a term that is evocative of the name Christopher, or Christ Carrier (Escalante Gonzalbo 2010, 171–173). If the painter of the Mexicanus were aware of this, he would be performing a bold maneuver by likening the Mexica teomama to St. Christopher and Huitzilopochtli to Christ.

On yet another level, one could also note similarities between the story of the foundation of Tenochtitlan and the story of the foundation of Rome. As Cummins (2016, 245) has noted, the story of the Mexica migration can be valuably compared to the Aeneid, which would have been taught to Nahua students after the conquest and which also tells the story of a migration and a founding, that of the Trojan

Aeneas who traveled to Italy and had numerous battles before founding Rome. Based on the educated nature of the Mexicanus contributors, it is likely they were just as familiar with these stories as they were with biblical ones. Thus, in this schema, the founding of Tenochtitlan could easily be equated with the founding of Rome, especially considering that both cities will grow into imperial leaders and later Christian capitals. Indeed, the link between Tenochtitlan and Rome is picked up in the next sections of the Mexicanus.

Imperial History: The Growth of Tenochtitlan

Upon the foundation of Tenochtitlan, the capital becomes the understood location of action in the Mexicanus. When distinct places are named, they stand out, and their inclusion suggests that the Tenochca somehow acted upon these territories, in contrast to the migration where others acted against the Mexica. Moreover, the protagonists soon shift to named rulers rather than mostly nameless migrants. For clarity, I provide a mostly chronological reading of the imperial history. I first consider the predynastic history and then shift to a consideration of specific rulers' reigns. To read the Mexicanus' imperial history, it is still useful to compare its records with other sources, both pictorial and alphabetic. As does the Mexicanus, many other accounts of Tenochtitlan's history focus on its important conquests as well as other important events, such as ruler inauguration and death statements as well as temple dedications. However, the Mexicanus also takes an interest in recording the natural disasters that marked Tenochtitlan's imperial history, more so than other pictorial histories. Of course, the climax bringing this chapter of Mexica history

to a close is the conquest, but long before the Mexicanus pictures the first Spaniards, it begins recording omens that presaged the military and spiritual invasion. As this reading of the imperial history reveals, the Mexicanus communicates a distinctive message about Tenochtitlan's past glories and ability to overcome adversity, but when considered in the light of the codex as a whole and its contributors' identity as Nahua Christians, the imperial history also shows that Tenochtitlan was a chosen land destined to receive and accept Christianity.

PREDYNASTIC HISTORY

The Mexicanus painter records a few events concerning Tenochtitlan between its foundation in 1325 and the seating of its first ruler in 1376. These mostly include conquests, environmental events, and the deaths and inaugurations of rulers from other polities.[28]

The first historical notice after the foundation of Tenochtitlan comes on page 47 (Plate 24) in the year 3 Reed (1339) and includes the obsidian club/shield sign that will be the traditional sign for war and conquest throughout the imperial history. In some instances, such as this one, the painter includes a flower, which characterizes this particular battle as a *xochiyaoyotl*, or "flower war," a term used to describe more ritualistic battles that were conceptually distinct from ordinary wars in that they are believed to have been fought to keep armies well trained, demonstrate military skill, and determine dominance rather than for economic expansion (Hassig 1992, 129). This seems like a strange event to happen so soon after the foundation, but it may point to the people of Tenochtitlan actively training as warriors at an early stage in their history. For example, the Codex Boturini shows the Mexica working as mercenaries for the Culhua toward the end of their migration.

Such training would enable them to eventually conquer a large territory and establish themselves as imperial leaders.

The place-name compound above the xochi-yaoyotl icon must record the place of the battle. The compound consists of an owl (chich-itl), shown in its characteristic frontal view, with a stone (te-tl) icon at its mouth, presumably referencing a place called Techichco. According to the *Anales de Cuauhtitlan* (2011, 109, 119–121), Techichco was located near Culhuacan but was settled by the Chalca. A war between the Chalca and the Culhua began there in 1339 and lasted until 1376. In that same year, a flower war between the Mexica and the Chalca began at the same place; it lasted nine years and then was followed by a more full-fledged war that lasted until 1457. Chimalpahin Cuauhtlehuan-itzin (1998, 1: 225–227; 2: 49) also mentions a flower war between the Chalca and the Mexica that began in 1376, but he does not name its location. Given the enmity between the Chalca and the Mexica, the Mexicanus' record likely refers generally to a flower war between the two polities.[29]

Early in their history, the Mexica also seem to have tried to establish diplomatic relations with other territories. For example, on this same page, footprints under 6 Rabbit (1342) lead to three men's heads and the Culhuacan place sign, suggesting that three men traveled from Tenochtitlan to Culhuacan for a meeting of some sort. The men bear no name tags or signs of rank, which is fitting, as the Mexica had yet to appoint an official *tlatoani*, or speaker, the Nahuatl term for a hereditary leader. Some sources relate that the Mexica went to Cul-huacan soon after Tenochtitlan's foundation to procure a king and/or queen for the newly founded city. For example, Durán (1994, 48–49) writes that the Mexica traveled to Cul-huacan to ask that Acamapichtli, who he says

was the grandson of Culhuacan's ruler, come to rule Tenochtitlan. Permission was granted, and he was even married to a Culhua noblewoman, Ilancueitl. However, if the Mexicanus' history is read in dialogue with its genealogy, the reader would see that a familial link between the Mexi-ca and the Culhua is deemphasized. Indeed, the Mexicanus annals suggest that the meeting at Culhuacan was unsuccessful because five years later, Tenochtitlan conquered Culhuacan, as is shown on the next page under 11 Reed (1347) with the obsidian club/shield icon over the Cul-huacan place sign (Plate 25).

A few years later, in 2 Reed (1351), the Mexi-ca oversaw the completion of one calendrical cycle and start of a new cycle, signified with the knotted cord under the year sign (page 49, Plate 25). This new cycle, however, was marked early on by hardships. An extended environmental event is shown on the same page under 5 Rabbit (1354), but the image is also linked by a line to 7 Flint, suggesting that it continued over a few years. The event concerns a volcano, shown here as a hill with flames at its base and a black shape emerging from an opening at its top. This must reference the volcano Popocate-petl, which was said to have started smoking in the mid-fourteenth century (Chimalpahin Cuauhtlehuanitzin 1997, 2: 43, 47). Just next to this, in 6 Reed (1355), an image of a grass-hopper in wavy lines likely references a plague of locusts destroying crops. On the next page, on the lower register under 10 Reed (1359), an image of a bird eating a corn plant shows more devastation of crops (Plate 26). Together, these events provide commentary on the difficulties the Mexica must have endured while attempting to establish themselves as agricultural producers at Tenochtitlan.

The painter records a more enigmatic event concerning the death of an important person in 1 Reed (1363) on page 51 (Plate 26). Throughout

the Mexicanus' imperial history, deaths of important men are shown with wrapped funerary bundles in the shape of a seated figure.[30] In this case, the exact identity and relationship of the deceased to Tenochtitlan is unclear. The funerary bundle is marked with a distinctive tie on its head and a shield icon (*chimal-li*) is also linked to its head, presumably acting as a name tag. The bundle is flanked by two images of smoking stars (*citlalpopoca*) and is circled by footprints that end in a black disk; these could reference locations and/or events. Although not shown in the traditional manner, this compound may suggest another conquest; however, I have been unable to find references to an event concerning a "shield" person for this time in other sources.

A second major conquest for the Mexica happened several years later, in 8 Rabbit (1370), where the obsidian club/shield icon is shown above the place sign for Tenayuca (page 52, Plate 27). The painter records this victory and the earlier one over Culhuacan before any rulers have been shown in the annals, which points to the Mexica in general being the victors in these battles, as they are the protagonists of this history. Nevertheless, at this point in their history, it is likely that the Mexica were subjects of Azcapotzalco, the leading power in central Mexico. Therefore, this conquest and future ones until the reign of Itzcoatl, who would earn Tenochtitlan's independence, would have been joint undertakings (Hassig 1992, 126–128). Nonetheless, the Mexicanus record implies that these are the conquests of Tenochtitlan alone, as does the Codex Mendoza, which shows these same two conquests just underneath its image of the foundation of Tenochtitlan (see Figure 5.2).

The Mexicanus painter does reference Azcapotzalco's ruler on this same page, but after these battles had been fought. Identified with his Smoking Stone name tag as Tezozomoc,

he appears two years after the conquest of Tenayuca, in 10 Flint (1372). Placed in front of the Ant Heap place sign for Azcapotzalco, he is shown seated with knees drawn up in front and tucked under a white mantle. He wears a diadem and issues a speech scroll, indicating his authority. The appearances of men like this in the Mexicanus typically function as inauguration statements.

Indeed, the Mexicanus records another accession using the same iconographic assemblage on the next page, where a man identified with a deer antler (*cuacuahu-itl*) name tag sits in front of the sandy-hill place sign for Tlatelolco (Plate 27). This records the inauguration of Cuacuauhpitzahuac over Tlatelolco in 13 Reed (1375). Cuacuauhpitzahuac was said to have been the son of Tezozomoc of Azcapotzalco, which may explain their proximity in the Mexicanus, though an exact link is not shown (*Anales de Tlatelolco* 2004, 47). Like his father, he issues a speech scroll, which further marks his power.

ACAMAPICHTLI (R. 1376–1396)

The accession of Acamapichtli, Tenochtitlan's first official tlatoani, happens one year later than Tlatelolco's first ruler inauguration. However, the Tenochca leader is seated in the year 1 Flint (1376), an anniversary date with the departure from Aztlan, giving the reign of Acamapichtli sacred implications by suggesting it was cosmically ordained. Acamapichtli's accession is shown in the standard manner (Plate 27). However, unlike the earlier images of Tezozomoc and Cuacuauhpitzahuac, Acamapichtli does not carry a speech scroll, nor do future rulers of Tenochtitlan. At the same time, none of these early leaders sit on the *tepotzicpalli*, or woven reed throne, which does not appear in the annals history until the inauguration of Itzcoatl.

Identified with his familiar name tag of hands clasping arrows, Acamapichtli is also linked with a Tenochtitlan place sign. This is unusual in that Tenochtitlan is the understood locus of action in the Mexicanus imperial annals, but in this instance, it must distinguish him from his counterparts from Tlatelolco and Azcapotzalco. One of the annotators also added a *1* here to further mark Acamapichtli as Tenochtitlan's first ruler and will continue to keep count of its subsequent rulers throughout the imperial history.

Three significant conquests are recorded for Acamapichtli, all Tepanec communities and economically valuable *chinampa* lands (Plates 27–29): Xochimilco in 4 Reed (1379), Mizquic in 7 Rabbit (1382), and Cuitlahuac in 5 House (1393). Nevertheless, there also continued to be hardships. Under 11 Rabbit (1386), the painter shows a flooded house and two men carrying another on a net (Plate 28).[31] According to the *Anales de Tlatelolco* (2004, 85), Tenochtitlan was inundated by rains, which caused flooding and famine during Acamapichtli's reign.

HUITZILIHUITL (R. 1396–1417)

According to the Mexicanus, Huitzilihuitl acceded to the throne in the same year as Acamapichtli's death, 13 Flint (1396, Plate 29). Huitzilihuitl's inauguration is communicated with the standard iconography, with a faint 2 added to track him as Tenochtitlan's second ruler. A large disk (for twenty) and a smaller disk (for one) float between the two rulers and record the twenty-one years of Acamapichtli's reign. Disks at each ruler's death statement track the total number of years of their reigns throughout the annals history.

The births of two important historical figures are noted under Huitzilihuitl's reign. The first was Moteuczoma Ilhuicamina, who is shown as a baby under 10 Rabbit (1398) and identified by his second name, Ilhuicamina, or "Shooting Arrows Skyward" (page 56–57). The imagery just next to this suggests a falling star, which the historian may have coincided with Moteuczoma's birth, giving it a sense of cosmic importance in both the Nahua and Western worldviews. Then, a few years later, the birth of Nezahualcoyotl, future ruler of Texcoco and key ally of Moteuczoma Ilhuicamina, is linked to the year 1 Rabbit (1402). His name glyph of a coyote wearing a fasting cord is clear, though the baby is now effaced. These are the only two birth statements to be included in the Mexicanus, which underscores the importance of these two men.

Over the next few years, Huitzilihuitl witnessed some significant battles. The first happened in 2 Reed (1403), when he would have also overseen the binding of the years (Plate 29). On the lower register, a man identified with a Chalco name tag grabs another man by the hair and holds a club over him, suggesting that the Chalca defeated another group in this year.[32] The defeated man is linked to a place or name glyph of a maguey plant (*me-tl*). A similar battle vignette appears on the upper register in the next year, 3 Flint (1404). Here a man identified with a copper axe (*tepoz-tli*) name tag associated with Tepoztlan repeats the action from the lower register; he wields a club in one hand and with the other grabs a defeated, but unnamed, man by the hair. Chalco and Tepoztlan were in the same province toward the southeast of the Valley of Mexico and a constant irritation to the Mexica, who spent much time and effort trying to subdue them (Berdan and Anawalt 1992, 2: 95). Thus, the imperial history points to the rebellious and bellicose nature of these territories. Indeed, the migration account noted a battle between the Chalca and the Mexica, which points to the long-standing nature of their enmity. On this same page, a funerary

bundle identified with a name tag of a crowned animal head (note the round nose and eye) is shown just to the right of the Chalco battle, but it is unclear whom this represents and if it was meant to be linked to the battle scenes.

Huitzilihuitl himself must have overseen a number of conquests, all of which are shown using the obsidian club/shield icon. First, in 6 Reed (1410), he conquered a place identified with the head of a man who wears a distinctive nose bar, which likely represents Otumba, as figures wearing nose bars often reference northern peoples and this was an Otomí town whose defeat is credited to Huitzilihuitl in other sources (page 58, Plate 30). His next conquest was over Xaltocan, shown above 13 Rabbit (1414) and followed by some footprints leading to now effaced imagery (page 59, Plate 30). This was quickly followed with a conquest over Acolman (Water Arm) in 2 Flint (1416).[33] Another conquest is shown under 2 Flint, but it is difficult to read. The obsidian club/shield icon is shown in an abbreviated manner, and the place sign includes a banner (pan-tli) over what may be stones (te-tl), perhaps giving a general sense of victories over Tepanec territories.

CHIMALPOPOCA (R. 1417–1428)

Huitzilihuitl died in 3 House (1417), and remnants of disks recording the twenty-two years of his reign float toward the top of the page (Plate 31). Immediately following this death, Chimalpopoca (Smoking Shield) took the throne. His inauguration statement is marked with a 3 to indicate that he was Tenochtitlan's third tlatoani. Although he ruled for just ten years, the Mexicanus shows that his was an eventful reign packed with important events, not all of them positive, that would pave the way for the establishment of Tenochtitlan as the supreme power in the Valley of Mexico.

On the register below Chimalpopoca's inauguration, a hieroglyphic compound records another xochiyaoyotl, or flower war, at the same "owl" place that began Tenochtitlan's imperial history. Linked to 3 House (1417), this flower war happened seventy-eight years, or exactly one and a half calendar cycles, after the first flower war of 3 Reed (1339), which may point to a more sacred event. It may also suggest the flower war skirmishes with Chalco continued over these seventy-eight years. The flower war seems to be linked by a line to a battle scene just to the right. The warriors wear elaborate clothing that helps to distinguish them. Dressed in quilted armor and identified with a snake (coa-tl) name tag that looks like it has fire (tle-tl) underneath, the victor grabs his victim by the hair in an act of domination. The defeated wears a large battle standard and a conical cap that is typically associated with the god Xipe Totec. Later, the Tenochca ruler Axayacatl will wear a similar Xipe outfit, which suggests the defeated figure is also a Mexica warrior, perhaps Chimalpopoca.

The battle is somehow also linked with Texcoco, as a line from the warriors continues to the right and ends at a cave inside of which Nezahualcoyotl, shown as a face hidden within his fasting coyote name tag, hides. Footprints from the cave lead toward the right and forward in time, ending on the next page as they ascend into the timeline at 13 Reed/1 Flint (1427/1428). These events clearly reference the outbreak of war between Tenochtitlan and its allies versus Azcapotzalco and its Tepanec allies. Preceding the war, Nezahualcoyotl went into hiding and then aided the Tenochca. A related image on the top register of the previous page explains why. The death of Nezahualcoyotl's predecessor and father, Ixtlilxochitl (Black Face Flower), is recorded above 5 Reed (1419). He is shown as a prone figure with a rope around his

5.3. Death of Ixtlilxochitl, Codex Xolotl, detail of map 7. Courtesy of the Bibliothèque nationale de France.

neck. Ixtlilxochitl's name is incorporated into the image, as his face is darkened and linked with a flower. A hill sign floats to the upper left, and there is an image that looks like a tree next to it. The Codex Xolotl (Figure 5.3) pictures Nezahualcoyotl witnessing the killing of his father from a hiding place in a tree, which makes me wonder whether the same idea was originally communicated by the Mexicanus. A disembodied head carrying the Tezozomoc name tag floats above and to the right of Ixtlilxochitl and issues a speech scroll, revealing that the Azcapotzalco ruler had ordered the killing of Texcoco's leader, which must have compelled his son to go into hiding to avoid a similar fate.

In the midst of these machinations, the Mexicanus also records issues related to urban life. According to Durán (1994, 66–67), one of the ongoing projects during the reign of Chimalpopoca was the acquisition of drinking water for Tenochtitlan. I suspect that two events noted on page 60 (Plate 31) deal with this issue. First, a drawing of a hill sign with water underneath is linked to the year 6 Flint (1420). Second, a drawing of Chimalpopoca, identified with his smoking shield name tag and holding a digging stick, appears on this same page above 8 Rabbit

(1422). This image is associated with a glyph of a deer's (*maza-tl*) leg (*mez-tli*), which may record the name of a place where he had attempted to build an aqueduct. Although seemingly mundane, a concern with water will be a recurring theme throughout the Mexicanus' imperial and colonial history.

An event associated with Tlatelolco also happened in 6 Flint (1420) according to the Mexicanus, but its meaning is not clear. A hieroglyphic compound of a heart (*yollo-tl*) and what might be chili peppers (*chi-li*) is attached to the sandy-hill place sign of Tlatelolco. This might refer to the accession of a new ruler over Tlatelolco, as Cuacuauhpitzahuac died about this time and his successor Tlacateotzin was installed. However, this would be an unusual means of communicating a ruler's accession, and it is difficult to see how the hieroglyphic compound could elicit the name Tlacateotzin. Unfortunately, the key source on Tlatelolco, the *Anales de Tlatelolco* (2004, 89), simply says that in this year, "no sucedió nada" (nothing happened).

The Mexicanus includes three major battles for Chimalpopoca. The first battle was a flower war against Chalco in 8 Rabbit (1422). This

points to continuing tensions between Chalco and Tenochtitlan and the latter's inability to conquer the former. The second was a conquest in 12 Rabbit (1426) over a "tree" (*cuahui-tl*) place, which likely refers to Cuauhtitlan. The third was the general tumult surrounding the Tepanec War that would claim Chimalpopoca as a victim. Rather than recording his death with the standard funerary bundle, the Mexicanus painter shows him on page 61 (Plate 31) lying prone with a rope around his neck, much like Ixtlilxochitl earlier. This composition communicates that Chimalpopoca died an unnatural death, and many sources note that he was killed by the Tepanecs, or more specifically by Maxtla, ruler of Azcapotzalco.[34] A flower grows from Chimalpopoca's leg, but its meaning here is unclear, unless it suggests he died in a flower war. The disks linked to Chimalpopoca's death statement record a reign of twelve years, which would put his death at 1 Flint (1428).

ITZCOATL (R. 1428–1441)

The accession of Itzcoatl (Obsidian Serpent), Tenochtitlan's fourth ruler, is shown above 1 Flint (1428), which is the anniversary date of the start of the migration and of Acamapichtli's inauguration (Plate 31). Thus, Itzcoatl's rule is also given sacred significance, which is fitting, as he will earn Tenochtitlan's independence. Indeed, Itzcoatl is the first ruler in the annals history to sit on the woven reed throne, called a tepotzicpalli, signifying an elevation in status for the Tenochca ruling dynasty and for Tenochtitlan itself.

This elevation surely came about because of Itzcoatl's conquest of Azcapotzalco, which is shown below 1 Flint with the obsidian club/shield sign placed above the Ant Heap place sign for Azcapotzalco. Just beside this is the place sign for Tlacopan, which tells readers

it was conquered in the same year. A trace of Nezahualcoyotl's name glyph floats just below the place signs, suggesting his aid in these defeats. Just before the place signs, the painter included an image of Azcapotzalco's new ruler, Maxtla (Loincloth), who inherited the throne upon the death of his father, Tezozomoc, whose funerary bundle is shown on the register above. A drawing of a temple platform topped by an arrow and shield is shown just before Maxtla and linked by a separate line to the year 1 Flint. The meaning of this icon is not entirely clear. The shield and arrow suggest a different type of defeat than the obsidian club/shield icon used throughout the Mexicanus. The presence of a temple platform and the eagle-down balls that decorate the shield may point to this being a reference to some type of sacrificial ceremony.

Itzcoatl was known as a great warrior, which may explain the additional war ideogram attached to his accession statement in the Mexicanus. Statements on his conquests continue on the next page, where the deaths of a number of central Mexican leaders are pictured (Plate 32). All are shown as naked and prone figures with garrotes tied around their necks, surely in revenge for the earlier deaths of Ixtlilxochitl and Chimalpopoca, which were recorded in an identical manner. Indeed, one of these victims is Maxtla, the ruler of Azcapotzalco, who was said to have ordered the death of Chimalpopoca. Another victim is under him and identified with a name tag of a deer antler (*cuacuahui-tl*) and rump (tzin-tli); this may be another son of Tezozomoc who was named Cuacuauhtzin.[35] These men are linked by a line to 3 Rabbit (1430), as is a house sign with a series of footprints leading to it from a series of place signs. Reading from left to right, they are Coyoacan, Azcapotzalco, and Tlacopan. The last one is a stone (te-tl) and a banner (pan-tli), which may more generally refer to the fact that these are all Tepanec

communities, and I suspect this composition is meant to communicate that Tenochtitlan now has authority over these communities and their royal houses.

A complicated vignette to the right suggests that difficulties with the Tepanecs continued into the next year. The sandy-hill place sign linked to 4 Reed (1431) places the action in Tlatelolco, whose ruler, Cuauhtlatoa (Speaking Eagle), had sided with the Tepanecs over the Tenochca. A small figure seated above the year is identified with Cuauhtlatoa's name tag. He wears no crown, nor does he sit on a woven reed throne, which suggests that the Mexicanus painter did not consider him a true ruler. Cuauhtlatoa's aggressions against Tenochtitlan are recorded via his speech scroll that ends in the obsidian club/shield icon, thereby communicating that Cuauhtlatoa called his people to war. He must have been unsuccessful, as evidenced by his dead body—naked, prone, and with a garrote around the neck—just above and linked to the same Cuauhtlatoa name tag. Although he is not pictured, the implication is that Itzcoatl is the agent causing these events, as they happened under his reign. Indeed, Itzcoatl's defeat of Cuauhtlatoa must have been especially important, as it is one of the few conquests in the Codex Mendoza (5v–6r) to be highlighted with the inclusion of the defeated ruler.[36]

The next few images associated with Itzcoatl's reign are enigmatic. First, a general association with war may be communicated at 8 Reed (1435) with the image of a shield, now decorated with a checkerboard pattern and placed over a group of spears rather than an obsidian club (Plate 32). Then, two years later in 10 House (1437), the painter includes an image of scaffolding with three men, dressed simply in loincloths, falling from it. The image is ambiguous as there are no glyphs to identify people or place.[37] Next to this is an image of a shield covered in eagle-down

balls and with an element above that might represent fire. Unfortunately, the meaning of these elements and their relationship with each other or lack thereof are difficult to determine, as is the meaning of the Nahuatl gloss that floats on the lower register under these events and references the plowing of lands where flowers grow, *tlacuepa xochitlaua yecoztli.*

MOTEUCZOMA ILHUICAMINA (R. 1441–1470)

Itzcoatl's death is shown above 1 House (1441), and the years of his reign are recorded with fourteen disks to the right of his funerary bundle (Plate 33). The inauguration of Moteuczoma Ilhuicamina is shown in this same year. He is identified by his Ilhuicamina name tag, an arrow shooting into a starry sky, as he was in his birth statement earlier. A 5 marks him as Tenochtitlan's fifth ruler. Moreover, he is shown with a distinctive nose ornament that communicates his first name, as the golden nose bar is a sign of rulers and forms a part of his first name, *teuhctli,* for lord.

Hardships continued to afflict the Mexica under the reign of Moteuczoma I. The Mexicanus first shows an image of a grasshopper eating a corn plant in 6 Rabbit (1446), suggesting that grasshoppers destroyed crops in this year. Then, eight years later, a great famine occurred in the year 1 Rabbit (1454); many sources note the devastation the famine caused.[38] The Mexicanus references the famine with an image of a small man who appears to be floating above the timeline at 1 Rabbit (Plate 34). This figure must communicate the large number of deaths caused by the famine, as prone figures elsewhere in the Mexicanus also signify death. A line above this year begins at 13 House (1453) and extends to 2 Reed (1455), perhaps suggesting that the famine continued over these years. The year 2 Reed

is also marked with the standard year bundle tie for a new cycle. According to some sources, the binding of the years had traditionally been celebrated in the year 1 Rabbit, but because of that year's famine, Moteuczoma I moved it to 2 Reed, a practice that his great-grandson Moteuczoma II would continue for the next ceremony and that the majority of codices, including the Mexicanus, would retroactively apply to past years (see Hassig 2001, 38–39). While the meaning of the staff over the next year, 3 Flint (1456), is not entirely certain, it may reference ceremonies undertaken to commemorate the end of the famine.

Surprisingly, the Mexicanus shows just a few military victories for Moteuczoma I. One of these also occurred in 1 Rabbit (1454). Unfortunately, the place sign here is difficult to read. It appears to include a tree of some sort plus a rump (tzintli). This may refer to Huexotzinco; however, no other sources credit this town's conquest to Moteuczoma. The military standard placed over 3 Flint (1456) may alternatively reflect another victory, but there are no additional details. Then in 12 House (1465), a number of victories are recorded, though only one obsidian club/shield icon is shown (Plate 35). Two place-name signs are linked to the conquest icon on the upper register. The place sign for the first resembles that of Teteuhtepec, which is also shown as a conquest of Moteuczoma I's in the Codex Mendoza (7v). The second is not entirely clear but includes a bean (e-tl) and a semicircle of dots, perhaps for sand (xil-li). On the lower register is a ball court (tlach-tli) with a prone figure inside. As the Codex Mendoza (8r) also shows Tlachco (Place of the Ball Court) as one of Moteuczoma I's conquests, the Mexicanus must reference the same event here.

The Mexicanus again refers to Texcoco's ruler Nezahualcoyotl, who is shown on the upper register above 13 Rabbit (1466), where he holds a digging stick and stands in front of a Chapultepec place sign that issues a stream of water (Plate 35). The vignette records his construction of an aqueduct at Chapultepec, which was used to bring freshwater into Tenochtitlan. Because the Codex Mexicanus tends to focus on the heroic exploits of the Mexica of Tenochtitlan, the references to Nezahualcoyotl stand out and support his status as a key ally of the Tenochca. Moreover, his engineering feat stands out as a mark of the ingenuity of the Nahuas.[39]

AXAYACATL (R. 1470–1483)

Moteuczoma Ilhuicamina died in 4 Rabbit (1470, Plate 35). In contrast to his accession, which identified him with his Ilhuicamina name tag, now his funerary bundle is identified with a name tag of a diadem over hair, which is the traditional sign for his first name, Moteuczoma (Our Lord the Angry One). His death is also notated in Nahuatl, "momiquili huehue motecuhçomatzin" (he died, Moteuczoma the Elder), and the twenty-nine years of his reign are indicated with a large disk, standing for twenty, plus nine smaller disks that are now slightly effaced. The accession of the next ruler is shown with the standard iconography though lacking a name sign. This must be Axayacatl (Water Face), which a later contributor noted by writing in his name, and the 6 under his reed throne indicates that he was Tenochtitlan's sixth ruler.[40]

The Mexicanus lists a number of conquests for Axayacatl. The first two occurred in the same year as his accession. These victories are shown under 4 Rabbit (1470). At the bottom is the obsidian club/shield icon for conquest, and above this is the place sign of a tied leather cord for Cuetlaxtlan (Place of Leather). To the left of this, and linked to Cuetlaxtlan by a faint line, is a drawing of a net with a fish below. This sign

typically references Matlatzinco, and here may reference a campaign undertaken by Axayacatl in the Toluca Valley (Carrasco 1999, 251).

Axayacatl's most significant victory was over Tenochtitlan's island neighbor, Tlatelolco. Just one year after his accession, the Mexicanus painter shows a dedication of a temple at Tlatelolco. The temple is shown in profile view with shell merlons at the summit marking it as a temple to Huitzilopochtli. A small Tlatelolco place sign just to the right communicates the temple's location. Although a variety of reasons have been given for the outbreak of war between Tenochtitlan and Tlatelolco, the Mexicanus' inclusion of Tlatelolco's temple dedication suggests the main cause was the city's pretensions.[41] With Itzcoatl's defeat of Cuauhtlatoa many years earlier, Tlatelolco's

5.4 Axayacatl's defeat of Moquihuix, Codex Cozcatzin, detail of folio 15r. Courtesy of the Bibliothèque nationale de France.

latest ruler, Moquihuix, was now a subordinate to Tenochtitlan, and by building a temple to Huitzilopochtli that would have surpassed his temple in Tenochtitlan, Moquihuix was making a provocative statement. Indeed, the Mexicanus painter draws a line, literally, from the temple dedication to the outbreak of war. An elaborately dressed warrior stands on this line and approaches another view of Tlatelolco's temple, now shown in a three-quarter view with a double summit that appears to be burning, marking Tlatelolco's defeat in 7 House (1473). A smaller figure stands at its top. The larger warrior, who must be Axayacatl, holds an obsidian club and a shield decorated in a unique pattern in one hand and a rattle staff in the other. Axayacatl was said to have dressed as Xipe Totec when in battle, and here he is shown in the conical cap, feather panache, and skirted armor associated with the god. The Codex Cozcatzin devotes attention to this same battle and also shows the ruler dressed as the god (Figure 5.4). The smaller figure on the temple in the Mexicanus must represent Tlatelolco's ruler, Moquihuix, who retreated to Tlatelolco's temple during the battle. There he died, either having jumped or been thrown, as also shown in the Codex Cozcatzin image and the Codex Mendoza (10r).[42]

More conquests surrounded Tlatelolco's. The first happened the year before, in 6 Flint (1472), recorded with the standard war icon and place-name sign of a flower (xoch-itl) over teeth (tlan-tli), for Axayacatl's conquest of Xochtlan. He also conquered Ocuillan (Worm Place) in 10 Flint (1476). Yet another conquest appears on the next page, in 11 House (1477), but the place-name sign seems to be the sandy-hill for Tlatelolco, which presumably remained rebellious and had to be subdued once again (Plate 36).

Another well-documented battle happened in 12 Rabbit (1478), when an enemy warrior

named Tlilcuetzpal (Black Lizard) injured Axayacatl's leg by cutting it to the bone (Durán 1994, 268–269). In the Mexicanus, Tlilcuetzpal is identified with his Black Lizard name tag and shown in the act of cutting Axayacatl's thigh with his obsidian club (Plate 36). Axayacatl is again dressed in his Xipe warrior outfit, though now less elaborate. Tlilcuetzpal is linked to two other icons just above his head. Although unclear, the first is likely an incense bag (*xiquipil-li*), and the second is a house sign (*cal-li*). Based on the record of this same event in the Codex Aubin (37v), these must be place signs for Xiquipilco and Calimaya. The Codex Aubin uses a house sign to mark this same battle, and the associated annotation says that the homeland of Tlilcuetzpal was Xiquipilco and that people of Calimaya also fought in the battle.[43]

Two environmental events also happened under Axayacatl's reign. The first was an earthquake in 9 Reed (1475). In the Mexicanus, this is shown with an *ollin*, or movement, sign under what looks like a destroyed house (Plate 35). This was followed by an eclipse in 13 Reed (1479), which the painter of the Mexicanus records with a drawing of a sun with three stars above it, suggesting that stars appeared after the sun disappeared (Plate 36).

TIZOC (R. 1483–1486)

The trace of a funerary bundle that falls at the binding of page 71 records the death of Axayacatl (Plate 36). The fourteen years of his reign are shown below the accession of the next ruler, Tizoc (Chalk Leg), in 4 Reed (1483) with a 7 to indicate his place as the seventh ruler of Tenochtitlan. Tizoc's reign is noted in the Mexicanus for just two events. One is the beginning of his renovation of the Templo Mayor, which is recorded with the temple platform shown just to his right. The other event does not put

Tizoc in the best light, as it suggests a defeat for the Tenochca. Above 6 House, a Matlatzinca warrior victoriously grabs another figure by the hair; according to Durán (1994, 300), Tizoc led a disastrous campaign in the area. Known as an ineffectual ruler, Tizoc's reign only lasted four years, as noted by the four disks at his funerary bundle on this same page at 7 Rabbit (1486).

AHUITZOTL (R. 1486–1502)

The year of Tizoc's death saw the inauguration of Tenochtitlan's eighth ruler, Ahuitzotl (Water Rat). A major achievement for Ahuitzotl was his completion of the Templo Mayor expansion in 8 Reed (1487, Plate 36). The Mexicanus shows this with a three-quarter view of a tall pyramid with twin temples. The south side of the temple, dedicated to Huitzilopochtli, is a bit taller and more lavishly decorated than the north side, dedicated to Tlaloc. A rack shown to the lower left of the temple may reference the skull rack that would have been placed near the temple, but otherwise the Mexicanus only indirectly references the victims that would have been sacrificed to dedicate the temple. The sixteen banner signs here do not relate to the dedication but instead note that 320 years have passed since the departure from Aztlan.

Other sources mention the numerous sacrificial victims brought in for the dedication, and the signs on the register below 8 Reed likely refer to their homelands. For example, one of these is clearly a deer (maza-tl), and the Codex Aubin (Figure 5.5) identifies some of the victims as Mazateca. One of the other place signs in the Mexicanus includes a leaf (*xihui-tl*) and a snake (coa-tl), for the Xiuhcoaca people, who are listed as victims in other sources as well.[44] The third place sign includes a chili pepper (chil-li), water (a-tl), and a banner (pan-tli), presumably for a place called Chilapan, which was a tribute

payer of Tenochtitlan and located to the south of the capital. A fourth place sign includes a banner (pan-tli) and perhaps teeth (*tlan-tli*) for Tlapan, which is also included in the Codex en Cruz list of territories that supplied sacrificial victims for the dedication (Dibble 1981, 1: 29). With Mazatlan and Tlapan to the southeast near the Pacific Coast and Xiucoac associated with the Huaxtecs to the north near the Gulf, the places recorded here suggest that Ahuitzotl had the farthest reaches of the empire supply victims for the dedication. Nevertheless, the relation of these places with sacrificial victims must be added by a knowledgeable reader, as the Mexicanus makes no direct references to

sacrifice, in contrast to other sources that list the large numbers of people sacrificed for this ceremony.[45]

Soon after the dedication of the Templo Mayor, the Mexica suffered through four years of natural catastrophes. First an earthquake struck in 10 House (1489), then in 11 Rabbit (1490) there was an event involving rain and fish (Plate 37). A similar representation is shown in the Codex Aubin (Figure 5.5) for the same year, and an associated Nahuatl annotation mentions a hailstorm and the death of fish. Then in 12 Reed (1491), a plague of grasshoppers descended again to devour corn plants, as is also mentioned in the Codex Aubin (Figure 5.5).

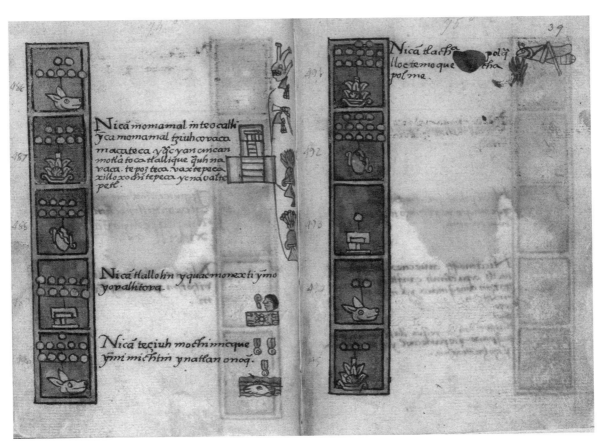

5.5. Historic events from 7 Rabbit (1486) through 3 Reed (1495), Codex Aubin, folios 38v–39r.
© The Trustees of the British Museum.

The sun above 13 Flint (1492) suggests another drought in this year, though the Codex Aubin mentions no events for 13 Flint. After three years of calm, another earthquake struck in 4 Flint (1496; page 73), as was also noted in the Codex Aubin (Figure 5.6)

Probably the greatest disaster under Ahuitzotl's watch was the great flood of 7 Reed (1499), recorded with a slash of water above the timeline on page 73 (Plate 37). The significance of this event is highlighted by the use of bright blue paint, making this the only image to receive paint in the imperial section. The flood happened after Ahuitzotl had commissioned a new aqueduct to bring more freshwater into the city. Called the Acuecuexco Aqueduct, it was modeled after the one built earlier by Nezahualcoyotl at Chapultepec (see Mundy 2015, 64–69). However, it brought too much water into the city, resulting in a massive flood (Durán 1994, 370). It is unclear whether the event in the next year was in response to the flood, but the painter depicts a man quarrying stone at Malinalco. The flood and quarrying of stone are also mentioned in the Codex Aubin (Figure 5.6). According to Durán (1994, 373), Tenochtitlan had to be rebuilt after the flood, and one wonders if the quarrying of stone at Malinalco was done to aid in these efforts.[46]

Although other sources detail how Ahuitzotl

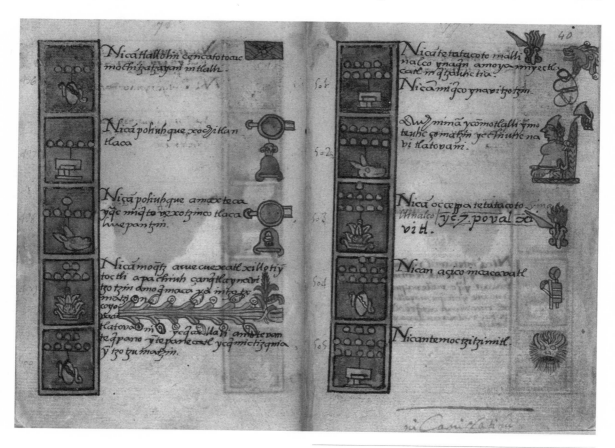

5.6 Historic events from 4 Flint (1496) through 13 House (1505), Codex Aubin, folios 39v–40r. © The Trustees of the British Museum.

had greatly expanded the empire, the Mexicanus is silent about this expansion until just before the great flood of 1499. In 5 House (1497), he reconquered Xochtlan (Place of Flowers), which was originally conquered by Axayacatl (Plate 37). In the next year, 6 Rabbit (1498), he conquered Amaxtlan (Place of Water Loincloth). These conquests are also pictured in the Codex Aubin (see Figure 5.6). Each of these places is in the Oaxaca area and would have greatly expanded Tenochtitlan's geographic and economic reach (Berdan and Anawalt 1992, 2: 23).

MOTEUCZOMA XOCOYOTZIN (R. 1502–1519)

Having ruled for seventeen years, Ahuitztotl died in 10 Rabbit (1502) and was immediately succeeded by Moteuczoma II, Tenochtitlan's ninth ruler (Plate 38). The years of his reign are full of newsworthy events. First, he continued to quarry stone, as shown by the digging stick breaking up a pile of rocks under 11 Reed (1503). The reference for the next year, 12 Flint (1504), includes a sun over a burning field, while a bird's head floats nearby.[47] The early years of Moteuczoma's reign were said to have been times of drought and famine, which may be referenced with this event in the Mexicanus. According to the iconography, a strong sun parched the fields and, along with birds, damaged the crops.

A rare supernatural reference appears under 13 House (1505), where a monstrous face is drawn and marked by a bulging eye, curly hair, and prominent teeth with which it eats a human figure, only his legs remaining. A descending footprint above the image confirms that this is a *tzitzimitl*, a monstrous creature that was believed to descend to earth to devour humankind. The Codex Aubin (see Figure 5.6) also mentions the appearance of a tzitzimitl in this year.

A conquest over a place identified with an unclear place-name sign happened in the next year, 1 Rabbit (1506). I suspect this references a place identified in other sources as Zozola (Place of Snoring). Associated with this same year is an image of a man wearing a diadem and a nose bar. As the northern Huaxteca were known for their perforated septums, this may record a journey to the north in order to procure food during the famine that was said to have continued through 1 Rabbit and reveals another sense of historical patterning, as the previous 1 Rabbit year was also a time of famine and one that also struck under a ruler named Moteuczoma. The next year, 2 Reed (1507), marked another binding of the years.

The images over 3 Flint (1508) reference the Spaniards long before their arrival in Mexico (Plate 38). The first, an image of a European sword with a footprint below, is linked to a series of disks. The top row includes five disks, with five more below this and two more on the bottom, giving a count of twelve. Counting from 1508 twelve years forward brings the reader to 1519, the year of the conquest. Thus, the painter is giving notice of the coming Spanish military invasion. Moreover, this composition is linked to another by a line to the right. The second image shows a shield superimposed on a European sword, with two dots below. This construction references the conquest that would happen two years later, in 1521. In this case, the obsidian club/shield icon for conquest is replaced with a Spanish shield/sword icon, signifying that this would be a Spanish conquest, not a Mexica one. In this same year and in the middle of the military iconography, the painter depicts a dove descending toward the timeline. As doves came to signify Christianity in Aztec pictorials, its appearance in the Mexicanus suggests the arrival of the holy spirit, or Christianity, in the New World before the Spaniards themselves.[48]

I suspect the painter includes these icons at this point in his history because they introduce the next few events shown in the Mexicanus, which will be interpreted as omens of the Spanish arrival. That the dove precedes these events in the Mexicanus suggests that the painter was communicating that these were sent by God, thereby marking the conquest as divinely sanctioned and Tenochtitlan as chosen by God to receive the Holy Spirit. Indeed, Acosta (2002, 428) writes about these omens and attributes them to God: "it is not erroneous but correct to believe that the wisdom of the Most High orders and permits things that give some indication of what is to be, so that it may serve, as I have said, to warn some and chastise others, and is a sign to all that the King of Heaven is concerned in the affairs of men."

The omens extend over a few years. The first in the Mexicanus appears above the year 4 House (1509) and is pictured with descending footprints and a tall column (Plate 38). This likely references an event noted also in the Codex Aubin (40v), which mentions that a stone column fell in this year. In the next year, 5 Rabbit (1510), the Mexicanus painter shows a field with a lighter, triangular element above. A notation in Nahuatl reads, "tlahuize alihual moquetzaya" (a light came and stopped here). The image in the Mexicanus is evocative of a description of this event in Book 12 of the Florentine Codex (Sahagún 1950–1982 13, 1):

> Ten years before the Spaniards arrived here, an omen of evil first appeared in the heavens. It was like a tongue of fire, like a flame, like the light of dawn. It looked as if it were showering [sparks], as if it stood piercing the heavens. It was wide at the base, it was pointed at the head. To the very midst of the sky, to the very heart of the heavens it stood reaching; to the very midpoint of the skies it stood stretched as it was seen.

Yet another omen happened in the next year. A large stone platform shown above 6 Reed (1511) refers to an episode recounted by Durán (1994, 477–482) that was also prophetic in nature. Moteuczoma II had ordered Tenochtitlan's old sacrificial stone be replaced with one that was larger and more fitting for the imperial capital. He called on stonemasons to find the largest and finest stone to be carved into a new *temalacatl*, or round stone, to be used for sacrifice. However, according to Durán (1994, 479), the stone was difficult to move and spoke to the people, saying,

> Poor wretches! Why do you labor in vain? Have I not told you I shall never reach Tenochtitlan? Go, tell Moteuczoma that it is too late. Now he no longer will need me; a terrible event, brought on by fate, is about to take place. Since it comes from divine will, he cannot fight it. . . . Let him know that his reign, his power, has ended.

Despite the prophetic warning, Moteuczoma II still ordered his people to move it, but the stone eventually collapsed through a bridge, taking many men with it and drowning them.

In the midst of these omens, more mundane events, such as conquests, continued to be included in the Mexicanus history. For example, a flower war took place in the same year as the prophetic stone event and against a place identified with a spindle of thread (*icpa-tl*) above a hill sign (*tepe-tl*). This must be Icpatepec, or Place of Thread, and Moteuczoma II conquered another town, Tlachquiyauhco (Ball Court Rain), in the next year, 7 Flint (1512).

Hardships also continued to afflict the area, as indicated above 9 Rabbit (1514), where an

image of the earth appears with sand above (Plate 39). The Codex Aubin (41r) and Chimalpahin Cuauhtlehuanitzin (1998, 1: 303) also note a dust storm in this year that resulted again in hunger for the people. In the Mexicanus, a line from this year extends to 13 Rabbit, suggesting that the famine lasted over these four years. The image on the upper register in the next year includes a digging stick, but the other icons here are not entirely clear. According to the Codex Aubin (41r), more excavation of stone was carried out in 10 Reed (1515) at Malinalco, though the image in the Mexicanus is linked by a line to 9 Rabbit (1514), and the icons shown are not the ones used earlier to refer to Malinalco.

Under 10 Reed (1515), the Mexicanus shows descending footprints leading to the place sign for Huexotzinco (Plate 39). According to Chimalpahin Cuauhtlehuanitzin (1998, 1: 303), the people of Huexotzinco had taken refuge in Tenochtitlan in 7 Flint (1512) because of a war between themselves and the Tlaxcalteca and the Cholulteca, and they remained there for four years. The footprints leading toward the Huexotzinco place sign in the Mexicanus may indicate their departure from Tenochtitlan and return to their homeland. The writer of the Codex Aubin (41r) also references people from Huexotzinco being in Tenochtitlan in 10 Reed (1515) but describes them as spies.

The image next to this of three men's heads records events related to the conquest. Because the Spanish arrival was such a monumental event, the Mexicanus painter fills his record with a detailed account that necessitated he include imagery related to the conquest on the page preceding the actual date of the Spanish arrival (Plate 39). The first man is identified with the sign for Cuetlaxtlan, which gives his homeland. His name tag is a circle of flour (*pinol-li*). The second one has a shield and spear name tag, for war (*yao-yo-tl*). The third one is identified with a name tag of speech scrolls (*ten-tli*). Men by these same names are identified in Sahagún's (1950–1982, 13: 5) account of the conquest:

And when were seen those who came to the seashore, already they were traveling by boat. Then in person went Pinotl of Cuetlaxtlan, the high steward. He took with him still other stewards. The steward of Mictlanquauhtl—Yaotzin—[was second]. Third was the steward of Teocinyocan, named Teocinyacatl. Fourth was Cuitlalpitoc, who was only an underling, a guide. Fifth was Tentlil, likewise a guide. For the time being these went only to look at [the Spaniards]. They went as if to sell [goods] in order to go to spy upon them, to find out about them. They went to offer them precious capes, precious goods: indeed, capes pertaining to Moctezuma alone, which no one else wore.

Thus, the three named men are the ones who conveyed goods for Moteuczoma. Some of these goods are shown on the lower register to the right. Boone (2000, 233) links some of the gifts to the regalia of the god Quetzalcoatl and identifies them as "a beaded cape, two feather headdresses, two feather cloaks, five disks of turquoise mosaic (below), a tunic, and two shields." The gifting of shields, along with the protective regalia of a god, suggests that Moteuczoma II was preparing the Spaniards for war.

A ship shown on the upper register records the Spanish arrival; it has three sails and pointed banners to mark it as a Spanish ship. Hernán Cortés is seated before the ship and in communication with the head steward, Pinotl, who is identified with his "flour" name tag. He wears a simple mantle and stands with a bowed head before Cortés, who is seated in a European folding chair, which came to symbolize Spanish

authority in native manuscripts (Diel 2005b, 307–312). Cortés' European identity is also communicated by his bearded face and black clothing that includes a jacket, pants, stockings, and brimmed hat. The hieroglyphic compound behind him of a mouth (*camac-tli*) and a stone (te-tl) may have been meant to approximate "Cortés," *can-te*. He gestures toward Pinotl in communication and presumably gives him gifts in return for Moteuczoma II. These include a beaded necklace and European shoes, as well as a European steel-tipped lance, which stands between them. Thus, Cortés' gift also includes goods pertaining to war.

The entry into Tenochtitlan is shown succinctly on the next page with an image of a Spanish warrior above the year 1 Reed (1519). He is dressed in armor and holds a shield and sword in one hand and a pointed banner attached to a lance in the other. He looks toward the right, drawing attention to a burning temple, signifying the battles at Tenochtitlan in 2 Flint (1520). One large disk is linked to the Templo Mayor, and another line leads from this disk to a series of smaller disks at the left. Unfortunately, their exact number is obscured because they fall at the book's binding. If the larger disk referenced twenty and the smaller disks totaled thirteen (three groups of four are just barely visible), this could have recorded the thirty-three years that had passed since the dedication of the Templo Mayor in 1487. Thus, the contributor could have been recording the age of the Templo Mayor upon its destruction, much as the reigns of Mexica rulers were noted upon their deaths.

Below the temple is a prone figure covered in pockmarks and communicating the arrival of smallpox along with the Spaniards. Sahagún's (1950–1982, 13: 83) description of this first outbreak—many more would follow—is especially harrowing:

There spread over the people a great destruction of men. Some it indeed covered [with pustules]; they were spread everywhere, on one's face, on one's head, on one's breast, etc. There was indeed perishing; many indeed died of it. No longer could they walk; they only lay in their abodes, in their beds. No longer could they move, no longer could they bestir themselves. . . . And when they bestirred themselves, much did they cry out. There was much perishing. Like a covering, covering-like, were the pustules.

Thus, the Mexicanus makes it clear that the Spaniards did not just unleash a military conquest over Tenochtitlan, but they unleashed a viral one too.

Adding to the devastation brought with the Spanish arrival was the untimely death of Moteuczoma II in 2 Flint (1520). Moteuczoma II's funerary bundle is drawn on the lower register with additional elements to highlight the chaotic circumstances surrounding his death. Moteuczoma II was imprisoned in his palace by Cortés and was said to have suffered injuries there that caused him to die. The accounts vary as to who caused these injuries—his own people or the Spaniards. The Mexicanus leaves the question unanswered and simply shows an arrow piercing his bundle and marking his death as unnatural. The painter also includes flames under the bundle, referencing accounts that some Mexica, having seen the Spaniards trying to dispose of his body, took it and gave it a proper burial by fire (Sahagún 1950–1982, 13: 65–66). Just next to the funerary bundle is an image of a shield, as if Moteuczoma II himself were conquered.

The painter records the reign of Moteuczoma II's successor, Cuitlahuac, in an abbreviated fashion that corresponds to the truncated

nature of his rule. Cuitlahuac is identified with a name tag of excrement (*cuitla-tl*) and water (*a-tl*). This is linked to four disks, which refers to the fact that he reigned for just eighty days before dying of smallpox. The four disks reference the four twenty-day months of his reign, just as the nineteen disks above Moteuczoma's bundle reference the nineteen years of his reign. The conventionalized image of a newly inaugurated ruler at the bottom of the page must represent Cuitlahuac's successor, Cuauhtemoc (Descending Eagle), though his name tag is no longer visible.

CUAUHTEMOC (1520–1526)

Cuauhtemoc must have continued to subdue other territories even while under threat by the Spaniards. According to the Mexicanus, in the year 3 House (1521), he conquered two territories, as communicated by two obsidian club/shield icons (Plate 39). The first was Chalco, finally subdued after so many fractious years, extending even back into the migratory past. The city is identified both through its place-name icon and an alphabetic text, *chalcatli*. The second is identified only with the alphabetic text reading *xocotitlan*. The Codex Aubin (45r) clarifies that Cuauhtemoc conquered these territories during the month of Tlacaxipehualiztli, which fell in March. Accordingly, these two conquests are squeezed in on the upper register just to the left of, and therefore earlier in time than, the Spanish conquest of Tenochtitlan, which was complete upon Cuauhtemoc's surrender on August 13, the day of St. Hippolytus.

The defeat of Tenochtitlan is told purely in symbolic form, but updated to signify that this was a Spanish victory, not a Mexica one (Boone 2000, 233–234). The traditional obsidian club/shield icon that had marked conquests throughout the Mexicanus is now replaced with a Spanish shield, so identified by its shape and stitching, placed over a steel-tipped lance and a sword, with an armor helmet linked above. This marks the victory in 3 House (1521) as a Spanish one, and because the place of action is understood to be Tenochtitlan, there is no need for its place sign. With this, the history shifts, but it does not end. Because Cuauhtemoc continued to rule through the first few years of Spanish authority, I return to the final years of his reign in the next section.

IMPERIAL HISTORY DISCUSSION

The Mexicanus' account of Tenochtitlan's history is clearly based on accounts recorded in the preconquest past that served to legitimize and exalt Mexica rule. Nevertheless, the contributors to the annals history necessarily reconceptualized the historical past in order to make sense of how this past prepared them to live as Nahua Christians in late sixteenth-century New Spain.

A primary focus in the Mexicanus' imperial history is the seamless nature of rule over Tenochtitlan. That is, the Mexicanus shows no breaks in Tenochtitlan's dynastic succession, with each ruler's death being immediately followed by a new tlatoani accession, even in the event of a ruler's unnatural and/or premature death. Moreover, the Mexicanus suggests a sacred underpinning to the Tenochca dynastic line. For example, the accessions of both Acamapichtli, the initiator of the dynastic line, and Itzcoatl, the initiator of Tenochtitlan's imperial growth, happened in 1 Flint years, anniversary markers with the migration that suggest a sense of divine providence and cosmic order for its ruling line, as was also emphasized in the Mexicanus' genealogy. Although the sacred nature of this date and of its recurrence in Mexica history was a preconquest construct intended to

validate Tenochca supremacy, it continued to have resonance into the colonial period.

Additionally, the Mexicanus records an expansive conquest history for Tenochtitlan. Although by no means as exhaustive as the Codex Mendoza in terms of numbers of conquests shown, the Mexicanus does show key victories that resulted in a vast empire. It is surely no coincidence that the earliest victories celebrated by the Mexica were against each of those towns that had attacked them during their migration. On the one hand, these victories suggest revenge against all who had wronged the Mexica. On the other hand, with each victory, the Mexica usurped the power of those who had controlled the Valley of Mexico, culminating in their defeat of Azcapotzalco in 1428, which resulted in Tenochtitlan's meteoric rise into an imperial power.

The Mexicanus' imperial history also focuses on rivalries Tenochtitlan had with two territories. The first, Tlatelolco, is understandable given that the two cities shared an island location and were independently founded by Mexica migrants, making it natural for these two cities to become rivals. Accordingly, the Mexicanus painter stressed Tenochtitlan's numerous victories over Tlatelolco, concluding with Axayacatl's defeat of Moquihuix, which resulted in the political unification of the island, much like the Mexicanus' genealogy stressed the familial links between Tenochtitlan and Tlatelolco. This unification would have repercussions in the colonial period, when Tlatelolco asserted its independence from Tenochtitlan. A focus on Chalco also dominates the Mexicanus' history of Tenochtitlan, though Chalco does not figure at all in the Mexicanus' colonial account. Although Tenochtitlan had numerous rivals throughout its history, Chalco was a thorn in its side going all the way back to the migration. Soon after the foundation of Tenochtitlan, the Mexicanus

painter depicted the people of Chalco defeating another territory, which reiterated the city's bellicose nature. In fact, the ongoing flower war with the Chalca people suggests that the Mexica were unable to subdue the city. Although other sources, such as the Codex Mendoza and the preconquest Tizoc Stone, list Chalco as an early victory of the Mexica, the Mexicanus does not show its defeat until 1520. This timing suggests that this defeat was so important to Tenochtitlan that they took resources away from their capital just as they were dealing with the Spanish invasion.

By contrast, the Mexicanus highlights Tenochtitlan's positive relationship with Texcoco. For example, the Mexicanus only includes two birth statements, and one of these is for Texcoco's ruler Nezahualcoyotl, which points to his significant role in Mexica history. The Mexicanus also communicates Texcoco's key role in the Tepanec War, recording Ixtlilxochitl's death at the order of Azcapotzalco's ruler and Nezahualcoyotl's subsequent alliance with Tenochtitlan to defeat the Tepanecs. The Mexicanus even credits a major engineering feat, the Chapultepec Aqueduct, to Nezahualcoyotl, which speaks to the intellect of Texcoco's ruler.

The record of Nezahualcoyotl's aqueduct, along with other building projects, reveals a concern with water control that will continue into the colonial period, while it also points to the civility of the Nahuas more generally. As Angel Palerm (1973, 32) has noted, the hydraulic projects of Aztec Mexico were a sign of its imperial achievements and placed the empire in the same league as the greatest Western nations. Indeed, the Romans were greatly renowned for their aqueducts. Accordingly, the reference to the Chapultepec Aqueduct highlights similarities between the Aztec and Roman empires, and it must have been included in the Mexicanus history because of the prestige it leant the Aztec

past, cementing its status as a great empire capable of technological achievement. Moreover, water control will continue to be an issue into the colonial period. Of course, the Mexicanus also references a moment of hubris for the Mexica through the record of the great flood of 1499, which was caused by Ahuitzotl's failed attempt to build an aqueduct. The flood of 1499, however, is immediately followed by an image of the quarrying of stone, which points to the Mexica's continual attempts to control nature.

In fact, the Mexicanus devotes a significant amount of attention to natural disasters that plagued Tenochtitlan. In addition to floods, these included earthquakes, hailstorms, droughts, and the invasions of birds and grasshoppers that destroyed crops. Although other pictorial and alphabetic accounts of the preconquest past mention environmental hardships experienced by the Mexica, none include as many notices of natural disasters as the Mexicanus. One could interpret these records as a further sign of the greatness of the Mexica people in terms of their ability to overcome adversity, which continues a theme seen in the migration account. Although the Mexicanus shows that the Mexica were continually threatened by nature, their capital city endured. However, when considered in the light of the sixteenth-century context in which this history was written, one might also read these disasters as a sign of the impotence of the Aztec gods, who despite their constant propitiation were unable to avert them, an issue to which I return at the end of this chapter.

Surely also tied to the context in which this history was recorded, the Mexicanus' imperial history stands out for making no direct references to sacrifice. In the preconquest past, the triumph of the Mexica would have been attributed to their ability to care for the gods who controlled nature, and one of the primary means of doing so was through the offering of sacrificial victims in religious ceremonies. Of course, each conquest would have been followed by the sacrifice of war captives, but these sacrifices are never shown in the Mexicanus. By contrast, the Codex Telleriano-Remensis is filled with conquest statements associated with figures who have been prepared for sacrifice. Indeed, pictorial signs at its rendition of the Templo Mayor dedication indicate that twenty thousand people were sacrificed in the associated celebrations. While the Mexicanus references the Templo Mayor dedication, it only refers to the sacrificial victims via place signs for their homelands; it does not explicitly picture the associated sacrifices or provide numbers. I suspect this is yet another way in which the contributors to the Mexicanus stress their civility via Christian ideology. The imperial history emphasizes Mexica military conquests and the building of a fine temple, but not the religious rationale behind these events. Indeed, the dedication of the Templo Mayor was immediately followed by a number of natural disasters, suggesting a sense of ambivalence about the Aztec gods on the part of the Mexicanus historians.

In fact, the only direct reference to a supernatural figure throughout the imperial history is the notice of a malevolent tzitzimitl devouring a person soon before the Spanish arrival. The friars saw tzitzimime as demonic beings (Boone 1999; Klein 2000). As a Nahua thoroughly indoctrinated into Christianity, the contributor to the Mexicanus may have internalized this idea of the tzitzimitl as a satanic creature and its inclusion here would be linking the preconquest past with a time of darkness. I suspect it is no coincidence that the Mexicanus' only reference to an Aztec supernatural precedes by just a few years the dove of Christianity and omens that foretold the coming of the Spaniards, as if a battle between the pagan, Aztec past and the Christian future were about to be unleashed.

This inclusion of omens presaging the Spanish arrival also reflects a reworking of the Mexica past to make sense of the present. The idea that the conquest was preceded by omens was established by the mid-sixteenth century, and the earliest sources to mention these were Spanish. For example, the Spanish friar Motolinía included the omens in his *Memoriales,* and Sahagún later expanded on these in the Florentine Codex (Laird 2016, 177–180). As Felipe Fernández-Arnesto (1992) has argued, the omens that concerned comets and lights in the sky were based on classical and Christian traditions. The omen of a stone that would not move can also be traced to the Roman past. Nevertheless, native historians came to accept these omens, adapting them to their own circumstances, as seen in the story of the stone that warned Moteuczoma II of his coming downfall. There was a prophetic quality to Aztec history, and the omens made sense in this schema. As Stephen Colston (1985, 240) wrote, "Most, if not all, of these omens were likely composed by post-Conquest native raconteurs who, by presenting these events as though they occurred before the Spaniards arrived, sought to demonstrate the imminence of a calamity and, by extension, the inevitability of this event." Additionally, the omens mark Tenochtitlan as a land chosen by God to receive Christianity. In Christian theology, for an omen to be true, it must have been sent by God. Accordingly, the painter of the Mexicanus' imperial history shows the dove of Christianity arriving in Tenochtitlan before the Spaniards themselves. The dove then launches the omens, suggesting that the coming Spanish invasion and conquest were preordained and unleashed by God.

The conquest itself was a key moment in Tenochca history, and the large amount of space devoted to the conquest in the Mexicanus points to the significance of this cataclysmic event for Tenochtitlan. And yet, the primary focus in the representation, space-wise, is the gift exchange between the Mexica and the Spaniards, suggesting a meeting of equals. Missing from the Mexicanus' record are the Spaniards' native allies. This was a battle between Tenochtitlan and Spain, and the superior weapons of the Spaniards and the diseases they brought guaranteed their victory, along with God's approval, of course. Although the transition to Spanish rule may not have been seamless, the omens that presaged this event confirmed that it was God's plan.

Colonial History: From Tenochtitlan to New Spain

The Mexicanus' account of the Mexica migration and Tenochtitlan's imperial history benefitted from a historical distance that allowed the past to be reconceptualized based on present circumstances. In contrast, events associated with the colonial era appear more chaotic and without the symbolic import seen before, which is fitting, as these were recorded closer in time to when they happened. Moreover, the variety in style seen in this section points to multiple contributors. The Mexicanus' colonial history exhibits continuities with the preconquest past, but there are also changes that necessarily came about with the imposition of new political, religious, and economic systems, as well as the arrival of new contagions. Thus, the Mexicanus makes Tenochtitlan's transformation into Christian New Spain clear, but it also informs readers that this was by no means a painless transition.

The significance of some events in the Mexicanus' account of the sixteenth century is not always clear, but the majority of this material can be read, especially by comparing the Mexicanus' records with other sources. Two of the

most useful are the Codex Aubin and Chimalpahin Cuauhtlehuanitzin, especially his Seventh Relation (Chimalpahin Cuauhtlehuanitzin 1998, 2: 10–269). The Codex Aubin was set down in Mexico City in the final quarter of the sixteenth century, and the frequent similarities between this source and the Mexicanus make one wonder if its authors were in contact with each other and/or familiar with their respective projects. Although a native of Chalco, Chimalpahin Cuauhtlehuanitzin wrote his work in Mexico City in the early seventeenth century and used pictorial manuscripts as a source; perhaps one of these was the Mexicanus. Because the events in this section are so plentiful, I provide a reading of the colonial history by going through it year by year, page by page. In the discussion that follows, I pull together themes that characterize the colonial history. Much of these contents focus on the transformation of Aztec Tenochtitlan into Christian New Spain and suggest the active role the Mexica played in making Tenochtitlan into a City of God for the New World.

PAGE 77: 4 RABBIT (1522)–6 FLINT (1524)

The first year after the conquest was a busy one for Hernán Cortés (Plate 39). Dressed in the same garments as his earlier representation, he sits on a curule chair, a European equivalent to the woven reed thrones occupied by native rulers (Diel 2005b, 307–312). He gestures and speaks to three Nahua men who are shown in a subordinate fashion, referenced only with heads that do not speak nor carry insignia of rank such as crowns. Accordingly, one could interpret the imagery as communicating Cortés' new authority over Tenochtitlan.

Although stripped of rank, the Mexica before Cortés have name tags that reflect their historic importance. Reading from top to bottom, the first is surely Cuauhtemoc (Descending Eagle), though only the footprint for the "descending" portion of his name tag remains. The second is Motelchiuhtzin, who is typically identified with a name tag that includes a stone (te-tl). Motelchiuhtzin appears in many accounts of the immediate aftermath of the conquest, wherein he is described as an important warrior and one of Cuauhtemoc's advisors, though not a nobleman (Chimalpahin Cuauhtlehuanitzin 1998, 2: 159). The third is identified as a *cihuacoatl* (Woman Snake), the term used to designate the second in command to the Mexica ruler. In this case, it marks a man named Tlacotzin, who served in this capacity under Cuauhtemoc. The meeting must have taken place in Coyoacan (Place of the Coyote), whose coyote place sign is included on the lower register. Cortés had settled there soon after the conquest and during the rebuilding of Tenochtitlan.

A figure stands behind Cortés' throne. Wearing the garments of a Franciscan, he may represent the friar who accompanied Cortés' expedition to Mexico. However, he mimics Cortés in speech, which indicates that this figure could also represent Gerónimo de Aguilar, a Spanish shipwreck victim who lived amongst the Maya and learned their language. He rejoined his countrymen upon their arrival in the Yucatán and facilitated their interactions with the indigenous peoples by acting as a translator. He was also a Franciscan, which could explain the garments in the Mexicanus. Although the figure's exact identity is unclear, the presence of a Franciscan along with Cortés places the Christianization of the natives as one of the first messages in the Mexicanus after the military conquest was complete.

Nevertheless, evangelization was not necessarily the only purpose of this meeting, as suggested by the fire pit placed between the Europeans and the Nahuas. The presence of a

fire pit and the setting of Coyoacan suggest that the painter is also referencing Cortés' torture of Cuauhtemoc. As described by Chimalpahin Cuauhtlehuanitzin (1997, 1: 217–219),

> From there they sent them, they took them to Coyoacan. There they bound their feet in irons on order of don Hernando Cortés, Marquis del Valle, and there burned [their feet] when they interrogated them as to the gold that was lost, that the Spaniards had hastily cast away in the Tolteca canal when they fled by night as they went to Tlaxcala. And the rulers who lay bound in Coyoacan were, first, don Hernando Quauhtemoctzin; the second one was named don Andrés de Tapia Motelchiuhtzin, a lord steward; the third was named don Juan Velásquez Tlacotzin cihuacoatl.

The Mexicanus' representation implicates both the religious and secular spheres in the torture of the Mexica officials. Moreover, an image on the lower register points to an additional place of torture. Linked to 4 Rabbit (1522) is an image of a native head that floats above a banner (pantli) sign and another image of fire. According to the Codex Aubin (45r), Cortés stopped at a place called Pantlan in the same year he went to Coyoacan. Thus, one could interpret this vignette as communicating that Cortés tortured natives there as well.

The Mexicanus painter contrasts the subordination and torture of Tenochtitlan's rulers with the elevation of one of Texcoco's rulers. Ixtlilxochitl II (Black Face Flower) is shown on the lower register immediately underneath Cortés. Identified by the same darkened face and flower name tag as his namesake years earlier, Ixtlilxochitl II sits on the tepotzicpalli, wears the turquoise diadem, and issues a speech scroll. This iconography communicates his power and sets him apart from the Mexica rulers above. Indeed, he and Cortés both appear as rulers, Cortés over the Spanish sphere and Ixtlilxochitl over the native one. A son of Texcoco's former ruler Nezahualpilli and grandson of Nezahualcoyotl, Ixtlilxochitl II battled his brother for control of the Acolhua State just before the Spanish arrival. He refused to recognize Tenochca authority and established an alliance with the Spanish invaders (Hicks 1994). As acknowledgment of his help, Cortés officially named him as ruler of Texcoco in 1522.

Tenochtitlan's rulers, however, were not kept down for long. The Mexicanus suggests that they were soon reconfirmed and sent back to the capital. Above 5 Reed (1523), the painter shows a *tecpan*, or palace, which is a standard house sign embellished with circles at the top. The nopal cactus above the palace verifies its location at Tenochtitlan, and footprints descend into it, suggesting arrival. In this case, it likely relates that Cortés sent the three Mexica shown the year before back to Tenochtitlan to retake control over the city's native sphere. A general sense of unease may have characterized this transitional moment, as an image on the lower register of a personified sun fading to black records an eclipse in this same year.

A partnership between the Mexica and the Spaniards is suggested just one year later. A conquest is shown above 6 Flint (1524), but it is now marked as a joint undertaking of Spanish and Mexica forces, as shown by the addition of a Spanish sword to the standard obsidian club/shield icon for conquest. Unfortunately, the exact place conquered is now effaced. Imagery under 6 Flint is also effaced, with the paint having flaked away, making it impossible to determine what was once shown here, though something was clearly depicted. I cannot help but wonder whether this originally recorded the arrival of the first twelve Franciscans sent

to convert the natives, a significant event that is consistently recorded in native histories and would be an odd omission for the Mexicanus.

PAGE 78: 7 HOUSE (1525)–12 RABBIT (1530)

More joint conquests are shown on page 78 (Plate 40). The first occurred in 7 House (1525), over a place identified with a tripod vessel with a human face inside.[49] A similar vessel appears in the Codex Aubin (45r) to refer to Cortés' journey to Honduras. The same place must be recorded in the Mexicanus. During this expedition, Cortés accused Cuauhtemoc of fomenting a rebellion and had him hanged. In the Mexicanus, a line from the Honduras place sign leads to a funerary bundle that records Cuauhtemoc's death. The top portion, where his name tag would have once been, is now effaced, but a trace of a crown is barely visible and likely marked him as a nobleman. The Mexicanus painter does not include the exact means of death, perhaps in an attempt to suppress a telling of Cuauhtemoc's supposed rebellion.[50] Another funerary bundle appears next to Cuauhtemoc's and records the death of the cihuacoatl, Tlacotzin. He was appointed as a ruler after Cuauhtemoc's death, but he died on the journey back to the capital (Chimalpahin Cuauhtlehuanitzin 1997, 2: 169). Cortés then installed Motelchiuhtzin as the new ruler. He is shown under his predecessors' funerary bundles, and he wears a crown but does not sit on the woven reed throne. This suggests he was not a full ruler. Indeed, Chimalpahin Cuauhtlehuanitzin (1998, 2: 171) refers to him and Tlacotzin as *cuauhtlatoque*, or Eagle Rulers, a term used to designate nonnoble rulers. According to the Mexicanus, these deaths and accessions happened in 8 Rabbit (1526), and the footprints that lead from the Honduras place sign back to the timeline suggest the journey back from Honduras to Tenochtitlan/New Spain.

The next year, 9 Reed (1527), witnesses two natives and two Spaniards leaving New Spain, as conveyed by the footprints that lead away from the timeline and toward a round mass that may signify Spain. The ethnic identities of these men are distinguished, as the two indigenes are shown with simple haircuts, while the two Spaniards are so marked by their brimmed hats. This vignette records the journey of Hernán Cortés back to Spain, though he actually departed in March 1528 (Cline 1969, 71). The higher status of the Spaniard at the top right is communicated by his beard and ruffled collar. Accordingly, this must be Cortés, though he is identified with a different name tag than seen earlier. I suspect the "rain" (*quiyahui*) sign somehow approximates Marques, the title he received on this trip. A man identified with the same rain name tag is shown returning to New Spain on this same page in 12 Rabbit (1530), and Cortés did in fact return that year, which confirms the rain name tag must be his. The other Spaniard may be Andrés de Tapia, who accompanied Cortés to Spain (Cline 1969, 70). His name sign of a stone (te-tl) and water (a-tl) combined with his speech scroll (*ten-tli*) approximates his name. If the water sign does double duty, the name may read *a-ten* for Andrés and *te-a* for Tapia.

Cortés brought a number of Nahuas with him to Spain, but the Mexicanus only records two of the highest-ranking ones, both Mexica nobles.[51] The first at the top is identified with an owl (*tecolo-tl*) name tag, which records a son of Moteuczoma's named Nezahualtecolotzin, who was just nine years old at the time of the Spanish arrival. After the fall of Tenochtitlan, he was taken into Cortés' household, where he received his full name, Don Martín Cortés Nezahualtecolotzin.[52] The Nahua below Don Martín is identified with a name tag that includes a snake (coa-tl) and likely references a nobleman named Matlacoatzin, who was a nephew of

Moteuczoma and was also brought to Spain on this same passage (Chimalpahin Cuauhtlehuanitzin 1998, 2: 183). This journey of Mexica nobles to Spain, where they were received in the court of Charles V, speaks to their high status, placing the Mexica nobles on the same level as their Spanish counterparts.

Descending footprints mark the arrival of two Spanish officials in New Spain in 10 Flint (1528). The first arrival, simply identified with a bishop's miter, is that of Bishop Zumárraga, who was appointed protector of the Indies and bishop-elect, as he left for New Spain before being officially consecrated as its bishop. The second is a Spanish secular official who is identified with a name tag of a large hand (*ma-itl*), perhaps for Maldonado, one of the Spaniards appointed to the newly created *audiencia*, a council of Spaniards that was meant to rule New Spain. However, Francisco Maldonado died soon after his arrival in New Spain, and the audiencia itself was marked by turmoil and quickly disbanded, its members replaced by a new group. Again, a sense of turmoil is echoed in environmental events, as the painter records a meteor shower immediately under the arrival of the Spanish religious and secular leaders.

The introduction of an important Christian sacrament, marriage, happened in 11 House (1529).[53] This is shown with a representation of a cloaked friar standing behind a man and woman with hands joined. The man wears a cotton mantle along with a shirt and pants, showing that he has adopted the more modest clothing standards of the Spaniards. The woman wears a traditional huipil and skirt, and her braided hair continues to reference married status in the colonial period. The friar raises his hand in blessing to the newly married couple. Frontal views are rare in Aztec pictorial writings and also in the Mexicanus, which makes this scene, with its frontal representation of the friar, stand

out. The painter likely saw a European representation of marriage and follows it here.[54] The introduction of Christian marriage to the native peoples can be read as a sign of the success of evangelization efforts in New Spain, as the taking of marriage vows was meant to be preceded by proof that the couple had been instructed in Catholic doctrine (Burkhart 1989, 24; Zaballa Beascoechea 2016, 64).

The year 12 Rabbit (1530) saw the return of Cortés to New Spain and the departure of Zumárraga for Spain. The miter that records Zumárraga's departure is just barely visible at the binding of the page. This same year also witnessed another combined Spanish/Mexica battle. Although the battle is shown above 12 Rabbit, a line also links it to 11 House (1529). The conquered place is identified with a curved hill place sign and references a battle that took place at Culiacán, a rebellious territory located near the Pacific Coast. Culiacán was conquered in 1530 by the Spanish conquistadors and by the first president of the audiencia, Nuño de Guzmán, who set out in 1529 with an expeditionary force that included hundreds of Spaniards and thousands of natives from a number of territories (Mota Padilla 1870, 23, 87). By recording this victory with the Spanish sword/obsidian club/shield icon, the Mexicanus shows the victory as an alliance between Mexica and Spanish forces and shows that the military strength that marked Tenochtitlan's imperial history continued into the colonial period.

PAGE 79: 13 REED (1531)–5 FLINT (1536)

A praying figure on the register above 13 Reed (1531) is placed below a giant orb topped with a cross (Plate 40). Although the figure falls at the binding of the page, her skirt marks her as a woman, and her head covering reflects an event described by Chimalpahin Cuauhtlehuanitzin

(1998, 2: 187) and the author of the Codex Aubin (46r). According to these authors, it was declared that women had to cover themselves with a white cloth (mantilla) when they entered the church; the Aubin places this declaration in the next year, but Chimalpahin Cuauhtlehuanitzin agrees with the date in the Mexicanus. Accordingly, the orb in the Mexicanus must reference the Catholic Church more generally. It is interesting to note that though women played an important role in the Mexicanus' genealogy and migration account, they disappeared from Tenochtitlan's imperial history and only reappeared in its colonial-era history in a more generic manner related to the new Catholic religion.

Two political events also occurred in 13 Reed (1531). On the upper register, the president of the second audiencia, Sebastián Ramírez de Fuenleal, arrived in New Spain, as communicated by the descending footprints under the image of a Spaniard's head. He is identified with a name sign of a lip labret (tente-tl) to approximate the final syllables of his title, presidente. Meanwhile, the inauguration of a native ruler is shown on the lower register. The Texcocan ruler Ixtlilxochitl died in 1531 and was succeeded by his half-brother Don Carlos Ometochtzin (Chimalpahin Cuauhtlehuanitzin 1998, 2: 187).[55] The name tag that appears to be a necklace (cozca-tl) may be an approximation of Carlos, though it would have been far easier for the painter to have written his Nahuatl name, Ometochtzin, or Two Rabbit. Strangely, the painter includes no reference to Texcoco here or at Ixtlilxochitl's earlier representation. The inauguration statement shows Don Carlos wearing the turquoise crown, but only his head is shown on top of the woven reed throne, rather than his full body, perhaps due to space limitations.

Another outbreak of smallpox occurred in 1 Flint (1532). It is noted via an image of a figure placed horizontally and covered in pockmarks that are shown on top of the shroud that modestly covers the body. A gloss in Nahuatl reads, "hueue içahuatl ic micohuai" (there was a large sickness/pox; there was much death). This year was also marked by an astrological event of a smoking star, as also mentioned by Chimalpahin Cuauhtlehuanitzin (1998, 2: 185). This notice continues the association between astrological phenomena and times of trouble in New Spain.

The familiar ollin icon on the upper register above 2 House (1533) records yet another earthquake. The icon on the lower register is a new one for the Mexicanus; it is a stone wheel that signifies a market. In this case, it records the establishment of the market of Santo Domingo in this year.[56] The wheel is topped with scrolls that I suspect refer to smoke, or popo-tl, as an approximation of domingo.

In 3 Rabbit (1534), the bishop's miter and descending footprint seen earlier at 10 Flint repeat and communicate the return of Bishop Zumárraga, who had traveled to Spain for his consecration and arrived back in New Spain in 1534, now officially a bishop. On the lower register, another native ruler's inauguration is shown in an abbreviated manner similar to that of Don Carlos Ometochtzin, with just a head occupying the throne rather than a full-sized body, which may suggest these were drawn by different artists. The name tag of a flower (xochi-tl) over a garment (quem-itl) gives the name (Don Pablo) Xochiquentzin, though others place his accession a few years earlier (Chimalpahin Cuauhtlehuanitzin 1998, 2: 187; Codex Aubin 46r). It is interesting to note that Xochiquentzin is shown with the crown and throne, proper accoutrements of a noble ruler, though he was not born of noble blood.

The Mexicanus notes a transfer in Spanish authority in 4 Reed (1535). A pair of descending footprints brings the arrival of a new

Spanish leader, identified by his bearded face and brimmed hat, along with an eye (*ix-tli*) and a bean (*e-tl*) icon. The *ix-e* name tag approximates the word *visorey*, or viceroy, and marks a change in New Spain's political structure, with control shifting from the audiencia to the viceroy. Thus, this image records the arrival of the new viceroy Don Antonio de Mendoza, as is also confirmed by the associated alphabetic notation that reads, "do antonio mendoça yacuican acico visorey," or "Don Antonio Mendoza, newly arrived viceroy." Just after Mendoza's arrival, the painter shows President Ramírez de Fuenleal's departure. He is identified with the same lip labret name tag seen earlier and did in fact return to Spain in this year. A semicircular shape appears at the top of the page above Mendoza and Ramírez de Fuenleal; this may reference Spain, as was seen on page 78, though the icon on page 79 has unclear signs within it. The alphabetic annotation that mentions Doctor Ceynos, an *oidor* in the second audiencia, must be a mistake, as he remained in New Spain until 1546 (Ruiz Medrano 2006, 61).

PAGE 80: 6 HOUSE (1537)–10 HOUSE (1541)

An icon of a disk filled with T-shaped designs above 6 House (1537) records the introduction of money in New Spain (Plate 41). Coins, called *tomines*, were equal to one-eighth of a peso, and the arrival of the *tomín* is also referenced by Chimalpahin Cuauhtlehuanitzin (1998, 2: 197) and the Codex Aubin (46v).[57] The alphabetic notation here likely clarifies the imagery, but it is too effaced to read.

A native ruler succession occurred in 7 Rabbit (1538). Although rulers in the Mexicanus can be identified based on other sources, the dates and name tags in the Mexicanus are not always consistent with other sources or even within the Mexicanus itself. For example, the ruler's death

in this year must be Don Pablo Xochiquentzin's, as the five disks point to Don Pablo's accession five years earlier. However, Xochiquentzin had died in 1536, and the new viceroy waited a year or more before appointing his successor (Chimalpahin Cuauhtlehuanitzin 1998, 2: 193; Mundy 2015, 101). By placing his death in the same year as that of the next ruler's accession, the Mexicanus painter stresses the continuity of native rule over the city. However, the painter now identifies Don Pablo's funerary bundle with a different name tag, a bird's head (*toto-tl*) and a Spanish sword (*espada*), perhaps reading *to pada* for Don Pablo.[58] The next ruler to be inaugurated must be Don Diego de Alvarado Panitzin, who is typically identified with a banner (*pan-tli*) name tag, as seen in the genealogy section of the Mexicanus. However, in some sources he is called Huanitzin, which corresponds to the alphabetic notation and to his name tag in the Mexicanus annals, which includes water (*a-tl*) and a type of plant that, based on its better condition at his death statement a few years later, is an amaranth (*huau-tli*).

Don Diego de Alvarado Huanitzin/Panitzin was a nobleman, being the grandson of the former ruler, Axayacatl. Accordingly, his accession marks a return of rule to the Tenochca royal dynasty. Moreover, he was the first Mexica ruler to receive the Spanish title of *gobernador*. By this time, Mexico City's native sphere was ruled by an indigenous *cabildo* (town council), whose leader was called a gobernador. This new position replicated the preconquest tlatoani to some extent, and the Mexicanus even shows colonial-era gobernadores, such as Huanitzin, with the same attributes (woven reed throne and crown) as preconquest *tlatoque*.

In the next year, the painter records a military expedition, shown with war icons plus an ascending footprint, which references the start of the Mixton War in Nueva Galicia.[59]

The war dragged on over a number of years and necessitated thousands of native warriors, but now the war icon shown in the Mexicanus is purely Spanish—a crossed spear and sword under a stitched shield. The omission of obsidian clubs from the rest of the Mexicanus may suggest that Mexica warriors now fought for the Spanish military. The final battle in the Mixton War occurred at a place called Xochipillan, which is shown, a few years later. Above 10 House (1541), the war icon plus footprint is shown, while a small image of a flower (xochi-tl) and a baby (*pil-li*) give the place of the final battle and Spanish victory.

An image of a man tied to a pole is also shown above 8 Reed (1539). The dark skin coloring, curly hair, and Spanish clothing point to this being the hanging of an African man. Two years earlier in Mexico City, a group of African slaves had planned a rebellion with the goal of driving Spaniards out of Mexico. The plot was exposed, and twenty-four of the rebels were hanged and quartered as punishment (Love 1967, 96). This event clearly interested native historians, as it is noted by Chimalpahin Cuauhtlehuanitzin (1998, 2: 199) and the *Anales de Tecamachalco* (1992, 26). The hanging is also pictured in the Codex Telleriano-Remensis (45r), where the African slave is also shown with shaded skin, curly hair, and European clothing. The Mexicanus, however, shows the hanging two years late, which may have confused one of the later annotators of the manuscript. An alphabetic notation on the lower register is in poor condition, but the word *tetzcoco* can just barely be made out, which suggests this annotator interpreted the image of a hanging as the punishment of Don Carlos Ometochtzin, ruler of Texcoco, who had been accused of idolatry, found guilty by the Inquisition, and burned at the stake.[60] This event did indeed happen in 8 Reed (1539), which likely caused the annotator

to think the image referenced Don Carlos or at least to feel that a mention of this event should have been recorded in the Mexicanus.

The next year brings the departure of Cortés, who is identified again with his "Rain" name tag, which is linked with 10 disks recording the ten years he had spent in New Spain since his return in 1530. As the Mexicanus painter typically includes disks at the end of a native ruler's term in office, their appearance here suggests that he considered Cortés as a Spanish equivalent to a Mexica ruler.

Having ruled for four years, Don Diego de Alvarado Huanitzin died in 10 House (1541) and was succeeded by Don Diego Tehuetzquititzin, a name that has the root *huetzca*, "to laugh," and is shown with a name tag of a fantastical laughing face. As recorded in the Mexicanus' genealogy, Tehuetzquititzin was the grandson of the former ruler Tizoc, making him a fully noble gobernador but shown using the traditional iconography of a Mexica tlatoani. In this same year, a more diminutive earthquake sign is shown on the lower register, along with five disks and an alphabetic notation that remarks on this being the fifth earthquake, or *chiqueye hueytlalilli*, in the history.

PAGE 81: 11 RABBIT (1542)–3 REED (1547)

Falling at the binding of the page above 11 Rabbit (1542), an image of a cross inside a circle provides another reference to the imposition of a monetary system over New Spain (Plate 41). Here it records the *cuarto*, a coin of copper equal to one-quarter of a peso (see also Chimalpahin Cuauhtlehuanitzin 1998, 2: 201; Codex Aubin 47r).

A small figure is shown above 12 Reed (1543). He is dressed in a simple mantle and has speech scrolls coming from his mouth. A similar image in the Codex Aubin (47r) is accompanied

by a Nahuatl annotation that provides a bit of clarity; it says that a man named Bartolomé, who was the *atempanecatl*, preached in the temple. The term *atempanecatl* was a preconquest one used to refer to officers of the ruler who were responsible for administering justice (Berdan and Anawalt 1992, 2: 195). In the Codex Mendoza (65r), the official wears a mantle with a contrasting border, which is evocative of the heavy black line used to delineate the figure's mantle in the Mexicanus. Unfortunately, the significance of his preaching and why it merited inclusion in these two codices remain unknown.

The first reference to Tlatelolco in the colonial era occurs in 13 Flint (1544). Two native men are shown in front of the Tlatelolco place sign. Unfortunately, neither carries a name tag and sources on early colonial Tlatelolco are fragmentary, which makes it difficult to fully interpret this record. Each wears a crown and holds a *vara*, or staff of justice, iconography that the Mexicanus painter uses to identify native judges, a title given to nonnobles who had attained positions of power. By contrast, noble leaders, called gobernadores, are distinguished by their woven reed thrones. Thus, the painter is communicating in a general sense that at this time, Tlatelolco was ruled by judges, whereas Tenochtitlan was still ruled by noblemen.

An image on the lower register of a figure wearing the cloak of a friar and carrying an item with spiky ends evocative of a scourge appears to record a penitent of some sort. I suspect this image references the work of Francisco Tello de Sandoval, a Spanish church official who was sent to New Spain in this year to act as a *visitador*. He conducted a sweeping investigation of the viceroyalty's administration, which especially targeted the corrupt audiencia. His charge compelled him to travel the region so that people could come to him and seek justice for any mistreatments they had received from Spanish officials (Ruiz Medrano 2006, 135–136). Thus, the image of a religious figure in the Mexicanus at this time likely references this visit and the notice that the Nahuas must have taken of it, perhaps feeling a sense of agency as it would have provided them a means of holding Spanish officials accountable for their actions.

Another sickness broke out in 1 House (1545). This time its main symptom was bleeding from the nose and mouth, as shown in the Mexicanus, where the painter atypically adds color, red of course to signify blood. The sick figure is shown lying prone and floating above a rectangular block that is textured on the top. Despite the devastating outbreak, a stone wheel above the sick figure references a more mundane event, the opening of a market at San Hipólito, as also recorded in the Codex Aubin (47r).

The event associated with 2 Rabbit (1546) is not entirely clear. The painter shows a tall, thin structure with two levels and a roof decorated with pointed parapets. A figure occupies the entire first level, while the second level is smaller and may have smoke coming from its top. The figure seems to have his hands bound at his chest and wears Spanish-style clothing, which points to this being some type of punishment or imprisonment carried out in this year, but, unfortunately, other sources are silent on the matter. For example, the historian for the Codex Aubin leaves this year blank (Figure 5.7).

The building drawn above 3 Reed (1547) is the first reference to a church in the Mexicanus. It is shown as a raised structure with two arched doorways. There is an X pattern at its top and a cross on its roof. The Codex Aubin references the establishment of the Church of San Juan in this same year and includes a more elaborate image of the church but with some of the same features, such as an arched first level (see Figure 5.7). The image in the Mexicanus to the right of the church is a strangely shaped swatch

of water, which I suspect references another event mentioned in the Codex Aubin for the same year, the building of a canal at Apepetzpan. Something else was noted on the lower register at this time, but its poor condition makes it difficult to interpret.

PAGE 82: 4 FLINT (1548)–9 HOUSE (1553)

The funerary figure wearing a bishop's miter and placed horizontally above 4 Flint (1548) must refer to the death of Bishop Zumárraga in this year (Plate 42). Above this are two Nahuas who are marked as judges by their *varas de justicia* and crowns, but they do not carry name or place signs to identify them further. They seem to be

associated with two buildings to the right and linked to the same year by a line. The Codex Aubin mentions the "entrance" of two judges from Huexotzinco in this same year (see Figure 5.7), which suggests the Mexicanus is recording an event related to these same judges, but the poor condition of this section and lack of details in both sources make the import of these judges and their actions unclear.

Another reference to Tlatelolco is found at 5 House (1549), where a standard, but abbreviated, accession statement records the inauguration of Don Diego de Mendoza Imauhyantzin as governor of Tlatelolco (Chimalpahin Cuauhtlehuanitzin 1998, 2: 205). The hand (*ma-itl*) portion of his name tag may call forth his native

5.7 Historic events from 2 Rabbit (1546) through 8 Flint (1552), Codex Aubin, folios 47v–48r. © The Trustees of the British Museum.

name. Most of the information on this ruler comes from documents written in later centuries, which makes his exact identity and level of nobility unclear (Castañeda de la Paz 2013, 293–294). However, the inclusion of a woven reed throne indicates that the painter of the Mexicanus considered him to be a gobernador.

On the lower register under this same year, the Mexicanus shows a tall structure typically used in a preconquest ritual known as the *volador* ceremony. In this ceremony, men climb to the top of a pole and attach themselves to ropes wound around the pole. They then jump and appear to fly as the ropes unspool and they circle the pole. The ceremony continued to be popular after the conquest. For example, according to the *Anales de Juan Bautista* (2001, 155) and the *Anales de Tecamachalco* (1992, 52), the ceremony was performed to celebrate the arrival of a new viceroy in 1566. The inclusion of the pole in the Mexicanus suggests it was also performed earlier, but the circumstances behind its performance are not mentioned, nor is this particular event mentioned in other sources.[61]

Another punishment is recorded in 6 Rabbit (1550), wherein a man wearing Spanish-style clothing is shown hanged. A speech scroll comes from his lips, but he is not further identified. In what might be a related representation, four men are recorded on the register below. Each is shown as a simple head with a footprint extending down, suggesting flight away from Mexico City. Name tags identify the men as Jaguar Road (*ocelo-tl*, *oh-tli*), Reed (*aca-tl*), Arrow or Hunt (*tlama-ni*), and Flower Arrow (*xochi-tl*, *mi-tl*). The Codex Aubin mentions events over a few years related to Tenochca men with similar names. First, in 1548, it mentions a man named Francisco *Ocelotecatl*, who was jailed (see Figure 5.7). Then, in 1550, it mentions three men who were meant to be hanged but had fled to Atenco; they were named Pablo *Ezuauacatl*,

Miguel Atlaua, and Baltasar *Xochimitl*. Then, in 11 Reed (1555), the Codex Aubin (48v) mentions the return from Atenco of Francisco *Ocelotecatl* (the man who was jailed in 1548), along with Baltasar *Xochimitl* and a new man, Gabriel *Tlamiyauh*. In this same year, shown on page 83, the Mexicanus shows footprints and two more men's heads, but without any identifying characteristics. The match between the names and dates in the Aubin and the Mexicanus indicates that they are recording the same events surrounding these men, but what they did to merit such a punishment is not explained, though a possibility may have been a refusal to pay an increase in tribute that was ordered the year before. Several natives were hanged because they refused to pay it (Gibson 1964, 390).

More-mundane events are shown in the same year on the top register: the departure of Antonio de Mendoza and arrival of the new viceroy, Don Luis de Velasco. The name sign for Mendoza is no longer visible, but Velasco's includes a bird (*toto-tl*) and an eye (*ix-tli*), perhaps approximating *to-ix-to* for Velasco. Yet another earthquake struck New Spain in 7 Reed (1551). This is shown with the typical *ollin* sign, but the meaning of the tree-like shape that appears above is unknown. The sign above the next year, 8 Flint (1552), includes water and may refer to the enlargement of the canal at San Francisco, as is mentioned in the Codex Aubin (see Figure 5.7).

PAGE 83: 10 RABBIT (1554)–2 REED (1559)

Above 10 Rabbit (1554), an image of Tehuetzquititzin's name glyph is drawn along with a free-floating diadem (Plate 42). The shape underneath the name tag may be his funerary bundle, now laid flat in the Christian fashion, but if so, it has been cut off by the binding of the page. Disks are visible on the previous page, surely in reference to the years of his

reign, though they too fall at the binding and are impossible to count. His successor is also shown, though the vara that he holds indicates that he was a judge rather than a gobernador. This ruler was Don Esteban de Guzmán, and he is identified with a glyph of a flower (xoch-itl) on a field (mil-pa). This sign provides his hometown as Xochimilco, which further sets him apart from previous rulers, as he was not a nobleman nor was he from Tenochtitlan. In this same year, an iconic reference to a new bish-op's arrival is shown; here it marks the arrival of Bishop Zumárraga's replacement, Bishop Alonso de Montúfar.

A funerary bundle, again laid flat in the Christian tradition, records the death of an important person above 11 Reed (1555). The Water Stone name tag of the deceased is similar to that used for the former ruler Motelchiuhtzin, which makes it likely that this records the death of his son, Hernando de Tapia, who was not a ruler but was known as a *nahuatlato*, a translator for the court.[62] Chimalpahin Cuauhtlehuanitzin (1998, 2: 209) also mentions his death in this year. The change in funerary bundles, from seated to flat, is yet another sign of the spread of Christianity in New Spain.

This was also the year of torrential rains that flooded Mexico City (*Actas de Cabildo* 1889, 5: 198; Chimalpahin Cuauhtlehuanitzin 1998, 2: 209).[63] This event is marked in the Mexicanus by a drawing of rain above a water icon. The same name tag used to identify Viceroy Velasco on the previous page floats at the top of this year as well. There are no details to clarify why Velasco is included here, but his presence may refer to his quick reaction to the flood, as he was said to have turned to native leaders for guid-ance and followed their suggestion to build a dike for future protection (Mundy 2015, 199).

A star and a fish float above the timeline at 12 Flint (1556). According to the Codex Aubin (50r), in this year, fish fell from the sky, and according to the *Anales de Tecamachalco* (1992, 35), a smoking star was seen in this same year. The Mexicanus image must refer to these same incidents. The painter also includes a chalice on the lower register that likely references another occurrence mentioned on the same page of the Codex Aubin, the commencement of a project to build a sacristy at the Church of San José. As the chalice is an attribute of San José, it calls forth the patron of the church.

The inauguration of New Spain's next native governor is shown above 13 House (1557). Iden-tified with a name tag of two beans (e-tl), Don Cristóbal de Guzmán Cecepatzin was of noble blood. Accordingly, he is shown as a gobernador in the Mexicanus, though in the abbreviated manner, wherein only his head is shown rather than his full body. In this same year, the painter shows an Aztec house icon linked with a red line to the timeline. Associated departing footprints communicate that the "house" left Mexico City. A number of years later, in 6 Reed (1563), the "house" returns to the timeline. I suspect the house sign references the Audiencia Real, which according to Chimalpahin Cuauhtlehuanitzin (1998, 2: 217), returned to the viceregal palace in 1563, after having been transferred to Cortés' palace. The Mexicanus suggests the initial move happened in 1557.

Just as before the conquest, 1 Rabbit years continued to be times of unease. The one that fell in 1558 of the Christian calendar was marked by an invasion of grasshoppers that must have devastated local crops.

A Spanish conquest is shown above 2 Reed (1559), but the place conquered is impossible to read today. Also difficult to fully read is news of a native ruler on the lower register. Only his diadem and an "eye" (ix-tli) sign are visible today. Other sources are silent on these records. By contrast, many sources detail the other

important event for 2 Reed.[64] News of the death of Charles V reached New Spain in this year, and a catafalque was raised to celebrate him. In the Mexicanus, this is shown as a simple structure with a pointed arch and a candle below to refer to the masses said at this time in his honor. It is interesting to note that this ceremony occurred in 2 Reed, a year with sacred connotations for the Nahuas, as ceremonies associated with the binding of the years took place in 2 Reed years and were often marked by ceremonies involving the lighting of a new fire. The Mexicanus annalist recorded knots at 2 Reed years to mark these sacred events in the preconquest section but no longer included them in the colonial section.

PAGE 84: 3 FLINT (1560)–8 HOUSE (1565)

The poor condition of the next page makes many of the events shown difficult to fully interpret (Plate 43). For example, in 3 Flint (1560), an arriving Spaniard is shown, possibly recording the return of Dr. Ceynos, an *oidor*, to New Spain, as also mentioned in the Codex Aubin (52r). A name tag of a bird with a single disk at its mouth identifies a shrouded figure attached to the 4 House (1561) year sign. Placed horizontally and topped by a candle, the figure evokes death, but whose death is not known. These two years were also marked by earthquakes. The ollin sign above 3 Flint is barely visible, but the one above 4 House is clearer. However, why a Spanish military banner is also included here is not known.

Events are not much clearer for 5 Rabbit (1562). At the very bottom of the page, the death of Don Cristóbal de Guzmán Cecepatzin can just barely be made out by a funerary bundle laid flat and identified with a trace of his "two beans" name glyph, with disks indicating the years of his reign. Unfortunately, I am not able to decipher the image just above his death

statement. Moving to the upper register, a stone icon may refer to Chimalpahin Cuauhtlehuanitzin's (1998, 2: 215) statement that the building of the cathedral of Mexico City began in this year with the collecting of stone. Next to this is a very faint image of a man shown frontal and standing between two large posts. His hands appear to be bound, which again suggests a punishment, but further details are not provided.

More enigmatic images are shown for 6 Reed (1563). On the upper register is a drawing of a Spanish sword placed on a rectangular platform. Although its meaning is not secure, it may refer to a building campaign begun the year before by Cecepatzin that called for the acquisition of hundreds of wooden beams to be harvested from nearby forests (Mundy 2015, 167). In this case, the circles on the platform may represent the wooden beams, and the sword could refer to tools needed to cut them down. Next to this is the returning "house" sign mentioned previously, and then an accession sign for the next native ruler of Mexico City, Don Luis de Santa María Cipactzin. His name sign includes a bird (toto-tl) and an eye (ix-tli), perhaps reading *to-ix* for Luis. Cipactzin was a member of the Tenochca royal dynasty, and his inauguration is accordingly shown with the tepotzicpalli and crown that mark him as a gobernador. The arrivals of two Spaniards are shown on the lower register. The Spaniard on the right carries the same "rain" name glyph used previously for Hernán Cortés; thus, this must represent the arrival of his son Don Martín Cortés, second Marqués del Valle, in New Spain. The second Spaniard is identified with a rather complicated name sign that includes an eye (ix-tli), a stone (te-tl), and a face (yaca-tl). As the visitador Gerónimo de Valderrama arrived in New Spain this year, the sign may read *ix-te-yaca* for Valderrama.

One of Valderrama's charges was to overhaul the tax system, the consequences of which can

be found in the next year on the upper register. The new system forced Nahuas to pay their tribute in money rather than in labor or in kind. This system was imposed in 7 Flint (1564), and the Mexica gobernador, Cipactzin, tried to have the burdensome tribute obligation reduced, but to no avail. Upon receiving news of this failure, the people rose up against him, throwing stones at the gobernador and *alcaldes* (administrative officers) and then at the tecpan itself (*Anales de Juan Bautista* 2001, 213, 215). The painter of the Mexicanus succinctly records the protest by depicting a Spanish coin, stamped with a cross, at the center of the composition. This is the *tomín*, whose introduction the Mexicanus had earlier noted, and three disks are linked to it above, referencing the new tax of three *tomines* per citizen. Stones surround the tomín, and a figure with an oversized arm throws more stones, standing in for the protestors.

The new tribute obligation was an even greater burden due to sickness and drought, which the Mexicanus shows on the lower register directly below the scene of protest. First, a prone figure covered with pockmarks records another devastating outbreak of smallpox that must have begun in the previous year, as a line links the victim to this year as well, and continued into 1564. Moreover, a slash of water under the smallpox victim records not a flood but that year's scarcity of fresh drinking water, which surely exacerbated the epidemic and compelled the Spanish cabildo to look for a solution. They came up with two. One was to build an aqueduct at Santa Fe, and another was an attempt to revitalize the Acuecuexco Aqueduct disastrously created by Ahuitzotl at the end of the fifteenth century (Mundy 2015, 197–198). As the Mexicanus will later make clear, neither of these was successful.

In the next year, the governor who had to oversee the imposition of the new tribute obligations, Don Luis de Santa María Cipactzin, died. His funerary bundle in the Mexicanus is laid flat in the Christian fashion, but a native crown identifies this as the bundle of a native nobleman and may emphasize that he was the last member of the Tenochca royal lineage to control Mexico City's native government. The name sign that floats above refers to the alligator (*cipac-tli*) portion of his name. Falling at the binding of the page, the repeating image of Valderrama's name sign with descending footprints records his departure in this same year.

PAGE 85: 9 RABBIT (1566)–1 REED (1571)

Controversy engulfed New Spain over the next few years (Plate 43). The story begins in the Mexicanus in 9 Rabbit (1566) on the lower register. Shown in a dark ink, Don Martín Cortés is identified with his familiar "rain" name tag. He is placed over a shield and Spanish sword, a reference to the rebellion against the Spanish Crown that he was accused of instigating. Viceroy Velasco had died two years earlier, and in early 1566, the new viceroy had yet to arrive.[65] Seeing a power vacuum, Martín Cortés plotted to take control of New Spain. However, word about the coup escaped, and Don Martín, along with two of his co-conspirators, the brothers Alonso and Gil González de Avila, among many others, were arrested. The Avila brothers were tried first and executed that summer, beheaded in the central plaza (Flint 2008). The painter of the Mexicanus shows their severed heads with red added to highlight the blood. The Spaniard shown on the register above represents the arrival of the newest viceroy, Gastón de Peralta, who arrived later in 1566, after the brothers' execution but before the other conspirators, including Don Martín Cortés, were tried. Rather than try him in New Spain, Gastón de Peralta insisted that Martín Cortés return to Spain; thus his departure in the

next year, 10 Reed (1567).⁶⁶ Gastón de Peralta's handling of the punishments of Cortés and the other jailed conspirators was controversial, and he was ordered back to Spain in the next year. Accordingly, the arrival of the newest viceroy, Don Martín Enríquez, is recorded in the very next year above 11 Flint (1568).

Other events on this page are more mundane. A reference to the new judge, Francisco Jiménez, appointed to oversee the native sphere of government in Mexico City, was added in under 10 Reed (1567). He is shown with vara and crown, the conventionalized manner for judges. A shift, however, is that the Mexicanus contributor now shows a break in the native ruling line, as the previous ruler had died two years previously. This further stresses a breakdown in the native sphere of government, as the next ruler after this will also be marked as a judge rather than a noble gobernador.

An image of rain on the top register may record another torrential downpour that would have resulted in flooding, though no other sources mention a similar occurrence in this year. A fish floats above 11 Flint (1568), and a conquest is shown on the lower register, but the place conquered is largely effaced. Other sources are silent on these matters.

On the lower register in the next year, 12 House (1569), an image of a man walking on a long stream of blue water likely refers to the water control projects begun earlier by Viceroy Velasco. The revival of the Acuecuexco Aqueduct was nearing completion in 1569 (Mundy 2015, 191), which points to this imagery recording this construction. Although not entirely clear, the hieroglyphic compound next to the stream of water may be a place sign for Acuecuexco.

On the upper register at 12 House (1569), there is an intriguing image of a larger figure speaking to and blessing a smaller figure. Both

are dressed as friars and may refer to an uprising that happened in this year. The viceroy Montúfar, wishing to rein in the regular clergy, had sent secular clergy to say the Mass in the place of Franciscan friars. The native congregants reacted against this and stoned the secular clergy and a Spanish judge. The viceroy had to relent and restored the Franciscans to their posts (Gibson 1964, 110). By referencing the restoration of the Franciscans, the record conveys a sense of native agency and concern with the church's actions against the friars.

PAGE 86: 2 FLINT (1572)–11 HOUSE (1581)

The poor condition of the last painted page of the annals history makes much of its imagery difficult to interpret, which is compounded by the fact that many of the images are squeezed together in the first few years (Plate 44).

Indeed, a number of events are linked to the year 2 Flint (1572). The top register records the death of Bishop Montúfar, whose body lies horizontally and is covered with a shroud, though his head is exposed and topped by a bishop's miter. I suspect the associated name tag of something piercing blue water provides an approximation of his name. Some type of architectural compound is depicted toward the upper right over 4 Rabbit (1574), but it is linked by a line to 2 Flint. The Codex Aubin (58v) records the laying of the foundation for the shops of San Hipólito in this same year, and the Mexicanus imagery may reference the same event. Another event is shown on the lower register of 2 Flint (1572), where a funerary bundle is laid flat and associated with six disks; hence, it must record the death of Tenochtitlan's judge, Don Francisco Jiménez.

The inauguration of the next judge, so distinguished with his crown and vara, is shown just to the right under 3 House (1573). This is Don

Antonio Valeriano, who would have been the ruler of Mexico City's native sphere at the time the Mexicanus was created. By depicting him as a judge rather than a gobernador, the painter of the Mexicanus communicates that Valeriano was not a nobleman, and many other sources agree.[67] However, Castañeda de la Paz (2011, 9–10) has shown that Valeriano was indeed noble, though not from Tenochtitlan. Thus, it is likely that these sources were emphasizing that Valeriano was not of the Tenochca royal lineage. He was also exceedingly well educated. He received his schooling at the Colegio de Santa Cruz at Tlatelolco and even worked with Sahagún on the Florentine Codex.

Another event related to water, clearly an overwhelming concern for Tenochtitlan before and after the conquest, is included for 3 House (1573). On the lower register, a stream of water extends down from the timeline and ends at an image that includes a hill sign and something red at its top. Although the poor condition of the image at the bottom of the page makes it difficult to read, based on the date and relation to water, it likely concerns the disastrous outcome of the other water control project initiated by Viceroy Velasco, the Santa Fe Aqueduct. In 1573, it was discovered that the aqueduct was so poorly constructed that water was overflowing from its proper course (Mundy 2015, 198). The Mexicanus imagery likely depicts the overflowing stream of water, which the Codex Aubin (58r) also mentions, though for the previous year.

A two-story building is shown just above 4 Rabbit (1575), but it is joined to 3 House by a line that also extends up to a praying figure at the top of the page. A hieroglyphic compound—of a stone (te-tl) and a frog (cueya-tl)—is placed just next to the building. Whether and how these images relate and what their larger significance is remain unclear.

Another hieroglyphic compound is linked to 4 Rabbit (1575) on the lower register and includes a circular device (perhaps a shield or a coin) and a banner (pan-tli). This compound is just next to the head of a mendicant, suggesting it may act as his name tag, though the ink used for the two is quite distinct, making the exact meaning of these images elusive. The identity of a figure on the upper register that is linked to both 4 Rabbit (1574) and 5 Reed (1575) is easier to establish. This figure is dressed in the garb of a victim of the Inquisition, highlighted by the tall cap and arms bound at the waist.[68] The Inquisition had been established in 1571 in New Spain, brought by its new bishop, Pedro Moya de Contreras, though he is not pictured in the Mexicanus. The Codex Aubin (59r) also includes a reference, both pictorial and alphabetic, to the Inquisition in 1574. The alphabetic text in the Aubin indicates that the inquisitor disclosed the different sins at this time.

A Chapultepec place sign is also linked to 5 Reed, and yet again it refers to a water control project, this time instigated by the native ruler, Antonio Valeriano, who proposed the building of an aqueduct to bring more water from Chapultepec into Mexico City. Surprisingly, but begrudgingly, the Spanish cabildo agreed to fund some of the costs, and the project was approved (Mundy 2015, 199).

The link between water issues and sickness is seen in the Mexicanus in the very next year. The pictorial portion of the annals history ends with references to the difficulties of Mexico City's native citizens. First, a strange shape floats above 6 Flint (1576); this may record a comet that is also noted in the Anales de Tecamachalco (1992, 75). Next a skull linked to both 6 Flint (1576) and 7 House (1577) refers to the massive epidemic that struck New Spain in these years and particularly devastated the native populations. The word cocoliztli, sickness, on the

register below also points to the epidemic. Two astrological events must have happened later in 1577, one included a star in the night sky. The other was a smoking star that Chimalpahin Cuauhtlehuanitzin (1998, 2: 247) and the Codex Aubin (60v) also record. A hieroglyphic compound of a flesh-colored hand (*ma-itl*) and water (a-tl) above 8 Rabbit (1578) may reference a famine, as suggested by the associated alphabetic annotation that reads, *mayanalloc*, or "there was hunger." This would also make sense given the devastation experienced in the previous years due to the epidemic.

A final event noted by the Mexicanus painter is the arrival of the latest viceroy, Don Lorenzo Suárez de Mendoza. His name tag calls to mind the beginning of the Mexicanus, as it includes the grill used to record St. Lorenzo; here it is used to elicit the name, not the saint, and the painter adds a bird, perhaps for *don*. I suspect the small image of a funerary bundle, drawn in red ink, was added by a later contributor, as was the next page of historical events, which is written on page 87; there the timeline is written in an abbreviated fashion and only one historical event is noted, and this time with alphabetic text. Under 13 Reed (1583) is witten, "ypan mic don loreço co te visorey," or "here he died don Lorenzo, viceroy." And with that rather anticlimactic message, the Mexicanus annals history comes to a close.

COLONIAL HISTORY DISCUSSION

Ultimately, ambivalence marks the Mexicanus' colonial history, especially in regard to the link between Mexica nobility and Tenochtitlan/Mexico City. Early on, the Mexicanus' colonial history emphasized continued rule by the Tenochca royal lineage, even modifying the dates of some rulers' reigns to stress continuity. As in the imperial history, the contributors consistently showed the death of one ruler immediately followed by the succession of another. However, the breakdown of this system is suggested by the interregnum between the death of Tehuetzquititzin and the accession of a new judge, Don Esteban de Guzmán, which points to an eroding of Mexica power. This is all the more apparent because the painter included the new judge's Xochimilco place sign, thereby emphasizing that he was not a Tenochca native. Although Guzmán's rule was followed by two gobernadores from Tenochtitlan's royal dynasty, the final two rulers of the city were marked as judges, revealing that as the sixteenth century came to a close, rule over the city was completely out of the hands of the Tenochca royal line. This concern with the noble line of Tenochtitlan speaks also to the genealogy that preceded the annals history. Although the Mexicanus' history records nonnoble judges maneuvering into positions of power over Tenochtitlan, they had no place in its genealogy.

Nevertheless, the Mexicanus makes it clear that the Spanish ruling sphere did not supersede the native one. For example, members of Spain's ruling hierarchy are included in the Mexicanus alongside native rulers. By referencing both spheres of government, the Mexicanus suggests that the leadership of Mexico City was a joint Mexica-Spanish undertaking. Thus, the Mexicanus does not show Spaniards replacing native leaders but working with them, separate and unequal perhaps, but still important to the history of New Spain.

Military control also seems to have been viewed as a shared mission, as succinctly communicated with the new conquest icon of a shield over an Aztec obsidian club and a Spanish sword. However, by 1541, the Mexicanus no longer includes the obsidian club, suggesting the Mexica integration into the Spanish military. Colonial-era conquests also highlight the

rebellious nature of other territories in contrast to the Mexica. Although the Mexicanus shows that the Tenochca-Mexica were militarily conquered, it also shows that they soon accepted Spanish rule and alliance. Indeed, the cause of Cuauhtemoc's death goes without mention in the Mexicanus, perhaps so that his presumed rebellion could also go unmentioned.

Of course, the Mexicanus' colonial history also focuses on the spread of Christianity. One of the first scenes after the conquest includes a friar alongside Cortés, suggesting the conquest was undertaken for both religious and secular purposes. Other references to Christianity are subtler, communicated by the comings and goings of church officials and the construction of religious buildings, and also through the acceptance of Christian traditions, such as the sacrament of marriage and the new funerary custom of laying the deceased flat rather than seated. Although the exact significance behind the image of two friars in 1569 is not entirely secure, if it does relate to a native rebellion in response to secular clergy replacing friars, then the Mexicanus also stresses a sense of native agency over their religious practices, which is reiterated in the very creation of the Mexicanus itself.

The hardships that the people of Tenochtitlan had to endure before the Spanish arrival continued into the colonial period. Christian New Spain was by no means a peaceful paradise, as evidenced by continued earthquakes and crop devastations, as well as droughts, famine, and water control issues. And of course, the relentless and devastating epidemics of the colonial period saw no equal in the preconquest past. Moreover, the imposition of new forms of tribute reveals a breaking point in the Mexicanus, a time when the native peoples rose against the Spanish economic system. Although the native peoples may not have been successful

in advancing change, the Mexicanus makes it clear that they were not passive. Indeed, another sign of native agency is the documentation of a contrast between present-day privations and past glories. This same strategy is seen in other native histories, such as the Tira de Tepechpan (Diel 2008), and current hardships were often cited in viceregal legal documents to petition for decreases in tribute payments or access to lands. Although there is no evidence that the Mexicanus was created for legal purposes, it certainly could have been put to such use if necessary.

Nevertheless, a distinctive feature of the Mexicanus' colonial history is the lack of legal references, especially in relation to landholdings. Mexico City was split between Nahuas and Spaniards, who were continually encroaching on native lands, and a number of documents were commissioned by native patrons to argue against such usurpation. For example, the Plano en Papel de Maguey and the Beinecke Map reference the native leaders of colonial-era Tenochtitlan in order to document their ties to land in and around Mexico City, and the *Libro de Tributos de San Pablo* shows the tribute obligations of native residents of this barrio, likely the same one in which the Mexicanus was created.[69] Thus, the Mexicanus history, indeed the Codex Mexicanus as a whole, stands out for its lack of a clear legal purpose.

Annals History Conclusions

The extensive annals history in the Mexicanus presents a grand narrative of the Mexica people, from their humble beginnings as they left Aztlan in search of a new homeland, to their settlement at Tenochtitlan and expansion into an imperial power. Their conquest by the Spaniards opened a new chapter in this history, one

in which their city transformed into New Spain, a Christian capital controlled jointly by Mexica and Spaniards. Although still recorded in the pictorial system of the Aztecs, the annals history transformed from a Mexica one tied to the Aztec empire to a Christian one tied to the Spanish empire, and just as Aztec history was linked with the sacred world, Spanish history was linked with its Christian mission. As Enrique Florescano (1994, 77) writes, "The Christian idea of history also supported the imperial expansion of Spanish power, infusing it with a providentialistic and messianic sense." That is, from the Spanish perspective, the conquest and evangelization of the New World fulfilled Christian history, and from the native perspective, if the conquest of Tenochtitlan were a part of God's plan intended to bring the native peoples to Christianity, then Mexica history must have been a part of this plan as well.

Thus, the contributors to the Mexicanus looked to their past in order to make sense of their place in the history of Christianity. In doing so, they were not alone. Diana Magaloni-Kerpel (2003, 218) noted a similar pattern in her study of the conquest images in the Florentine Codex, arguing that biblical exegesis shaped the images and story of the conquest, so that the biblical stories foretold the conquest, making it divinely ordained. As she wrote, "These associations show that the learned Christianized Nahua were familiar with the reading of the Old Testament as a prefiguration of the Christian era, and that they saw themselves as part of that sacred history." A similar phenomenon is seen in the testimonies that native rulers wrote in collaboration with Franciscan friars about the Aztec past; Peter Villella's (2016, 98) description of these testimonies applies equally well to the Mexicanus' historical narrative:

The result was a unique marriage of mendicant millennialism and Mesoamerican memory, in which the Aztec epic was revealed as America's Old Testament, rich with portents and omens heralding an inevitable Christian future. If the early natural lords alluded to an ideal of political continuity between Anahuac and New Spain, the Franciscans and the ladino caciques envisioned a spiritual continuity: Like St. Augustine's conception of ancient Rome, the Mexica Empire was a means by which God had prepared for the spread of the gospel in America.

This same sense of an epic Aztec history that prefigured the arrival of Christianity is seen in the Mexicanus. Moreover, St. Augustine's ideas would have been familiar to the Mexicanus' contributors, steeped as they were in the Christian world. For example, the Spanish friar Gerónimo de Mendieta (1945) wrote a history of the church in New Spain in the late sixteenth century. One of the arguments that percolates throughout his work is that Europe had become corrupt and it was up to the friars and Nahuas to work together to create a new home for Christianity, a City of God for the New World (Phelan 1970, 77).

Indeed, the teachings of St. Augustine would have had a special resonance for Nahua Christians, especially those living in the later sixteenth century, when the conquest was fading into historical memory and when the colony was reeling from epidemics and natural disasters. St. Augustine's *The City of God* offered an ideal model to make sense of Tenochtitlan's current condition. The work was written soon after the sack of Rome and in response to Romans questioning their Christian faith and asking if they were being punished by their ancient gods for

abandoning them and accepting Christianity. The sack of Rome was echoed in Tenochtitlan's destruction during the conquest, while the calamities that befell the fifth-century Romans were surely comparable to the devastations experienced by sixteenth-century Nahuas, especially the massive epidemic that ravaged the native population just before the *Mexicanus* was written. It would only have been logical for the epidemic's survivors to follow the Roman Christians and question whether these devastations were brought by their ancient gods as punishment for forsaking them and accepting Christianity. In *The City of God*, St. Augustine's larger argument was that no matter how devastated an earthly city might be, the City of God, the church, would be triumphant and eternal (Florescano 1994, 72).

The proofs brought forth by St. Augustine find resonance in Tenochtitlan's preconquest history and clarify one of the distinctive features of the *Mexicanus*' annals history, its focus on natural disasters during Tenochtitlan's imperial period. In Book 3 of his work, St. Augustine (2014, 1: 269) used the many disasters that marked the ancient Roman world as proof of the inefficacy of the ancient gods. These calamities included wars, famines, floods, swarms of locusts, and volcano eruptions (O'Daly 1999, 88). The *Mexicanus* records these same devastations in Tenochtitlan's own past, and like their Roman counterparts, the ancient Aztec gods were unable to avert these. Indeed, the string of disasters that struck Tenochtitlan immediately after Ahuitzotl's Templo Mayor dedication, when the gods should have been the most satisfied with the offerings presented to them, suggests the ineffectiveness of the pagan gods. Moreover, the one direct reference to a supernatural in the imperial history is the inclusion of a tzitzimitl devouring a human soon before

the Spanish arrival. This image underscores the malevolent nature of the pagan gods and their coming battle with the one true God.[70]

St. Augustine's points about the power and duration of the Roman empire also apply well to Tenochtitlan. In Books 4 and 5, St. Augustine explained how the Roman empire could flourish for so long and over such a vast territory despite being marked by pagan worship. His argument, in brief, was that God caused the empire to flourish, though its fall was inevitable because it lacked moral justice (O'Daly 1999, 94). The same could be said of Tenochtitlan's long history and imperial grandeur; it was permitted by God but, like Rome, lacked moral justice until the arrival of Christianity. Also like ancient Rome, it would regrow and continue to endure as a Christian nation. Thus, the *Mexicanus*' inclusion of Tenochtitlan's epic history makes sense, as its very existence, power, and endurance revealed its key place in God's plan.

Also a part of God's plan would have been the suffering of present-day Christians, which is also emphasized in the *Mexicanus*' colonial history and which St. Augustine (2014, 1: 211) linked with salvation:

> Christ's servants, whether they be kings or princes or judges, soldiers or provincials, rich or poor, bond or free, without regard to sex, are bidden to suffer the burden of this republic, wicked and most vicious though it be, if so it must be, and also by so suffering to gain a place of highest honour for themselves in that certain most holy and august assembly of angels in the heavenly republic where God's will is law.

Indeed, Nahua Christians could not help but correlate increased suffering and mortality with the arrival of the Spaniards and Christianity, but

the new religion offered a means of understanding and accepting this suffering; for a believer, the result was eternal salvation (Cervantes 1994, 44). Moreover, as Fernando Cervantes (1994, 62) has argued, Christianity offered Nahua Christians a means of remedying their suffering through an emphasis on particular facets of the new religion, such as the cult of saints and miracles. The Mexicanus, of course, emphasizes the cult of saints in the calendar that begins the codex, but it also records a miracle that, not coincidentally, immediately follows the annals history.

The annals history appears to end with a whimper rather than a bang, but upon turning the final page, one encounters the miraculous vision that marks New Spain as a Christian nation. The image of a native convert receiving a vision of Christ was discussed in the introduction to this book, but it is important to reconsider this image in relation to its placement at the end of the annals history.[71] In the painting, a native convert receives a vision of Satan taunting a starving Christ to turn stones into bread. The miraculous vision clearly happens in the New World. The stones Satan holds are depicted as the Aztec icons for stones, which places him in the Aztec world. Meanwhile, the witness is a native convert who has accepted Spanish ways; he is dressed in the traditional mantle but now with a Spanish shirt and pants underneath. Though he sees as a Nahua, as shown by the schematized eyes that are also drawn from

Aztec pictorial tradition, he prays as a Christian. Moreover, the suffering of Christ witnessed by the native convert mimics the devastations endured by contemporary Nahua Christians, and like Christ, they will find salvation in the afterlife. In his history of the church in New Spain, Mendieta (1945, 3: 105–109) lists a number of visions received by native converts; he says these were sent by God to communicate with the indigenes, which suggests God's blessing of New Spain and its native converts. The vision in the Mexicanus can be interpreted in the same way.

In short, through the transformation of Tenochtitlan into a Christian capital, the Mexica peoples became key figures in Christian history and earned a path to salvation. Their conversion hastened the religious unification of the world under the Spanish crown, which in turn would bring the Final Judgment (Florescano 1994, 72). In this regard, the Mexicanus' annals history makes sense in terms of the codex as a whole, as it ultimately explains Tenochtitlan's role in Christian history. Accordingly, the Mexica migration could be reinterpreted through the story of exodus in the Old Testament, the imperial Tenochtitlan could be seen as an equal of the ancient Rome of the New Testament, and New Spain could be envisioned as an equal of contemporary Rome, a City of God for the New World, much as Rome was the City of God for the Old World.

Conclusions and an Epilogue

The contributors to the Mexicanus took from Spanish books information that they considered vital to know and combined this with records from their own books that were necessary to remember. In so doing, they created a guide for living as Nahua Christians in late sixteenth-century New Spain and beyond. Though the *Reportorios de los tiempos* and their function as guides to living were a likely inspiration for the Codex Mexicanus as a whole,

as Tavárez (2011, 139) has argued, it is unlikely that the native intellectuals who borrowed from the *Reportorios* were "replicating the encoded cultural assumptions" of the Reportorio genre, nor were they simply transferring contents from a Spanish book to a Nahua one. Instead, like the Nahua who inserted astrological texts into his copy of Gante's *Doctrina christiana*, these native intellectuals were compiling a book filled with information important to their own lives. In the

case of the Mexicanus, its contributors left a record of issues that must have been of intense concern in late sixteenth-century New Spain; these spanned time and religion, astrology and medicine, lineage and history—all topics that generally appear in Spanish Reportorios as well as Aztec books.

The focus on the Christian sacred calendar at the beginning of the Mexicanus (pages 1–9) reflects the dominance of the Christian calendar

in New Spain and the natives' acceptance of Christianity. At the same time, the correlations of the Aztec monthly feasts with the Christian calendar (pages 1–8) and the inclusion of multiple references to the *tonalpohualli* (pages 13–14 and 89–102) speak to the continued importance of the native calendar for the Nahuas. The imposition of the Christian religion and means of tracking time did not result in the destruction of the native calendar but its adaptation and incorporation into a New Spanish one, marked by its own sacred days connected with New Spain. The hybrid calendar recorded in the Mexicanus is evocative of Spain's own calendar, and just as Spain's Christian calendar had its foundation in the pagan Roman past, New Spain's Christian calendar had its foundation in the pagan Aztec past. Indeed, the very existence of the Aztec calendar evidences the intellect of the native peoples and the achievements of their past. At the same time, the inclusion of these calendric records in the Mexicanus provided religious autonomy for its Nahua Christian owners, which would have been especially important given the religious tensions marking the colony at the time the codex was created.

Also fitting for the times in which the Mexicanus was produced is its focus on medicine. A massive epidemic had devastated the native population of Mexico City in the years just before the Mexicanus' creation. Accordingly, a contributor to the Mexicanus included a three-page section (pages 10–12, Plates 6 and 7) devoted to European medical astrology and likely drawn from a Reportorio, much like the perpetual calendar that began the Mexicanus. This section on medical astrology would also have contributed to a sense of autonomy for the Mexicanus' owners, who could consult their book for information on healing practices in the event of future illnesses. Moreover, the interest in astrology and its influence on human affairs,

as also seen in the insertion of the alphabetic text explaining the signs of the zodiac (pages 24–34, Plates 13–19), was likely of interest to Nahua intellectuals because these beliefs were similar to native traditions, hence the necessity to include this information in the Mexicanus.

The Mexicanus' two-page genealogy (pages 16 and 17, Plate 9) of the Tenochca ruling house also finds a counterpart in the later Reportorios that include kings' lists. These linked contemporary rulers of Spain to the biblical and Roman past, and likewise, the Mexicanus genealogy connects the colonial descendants of the Mexica ruling lineage to the pagan past. It also highlights the purity of the Tenochca ruling line and in so doing rebukes outsiders who were infiltrating the upper echelons of the native ruling sphere, such as Antonio Valeriano, who was the governor of Mexico City's native cabildo at the time the Mexicanus was produced. Although he may have been born of noble blood, the Mexicanus annals history marks Valeriano as a nonnoble judge rather than a governor, highlighting the fact that he was not of pure Tenochca nobility. Created when the descendants of the Mexica ruling lineage had lost access to power, the Mexicanus genealogy stresses the integrity and high status of this royal line.

The majority of the Mexicanus, however, is focused on the epic history of the Mexica people. While drawn from the Mexica historic tradition, the annals history recorded in the Mexicanus was necessarily reconceptualized in light of present circumstances. That is, the painters of the Mexicanus' history looked to the past to explain how the Mexica peoples became Christian peoples and how Aztec Tenochtitlan transformed into Christian New Spain. The Mexicanus' migration account finds parallels in other stories of the migration found in colonial sources, but it also highlights similarities between the Mexica migrants and their Old Testament counterparts.

Likewise, upon the foundation of Tenochtitlan, the Mexicanus annals follows other Aztec histories by recording the growth and glory of the empire, but it diverges from these by also showing how Tenochtitlan was continually ravaged by natural disasters that the pagan gods could not avert. The omens that the Mexicanus shows preceding the Spanish arrival communicate that the pagan gods were destined to be replaced by the one true God and that Tenochtitlan was destined to become a Christian capital, making the Mexica peoples key figures in Christian history, as they played a key role in transforming Tenochtitlan into a City of God for the New World. In this way, yet again, the Mexicanus mimics the contents of the Reportorios that also came to include historical records, reflecting a belief that knowledge of the past was necessary for understanding life in the present.

Although the contents of the Codex Mexicanus find correlations with the Reportorios, the similarities are not complete. The Reportorios contain a wealth of information on topics left unaddressed by the compilers of the Mexicanus, such as lunar charts, navigational charts, eclipse tables, and treatises on the heavens and the planets, among others. Moreover, the Mexicanus includes some material without clear corollaries to the Reportorios, such as the image of a miraculous vision and the pictorial catechism, which comment on the piety of the Mexicanus' owners despite the book's pagan references. The Mexicanus' creators may have been using a Spanish book as a model, but they did so for their own purposes, reconceptualizing the Reportorio as a book fitting for a native audience seeking to gain control in late sixteenth-century New Spain. Ultimately, this book was not a random assortment of miscellaneous material, but a curated guide filled with information drawn from the Spanish and Aztec worlds and instructive for life in colonial New Spain.

Through this book, the compilers of the Mexicanus were also crafting a vision and identity for themselves as Nahua Christians of New Spain, and the model they followed was that of Spain, whose own Christian identity was based on a pagan Roman foundation. David Lupher (2006) has shown that ancient Rome was a useful model for the Spanish project in the Americas; and for educated Nahua elites, the connections between Spain and New Spain would have been impossible to miss, as would the similarities between the ancient Roman and Aztec empires.[1] Indeed, one need only consider the Mexicanus' saints' calendar and annals history to see parallels between Spain's Roman foundation and New Spain's Aztec one. Moreover, the Mexicanus' references to the Aztec past would not necessarily have been antithetical to the Christian present. As Serge Gruzinski (2002, 100) has argued, "Like Europeans, literate Amerindians could legitimately feel that their pagan past was more than a pre-Christian era or period of demonic darkness. . . . The cult of classical antiquity showed that an indisputably pagan past could enjoy glamorous status and value." Thus, the Mexicanus pictures the Aztec past as a necessary step in the formation of Christian New Spain, and the Mexica people as key players in the history of Christianity.

Nevertheless, the book was made at a difficult moment: in the aftermath of a devastating epidemic, a time when the Spanish Crown was demanding ever-greater tribute payments of its colonial subjects, when the Mexica noble line that had controlled the city for almost two hundred years had lost its hold over the native sphere of government, when Spaniards were not only doubting the acceptance of Christianity by Nahua converts but also questioning their intellectual capacities and denying them the priesthood, when the native peoples themselves must have been questioning their Christian faith. In

sum, it was made during a time of "trauma and transition," to borrow Frances Berdan's (1993) characterization of sixteenth-century Mexico. Accordingly, the creation of the Codex Mexicanus must have been undertaken as an act of empowerment and salvation. Through this book, its readers could witness the strength of the Aztec pictorial system of writing, capable of recording information pertaining to the Nahua and Christian worlds and a sign of rational thinking. They could worship without guidance or interference from Spaniards. They could heal people through a record and understanding of European medical practices. They could see signs of the ingenuity of the Mexica peoples, evidenced by their complicated calendrical system and engineering projects that continued to be vital into the colonial era. They could understand the antiquity and integrity of the Mexica bloodline and the greatness of Tenochtitlan as it transformed from a prestigious Aztec past to a devout Christian present. They could remember a miraculous vision received by a native convert, a vision that would have marked New Spain as the home of the Christian faith and Nahuas as true Christians. In short, the Mexicanus would have stood as a testament to the Mexica peoples' civility and their essential place in the history of Christianity. Through this book they could have gained control over an unstable world that was increasingly threatening their way of life and autonomy. Similar in function to the ancient books of the Aztecs and modeled after the Reportorios of the Spaniards, the Codex Mexicanus would have guided the way for its beleaguered Nahua readers and helped them to understand their identity as Nahua Christians of New Spain, proud descendants of the great Mexica of Tenochtitlan.

Epilogue

The Codex Mexicanus likely remained in native hands for almost two hundred years, during which time it continued to be read, consulted, notated, and updated, as evidenced by the contents of the manuscript itself and also by the wear seen at the edges of its pages, testimony to numerous hands thumbing through its contents over time. Indeed, one can easily imagine members of the community consulting the owners of the book, still considered as *tlamatinime* and guiding community members on a variety of matters, from medical practices to religious celebrations to historical affairs. The Mexicanus may even have been accessible to native historians and to sympathetic Spanish friars who wrote their own histories of the Aztec past, as their accounts, referenced throughout this study, share many similarities with the Codex Mexicanus. Nevertheless, the small book was likely guarded and kept from those Spaniards who were suspicious of the Nahuas. Tavárez classifies the Mexicanus and other similar Nahua texts as clandestine documents, while the Books of Chilam Balam, which have contents similar to the Mexicanus, include admonitions to keep the books away from Spaniards (Farriss 1987, 580–581; Tavárez 2011, 132–139). Hanks (2010, 362) refers to these Maya books as "forbidden discourse," and one can imagine the Mexicanus being similarly guarded from those hostile to the Nahuas and doubtful of their intellectual capacities.

The Codex Mexicanus was likely maintained by its native owners until sometime in the eighteenth century, when a strange inscription, written in Nahuatl, was added to the manuscript, perhaps by one of its final owners as an act of prayer offered to the book before its departure

Color Plates

PLATE 1 May, page 1. Courtesy of the Bibliothèque nationale de France.

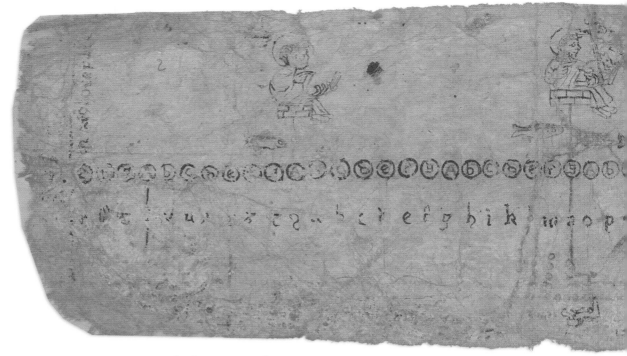

PLATE 2 June and July, pages 2 and 3. Courtesy of the Bibliothèque nationale de France.

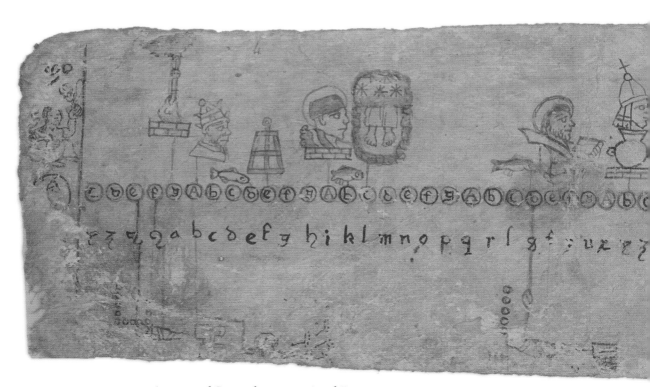

PLATE 3 August and September, pages 4 and 5. Courtesy of the Bibliothèque nationale de France.

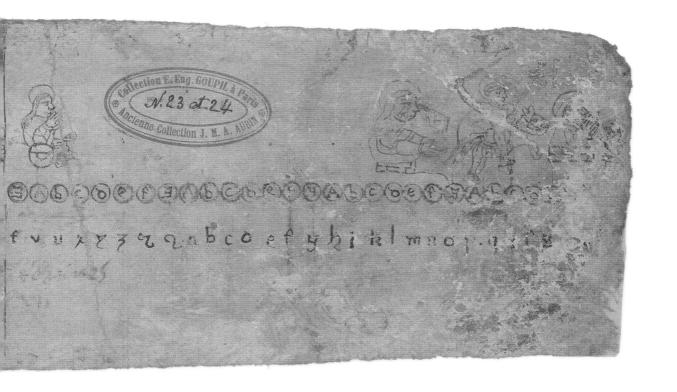

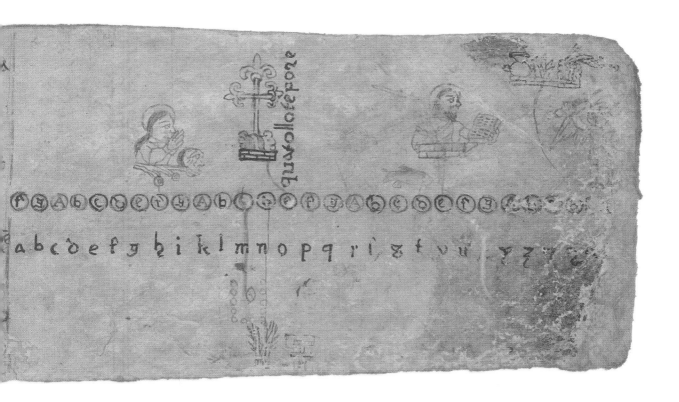

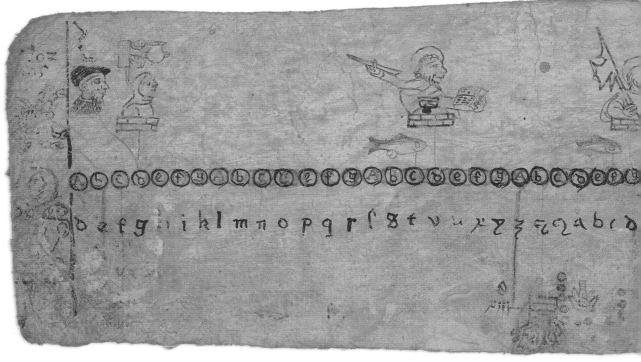

PLATE 4 October and November, pages 6 and 7.
Courtesy of the Bibliothèque nationale de France.

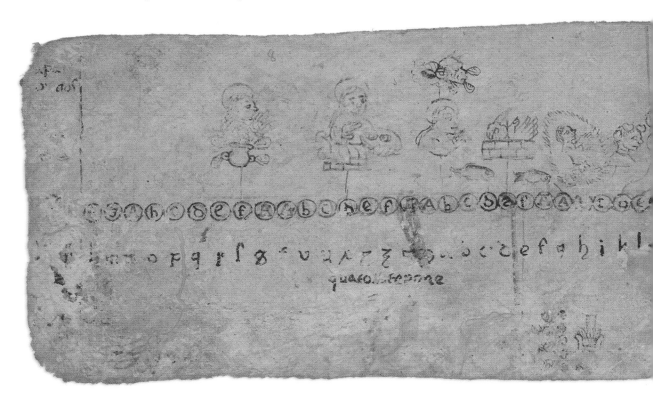

PLATE 5 December and Calendar Wheels, pages 8 and 9.
Courtesy of the Bibliothèque nationale de France.

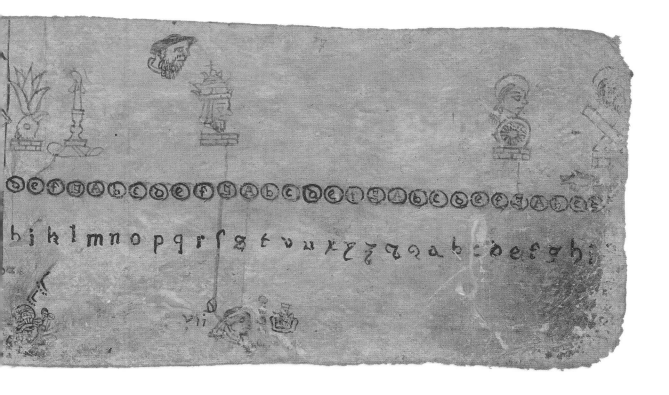

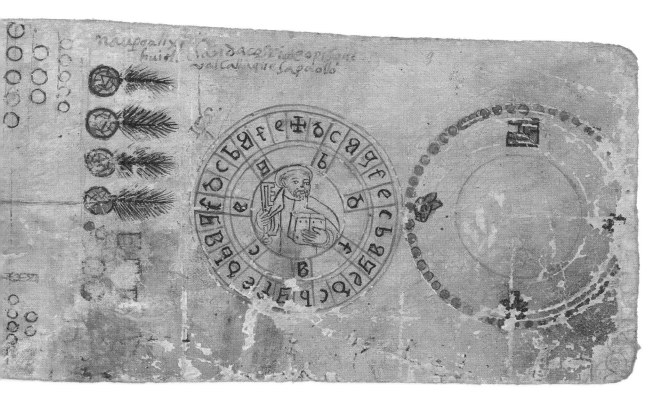

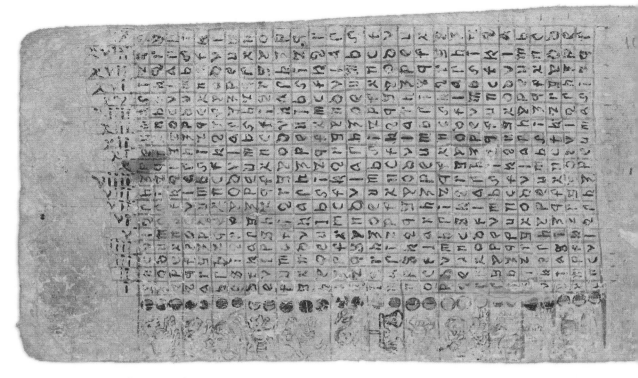

PLATE 6 Lunar Chart and Zodiac Chart, pages 10 and 11.
Courtesy of the Bibliothèque nationale de France.

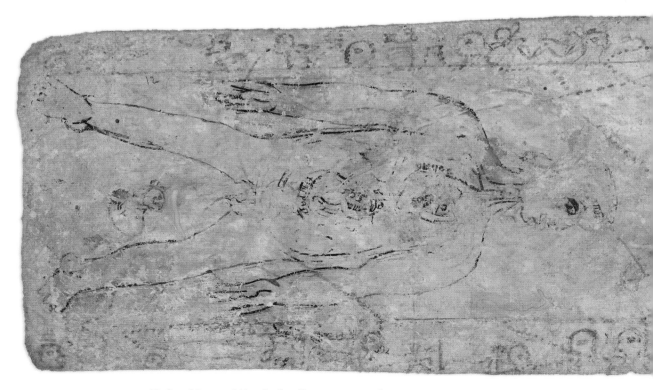

PLATE 7 Zodiac Man and *Tonalpohualli*, pages 12 and 13.
Courtesy of the Bibliothèque nationale de France.

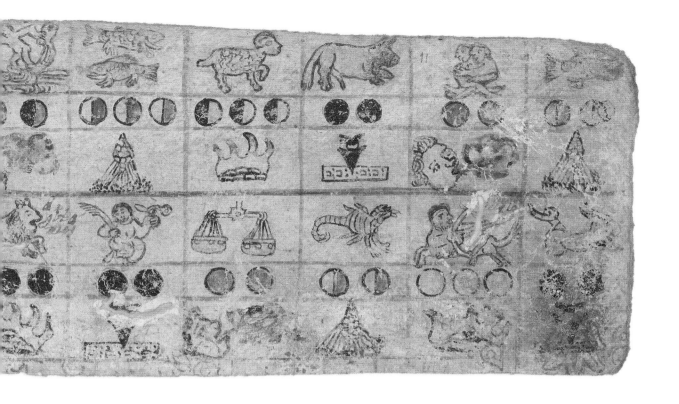

Ytzcuitli	acomatli	malli nalli	acatl miquiztli	ocelotl	quauh tli	cozca quauh	olli		tecpa
2	3	4	5	6	7	8	9	10	11
tzipac tli	hecatli	calli	cuetzpalli	covatl	miquiz	maça	tochtli	atli	ytz cuitli
13	1	2	3	4	5	6	7	8	9
nalina tli	acatl vei miça atl	ocelotl	quauh	cozca quauh	olli	tecpa vii	quiza	xochitl	tzipac
12	12	13	1	2	3	4	5	6	7
culli p vii	cuetzi	covatl	miquiz	maça	tochtli	atli	ytz tli	ocoma	nalli
	10	11	12	13	13		2	3	4
ocelotl	quauh	cozca quauh	olli	tecpa	quiavi	xochitl	tzipac tli	hecatli	
7	8	9	10	11	12	13	1		
covatl	miquiz	maça	tochtli	atli	tzipac tli	ocoma	nalli		
5	6	7	8	9	10	11	12		

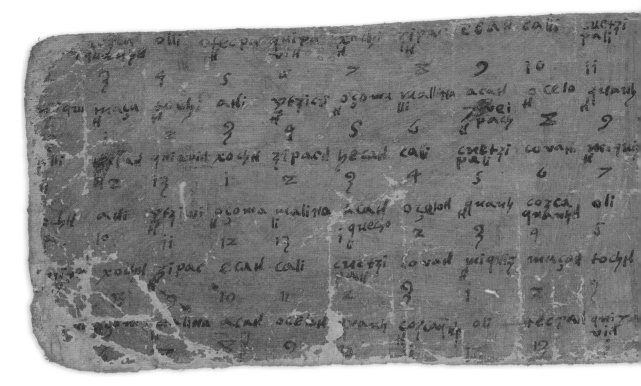

PLATE 8 *Tonalpohualli* and Calendrical Calculations, pages 14 and 15.
Courtesy of the Bibliothèque nationale de France.

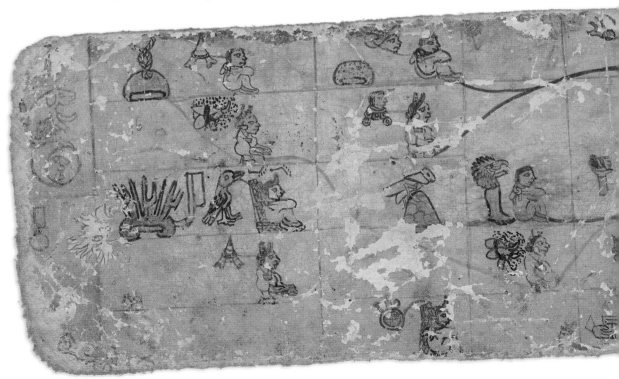

PLATE 9 Genealogy of the Tenochca Royal Dynasty, pages 16 and 17.
Courtesy of the Bibliothèque nationale de France.

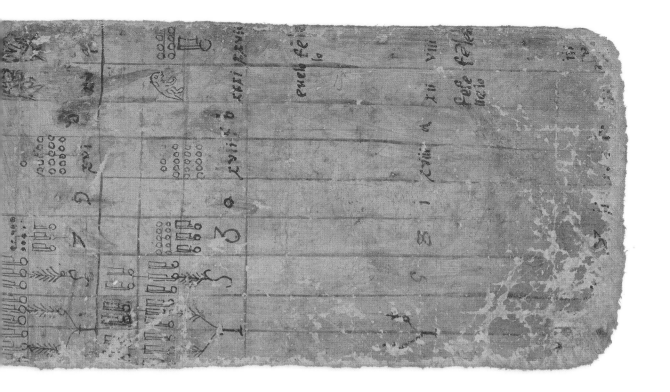

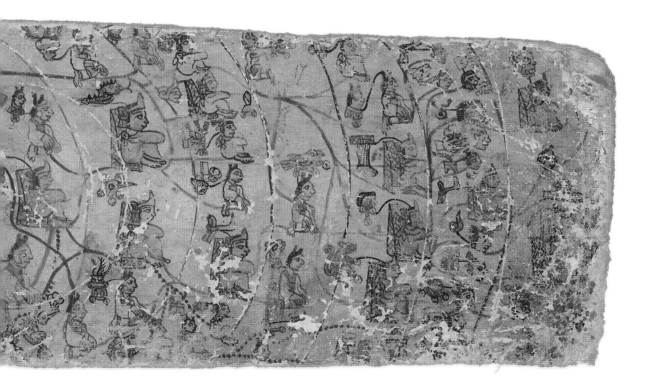

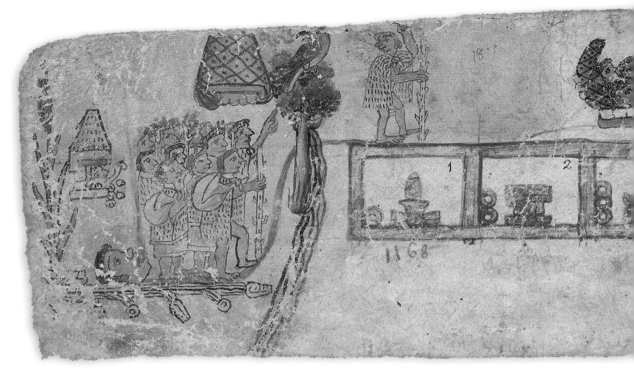

PLATE 10 Historic events from 1 Flint (1168) through 9 Flint (1176), pages 18 and 19. Courtesy of the Bibliothèque nationale de France.

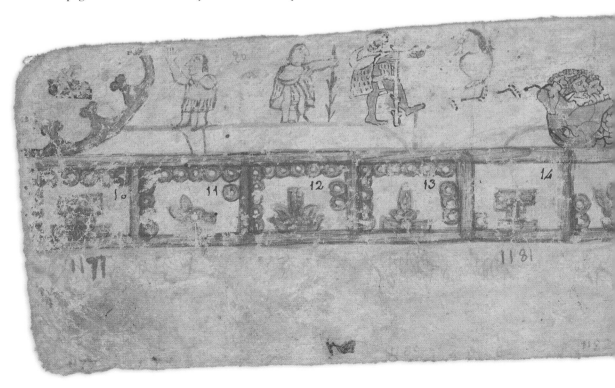

PLATE 11 Historic events from 10 House (1177) through 8 Flint (1188), pages 20 and 21. Courtesy of the Bibliothèque nationale de France.

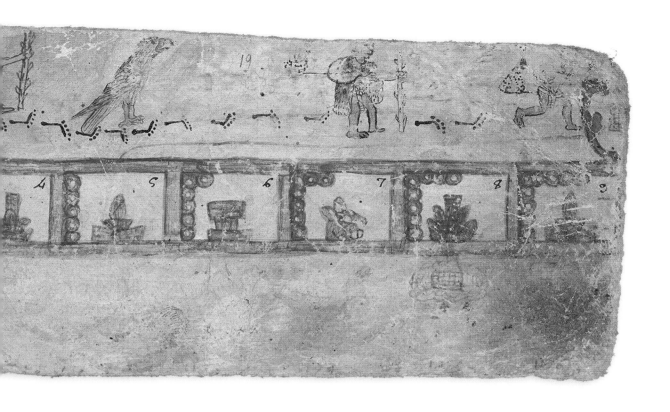

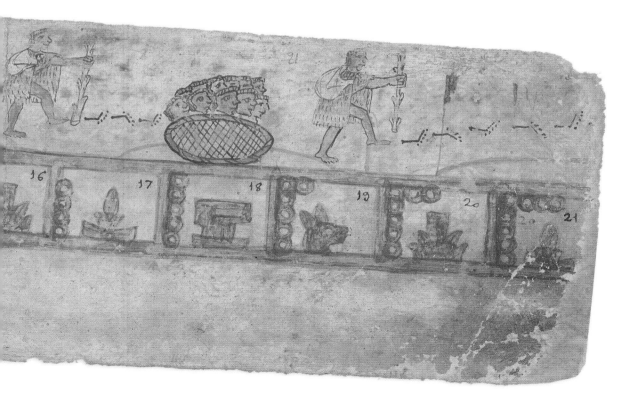

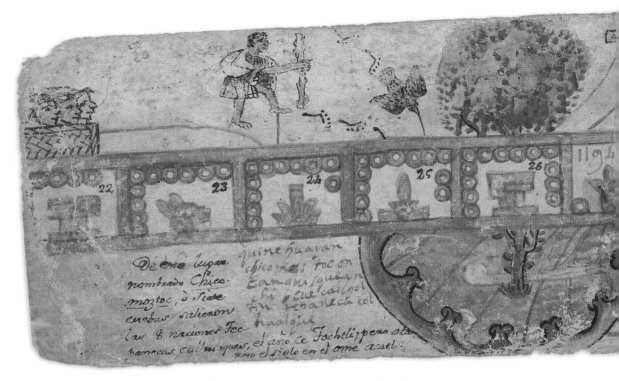

PLATE 12 Historic events from 9 House (1189) through 7 Flint (1200), pages 22 and 23. Courtesy of the Bibliothèque nationale de France.

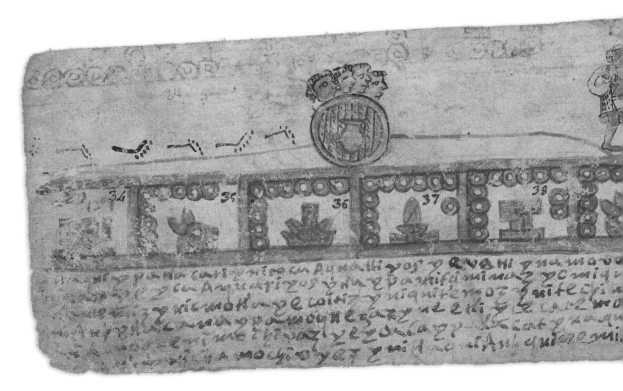

PLATE 13 Historic events from 8 House (1201) through 6 Flint (1212), pages 24 and 25. Courtesy of the Bibliothèque nationale de France.

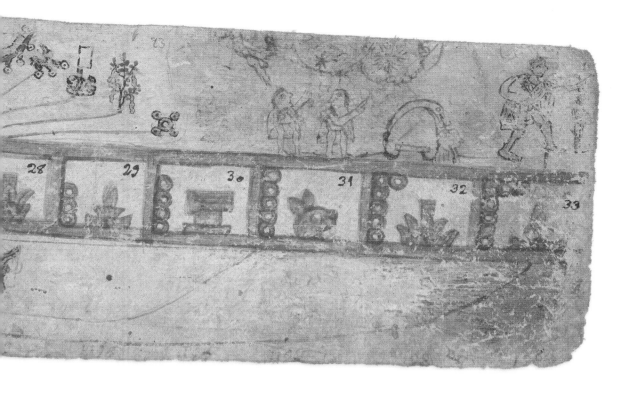

28 29 3o 31 32 33

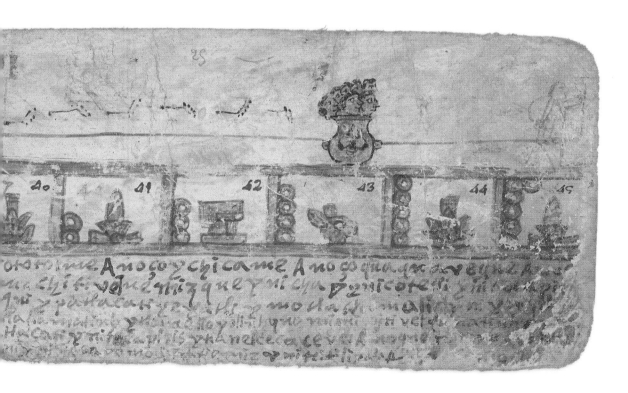

4o 41 42 43 44 45

Amocoychicame Amocoquaqui xvequiza
chi ven muzquey nicho Bonicoteni y
qui ypatacas ye ke amodademalidan y
ha te malih y ela elloyllih que mune yn velch
Hacan y niten phih vn nencecaccuel nopmi
no mo raheanne y nipien lijolla

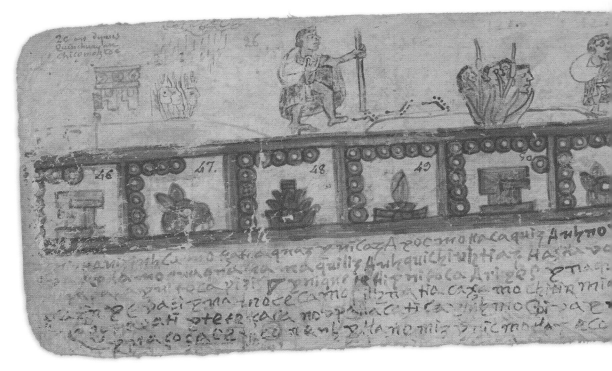

PLATE 14 Historic events from 7 House (1213) through 5 Flint (1224),
pages 26 and 27. Courtesy of the Bibliothèque nationale de France.

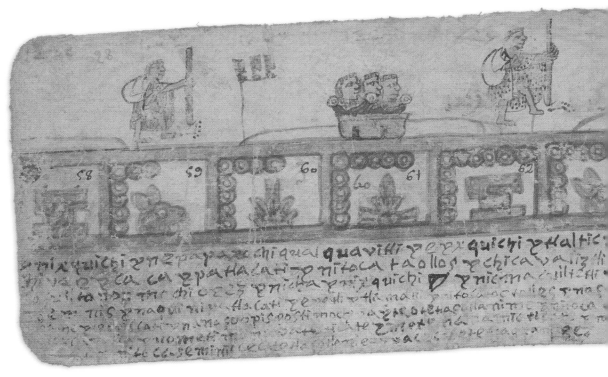

PLATE 15 Historic events from 6 House (1225) through 4 Flint (1236),
pages 28 and 29. Courtesy of the Bibliothèque nationale de France.

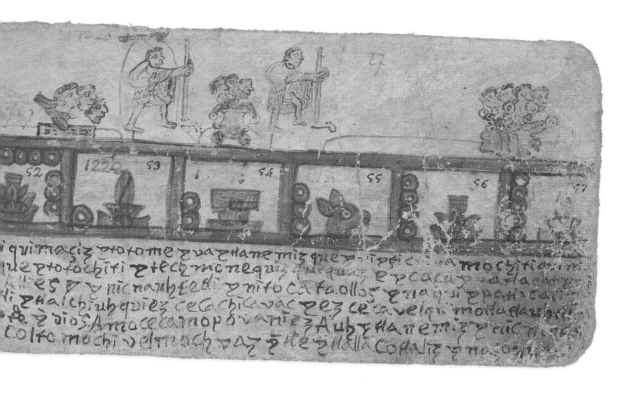

qui maciz protome 🜹 va 🜹 Hane miz que p̃ipi c... ua mochi tio...
que p torochiti 🜹 tece mo nequi... que 🜹 pcalaz ca la ch...
Alles 🜹 y nicnauh eeti 🜹 y nitoca ta ollo... 🜹 na qui 🜹 pca... ca...
ti 🜹 Halchiuh quiez ce ba chi a vac pez ce n a velqui moita tla chi...
te 🜹 dios Amoce camop̃ua niz 🜹 Auh 🜹 Hane miz y nic n...
colte mochi v el mach vaz 🜹 te 🜹 Ha lla COANIz 🜹 y noço m...

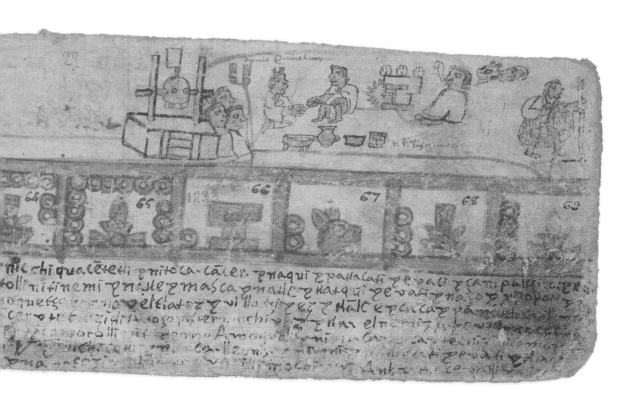

nic chi qua ce ueni 🜹 y nitoca ca ce... y naqui 🜹 p na la caz 🜹 ce vali 🜹 ca ti p... na...
toll ni si nemi 🜹 y n... 🜹 mascapa alle 🜹 ka la qui 🜹 ce vali 🜹 no po...
o quei ce... no vel tia tez 🜹 vi lla ti... 🜹 Hale 🜹 pcalaz pan...
coroto e... di...Amoça pa te mochi 🜹 a las el remiz 🜹 po...
... moralte... como Amoça... eni 🜹 in... a teniz...
... cu chicen... ca llanz... ue...
na pez... moca... 🜹 Auh 🜹 moce...

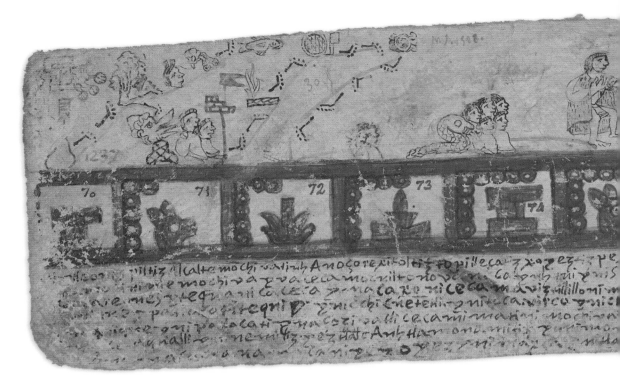

PLATE 16 Historic events from 5 House (1237) through 3 Flint (1248), pages 30 and 31. Courtesy of the Bibliothèque nationale de France.

PLATE 17 Historic events from 4 House (1249) through 2 Flint (1260), pages 32 and 33. Courtesy of the Bibliothèque nationale de France.

76 77 78 79 80 81

façenozivan eylamiquiz eyliraxnt çe maxolli eç uee palni
ri epicaqualle yn ca ye pruexxil onzyxi eynalaçae
papie yzoqui çaliçpa xproyoronhiz eç çe elaçaronçaxhii
oniqui zçollacaer çevari epacopeeaclizç mi yeç çe anni ynociu
laca naçis eyllacai çeç chioilleç qnzinymi çe nixaxuçul eço
ça moçiç abecayziniquiç epaniceli çeç açalipa

88 89 91 92 93

e ypapa caçpallaçaxi eç nioca satsittaries eyllaneleecaqu
que Amoquilaquiz eHaxolli ceca ueçllauelillocçez Ani
larpe coltiz molchixi qnimaziç yxoxome eç çe an
cuillez cuiahmi çeç eçuaçeca uellamicae
çeç caçpaua eç Hacamacaxi çe çi çi çe
ç rej one naqui çe nipaxlacaxi çe çe uari ecau

PLATE 18 Historic events from 3 House (1261) through 1 Flint (1272),
pages 34 and 35. Courtesy of the Bibliothèque nationale de France.

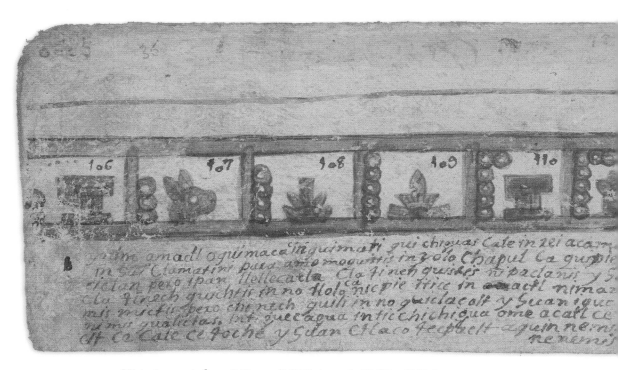

PLATE 19 Historic events from 2 House (1273) through 13 Flint (1284),
pages 36 and 37. Courtesy of the Bibliothèque nationale de France.

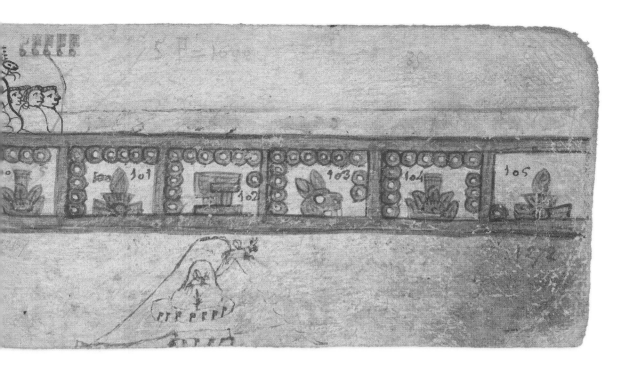

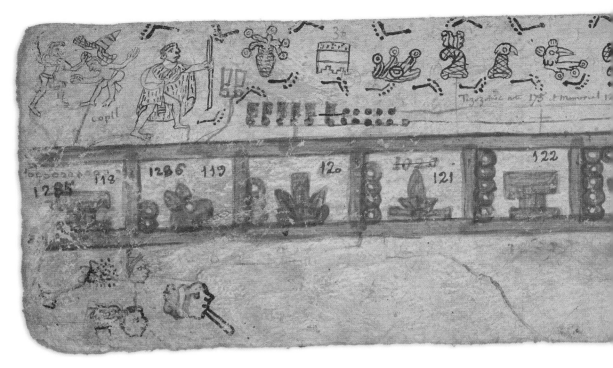

PLATE 20 Historic events from 1 House (1285) through 12 Flint (1296), pages 38 and 39. Courtesy of the Bibliothèque nationale de France.

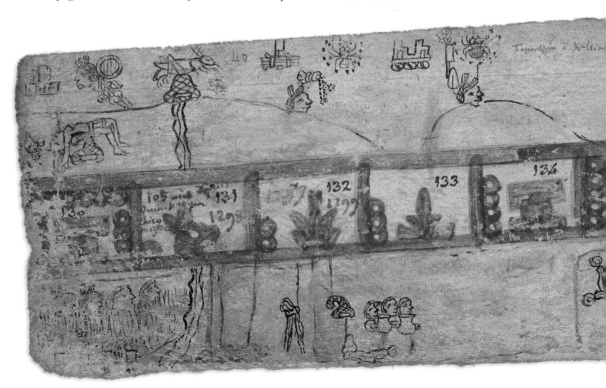

PLATE 21 Historic events from 13 House (1297) through 11 Flint (1308), pages 40 and 41. Courtesy of the Bibliothèque nationale de France.

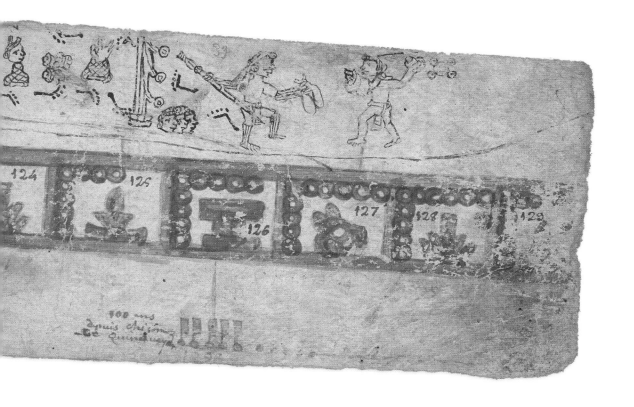

124 125 126 127 128 129

136 137 138 139 140 141

PLATE 22 Historic events from 12 House (1309) through 10 Flint (1320), pages 42 and 43. Courtesy of the Bibliothèque nationale de France.

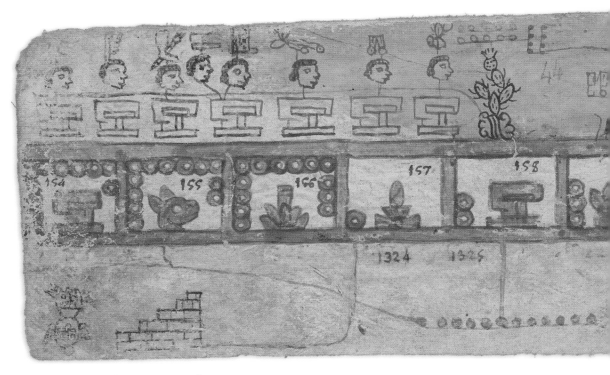

PLATE 23 Historic events from 11 House (1321) through 9 Flint (1332), pages 44 and 45. Courtesy of the Bibliothèque nationale de France.

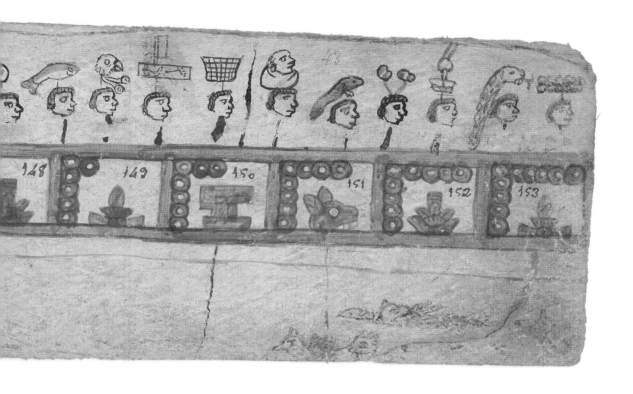

43

148 149 150 151 152 153

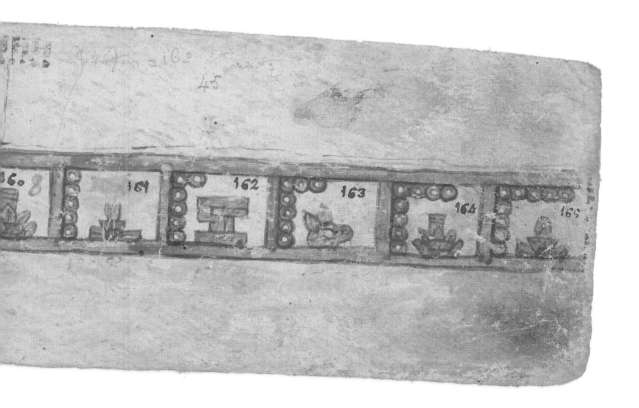

45

160 161 162 163 164 165

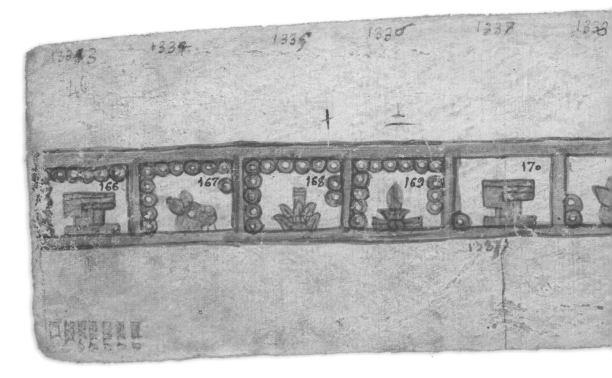

PLATE 24 Historic events from 10 House (1333) through 8 Flint (1344),
pages 46 and 47. Courtesy of the Bibliothèque nationale de France.

PLATE 25 Historic events from 9 House (1345) through 7 Flint (1356),
pages 48 and 49. Courtesy of the Bibliothèque nationale de France.

1342 1343 1344

172 173 174 175 176 177

39 1340 1341

184 185 186 187 188 189

160 ans
depuis Quauhtitlan
Chicomeztoc...

PLATE 26 Historic events from 8 House (1357) through 6 Flint (1368), pages 50 and 51. Courtesy of the Bibliothèque nationale de France.

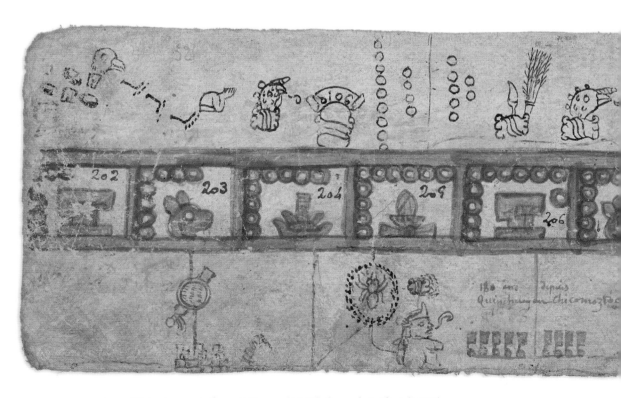

PLATE 27 Historic events from 7 House (1369) through 5 Flint (1380), pages 52 and 53. Courtesy of the Bibliothèque nationale de France.

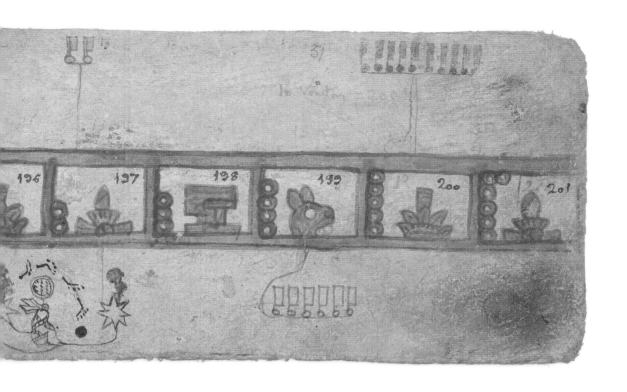

le Venter

196 197 198 199 200 201

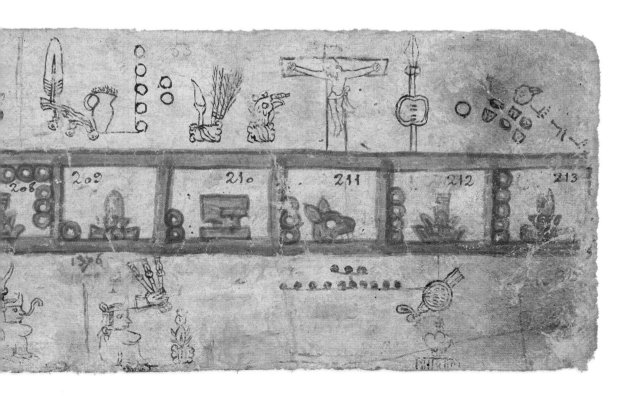

208 209 210 211 212 213

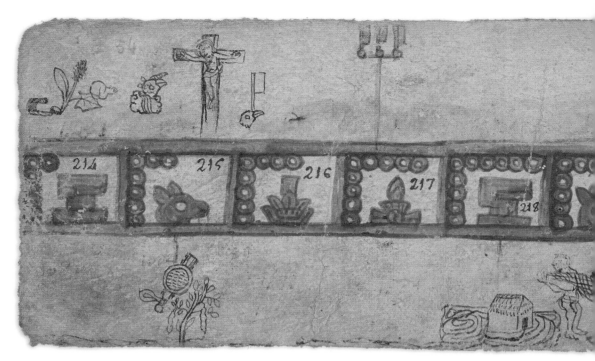

PLATE 28 Historic events from 6 House (1381) through 4 Flint (1392),
pages 54 and 55. Courtesy of the Bibliothèque nationale de France.

PLATE 29 Historic events from 5 House (1393) through 3 Flint (1404),
pages 56 and 57. Courtesy of the Bibliothèque nationale de France.

PLATE 30 Historic events from 4 House (1405) through 2 Flint (1416), pages 58 and 59. Courtesy of the Bibliothèque nationale de France.

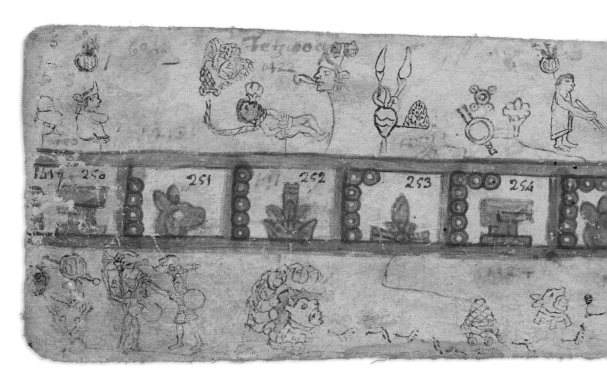

PLATE 31 Historic events from 3 House (1417) through 1 Flint (1428), pages 60 and 61. Courtesy of the Bibliothèque nationale de France.

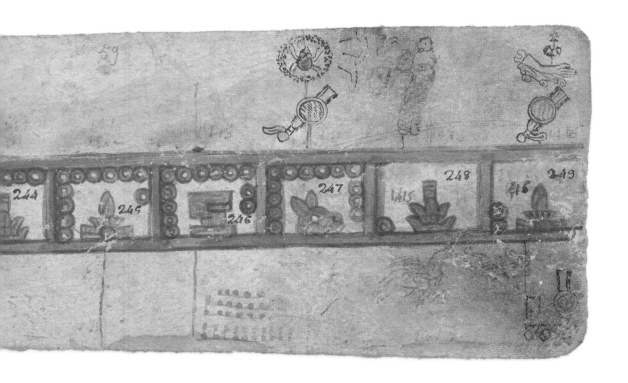

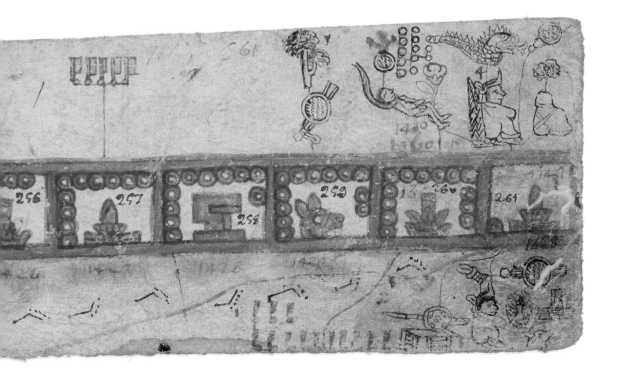

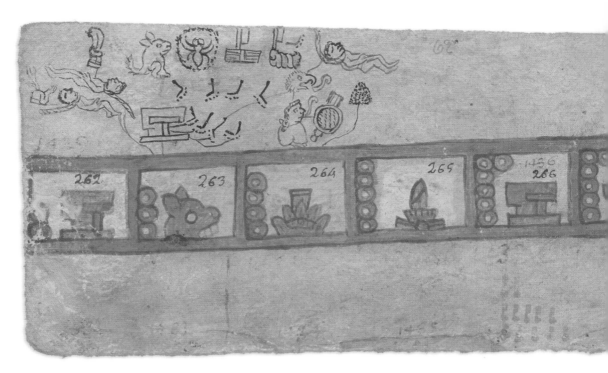

PLATE 32 Historic events from 2 House (1429) through 13 Flint (1440), pages 62 and 63. Courtesy of the Bibliothèque nationale de France.

PLATE 33 Historic events from 1 House (1441) through 12 Flint (1452), pages 64 and 65. Courtesy of the Bibliothèque nationale de France.

268 269 270 271 272 273

Hecuacpa
xochitlava
yecoztli

280 281 282 283 284 285

PLATE 34 Historic events from 13 House (1453) through 11 Flint (1464), pages 66 and 67. Courtesy of the Bibliothèque nationale de France.

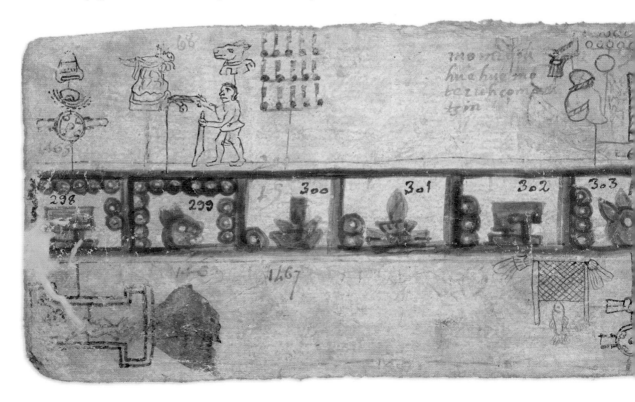

PLATE 35 Historic events from 12 House (1465) through 10 Flint (1476), pages 68 and 69. Courtesy of the Bibliothèque nationale de France.

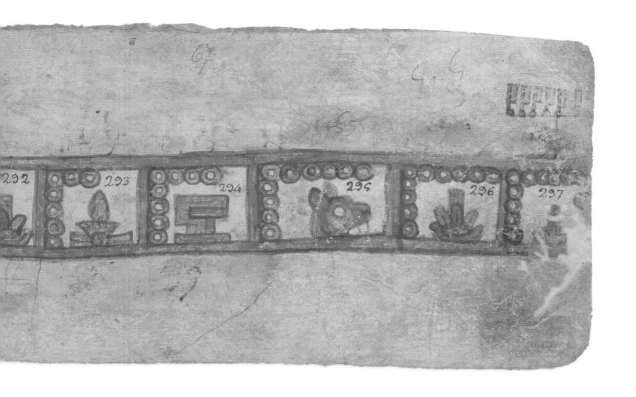

292 293 294 295 296 297

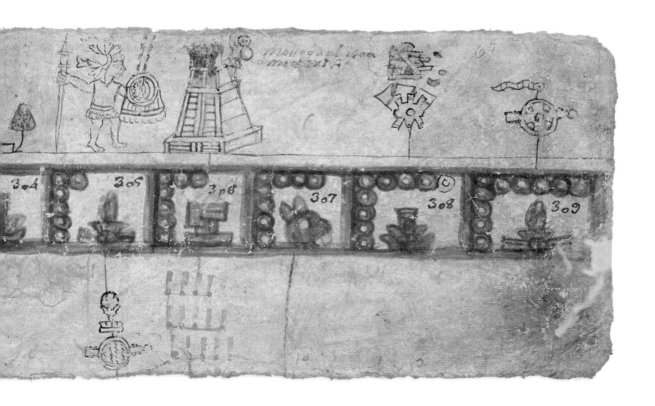

304 305 306 307 308 309

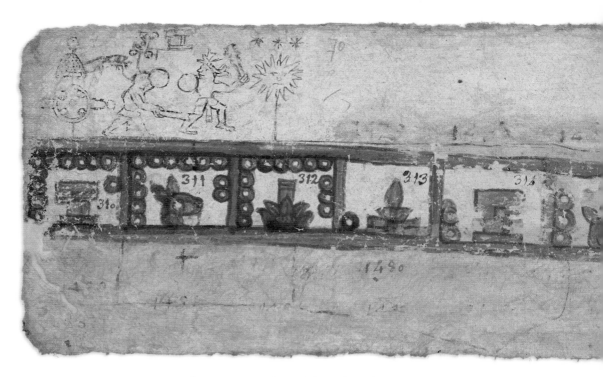

PLATE 36 Historic events from 11 House (1477) through 9 Flint (1488), pages 70 and 71. Courtesy of the Bibliothèque nationale de France.

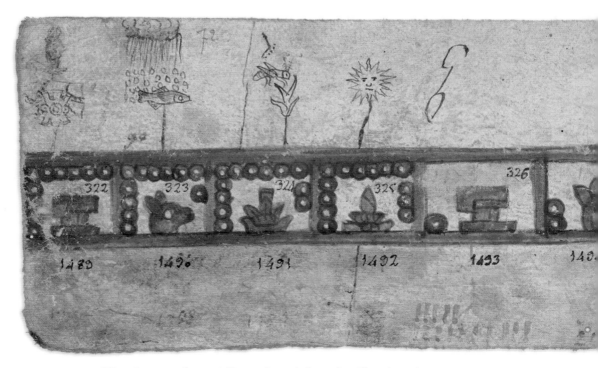

PLATE 37 Historic events from 10 House (1489) through 8 Flint (1500), pages 72 and 73. Courtesy of the Bibliothèque nationale de France.

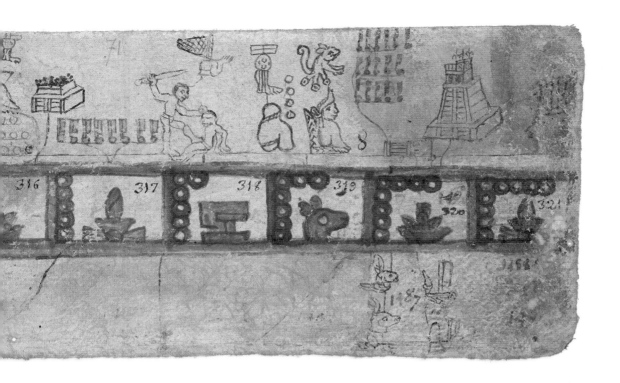

71

316 317 318 319 320 321

1186

1187

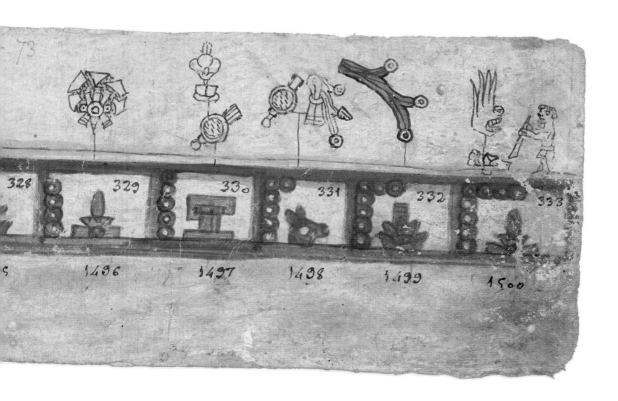

73

328 329 330 331 332 333

1496 1497 1498 1499 1500

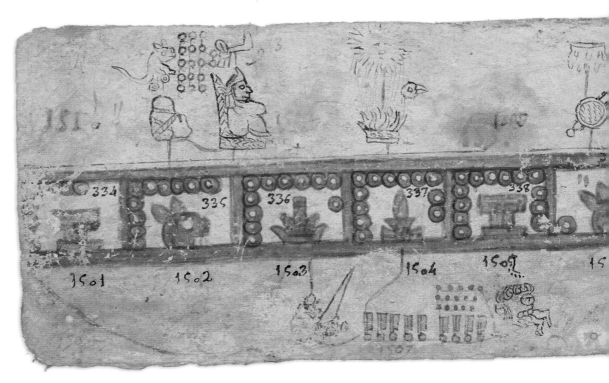

PLATE 38 Historic events from 9 House (1501) through 7 Flint (1512), pages 74 and 75. Courtesy of the Bibliothèque nationale de France.

PLATE 39 Historic events from 8 House (1513) through 6 Flint (1524), pages 76 and 77. Courtesy of the Bibliothèque nationale de France.

tlahuizcalihual moquetzaya

340	341	342	343	344	345
o7	1508	1509	1510	1511	1512

xocotihui chalcahi

352	353	354			
	1520	1521			

PLATE 40 Historic events from 7 House (1525) through 5 Flint (1536), pages 78 and 79. Courtesy of the Bibliothèque nationale de France.

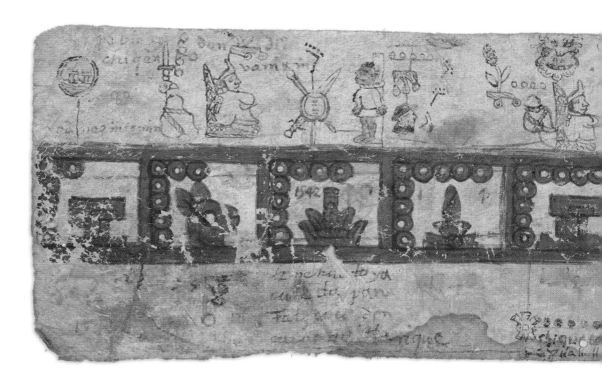

PLATE 41 Historic events from 6 House (1537) through 3 Reed (1547), pages 80 and 81. Courtesy of the Bibliothèque nationale de France.

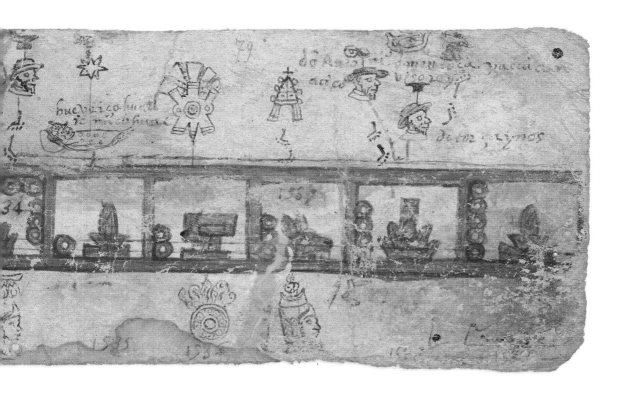

huevyicohuacz
te vicenhuac

79

dõ Anõ de ymemoca ynacuilcuz
acxc Vicazoy

1567

34

dum yeynos

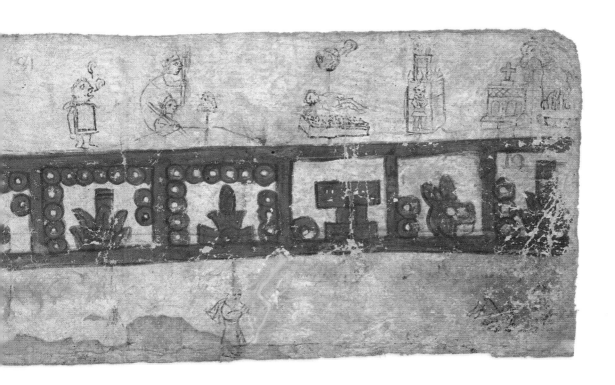

19

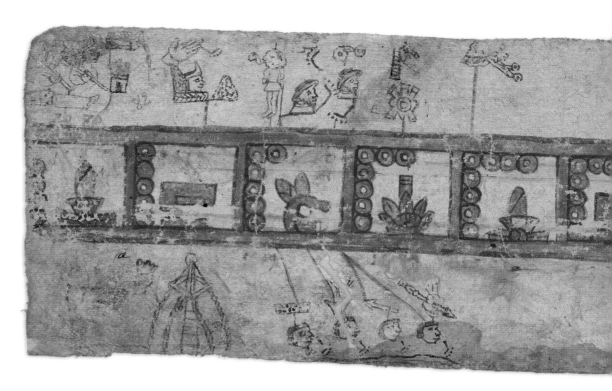

PLATE 42 Historic events from 4 Flint (1548) through 2 Reed (1559),
pages 82 and 83. Courtesy of the Bibliothèque nationale de France.

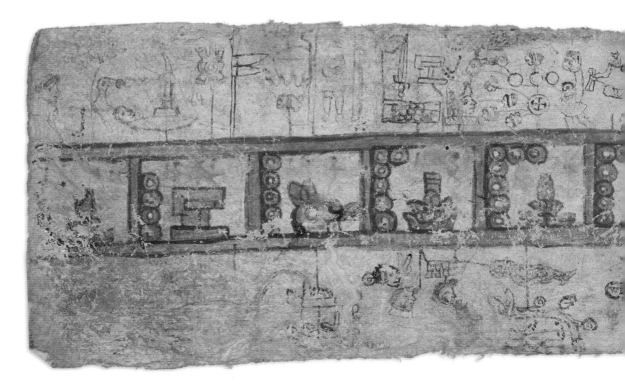

PLATE 43 Historic events from 3 Flint (1560) through 1 Reed (1571),
pages 84 and 85. Courtesy of the Bibliothèque nationale de France.

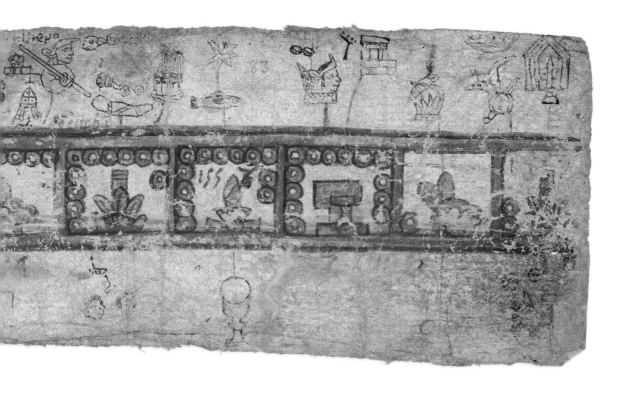

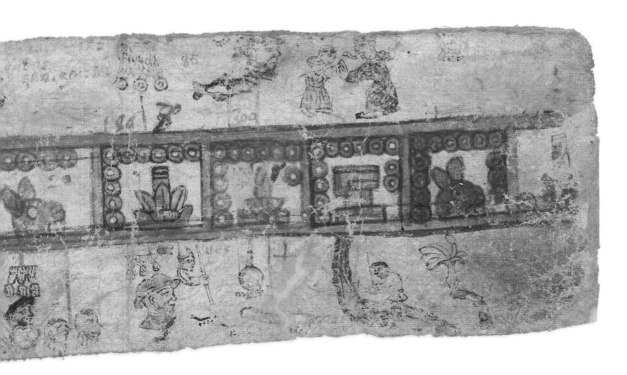

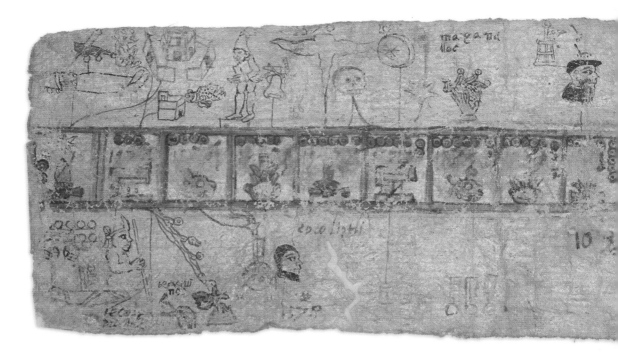

PLATE 44 Historic events from 2 Flint (1572) through 7 Rabbit (1590), pages 86 and 87. Courtesy of the Bibliothèque nationale de France.

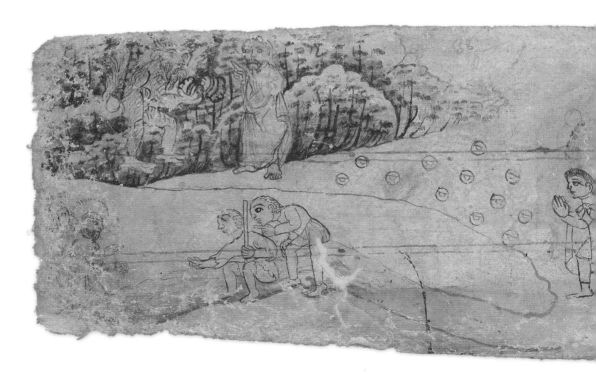

PLATE 45 Miraculous Vision and 1 Cipactli *Trecena*, Codex Mexicanus, pages 88 and 89. Courtesy of the Bibliothèque nationale de France.

12	13	1	2	3	4	5	6	

miquiztli	maçatl	toçiztli	Atl	pecicutl	oçomatli	malina	Acatl
			viiii		ɫi		

PLATE 46 1 Ocelotl and 1 Mazatl *Trecenas*, Codex Mexicanus, pages 90 and 91. Courtesy of the Bibliothèque nationale de France.

PLATE 47 1 Xochitl and 1 Acatl *Trecenas*, Codex Mexicanus, pages 92 and 93. Courtesy of the Bibliothèque nationale de France.

Fmalmaili	Acaui	ocelloni	quauhhli	cozcaqua olli rubhi		tecpaili	quizavini
vi	vii	viii	viiii		xi	xii	xii

tecpaili	quizavi	xoihini	epaili	Ecaui	caui	cozepaili
vi	vii	viii	viiii	x	xi	xii

PLATE 48 1 Mizquitl and 1 Quiahuitl *Trecenas*, Codex Mexicanus,
pages 94 and 95. Courtesy of the Bibliothèque nationale de France.

PLATE 49 1 Malinalli and 1 Coatl *Trecenas*, Codex Mexicanus,
pages 96 and 97. Courtesy of the Bibliothèque nationale de France.

vij

cuezpalli	couaatl	miquiztli	maçatl	tochtli	atl	iztcuintli	oçɇ
vi	vii	viii	viiii	x	xi	xii	xiii

vexto
iii

ozomatli	malina	acatl	ocelotl	quauhtli	cozcaquauh	oll
vii	viii	viiii	x	xi	xii	

PLATE 50 1 Tecpatl and 1 Ozomatli *Trecenas*, Codex Mexicanus, pages
98 and 99. Courtesy of the Bibliothèque nationale de France.

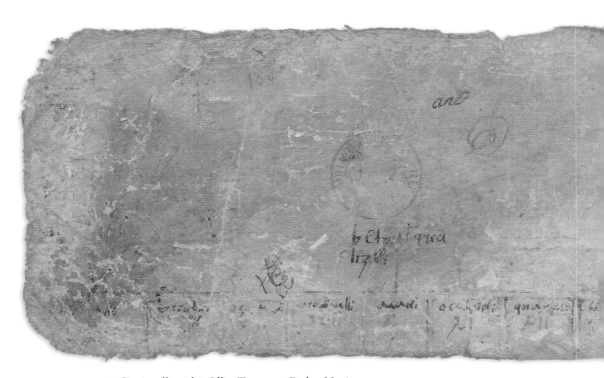

PLATE 51 1 Cuetzpalli and 1 Ollin *Trecenas*, Codex Mexicanus, pages
100 and 101. Courtesy of the Bibliothèque nationale de France.

99

toscatli

coçca	calli		nei padti	q̃ tepeuilt	xochitl		iquetli	ecatli		cipp
	VII		VIII	VIIII						

PLATE 52 1 Itzcuintli *Trecena*, Codex Mexicanus, page
102. Courtesy of the Bibliothèque nationale de France.

from the community (Plate 19). The unconventional orthography used for the text points to an eighteenth-century date but also makes its exact translation difficult.[2] Taking advantage of a blank section on page 36 of the migration portion of the annals history, the scribe wrote,

Ynin amatl oquimacac in quimati quichihuas calli in rei acamapich(tl)i ynhuan tlamatini para amo moquixtis inyollo chapultla(n) quipie yn citlan pero ipan ehecatl tla tinechquixtis nipatlanis yhuan tla tinechquixtis in noyollo ca nicpie itic in atl niman nimitzmictis pero quinechquili in no quitlazotl Yhuan iquac in on nimitzhualittas. In ti(c)huecahua in ti(c)chihchihua ome acatl ce tecpatl ce calli ce toche ihuan tlacotecpatl aquin nemis ipa nenemis[3]

The one who knew how to make it gave this book to King Acamapichtli and the wise men.

In 1 House, so that his heart would not be taken out at Chapultepec. He guards the stars, but upon the wind. May you put me out that I may fly. And may you take out my heart. Indeed, I keep it in the water. Then I will kill you. But he takes it [my heart] from me, he values it. And that is when I will visit you.

We kept what we worked on for a long time. 2 Reed, 1 Flint, 1 House, 1 Reed, and Half Flint, who will live where he will walk about.[4]

The first stanza suggests that the ancestors (those "who knew how to make it") had given a history book to Acamapichtli and his wise men. This first book must have focused on the migration and must have been added to and passed on to future generations, culminating many years later with the Codex Mexicanus itself, which could have only come about through such a preservation of historic traditions. The next stanza is rather enigmatic, but based on its contents and location within the book, I suspect the scribe is referencing the story of Copil.[5] The stanza begins with a reference to the year 1 House, which was the year of Copil's defeat at Chapultepec, as shown just two pages after the inscription (page 38). The Mexicanus does not picture the sacrifice of Copil that would have followed his defeat; however, according to Durán (1994, 32–33), his heart was extracted and thrown into the middle of Lake Texcoco. From this heart, a prickly pear cactus soon sprouted and became the perch for a glorious eagle, marking the location for the founding of Tenochtitlan. The text mentions a heart and water, which points to its referring to this sacred foundation and to the city itself. Thus, even in the eighteenth century, the Mexicanus' link with Tenochtitlan/Mexico City was considered a key aspect of its significance. The final lines evoke the maintenance of the Codex Mexicanus in the local community, and the listing of calendar days/years again suggests the theme of time that echoes throughout the book. Brotherston (2005, 79) suspected that one of the final words, *tlacotecpatl* (half flint), was someone's name, and perhaps it was the book's final owner who had the text added just before the codex was acquired by an outsider.

This acquisition likely happened toward the end of the eighteenth century, as there was an increasing interest in native manuscripts by European and Creole intellectuals at this time. The interest coincided with the arrival of the Italian antiquarian Lorenzo Boturini Benaducci (1702–1755) in Mexico in 1743 (Glass 1975; Cañizares-Esguerra 2001, 135–155). Boturini came to Mexico in order to write a new history of the Americas, one that relied on native

sources. To this end, he traveled the country and acquired a large collection of native manuscripts, both pictorial and alphabetic. The viceregal government, however, grew suspicious of Boturini and confiscated his collection. While many of the manuscripts that eventually ended up at the Bibliothèque nationale de France along with the Codex Mexicanus were once owned by Boturini, Eugène Boban (1891, 379) noted that the Mexicanus was not, in fact, a part of this collection. Thus, one must look elsewhere for the original collector of the Mexicanus. During the eighteenth century, a number of Creole intellectuals became interested in Boturini's collection and in acquiring other native manuscripts. Even the Spanish Crown launched an expedition toward the end of the eighteenth century with the goal of bringing all available native works to Madrid, but a number of Creole intellectuals resisted these efforts, seeking to keep these works in New Spain (Cañizares-Esguerra 2001, 300).

One of these intellectuals was Antonio León y Gama (1735–1802), and I suspect that he acquired the Mexicanus sometime before his death in 1802, upon which time his collection was left to Father José Antonio Pichardo (1748–1812), who was said to have the most extensive collection of native manuscripts in Mexico City at the turn of the nineteenth century (Boban 1891, 379; von Humboldt 2013, 99–100). Upon hearing of Pichardo's acquisition of the León y Gama collection, a friend warned, "I implore your Excellency to hide all those monuments which were in his possession, such as codices, ancient paintings, etc., lest they suffer the same fate as so many treasures that have been taken from this realm to be buried in the archives of Madrid" (in Rutsch 2004, 90). Perhaps fearing that his manuscripts, too, would be confiscated, Pichardo had copies of his collection made, including one of the Mexicanus. Upon Pichardo's death, some of the pieces in his collection were returned to the heirs of León y Gama, who then sold these pieces to the French antiquarian J.-M.-A. Aubin (Castañeda de la Paz and Oudijk 2010, 93–94). As Aubin acquired the Mexicanus and the Pichardo copy of the Mexicanus during his travels to Mexico in the 1830s, it is likely that the work was among the pieces sold by the heirs of León y Gama. A few years after returning to France, Aubin sold his collection of Mexican manuscripts to Eugene Goupil. A purple stamp marking it as a part of the Aubin-Goupil collection appears on the first page of the Mexicanus and also on page 89 (Plate 45). Later, Goupil's widow left his collection to the Bibliothèque nationale de France, where the Mexicanus remains today (Fonds Mexicain 23–24). Another stamp, this time in red, appears also on the first page and on page 100 (Plate 51), marking the work as a part of the Bibliothèque's holdings. Thus, even at the end of its collection history, the Mexicanus remained a living document onto which a number of contributors, interpreters, and collectors have left their marks.

Appendix 1

Pictorial Catechism

The pictorial catechism added to pages 52–54 of the Mexicanus' annals history is an abbreviated version of the Articles of Faith (Figure Appendix 1). The scribe used hieroglyphic compounds to write the introductory section of the articles, but then skipped the first seven articles, which pertain to God, and went straight to the first article of the second group, which pertains to Christ. Presumably, he meant to continue with the catechism, as he wrote an additional word that typically begins the second article of the second group, but he did not complete his work. Below I explain how the hieroglyphic compounds record the Nahuatl speech.[1]

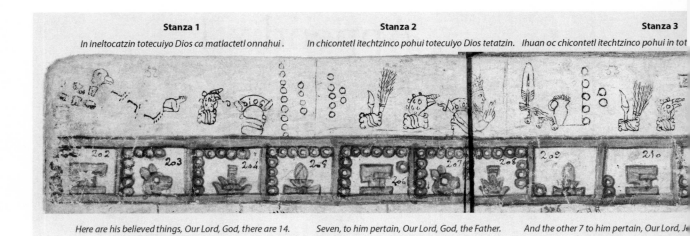

Stanza 1
In ineltocatzin totecuiyo Dios ca matlactetl onnahui .

Stanza 2
In chicontetl itechtzinco pohui totecuiyo Dios tetatzin.

Stanza 3
Ihuan oc chicontetl itechtzinco pohui in tot

Here are his believed things, Our Lord, God, there are 14. Seven, to him pertain, Our Lord, God, the Father. And the other 7 to him pertain, Our Lord, Jo

Stanza 1: *In ineltocatzin totecuiyo Dios ca matlactetl onnahui* (Here are his believed things, Our Lord, God, there are 14.)

The hieroglyphic compound that begins the Mexicanus' pictorial catechism is one of the most difficult to translate completely. The compound includes a grouping of corn kernels (*cin-tli*) and beans (*e-tl*), a bird's head (*toto-tl*), footprints, and a rump (*tzin-tli*). Together, these must record the traditional beginning of the Articles of Faith in Nahuatl, *In ineltocatzin*, or "Here are his believed things." The corn and beans together (*cin-e*) may be meant to approximate *inel*. The footprints likely record *toca*, or follow, and the bird (*toto-tl*) may act as a phonetic indicator telling one how to read the footprints. The rump (*tzin-tli*) at the end records the reverential suffix that is typically used for this word in the first stanza.

The next hieroglyphic compound repeats four times in the catechism. It includes a turkey (*toto-li*) placed over a stone (*te-tl*). In its first two appearances, the compound carries a speech scroll which may reference singing (*cuica*). Based on the phonetics of the compound and the recurring expression *totecuiyo*, "Our Lord," in the Articles of Faith, this must reference that

term. The turkey-stone compound is followed by an icon of a standing stone marker topped by a banner that reads *dios*, or God. The stanza ends with fourteen disks, referencing the 14 Articles of Faith.

Stanza 2: *In chicontetl itechtzinco pohui totecuiyo Dios tetatzin* (Seven, to him pertain, Our Lord, God, the Father.)

The next stanza begins with seven disks, which is followed by a hieroglyphic compound that repeats later in the text. The compound includes a stone (te-tl), a chili pepper (chi-li), and a grass broom (*popo-tl*) for the expression "to him pertain," which is *itechtzinco pohui* in Nahuatl. In this case, the stone and chili pepper must record *itechtzinco*, and the broom approximates *pohui*. This is followed by the turkey-stone and Dios icons, for *totecuiyo Dios*, which is followed by an image of a figure wearing a papal tiara and holding his hands in benediction, which here and elsewhere records God the Father, *Dios tetahtzin*, just as it does in the Atzaqualco Pictorial Catechism (Boone 2016, 47). Together, this stanza reads, "Seven, to him pertain, Our Lord, God, the Father."

Stanza 4

...to inic oquichtli. Inic centetl ineltoca ca yehuatzin in totecuiyo Jesu Christo.

Stanza 5

Topampa

212 213 214 215

...man. *First believed thing, it is he, Our Lord Jesus Christ.* *For our sake...*

APPENDIX I A pictorial catechism in the Codex Mexicanus, pages 52–54. Courtesy of the Bibliothèque nationale de France.

Stanza 3: *Ihuan oc chicontetl itechtzinco pohui in totecuiyo Jesu Chirsto inic oquichtli* (And the other 7 to him pertain, Our Lord, Jesus Christ, as a man.)

The catechism continues with a hieroglyphic compound of a feather (*ihui-tl*), water (*a-tl*), and a pitcher (*oc-tli*), which is linked by a line to seven more disks. The feather-water (*ihui-a*) icons approximate the word *ihuan* (and), while the pitcher gives *oc* (the other). Paired with the seven disks, the compound reads, "And the other seven." This is followed by a repetition of the stone-chili-broom compound (*itechtzinco*, "to him pertain") and the turkey-stone icon (now missing the song scroll), for *totecuiyo*, or Our Lord. Now the icons are followed by a crucified Christ and a shield-spear icon. A similar pairing of a crucified Christ next to a spear is seen in the British Museum's pictorial catechism (see Figure 1.4), where it is glossed as *oquichtzintli*, or man (Gaillemin 2011, 221). A spear icon is also used multiple times in the Gómez de Orozco pictorial catechism, where it is glossed *oquitzintli* (León-Portilla 1979, 37, 41, 46). Thus, the Mexicanus' shield-spear compound must also refer to Christ's humanity. Together, this section reads, "And the other 7 to him pertain, Our Lord, Jesus Christ, as a man."

Stanza 4: *Inic centetl ineltoca ca yehuatzin in totecuiyo Jesu Christo* (First believed thing, it is he, Our Lord Jesus Christ.)

The single disk refers to the number one, or "First." The compound that began the catechism then repeats, but without the reverential *–tzin* suffix, which makes sense, as it was typical to not use the reverential in the second part of the articles. The next compound is a nice phonetic rendering of *ca yehuatzin*, "it is he." It begins with a sandal (*cac-tli*), next to a bean (e-tl), an amaranth plant (*huauh-tli*), and a rump (tzin-tli), for *cac-e-huauh-tzin*. Next is the familiar turkey-stone-Christ icon, "Our Lord Jesus Christ."

Stanza 5: Topampa (For our sake . . .)

The text ends with a compound of a bird (to-to-tl) under a banner (pan-tli), which reads as *topampa* (for our sake), which is the next word in this article of faith, but the scribe does not continue with the rest of the sentence. The British Museum's pictorial catechism also uses a banner next to a crucified Christ to picture this next article of faith (Figure 1.4).

Appendix 2

Zodiac Text Transcription

Unfortunately, the Nahuatl text added to pages 24 through 34 (Plates 13–18) is in poor condition, especially at the edges and bindings of the book, making it difficult to offer a translation or even a full transcription. In lieu of this, I offer a partial transcription of the text. There are many effaced words and sections, which I indicate with ellipses. Based on the patterning, I am able to reconstruct some words, and when I do so, I place these in parentheses. The transcription that follows is organized by zodiac sign and then by page and line number for clarity. I attempted to make separate words clear, but this was an admittedly difficult task; see Chapter 3 for more on this section.

Aquarius

24.1 . . . *aqui ypa tlacati yn itoca Aqualliyos y auetli yn amo uelmitçi . . .*

24.2 . . . *ye yca Aquariyos ytla ypa mitçiminaz yc miquiz. A(uh)*

24.3 . . . *nemiz ynic motlayecoltiz y niquite-moz yn itechimo . . .*

24.4 . . . *Auh ytla cana ypa moquezaz y ue etli y ceca tema . . .*

24.5 *mochiuaz ye yauica ypa tlacat yn aquari(yos)*

24.6 *mochiu yez yni tlacani Auh quinemiltiz y*

25.1 . . . *naço totolme Anoço ychicame Anoço quaquaueque . . . A(noço)*

25.2 . . . *me mochiti uel nemizque yn icha*

Pisces

25.2 *ynic otetli yn itoca pi(zis)*

25.3 *yn aqui ypa tlacati yehuatli y mocla . . . mali yn*

25.4 *yaz tlatia matiuh y tla . . . aello yoli . . . que nimi . . . ti uel*

25.5 *ypa tlacati yn i(toca) pixis ytla nel ceca cehua Amo que*

25.6 . . . *hqui . . . mochiu . . . niz yn itlitili*

26.1 . . . *paniziuhc amo tlatiaquaz y nicaz Ayoc motlacaquiz Auh nouelqu*

26.2 *amo maquiliz Auh quichiuhtiaz tlaxtlaualiztli*

26.3 *yn itoca pizis*

Aries

26.3 *yniq uetetli yn itoca Ariyes yn aqui ypa*

26.4 . . . *(tlacati) yeuati yua ynoceca mopil-huatia caxa mochitin miqni yn*

26.5 . . . *euati y tetetçaca no opallacati ca ytlah mochihua yn axca*

26.6 . . . *yn aço ça ce . . . auh ytla nemiz ynic motlayecoltiz m(o)*

27.1 *chiti quimaçiz y totome yua ytla nemizque yni ytic . . . mochiti a..m . . .*

27.2 *zizque y totochiti y techmonequiz quiquaz e y caca ypa tlacat yni*

27.3 *toca Allies*

Taurus

27.3 *ynic nauhtetli yn itoca taolloes yn aqui ypa tlacati y(e)*

27.4 *uatli y tlalchiuhqui ez ceca chicauac y ez ceca uelqui motlatl uh t . . .*

27.5 *y tote y dios Amo ceca mopouani ez Auh ytla nemiz ynic motla*

27.6 *y ecolto mochiuel mochuaz yntle ytlalla cotlaliz yn aço . . .*

28.1 *ynix quichi y nepapaxe chiqual quauitli y eyxquichi y tlalticpac m(o)*

28.2 *chiuaz y caca ypa tlacati yn itoca taollos y chicaualiztli ceca*

28.3 *mochi oyez yn icha yn ixquichi*

Gemini

28.3 *Ynic macuiltetli yn ito*

28.4 *(ca) geminis yn aqui nima tlacati yeuatli ytlamati yn itoca toalles yn aço sace*

28.5 *cati ynanaço opispos timoc . . . ay teotetia catla nime yn itoca euatli*

28.6 *ynometi icate yn mictli . . . yn aqui y*

28.7 *(y)n itoca geminis*

Cancer

29.1 *ynic chiquacentetli yn itoca cancer yn aqui ypa tlacati yeuati y çanipaltçico yn i*

29.2 *motolli nitinemi yn atle y masca yn atle y tlatqui yeuati yn aço yxpoptl y(n)*

29.3 *vel moquetçaz y no uel tlatoz y uillatzi y
ez y ytlanl ce y caca ypan tlacati . . .*

29.4 *ca cancer y te . . . zicli Anoço . . . (mo)
chiuaz ytla uelnemiz . . . yc uel*

29.5 *ypa p . . . motolliztli nemi Amo qualani
. . . ca . . . ca y telniz*

29.6 *uani*

Leo

29.6 *Ynic chico(metetli) yn (ito)ca lleonis . . .
tlacati yeuati ytla . . .*

29.7 *pilti y ua mochi . . . Auh . . .
ceualliya . . .*

30.1 *. . . lleonis piltiz Alcalte mochiuatiuh
Anoço rexitoltiz topillecatiz xa yeztiz
pescalitiz*

30.2 *. mochihua yua ceca mocuil-
tono uanico yuhqui ynisinos*

30.3 *. mes y tequani cancer a yn aca xe
ni ceca mauiztillillo ni mochiu*

30.4 *. titequi*

Virgo

30.4 *ynic chicuetetli yn itoca virco yn ichipoch*

30.5 *. . . que yn ipa tlacati yn aço ziuatli ceca
mimatini mochiuaz ytl*

30.6 *. aqualli yn nemitiz y ez tlate Auh
tlamona*

30.7 *. na . . . cani y . . . oyez yni . . .
. . . nitlatqui*

31.1 *Auh ytla yc noziuatiz ytla miquiz y nima
mic ceca miatolliniz . . . pal . . .*

31.2 *iz maziui y ceca qualli yn aca ya yziuatli
yn yqui ypa tlaca yn itoca . . .*

31.3 *y çatepayil y toquiçalizpa yxpopomotiz*

Libra

31.3 *yn ic chicuinauhtetli yn itoca . . .*

31.4 *pexo yniqui ypa tlacatetl yeuatli ypochte-
catli yni yec y*

31.5 *y motlacamatiz y tlacaua yez chiuililez y
quiquaz*

31.6 *nequi cia callipa*

Scorpio

31.6 *(yn ic ma)*

31.7 *tlaca (tetli yn itoca scorpio)*

32.1 *. . . pilani iz ceca ueli techinetlaca necoz
ceca uel tlatia niyeliz Amo te tlame*

32.2 *. y ua cama y tli camatializ tecoch-
itiz ocate tlaqualtiz yc motlapi*

32.3 *. itlatqui yc mocuitono yc
motlaca matiz Auh ynanemiz ytlaz*

32.4 *. miz ceca caca y ua
tlacat yn itoca*

32.5 *. . . (scor)pio . . .*

Sagittarius

32.5 *yn ic matlactlocetetli oce . . . allios yn
itoca*

32.6 *. . . (tla)catli yn aqui ypa tlacati
. . .*

32.7 *.*

33.1 *y ez ypapa ca ypa tlacati yn itoca satsittar-
ios ytla nel ceca qui no*

33.2 *tlazque Amo quincaquiz ytlatolli ceca uey
tlauellilloc y ez Auh ynic*

33.3 *motlayecoltiz mochintin quinmazin y
totome yua quauh . . .*

33.4 *tlacuilloz cuicaui y ez y ua ceca uellia
minaz Auh te*

33.5 *niz ye yca ypa tlati y tlacamaçatli*

Capricorn

33.5 *xii. yn itoca ca(pricor)*

33.6 *nos y tetçone yn aqui yn ipa tlacati yeuatli*
 yçaquinis

34.1 *. . . y mitiz quaquaueque yna quinquin*
 motlaque uiz y quimictiliz y

34.2 *. . . aqua uecaua Auh yni yeuatli cami yec*
 mochiuaz yn inacayo

34.3 *. . . tlanemiz mimiquiz Amo quinmotla*
 acolliliz yn totexui yn os

34.4 *y tlaca moquichectiz y tlatlacol Auh*
 yniquac ye miquiz y tlacati

34.5 *. titequilizque y tlaca moquicue-*
 paz yni nemiliz ça . . .

34.6 *. z y mouilitiz ytla uel ceca miye-*
 ciuo tlatolli ypa ini

34.7 *.*

CHAPTER I: THE CODEX MEXICANUS AND ITS WORLD OF PRODUCTION

1. The Mexica of Tenochtitlan controlled a vast territory that is often called the Aztec empire, though it comprised a number of polities with different ethnic affiliations. In this book, I use the terms Mexica and Tenochca to refer to the leaders of the empire and the term Aztec in a more general sense to refer to the cultural traditions shared by members of the empire, while the term Nahua refers to Nahuatl-speaking peoples.

2. The Codex Mexicanus (Fonds Mexicain 23–24) is also accessible in its entirety online through the Bibliothèque nationale de France: gallica.bnf .fr/ark:/12148/btv1b55005834g.

3. A general overview of the Codex Mexicanus and its relation to the *Reportorios* was published in Diel (2016).

4. For examples, see Hanns J. Prem (1978, 2008); Gordon Brotherston (2000; 2005, 79–94; 2008); Susan Spitler (2005a, 283–285; 2005b, 187–192); and Anthony Aveni (2012, 47–49).

5. Monographs on specific Aztec pictorial histories often use the Mexicanus annals history as a point of comparison; for examples, see Charles Dibble's (1981) study of the Codex en Cruz; Eloise Quiñones Keber's (1995) work on the Codex Telleriano-Remensis; and my own analysis of the Tira de Tepechpan (Diel 2008). Elizabeth Boone's (2000) overview of Aztec pictorial histories also looks at the Mexicanus history as a part of the larger corpus, while Federico Navarrete's (2000) consideration of the Mexica migration account includes this portion of the Mexicanus' annals history.

6. David Tavárez (2011, 133–139) classifies the Codex Mexicanus and other similar works as clandestine works that were purposefully kept from Spanish eyes.

7. See Robertson (1959, 59–67) and Boone (2000, 31–63) for thorough overviews of the Aztec painting style and pictorial system of writing.

8. Nahuatl nouns include a root and an absolutive suffix; the latter is typically dropped when creating compound words such as place-names. For clarity, when I discuss hieroglyphic compounds, I separate the root from its absolutive suffix.

9. For an overview of Aztec pictorial histories, see Boone (2000), and for a review of the divinatory codices, see Karl Nowotny (2005) and Boone (2007).

10. Soon after the conquest, there was a push to establish the seat of native government in the San Pablo neighborhood, perhaps because this barrio was said to have been the first to be settled by Mexica migrants (Schroeder 2016, 12). However, after the arrival of the first viceroy in 1535, it was decided that the native *cabildo*, or council of indigenous government, would be located in the barrio of San Juan Moyetlan instead (Castañeda de la Paz 2013, 197–199).

11. I was tentative about the interpretation of this vignette as referencing Christ on the road to Emmaus but felt more secure in it when Nancy Thebaut (n.d., 4), a Medievalist, sent me a paper she had written on the Mexicanus in which she independently came to the same conclusion.

12. The reference to the story of Emmaus seems to be rare in New Spain. In a study of the murals in New Spain's monasteries, none referenced this event (Reyes-Valerio 1989).

13. The identification of this section as an excerpt of the Articles of Faith was helped immensely through personal communications with Elizabeth Boone (October 2016) and Louise Burkhart (January 2017), who also gave generous advice on similarities, or lack thereof, between this pictorial catechism and others.

14. Much has been written on this period of evangelization; for examples, see Ricard (1966); Phelan (1970); Schwaller (1987); and Florescano (1994).

15. The documents gathered in Franciso Fernández del Castillo's *Libros y libreros* (1982) give a sense of the types of books being targeted by church and Crown as well as the reactions of the mendicant orders in New Spain to this increasing censorship and the difficulties it was creating with their evangelization efforts.

16. The *cédula* is quoted in Fernández del Castillo (1982, 513): "estaréis advertido de no consentir que por ninguna manera, persona alguna escriba cosas que toquen a supersticiones y manera de vivir que estos indios tenían, en ninguna lengua" (you will be warned not to allow, in any way, any person to write things that touch on the superstitions and way of life that the natives had, in any language). For more on the reasons behind the confiscation of Sahagún's manuscript and of other Mexican chronicles, see Georges Baudot (1995, 500–524).

17. For more on colonial discourse and its relation to the artistic and textual productions of Latin America, see Patricia Seed (1991, 1993); Adorno (1993); and Dean and Leibsohn (2003).

CHAPTER 2: TIME AND RELIGION IN THE AZTEC AND CHRISTIAN WORLDS

1. Brotherston dates the Mexicanus to 1583 and argues that it was created as a negative commentary on the Gregorian Calendar Reforms of 1582. However, because the majority of the Mexicanus was more likely produced between 1578 and 1581, the reforms could not have been the original impetus behind the creation of the book.

2. William Hanks (2010, 338–364) similarly argues that the inclusion of Christian contents in the manuscripts known today as the Books of Chilam Balam provided a means of bypassing priests and enabling Maya intellectuals to practice Christianity independently of the Spanish sphere. In fact, the compilers of the Books of Chilam Balam also looked to *Reportorios* as source material for their work (see Bricker and Miram 2002; Caso Barrera 2011; George-Hirons 2015).

3. Much has been written on the Aztec calendar and notions of time; for general examples, see Alfonso Caso (1971); Rafael Tena (1987); and Ross Hassig (2001). For an understanding of how the calendar was linked to divination and expressed in books, see Boone (2007), and for a study of how the calendar was graphically

recorded before and after the conquest, see Prem (2008); Ana Guadalupe Díaz Álvarez (2011); and Aveni (2012).

4. These sources include the Codex Magliabechiano and its cognate, the Codex Tudela, as well as the Codex Telleriano-Remensis and its cognate, the Codex Vaticanus A. The *Historia de Tlaxcala*, by the mestizo chronicler Muñoz Camargo (2002), includes an insert of a calendar wheel devoted to the monthly calendar (see Figure 2.5). Also, the Spanish friars Fray Toribio Motolinía (1951, 114–121); Bernardino de Sahagún (1950–1982 3; 1993, 250r-253r); Juan de Tovar (in Kubler and Gibson 1951); and Diego Durán (1971) also included illustrations and explanations of the monthly festivals in their works.

5. The Kalends was the first day of the new moon; the Nones fell four or six days after the Kalends, depending on the month; and the Ides occurred eight days after the Nones.

6. Galarza (1980, 41) read this as a cross and suggested that it marks this particular day as Pentecost. However, Pentecost was not celebrated on a fixed date and could only have fallen on May 15 in 1564, which is too early for the Mexicanus. Alternatively, Brotherston (2005, 80) argued that this sign is a reference to the banner of the Aztec god Tezcatlipoca, but given that the icons on the top register record Christian holy days and the feast associated with Tezcatlipoca would have been celebrated in the previous month, I find this interpretation unlikely.

7. A Physician's Almanac housed in the British Library (Harley Ms 2332) uses the same visual device, suggesting that it was a common one with which the Mexicanus contributors were familiar.

8. For discussions of the celebrations associated with the different months, see Caso (1971); Broda (1991); and Milbrath (2013).

9. This layout can be further traced back in time to a French model for calendar layouts in printed books (Gravier 2011, 183).

10. When Prem (1978) first tried to correlate the Mexicanus' calendars with the Christian calendar, he found exact dates elusive. In a larger study of time in the Mesoamerican world, he returned to the problem of the Mexicanus' dates and concluded that the creators of the Mexicanus were likely trying to correlate the native and European calendars over a few successive years (Prem 2008, 153).

11. The Gregorian Calendar Reforms cut ten days from the calendar, with October 4, 1582, being immediately followed by October 15. Accordingly, if the Ochpaniztli festival fell on September 5 in 1580, then four years later (1584), it would have fallen on September 14; another four years after this, it would have fallen on September 13 (1588); and another four years after that (1592), it would have fallen on September 12.

12. The Aztec year correlations are not an exact match with the Christian ones, as the year 1 Rabbit would have begun on February 4, 1558, and ended on February 3, 1559.

13. Others have also questioned the extent to which Aztec calendar wheels recorded after the conquest reflect European influence over native conceptions of time; for examples, see Brotherston (2005, 69–78); Spitler (2005a); and María Castañeda and Michael Oudijk (2010, 106–121).

14. For examples, see Diego Valadés (1579, 100); Sahagún (book 7, 21v); an insert in Motolinía's *Memoriales* (1951); Fray Diego Durán's *Historia de las Indias* (1971, 359); the manuscript by Juan de Tovar (142r); the Boban Calendar Wheel in the John Carter Brown Library; and the Muñoz Camargo insert (figure 2.5).

15. According to the perpetual calendar, this festival fell on August 3. Therefore, this and the subsequent correlations on these pages fall six days earlier than the perpetual calendar correlations.

16. Septuagesima fell on February 15 in 1579, January 31 in 1580, and January 22 in 1581, while Ash Wednesday fell on March 4 in 1579, February 16 in 1580, and February 7 in 1581.

17. The scribe who wrote the day names is different from the one who wrote the days of the tonalpohualli on pages 13 and 14. When *ts* and *ls* are next to each other, they are not looped as they are on pages 13 and 14, and the scribe for pages 13 and 14 preferred to use the letter *z* when

writing words such as *cuetzipalli* and *itzcuitli*, while the trecena scribe preferred to use ç, giving *cuetçipalli* and *itçxuitli*. Also, *i*s were added to many of the day names in the *trecena* almanac, so *atl* becomes *atli*, *tecpatl* becomes *tecpatli*. Although this also happens on pages 13 and 14, it is much less frequent.

18. Based on the distinctive handwriting and lighter ink, one can conclude that the scribe who added the month names is not the same one who wrote the trecena days.

CHAPTER 3: ASTROLOGY, HEALTH, AND MEDICINE IN NEW SPAIN

1. The two books were Agustín Farfán's *Tractado breve de chirigia*, published in 1579, and Alonzo López de Hinojosos' *Suma y recopilación de cirugía*, published in 1578 (Skaarup 2016, 210–218).

2. The Metonic cycle is based on the fact that nineteen solar years are equivalent to 235 lunar months, resulting in a new moon occurring on the same day of the month every nineteen years (O'Boyle 2005, 1–2).

3. A chart such as this could also have been used to calculate the date of Easter, as it is based on a 532-year Paschal chart developed by the Venerable Bede.

4. Prem (1978, 276) too suspected the circles related to medical practices, such as bleeding, but he was unable to fully explain the circles and their varied colors.

5. This page was clearly reused. At the lower-right side of the page, the Reed sign that repeats frequently on the annals history timeline floats upside down, while disks also float along the lower border of this page.

6. The water-fire icon appears a number of times on the Museo Nacional de Antropología's Temple Stone, also known as the Stone of Sacred Warfare.

7. For a counterargument, see J. Richard Andrews and Ross Hassig (1988).

8. The descriptions of the zodiac signs in this manuscript reveal interesting similarities with the Codex Mexicanus. For example, in both sources, Gemini is related to *tlamatinime* (wise men), while Libra is related to merchants (*pochtecatl*), presumably because of their use of scales, and Sagittarius to *tlacamaçatl*, or deer people. A facsimile of the manuscript is published by the Maya Society (1935).

CHAPTER 4: DIVINE LINEAGE

1. The corpus of pictorial genealogies of the Mexica royal house includes the Fragmento de genealogía de los príncipes mexicanos (in Caso 1958), the Genealogía de la familia Cano (Bibliothèque nationale de France 388), and the Genealogical Tree of the Royal Lineage of Moteuczoma (Archivo General de la Nación [AGN] Tierras vol. 1586, exp. 1). Other pictorials contain more fragmentary genealogies of the Tenochca royal house. These include the Codex Cozcatzin (1994) and the Codex Telleriano-Remensis (1995), both from Mexico City; the Codex Xolotl (1996); the Tira de Tepechpan (Diel 2008); Mapa Quinatzin (Douglas 2010); Mapa Tlotzin (Douglas 2010); and Circular Genealogy of the Descendants of Nezahualcoyotl (see Figure 4.2), which were painted in early colonial Texcoco. Some alphabetic chronicles also include genealogical information. The best-known alphabetic genealogies are those written for Juan Cano, the Spanish husband of Doña Isabel, a daughter of Moteuczoma II. These accounts are known as the *Origen de los Mexicanos* and the *Relación de la genealogía*; they are published in Prem et al. (2015, 217–301). More genealogical information is also interspersed in histories of the Aztec empire, such as the *Anales de Tlatelolco* (2004) and those written by Hernando Alvarado Tezozomoc (1987); Fernando de Alva Ixtlilxochitl (1997); and Domingo Chimalpahin Cuauhtlehuanitzin (1997, 1998). Legal documents and petitions also contain genealogical information on the Tenochca royal house; many of these have been transcribed and published in Emma Pérez-Rocha and Rafael Tena (2000).

2. See Caso (1958) and Castañeda de la Paz (2011) for fuller treatments of this genealogy.

Castañeda de la Paz links the work to Pedro Dionisio and renames it Genealogía de Pedro Dionisio.

3. Two sixteenth-century native genealogies were modeled after Tree of Jesse genealogies. One was included in the *Xiu Family Chronicle* from colonial Yucatán, and the other was included in the *Relación de Michoacán*. These genealogies were directed to a European audience, which suggests that their native authors were making claims to nobility based on a European model (Cortez 2002, 201; Afanador-Pujol 2010, 296).

4. The paper used for the genealogy had been repurposed. At the far left, a column with information similar to that appearing in the introductory columns of the first eight pages of the manuscript is set apart from the genealogy by a red line. At the top is an animal sign, then the crescent face that indicated a new month in the perpetual calendar, and then a banner over a disk. Some of the gesso coating has also flaked away to reveal an upside-down European-style sun. Just below and to the right of this, remnants of an image of a seated Aztec ruler, later covered with gesso, can also be seen. The faint ground lines used to organize the genealogy on the rest of the page, however, must have been set down specifically for the genealogy, as these lines are not seen on the visible underdrawings.

5. The identification of the male figure as Huitzilopochtli is not entirely secure. For example, Castañeda de la Paz (2016, 132) reads the footprints above this figure as a part of his name tag and identifies him instead as Totoquihuaztli, who became ruler of Tlacopan after the Tepanec War of 1428. Accordingly, she sees his inclusion as referencing a later period of history. However, as the other figures surrounding him lived earlier in time, I lean toward an identification of this man as a key ancestral figure. Furthermore, I read the footprints not as a part of this figure's name tag but as a reference to travel for the female figure above.

6. The story is compiled from accounts in Alvarado Tezozomoc (1987, 226–227); Durán (1994, 31–33); *Crónica Mexicáyotl* (1997, 85–89,

103); Chimalpahin Cuauhtlehuanitzin (1998, 1: 159–163); Acosta (2002, 388–390); and *Anales de Tlatelolco* (2004, 59–61). In these accounts, the protagonists act as humans, which would also explain their human appearance in the Mexicanus.

7. Footprints are also used on the next page to mark a woman who has gone off to marry. As explained below, the footprints lead the reader from the woman's original appearance to her marriage statement.

8. In the Mexicanus annals history, Tenochca rulers will not be shown seated on the tepotzicpalli until the reign of Itzcoatl, who earned the city's independence with his defeat of Azcapotzalco, the reigning power in central Mexico at that time.

9. The *Relación de la genealogía* and the *Origen de los mexicanos* tell similar stories about Acamapichtli's wives but with a key difference (Prem et al., 2015, 228, 270). They relate that of the wives given to Acamapichtli, one was the most noble, and her children were the most loved and legitimate, destined to be the future rulers of Tenochtitlan. Included amongst these sons are Huitzilihuitl, Chimalpopoca, and Itzcoatl. Thus, these accounts equalize the ranks of Huitzilihuitl and Itzcoatl, with them as brothers rather than half-brothers, perhaps because these documents were written as a way of bolstering Isabel Moteuczoma's claims and it behooved her husband to omit the illegitimacy of Itzcoatl's birth.

10. Chimalpahin Cuauhtlehuanitzin (1998, 1: 239) includes a man named Yaocihuatl as a child of Huitzilihuitl instead (see also Castañeda de la Paz 2016, n. 41).

11. See Susan Schroeder (2016) for an in-depth study of Tlacaelel and the important role he played in building the Mexica empire.

12. For more on marriage as a political strategy within the Aztec empire, see Pedro Carrasco (1984) and Diel (2007).

13. This line also skirts under a turquoise diadem sign, which I suspect is meant to be associated with the woman seated above, who is Atotoztli, Moteuczoma's daughter. However, a tear at the paper makes this difficult to know with certainty.

14. I read this as a daughter of Huitzilihuitl rather than a secondary wife because it was common for names to skip a generation and then repeat (cf. Castañeda de la Paz 2016, 137).

15. Relying on an account in the *Crónica Mexicáyotl*, Castañeda de la Paz (2013, 138–139) reads this place sign instead as Tliliuhcan, which was affiliated with Tlacopan. However, the place sign in the Mexicanus is similar to that used for Tlatelolco in a number of Aztec pictorials, including the Mexicanus annals history, which leads me to conclude that it refers to Tlatelolco here.

16. The documents related to Doña Isabel, the daughter of Moteuczoma II, give contradictory information. According to the *Origen de los mexicanos*, Tezozomoc was actually a ruler of Tenochtitlan because of his marriage to Atotoztli. By contrast, the *Relación de la genealogía* states that Atotoztli and Tezozomoc ruled together but that most histories ignore this because she was a woman (Prem et al., 2015, 41).

17. This Chalchiuhnenetzin played a key role in Tenochca history. She was sent to marry Moquihuix, ruler of Tlatelolco, but he was abusive toward her. Her poor treatment angered her brother, Axayacatl, who was then ruler of Tenochtitlan and declared war on Tlatelolco and defeated the city (see Evans 1998, 174–176; Diel 2007, 268–269).

18. Other sources from Valeriano's own time also mark him as a judge rather than a noble governor. For example, the Codex Aubin (78v) names him as a judge and pictures him holding a vara and dressed in Spanish clothing, whereas native *gobernadores* in this same codex are shown with turquoise crowns and cotton mantles and are seated on woven reed thrones. The author of the *Crónica Mexicáyotl* (1997, 173) claimed that Valeriano was not born a noble, though he married into Mexica nobility through his union with a daughter of the Mexica gobernador, Don Diego Panitzin.

19. Some of these are found in the Archivo General de Indias (MP-Escudos 211, MP-Escudos 212, and MP-Mexico 48). A genealogy focusing on Don Pedro's descendants (AGI MP-Escudos 230) is dated much later, to the early nineteenth century.

20. Susan Spitler (1998, 77) has argued that the vertical orientation of native pictorial genealogies and their emphasis on direct descent may reflect the Spanish concept *por línea recta*, by straight line, that often shows up in colonial legal proceedings to reference direct descent in a manner similar to European genealogies. Alternatively, Justyna Olko (2007, 2012) has argued that the vertical orientation may be a case of European and native conceptions on lineage dovetailing, with the Nahua genealogies emphasizing *tlacamecayotl* (rope of kinship) in a manner similar to their European counterparts.

21. Alfonso Caso (1958, 25) suspected that the Fragmento was created to bolster the claims of Tizoc's descendants to landholdings in Ecatepec, a city referenced in an alphabetic annotation by the last female descendant. Most of the records related to Doña Isabel were written at the behest of Juan Cano, her Spanish husband. For more thorough studies of Isabel's claims, see Emma Pérez-Rocha (1998); Pérez-Rocha and Tena (2000); Donald E. Chipman (2005, 53–74); Martínez Baracs (2006, 133–147); and Anastasya Kalyuta (2008).

CHAPTER 5: A HISTORY OF THE MEXICA PEOPLE

1. Sepúlveda's larger argument was that Aristotle's doctrine of natural slavery should be applied to the native peoples of the Americas. Bartolomé de Las Casas countered that the native peoples were rational beings and as such not subject to slavery. For more on this debate, see Chapter 1 and Lewis Hanke (1994).

2. Much has been written on the Mexica migration. For syntheses and analyses of the various accounts, see Paul Kirchhoff (1966); Nigel Davies (1980); Boone (1991); Castañeda de la Paz (2002); and Christopher Beekman and Alexander F. Christensen (2003).

3. For more on Aztec sacred bundles and the bundle of Huitzilopochtli on the Mexica migration, see Molly H. Bassett (2015, 178–182).

4. This document was likely written by a Spanish scribe with access to a more thorough,

but now-lost, chronicle written by Fray Andrés de Olmos in Mexico during the 1530s (Baudot 1995, 193–201).

5. This account is contained in a three-volume work known as the *Codex Chimalpahin* (vol. 3, 87r–104r), which is now owned by Mexico's Instituto Nacional de Antropología e Historia. It is also translated into Spanish in Rafael Tena (2012, 199–247).

6. This account has been attributed to either the Mexica nobleman Alvarado de Tezozomoc or the Chalca historian Chimalpahin. See Schroeder (2011) and Sylvie Peperstraete and Gabriel Kenrick Kruell (2014) for the different sides of this debate. It is translated into Spanish in Tena (2012, 25–155).

7. Little is known about del Castillo's ethnic identity. He wrote his account in Nahuatl, and though it is unclear whether he was a mestizo or a native, he was clearly comfortable in both worlds (Christensen 1996, 445).

8. One source, the Tira de Tepechpan, shows Tepechpaneca migrants arriving at Teoculhuacan and in the year 1 Flint, but the Tepechpan painter often applied Mexica historical tropes to Tepechpan's history in the hopes of applying some of the capital's sacred prestige to the smaller city (Diel 2008, 28).

9. Navarrete (2000, 33) reads the sign instead as Tlatzallan, which is one of the first stops in the *Anales de Tlatelolco* (2004, 55). This identification accounts for the teeth portion of the name but not the divided hill.

10. The "Historia de los mexicanos por sus pinturas" (1965, 42) mentions the birth of three people at Chicomoztoc: two men and a woman, all *principales*, or nobles.

11. Figures by this secondary painter stand out because they are depicted in a faint black outline without color. The figures are also less skillfully drawn, being generally smaller and with distinctive heads with oversized noses. The additions by this contributor tend to be removed from the timeline and squeezed into blank spaces left by the primary painter, pointing to these being later additions.

12. Remnants of the dots used for coefficients are quite clear at the top of this page, suggesting another recycling of paper. Moreover, an extensive alphabetic text in Nahuatl begins on the lower register on page 24 and extends until page 34. As this deals with the zodiac, it is discussed in Chapter 3.

13. A similar place sign is not seen in other pictorial accounts of the migration. However, the *Crónica mexicáyotl* (1997, 85) mentions a stop at a place called Atenco soon after Atlitlalacyan.

14. An annotation here mentions Tezozomoc, but this name glyph is clearly not that of the Azcapotzalco ruler. I believe it was written in by the French annotator, as the handwriting and ink match the earlier annotation.

15. The accounts that follow are drawn from the "Historia de los mexicanos por sus pinturas" (1965, 45); Durán (1994, 29); *Crónica Mexicáyotl* (1997, 85); Chimalpahin Cuauhtlehuanitzin (1997, 1: 193–195; 1997, 2: 69); and *Anales de Tlatelolco* (2004, 57).

16. The leader is given different names: Tlahuizcalpotonqui, Tlahuizcalteuchtli, and Coyozacatzin. The last name is the best match for the name sign in the Mexicanus, if the spotted eye typical of dogs in Aztec pictorial writings was mistakenly read as a coyote (*coyotl*).

17. The faint lines that coincide with the footprints were likely guidelines used by the scribe to lay out his imagery before drawing it.

18. The "Historia" later confuses events at Michoacán with those concerning Malinalxochitl and Copil at Malinalco.

19. The meaning of the drawing of a wall and a European-style pointed banner is unclear, but it was likely painted by a different contributor, as the ink does not match that used in the rest of the scene.

20. The trace of another group of migrants floats above the year 8 Flint, but I suspect this was a mistake and was erased and replaced with the later migrants.

21. The green banner notations appear again above 9 House (1254) on page 32. The three banner signs signal that it had been sixty years

since the Mexica had left Chicomoztoc, as is re-iterated in the French annotation. However, five more dots were added, and a green line here leads to 13 Rabbit (1258) on page 33, giving sixty-five years since the Mexica had left Chicomoztoc and arrived at Chapultepec, as also noted by a French annotation.

22. There are five banners attached to the Chapultepec settlers, which references the 100 years that had passed since the Mexica began their migration. Also, an image a few years later on the lower register that looks like a craggy hill with grasshoppers crawling on it appears to be graffiti and is likely a later addition and not part of the primary migration account. The addition of eleven disks above 13 Rabbit (1258) may have been done to bring the reader forward to the additional Chapultepec sign, as it does indeed fall eleven years forward.

23. The rather fancy spear held by the Mexica warrior may be explained by Durán (1994, 34), who says that the Mexica invented a new weapon at this time, "a type of propelled spear."

24. This event must have been important, as it is also pictured in the Codices Aubin, Azcatitlan, and Boturini as well as the Tira de Tepechpan. Plus, there are a number of alphabetic accounts of the event; for examples, see "Historia de los mexicanos por sus pinturas" (1965, 49–51); Alvarado Tezozomoc (1987, 25–27); Chimalpahin Cuauhtlehuanitzin (1997 1: 205–207; 1997 2: 69–77; 1998 1: 159–171); and *Anales de Tlatelolco* (2004, 63–67).

25. It is interesting to note that the two founders who were highlighted in the genealogy, Tenzacatetl and Acacihtli, are not included in the Mexicanus foundation, suggesting that the contributors referenced accounts from different traditions.

26. Many central Mexican communities had migration accounts, and scholars have long questioned the historical versus mythical bases of these stories (see Smith 1984). While there is linguistic and archaeological proof to support a general migration of northern peoples into the Valley of Mexico in the Postclassic period, the specific stories of the migration were surely formed and

told for their symbolic and ideological import.

27. José de Acosta (2002, 387) also noted the similarity between the Mexica migration and the exodus of the Jews but ascribed this to Satan imitating God.

28. The hieroglyphic compounds that were added to pages 52 through 54 record a catechism using pictorial script and are discussed in Chapter 1 and Appendix 1.

29. For a more thorough analysis of the rationale behind this flower war between the Mexica and the Chalca, see Hassig (1992, 128–130).

30. In contrast to the Mexicanus' genealogy and the migration account, its imperial history includes no women.

31. There is a place-name sign for Matlatzinco just to the right, but it falls at the binding of the page, so whether and how it related to the vignette is not entirely clear.

32. Chimalpahin Cuauhtlehuanitzin (1997, 2: 53) records a rather complicated story concerning Chalco for this same year, claiming that the Chalca were falsely accused of hitting some Mexica on the heads with clubs.

33. The place sign for Acolman is difficult to distinguish from Acolhuacan, but since Acolhuacan is more of a general province that will come to be led by Texcoco, and Acolman was a town under Tepanec control, I suspect it is the town that is referenced here. The element above the Acolman place sign is difficult to read but may refer to the conquest of another town in the same year.

34. Chimalpopoca's death is recounted in Alva Ixtlilxochitl (1975 1: 357–358, 410); Durán (1994, 69); *Crónica Mexicáyotl* (1997, 129); and *Anales de Tlatelolco* (2004, 89).

35. According to the *Anales de Tlatelolco* (2004, 49), Cuacuauhtzin was sent to rule in Tepechpan. The Tira de Tepechpan does show a Tepechpaneca ruler with a homophonous name of a wooden stick (*cuahui-tl*), but it does not link him to Azcapotzalco. Moreover, though he also died an unnatural death, the Tira shows it later and due to different circumstances (see Diel 2008, 58).

36. For more thorough treatments of the relationship between Tlatelolco and Tenochtitlan, see Jaime Litvak King (1971); Robert Barlow (1987);

Ana Garduño (1997); Isabel Bueno Bravo (2005); and Castañeda de la Paz (2013).

37. The only link I could find in the sources to a scaffolding incident around this time involved the son of Itzcoatl, who was sent to rule Xilotepec and is also pictured in the Mexicanus genealogy (see Chapter 4). According to the Códice de Huichapan (2001, 32), this son died by falling off a scaffold in the year 1439.

38. Durán (1994, 238–241) provides a lengthy account of this famine.

39. The Chapultepec Aqueduct is also credited to Nezahualcoyotl in the Codex Azcatitlan (18r) and the *Anales de Cuauhtitlan* (2011, 187).

40. Traces remain of what must have been original paintings of Moteuczoma's death and Axayacatl's accession, but these were painted over and replaced with new ones just a few centimeters to the right.

41. One of the more intriguing causes of hostilities between Axayacatl and Tlatelolco's ruler, Moquihuix, was the abuse to which Moquihuix subjected his wife, who happened to be Axayacatl's sister, Chalchiuhnenetzin. For more on this, see Susan Toby Evans (1998, 174–176) and Diel (2007, 268–269).

42. The alphabetic sources that detail his death are Durán (1994, 260); the *Crónica Mexicáyotl* (1997, 139); and Alva Ixtlilxochitl (1997 2: 241). The *Anales de Tlatelolco* (2004, 95), not surprisingly, gives a very brief notice of his death.

43. For Spanish translations of the Nahuatl texts in the Codex Aubin, see Dibble (1963).

44. The Codex Telleriano-Remensis (39r) includes a place sign of a turquoise serpent, while the Codex en Cruz includes a victim from a place identified also with a snake and leaves (Dibble 1981, 1: 29). The Codex Aubin (38r) calls these people the Tziuhcouaca.

45. For example, the Codex Telleriano-Remensis (39r) claims that 20,000 were sacrificed, while Durán (1994, 339) puts the number even higher, at 80,400.

46. Alternatively, this may reference the construction of the well-known rock-cut temple devoted to eagle and jaguar warriors at Malinalco.

47. The contributor who had been adding red banners for each twenty-year span of time since the foundation of Tenochtitlan modified his work a bit under 1504. The nine banners record the 180 years that had passed since the foundation, but fifteen more disks were added to bring the count forward to 1519. This, then, lets viewers know that Tenochtitlan was only 195 years old when the Spaniards arrived. Either this or a different contributor started using red banners again in the colonial section to count the twenty-year increments since the arrival of the Spaniards. Accordingly, a single red banner is placed under 7 Rabbit (1538; Plate 41), then two red banners under 1558, and three red banners under 8 Rabbit (1578; Plate 43).

48. For example, the Tira de Tepechpan also signifies the arrival of Christianity (though in 1519) with an image of a descending dove (Diel 2008, 73). The Codex Aubin (40v) strangely references the appearance of *tlacahuillome*, or dove people, in 1508 and includes an image of a creature with the head of a man and body of a dove.

49. The 1528 year correlation inside the 7 House cartouche is incorrect, an error that continues in the correlations that follow.

50. The omission of Cuauhtemoc's exact means of death is typical in sources associated with Mexico City, whereas accounts from other localities note that he was hanged from a ceiba tree (Diel 2008, 75). The hanging is in the Tira de Tepechpan (page 15) and the Codex Vaticanus A (90r).

51. This trip to Spain is one of the more fascinating, but little-known, episodes of the early colonial period. To read more on it, see Howard Cline (1969) and Boone (2017).

52. Don Martín Cortés Nezahualtecolotzin had an interesting but short life. The 1528 trip to Spain was his second of three journeys there. During the first, he was placed in a Spanish monastery and received a Christian education. On his second trip, he was received at the court of King Charles V, and on the third, he was awarded a coat of arms, being one of the first Nahuas to receive such an honor. He appears to have

been groomed by the Spaniards for a leadership position, but he died soon after his return to New Spain in the 1530s (López de Meneses 1960; Castañeda de la Paz 2010, 290–291).

53. According to Motolinía (1951, 201), the first Christian marriage among natives took place in Texcoco in 1526. However, he is the only source to mention such an early marriage; others agree with the Mexicanus in placing this in 1529 (Lesbre 1999, 46). Patrick Lesbre (1999) has argued that Texcoco was deliberately chosen to host this first Christian marriage because of the political importance of the city in the immediate aftermath of the conquest. The lack of a place sign in the Mexicanus, though, suggests the first marriage took place in Mexico City.

54. The author of the Codex Aubin (45v) also shows the establishment of marriage in the same year and with a similar image; however, there the placement of the man and woman are flipped.

55. The Codex en Cruz records the death of Ixtlilxochitl II in this same year but records a man by a different name, Yoyotzin, as Texcoco's new ruler, though he died just one year later (Dibble 1981, 1: 50).

56. The Codex Aubin (46r) also uses a stone wheel to record the establishment of this market in the same year.

57. See James Lockhart (1992, 177–179) for a discussion of the introduction of money in New Spain.

58. A document in the collection of the Bibliothèque nationale de France known as the *Libro de tributos de San Pablo Teocaltitlan* (Fonds Mexicaine 376) includes many of the same solutions for Spanish name tags, including the Spanish sword for Pablo and the grill that will be seen later in the Mexicanus for Lorenzo. The book was created close in time to the Mexicanus and likely in the same barrio of San Pablo.

59. See Ida Altman (2010) for a thorough study of this war and the joint native and Spanish expeditions to Nueva Galicia in general.

60. The records related to this trial are published in *Proceso inquisitorial del cacique de Tetzcoco don Carlos Ometochtzin* (1980), and analyses

of the case, its background, and its aftermath can be found in Richard Greenleaf (1962); Patricia López Don (2008); and Ethelia Ruiz Medrano (2014).

61. The Codex Azcatitlan (24v) includes a volador pole with the flyers in motion, but according to Castañeda de la Paz and Oudijk (2012, 71–74), it refers to an event that would have happened in the late 1520s.

62. The notice of this death may further relate the Mexicanus to the San Pablo Barrio of Mexico City, as the Tapia family home was located there (Castañeda de la Paz 2013, 198).

63. Mundy (2015, 190–208) provides a thorough analysis of the issue of water control in late sixteenth-century Mexico City.

64. For pictorial examples, see Codex Aubin (51v), Codex Azcatitlan (25v), and the Codex en Cruz (3). The Codex of Tlatelolco presents a full narrative rendition of this event.

65. A trace of a funerary bundle is visible at the bottom of the page and may refer to Velasco's death, but it falls right at the book's binding, making an exact identification difficult.

66. The latest representation of Don Martín Cortés is distinct from the earlier ones, suggesting this was the work of a different painter.

67. For example, the Codex Aubin (78v) also names him as a judge and pictures him holding a vara, while the *Crónica Mexicáyotl* (1997, 173) notes that Valeriano married into nobility though he was not a nobleman himself.

68. The *Anales de Tecamachalco* (1992, 71) mention a Martín Cortés (presumably a different Martín Cortés than the son of the conquistador) being accused of idolatry in this year.

69. The Plano en Papel de Maguey (also known as the Plano Parcial de la Ciudad de México) is owned by the Museo Nacional de Antropología; for more on this work, see Castañeda de la Paz (2008). The Beinecke Map is owned by the Beinecke Library of Yale University and discussed in essays in Miller and Mundy (2012). The *Libro de Tributos de San Pablo* is owned by the Bibliothèque nationale de France.

70. Andrew Laird (2016, 176) points out that Sahagún also followed the model of St. Augustine in his descriptions of the Aztec gods, which, like the Roman gods described by St. Augustine, lacked morality.

71. Edward W. Osowski (2008, 608) sees colonial Mexican miracle narratives as expressions of history, and the image in the Mexicanus can be viewed in a similar light, as a visual narrative that also serves a historic function.

CHAPTER 6: CONCLUSIONS AND AN EPILOGUE

1. An edited volume by John Pohl and Claire Lyons (2016) also explores how the classical past influenced the encounter between the Spaniards and the Nahuas.

2. Also pointing to an eighteenth-century date are Spanish loanwords, such as *pero*, *para*, and *rei*.

3. This transcription corrects the orthography. For example, the scribe wrote *ctl* and *cl* for *tl* and left out some letters.

4. This translation was largely done by Camilla Townsend, who graciously read my original translation of this text and offered corrections for my mistakes and a new reading that made more sense. I divide the English translation into three stanzas to highlight the varied themes within the text.

5. Based on the confusing nature of the text, Camilla Townsend (personal communication, January 2017) suggested the likelihood of its having been written by a scribe who was trying to recall an ancient prayer but was not quite able to capture its exact phrasing.

APPENDIX I: PICTORIAL CATECHISM, CODEX MEXICANUS, PAGES 52–54

1. Louise Burkhart (personal communication, January 2017) and Elizabeth Boone (personal communication, October 2016) offered generous assistance in deciphering this section. A comparison with the Articles of Faith in the Atzaqualco Pictorial Catechism was also beneficial for this analysis (Burkhart 2016, 181–192), as was the Pictorial Catechism in the British Museum (see Figure 1.5).

Acosta, José de

2002 *Natural and Moral History of the Indies.* Edited by Jane E. Mangan, translated by Frances M. López-Morillas. Durham, NC: Duke University Press.

Actas de Cabildo

1889 *Actas de Cabildo de la Ciudad de Mexico.* Edited by Manuel Orozco y Berra. Mexico City: Aguilar e hijos.

Acuña-Soto, Rodolfo, David W. Stahle, Matthew D. Therrell, Richard D. Griffin, and Malcolm K. Cleaveland

2004 "When Half of the Population Died: The Epidemic of Hemorrhagic Fevers of 1576 in Mexico." *Federation of European Microbiology Societies Letters* 240:1–5.

Adorno, Rolena

1993 "Reconsidering Colonial Discourse for Sixteenth- and Seventeenth-Century Spanish America." *Latin American Research Review* 28(3):134–145.

Afanador-Pujol, Angélica J.

2010 "The Tree of Jesse and the 'Relación de Michoacán': Mimicry in Colonial Mexico." *Art Bulletin* 92(4):293–307.

Altman, Ida

2010 *The War for Mexico's West: Indians and Spaniards in New Galicia.* Albuquerque: University of New Mexico Press.

Alva Ixtlilxochitl, Fernando de

1997 *Obras históricas.* Edited by Edmundo O'Gorman. 2 vols. Mexico City: Universidad Nacional Autónoma de México.

Alvarado Tezozomoc, Hernando

1987　*Crónica mexicana*. Edited by Manuel Orozco y Berra. Mexico City: Editorial Porrúa.

Anales de Cuauhtitlan

2011　*Anales de Cuauhtitlan*. Translated by Rafael Tena. Mexico City: Consejo Nacional para la Cultura y las Artes.

Anales de Juan Bautista

2001　*Cómo te confundes? Acaso no somos conquistados? Anales de Juan Bautista*. Edited by Luís Reyes García. Mexico City: Centro de Investigaciones y Estudios Superiores en Antropología Social.

Anales de Tecamachalco

1992　*Anales de Tecamachalco, 1398–1590*. Edited by Eustaquio Celestino Solís y Luis Reyes García. Mexico City: Fondo de Cultura Económica.

Anales de Tlatelolco

2004　*Anales de Tlatelolco*. Translated by Rafael Tena. Mexico City: CONACULTA.

Andrews, J. Richard, and Ross Hassig

1988　"Aztec Medical Astrology." In *Smoke and Mist: Mesoamerican Studies in Honor of Thelma D. Sullivan*, edited by J. Kathryn Josserand and Karen Dakin, vol. 2, 605–627. Oxford: BAR.

Anonymous

1554　*Repertorio de los tiempos*. Francisco Fernández de Córdoba.

Anunciación, Fray Juan de la

1577　*Sermonario en lengua mexicana*. Mexico City: Antonio Ricardo.

Augustine, St.

2014　*City of God*. 7 vols. Cambridge, MA: Harvard University Press.

Avalos, Ana

2007　"As Above, So Below: Astrology and the Inquisition in Seventeenth-Century New Spain." PhD diss., European University Institute.

Aveni, Anthony

2012　*Circling the Square: How the Conquest Altered the Shape of Time in Mesoamerica*. Philadelphia: American Philosophical Society.

Barlow, Robert

1987　*Tlatelolco: Rival de Tenochtitlan: Obras de Robert Barlow, vol. 1*. Edited by Jesús Monjarás Ruiz, Elena Limón, y María de la Cruz Paillés. Mexico City: Instituto Nacional de Antropología e Historia.

Bassett, Molly H.

2015　*The Fate of Earthly Things: Aztec Gods and God-Bodies*. Austin: University of Texas Press.

Baudot, Georges

1995　*Utopia and History in Mexico: The First Chroniclers of Mexican Civilization (1520–1569)*. Niwot: University Press of Colorado.

Beekman, Christopher, and Alexander F. Christensen

2003　"Controlling for Doubt and Uncertainty through Multiple Lines of Evidence: A New Look at the Mesoamerican Nahua Migrations." *Journal of Archaeological Method and Theory* 10(2):111–164.

Berdan, Frances

1993　"Trauma and Transition in Sixteenth Century Central Mexico." *Proceedings of the British Academy* 81:163–195.

Berdan, Frances, and Patricia Anawalt

1992　*The Codex Mendoza*. 4 vols. Berkeley: University of California Press.

Boban, Eugène

1891 *Documents pour server à l'histoire du Mexique: Catalogue raisonné de la collection de M.E.-Eugène Goupil (ancienne collection J. M. A. Aubin)*. Paris: E. Leroux.

Bober, Harry

1948 "The Zodiacal Miniature of the Très Riches Heures of the Duke of Berry: Its Sources and Meaning." *Journal of the Warburg and Courtauld Institutes* 11:1–34.

Boone, Elizabeth Hill

1991 "Migration Histories as Ritual Performance." In *To Change Place: Aztec Ceremonial Landscapes*, edited by Davíd Carrasco, 121–151. Boulder: University Press of Colorado.

1994 "Aztec Pictorial Histories: Records without Words." In *Writing without Words: Alternative Literacies in Mesoamerica and the Andes*, edited by Elizabeth H. Boone and Walter Mignolo, 50–76. Durham, NC: Duke University Press.

1996 "Manuscript Painting in the Service of Imperial Ideology." In *Aztec Imperial Strategies*, edited by Frances F. Berdan et al., 181–208. Washington, DC: Dumbarton Oaks Research Library.

1999 "The 'Coatlicues' at the Templo Mayor." *Ancient Mesoamerica* 10(2):189–206.

2000 *Stories in Red and Black: Pictorial Histories of the Aztecs and Mixtecs*. Austin: University of Texas Press.

2005 "In Tlamatinime: The Wise Men and Women of Aztec Mexico." In *Painted Books and Indigenous Knowledge in Mesoamerica: Manuscript Studies in Honor of Mary Elizabeth Smith*, edited by Elizabeth Hill Boone, 9–25. New Orleans: Middle American Research Institute.

2007 *Cycles of Time and Meaning in the Mexican Books of Fate*. Austin: University of Texas Press.

2014 "Forward." In *Indigenous Intellectuals: Knowledge, Power, and Colonial Culture in Mexico and the Andes*, edited by Gabriela Ramos and Yanna Yannakakis, ix–xv. Durham, NC: Duke University Press.

2016 "A Merger of Preconquest and New Spanish Systems." In *Painted Words: Nahua Catholicism, Politics, and Memory in the Atzaqualco Pictorial Catechism*, edited by Elizabeth Hill Boone, Louise Burkhart, and David Tavárez, 35–51. Washington, DC: Dumbarton Oaks Research Library and Collection.

2017 "Seeking Indianness: Christoph Weiditz, the Aztecs, and Feathered Amerindians." *Colonial Latin American Review* 26(1):39–61.

Brandes, Stanley

1998 "Iconography in Mexico's Day of the Dead: Origins and Meaning." *Ethnohistory* 45(2):181–218.

Bricker, Victoria, and Helga-Maria Miram

2002 *An Encounter of Two Worlds: The Book of Chilam Balam of Kaua*. New Orleans: Middle American Research Institute.

Broda, Johanna

1991 "The Sacred Landscape of Aztec Calendar Festivals: Myth, Nature, and Society." In *To Change Place: Aztec Ceremonial Landscapes*, edited by Davíd Carrasco, 74–120. Boulder: University Press of Colorado.

Brotherston, Gordon

2000 "Indigenous Intelligence in Spain's American Colony." *Forum for Modern Language Studies* 36(3):241–253.

2005 *Feather Crown: The Eighteen Feasts of the Mexica Year*. London: British Museum.

2008 "America and the Colonizer Question: Two Formative Statements from Early Mexico." In *Coloniality at Large: Latin America and the Postcolonial Debate*, edited by Mabel Moraña, Enrique Dussel, and Carlos A. Jáuregui, 23–42. Durham, NC: Duke University Press.

Brown, Betty Ann

1977 "European Influences in Early Colonial Descriptions and Illustrations of the Mexica Monthly Calendar." PhD diss., University of New Mexico.

Bueno Bravo, Isabel

2005 "Tlatelolco: La gemela en la sombra." *Revista Española de Antropología Americana* 35:133–148.

Burkhart, Louise

1989 *The Slippery Earth: Nahua-Christian Moral Dialogue in Sixteenth-Century Mexico*. Tucson: University of Arizona Press.

2016 "Deciphering the Catechism." In *Painted Words: Nahua Catholicism, Politics, and Memory in the Atzaqualco Pictorial Catechism*, edited by Elizabeth Hill Boone, Louise Burkhart, and David Tavárez, 161–215. Washington, DC: Dumbarton Oaks Research Library and Collection.

Burkhart, Louise, Elizabeth Hill Boone, and David Tavárez

2016 "The Atzaqualco Catechism and Colonial Mexican Catechismal Pictography." In *Painted Words: Nahua Catholicism, Politics, and Memory in the Atzaqualco Pictorial Catechism*, edited by Elizabeth Hill Boone, Louise Burkhart, and David Tavárez, 1–33. Washington, DC: Dumbarton Oaks Research Library and Collection.

Cañizares-Esguerra, Jorge

1999 "New World, New Stars: Patriotic Astrology and the Invention of Indian and Creole Bodies in Colonial Spanish America, 1600–1650." *The American Historical Review* 104(1):33–68.

2001 *How to Write the History of the New World: Histories, Epistemologies, and Identities in the Eighteenth Century Hispanic World*. Stanford: Stanford University Press.

Carey, Hilary M.

2003 "What Is the Folded Almanac? The Form and Function of a Key Manuscript Source for Astro-Medical Practice in Later Medieval England." *Social History of Medicine* 16(3):481–509.

2004 "Astrological Medicine and the Medieval English Folded Almanac." *Social History of Medicine* 17(3):345–363.

Carlebach, Elisheva

2011 *Palaces of Time: Jewish Calendar and Culture in Early Modern Europe*. Cambridge, MA: Belknap Press of Harvard University Press.

Carrasco, Pedro

1984 "Royal Marriages in Ancient Mexico." In *Explorations in Ethnohistory: Indians of Central Mexico in the Sixteenth Century*, edited by H. R. Harvey and Hanns J. Prem, 41–81. Albuquerque: University of New Mexico Press.

1999 *The Tenochca Empire of Ancient Mexico: The Triple Alliance of Tenochtitlan, Tetzcoco, and Tlacopan*. Norman: University of Oklahoma Press.

Cartas de Indias

1877 *Cartas de Indias*. Madrid: Ministerio de Fomento.

Caso, Alfonso

1958 "Fragmento de genealogía de los príncipes mexicanos." *Journal de la Société des Américanistes* 47:21–32.

1971 "Calendrical Systems of Central Mexico." In *Handbook of Middle American Indians*, vol. 10, edited by Gordon Eckholm and Ignacio Bernal, 333–348. Austin: University of Texas Press.

Caso Barrera, Laura

2011 *Chilam Balam de Ixil: Facsimilar y estudio de un libro maya inédito*. Mexico City: Instituto Nacional de Antropología e Historia y Artes de México.

Castañeda de la Paz, María

2002 "De Aztlan a Tenochtitlan: Historia de una peregrinación." *Latin American Indian Literatures Journal* 18(2):163–212.

2006 *Pintura de la peregrinación de los culhuaque-mexitin (El Mapa de Sigüenza)*. Zinacantepec, Mexico: El Colegio Mexiquense; Mexico City: CONACULTA-INAH.

2008 "El plano parcial de la Ciudad de México: Nuevas aportaciones con base en el estudio de su lista de Tlatoque." In *Símbolos de poder en Mesoamérica*, edited by Guilhem Olivier, 393–426. Mexico City: Universidad Nacional Autónoma de México.

2010 "Privileges of the 'Others': The Coats of Arms Granted to Indigenous Conquistadors." In *The International Emblem: From Incunabula to the Internet*, edited by Simon McKeown, 283–316. Newcastle, England: Cambridge Scholars Publishing.

2011 "Historia de una casa real: Origen y ocaso del linaje gobernante en México-Tenochtitlan." *Nuevo Mundo Mundos Nuevos*. Accessed November 3, 2016. http://nuevomundo.revues.org/60624.

2013 *Conflictos y alianzas en tiempos de cambio: Azcapotzalco, Tlacopan, Tenochtitlan y Tlatelolco (siglos xii–xvi)*. Mexico City: Universidad Nacional Autónoma de México, Instituto de Investigaciones Antropológicas.

2016 "El árbol genealógico de la Casa Real de Tenochtitlan en el Códice Mexicanus." *Itinerarios* 24:123–146.

Castañeda de la Paz, María, and Michel Oudijk

2010 "La colección de manuscritos de Boturini: Una mirada desde el siglo XXI." In *El caballero Lorenzo Boturini: Entre dos mundos y dos historias*, edited by Michel Oudijk and María Castañeda de la Paz, 87–128. Mexico City: Museo de la Basílica de Guadalupe.

2012 "La conquista y la colonia en el *Códice Azcatitlan*." *Journal de la Société des Américanistes* 98(2):59–95.

Castillo, Cristóbal del

[1600] *Historia de la venida de los mexicanos y*
1991 *otros pueblos e Historia de la conquista*. Translated and edited by Federico Navarrete Linares. Mexico City: Instituto Nacional de Antropología e Historia.

Cervantes, Fernando

1994 *The Devil in the New World: The Impact of Diabolism in New Spain*. New Haven, CT: Yale University Press.

Chaves, Gerónimo de

[1543] *Chronographia o reportorio de los tiempos*.
1576 Seville: Alonso Escrivano.

Chimalpahin Cuauhtlehuanitzin, Domingo

1997 *Codex Chimalpahin: Society and Politics in Mexico Tenochtitlan, Tlatelolco, Texcoco, Culhuacan, and Other Nahua Altepetl in Central Mexico*. Edited and translated by Arthur J. O. Anderson and Susan Schroeder. 2 vols. Norman: University of Oklahoma Press.

1998 *Las ocho relaciones y el memorial de Col-huacan*. Edited and translated by Rafael Tena. 2 vols. Consejo Nacional para la Cultura y las Artes.

Chipman, Donald E.

2005 *Moctezuma's Children: Aztec Royalty under Spanish Rule, 1520–1700*. Austin: University of Texas Press.

Christensen, Alexander F.

1996 "Cristobal del Castillo and the Mexica Exodus." *The Americas* 52(4):441–464.

Clark, Charles

1979 "The Zodiac Man in Medieval Medical Astrology." PhD diss., University of Colorado at Boulder.

Cline, Howard F.

1969 "Hernando Cortés and the Aztec Indians in New Spain." *Quarterly Journal of the Library of Congress* 26(2):70–90

Codex Aubin

1981 *Geschichte der Azteken: Codex Aubin und verwandte Dokumente*. Edited by Walter Lehmann and Gerdt Kutscher. Berlin: Mann.

Codex Azcatitlan

1995 *Codex Azcatitlan*, vol. 2. Edited by Michel Graulich. Paris: Bibliothèque nationale de France, Société des Américanistes.

Codex Boturini

1964 "Tira de la Peregrinación, o Códice Boturini." In *Antigüedades de México basadas en la recopilación de Lord Kingsborough*, edited by José Corona Núñez, vol. 2, 8–29. Mexico City: Secretaría de Hacienda y Crédito Público.

Codex Cozcatzin

1994 *Códice Cozcatzin*. Edited by Ana Rita Valero de García Lasceráin and Rafael Tena. Mexico City: Instituto Nacional de Antropología e Historia

Codex en Cruz. See Dibble 1981, atlas.

Codex Mendoza. See Berdan and Anawalt 1992, vol. 3.

Codex Telleriano-Remensis. See Quiñones Keber 1995.

Codex Vaticanus A

1964 "Códice Vaticano Ríos, o Códice Latino." In *Antigüedades de México basadas en la recopilación de Lord Kingsborough*. Edited by José Corona Núñez, vol. 3. Mexico City: Secretaría de Hacienda y Crédito Público.

Codex Xolotl

1996 *Códice Xolotl*, vol. 2. Edited by Charles Dibble. Mexico City: Instituto de Investigaciones Históricas.

Códice de Huichapan

2001 *Códice de Huichapan: Paleografía y traducción*. Edited by Yolanda Lastra and Doris Bartholomew. Mexico City: Instituto de Investigaciones Antropológicas.

Colston, Stephen

1985 "'No Longer Will There Be a Mexico': Omens, Prophecies, and the Conquest of the Aztec Empire." *American Indian Quarterly* 9(3):239–258.

Connell, William F.

2011 *After Moctezuma: Indigenous Politics and Self-Government in Mexico*. Norman: University of Oklahoma Press.

Constituciones del Arzobispado

1556 *Constituciones del Arzobispado*. Mexico City: Juan Pablos.

Cook, Noble David

1998 *Born to Die: Disease and New World Conquest, 1492–1650.* Cambridge, England: Cambridge University Press.

Cortés, Hernán

1986 *Letters from Mexico.* Translated and edited by Anthony Pagden. New Haven, CT: Yale University Press.

Cortez, Constance

2002 "New Dance, Old Xius: The 'Xiu Family Tree' and Maya Cultural Continuity after European Contact." In *Heart of Creation: The Mesoamerican World and the Legacy of Linda Schele*, edited by Andrea Stone, 201–215. Tuscaloosa: University of Alabama Press.

Cosentino, Delia

2002 "Landscapes of Lineage: Nahua Pictorial Genealogies of Early Colonial Tlaxcala, Mexico." PhD diss., University of California, Los Angeles.

2007 "Nahua Pictorial Genealogies." In *Sources and Methods for the Study of Postconquest Mesoamerican Ethnohistory*, edited by James Lockhart, Lisa Sousa, and Stephanie Wood, 1–18. whp.uoregon.edu/Lockhart/index.html.

Crónica Mexicáyotl

1997 "Mexican History or Chronicle." In *Codex Chimalpahin: Society and Politics in Mexico Tenochtitlan, Tlatelolco, Texcoco, Culhuacan, and Other Nahua Altepetl in Central Mexico*, edited and translated by Arthur J. O. Anderson and Susan Schroeder, vol. 1, 27–177. Norman: University of Oklahoma Press.

Cummins, Thomas B. F.

1995 "From Lies to Truth: Colonial Ekphrasis and the Act of Crosscultural Translation." In *Reframing the Renaissance: Visual Culture in Europe and Latin America 1450–1650,* edited by Claire Farago, 152–174. New Haven, CT: Yale University Press.

2016 "Toward a New World's Laocoön: Thoughts on Seeing Aztec Sculpture through Spanish Eyes." In *Altera Roma: Art and Empire from Mérida to Mexico*, edited by John M. D. Pohl and Claire L. Lyons, 215–256. Los Angeles: University of California, Los Angeles, Cotsen Institute of Archaeology Press.

Davies, Nigel

1980 *The Toltec Heritage: From the Fall of Tula to the Rise of Tenochtitlan.* Norman: University of Oklahoma Press.

Dean, Carolyn, and Dana Leibsohn

2003 "Hybridity and Its Discontents: Considering Visual Culture in Colonial Spanish America." *Colonial Latin American Review* 12(1):5–35

Delbrugge, Laura (editor)

1999 *Reportorio de los tiempos.* London: Tamesis.

Díaz Álvarez, Ana Guadalupe

2011 "Las formas del tiempo: Tradiciones cosmográficas en los calendarios indígenas del México Central." PhD diss., Universidad Nacional Autónoma de México.

Dibble, Charles E.

1963 *Historia de la nación mexicana: Códice de 1576 (Códice Aubin).* Madrid: J. Porrúa Turanzas.

1981 *Codex en Cruz.* 2 vols. Salt Lake City: University of Utah Press.

DiCesare, Catherine

2009 *Sweeping the Way: Divine Transformation in the Aztec Festival of Ochpaniztli.* Boulder: University of Colorado Press.

Diel, Lori Boornazian

2005a "Women and Political Power: The Inclusion and Exclusion of Noblewomen in Aztec Pictorial Histories." *Res* 47(1):82–106.

2005b "Painting Colonial Mexico: The Appropriation of European Iconography in Mexican Manuscript Painting." In *Painted Books and Indigenous Knowledge: Manuscript Studies in Honor of Mary Elizabeth Smith*, edited by Elizabeth H. Boone, 301–317. New Orleans: Middle American Research Institute, Tulane University.

2007 "Till Death Do Us Part: Unconventional Marriages as Aztec Political Strategy." *Ancient Mesoamerica* 18(2):259–272.

2008 *The Tira de Tepechpan: Negotiating Place under Aztec and Spanish Rule*. Austin: University of Texas Press.

2013 "The Poetics and Politics of Aztec History." In *Thinking, Recording, and Writing History in the Ancient World*, edited by Kurt A. Raaflaub, 372–390. Chichester, West Sussex, England: Wiley Blackwell.

2015 "The Codex Mexicanus Genealogy: Binding the Mexica Past and Colonial Present." *Colonial Latin American Review* 24(2):120–146.

2016 "The Codex Mexicanus: Time, Religion, History, and Health in Sixteenth-Century New Spain." *The Americas* 73(4):427–458.

Douglas, Eduardo de J.

2010 *In the Palace of Nezahualcoyotl: Painting Manuscripts, Writing the Pre-Hispanic Past in Early Colonial Period Tetzcoco, Mexico*. Austin: University of Texas Press.

Durán, Diego

1971 *Book of the Gods and Rites of the Ancient Calendar*. Norman: University of Oklahoma Press.

1994 *The History of the Indies of New Spain*. Translated, annotated, and with an introduction by Doris Heyden. Norman: University of Oklahoma Press.

Edson, Evelyn

1996 "World Maps and Easter Tables: Medieval Maps in Context." *Imago Mundi* 48(1):25–42.

Ennis, Arthur O.S.A.

1957 *Fray Alonso de la Vera Cruz O.S.A. (1507–1584): A Study of His Life and His Contribution to the Religious and Intellectual Affairs of Early Mexico*. Leuven, Belgium: Imprimerie E. Warny.

Escalante Gonzalbo, Pablo

2010 *Los Códices Mesoamericanos antes y después de la Conquista Española*. Mexico City: Fondo de Cultura Económica.

Espantoso-Foley, Augusta

1964 "The Problem of Astrology and Its Use in Ruiz de Alarcon's El dueño de las estrellas." *Hispanic Review* 32(1):1–11.

Evans, Susan Toby

1998 "Sexual Politics in the Aztec Palace: Public, Private, Profane." *Res* 33:167–183.

Farriss, Nancy

1987 "Remembering the Future, Anticipating the Past: History, Time, and Cosmology among the Maya of Yucatan." *Comparative Studies in Society and History* 29(3):580–81.

Fernández, María

2014 *Cosmopolitanism in Mexican Visual Culture*. Austin: University of Texas Press.

Fernández-Arnesto, Felipe

1992 "'Aztec' Auguries and Memories of the Conquest of Mexico." *Renaissance Studies* 6(3/4):287–305.

Fernández del Castillo, Franciso

1982 *Libros y libreros en el siglo xvi*. Mexico City: Archivo General de la Nación, Fondo de Cultura Económica.

Flint, Shirley Cushing

2008 "Treason or Travesty: The Martín Cortés Conspiracy Reexamined." *Sixteenth Century Journal* 39(1):23–44.

Florescano, Enrique

1994 *Memory, Myth, and Time in Mexico: From the Aztecs to Independence*. Austin: University of Texas Press.

Foster, George M.

1987 "On the Origin of Humoral Medicine in Latin America." *Medical Anthropology Quarterly* 1:355–393.

Gaillemin, Bérénice

2011 "Images mémorables pour un texte immuable." *Gradhiva* 13:205–225. Accessed October 1, 2016. http://gradhiva.revues.org/2068.

Galarza, Joaquín

1980 *Estudios de escritura indígena tradicional (Azteca-Nahuatl)*. Mexico City: Archivo General de la Nación, Centro de Investigaciones Superiores del INAH.

Gante, Pedro de

1981 *Doctrina christiana en lengua mexicana*. Edited by Ernesto de la Torre Villar. Mexico City: Centro de Estudios Históricos Fray Bernardino de Sahagún.

Garduño, Ana

1997 *Conflictos y alianzas entre Tlatelolco y Tenochtitlan, siglos xii a xv*. Mexico City: Instituto Nacional de Antropología e Historia.

George-Hirons, Amy

2015 "Yokol Cab: Mayan Translation of European Astrological Texts and Images in the Book of Chilam Balam of Kaua." *Ethnohistory* 62(3):525–552.

Gibson, Charles

1964 *The Aztecs under Spanish Rule: A History of the Indians of the Valley of Mexico, 1519–1810*. Stanford, CA: Stanford University Press.

Gillespie, Susan

1989 *The Aztec Kings: The Construction of Rulership in Mexica History*. Tucson: University of Arizona Press.

Gimmel, Millie

2008 "Reading Medicine in the Codex de la Cruz Badiano." *Journal of the History of Ideas* 69(2):169–192.

Glass, John B.

1975 "The Boturini Collection." In *Handbook of Middle American Indians*, vol. 15, edited by Robert Wauchope, 473–486. Austin: University of Texas Press.

Gonzalbo Aizpuru, Pilar

1990 *Historia de la educación en la época colonial: El mundo indígena*. Mexico City: El Colegio de Mexico.

González Sánchez, Carlos Alberto

1999 *Los Mundos del libro: Medios de difusión de la cultura occidental en las Indias de los siglos XVI y XVII*. Seville: Diputación de Sevilla, Universidad de Sevilla.

Gramsci, Antonio

1971 *Selections from the Prison Notebooks of Antonio Gramsci.* Translated and edited by Quintin Hoare and Geoffrey Nowell Smith. New York: International Publishers.

Graulich, Michel

1995 *Codex Azcatitlan Commentaire.* Paris: Bibliothèque nationale de France and Société des Américanistes.

Gravier, Marina Garone

2011 "Sahagún's Codex and Book Design in the Indigenous Context." In *Colors between Two Worlds: The Florentine Codex of Bernardino de Sahagún,* edited by Gerhard Wolf and Joseph Connors with Louis A. Waldman, 157–197. Florence: Kunsthistorisches Institut in Florenz and Villa I Tatti.

Greenleaf, Richard

1962 *Zumárraga and the Mexican Inquisition: 1536–1543.* Washington, DC: Academy of American Franciscan History.

Gruzinski, Serge

1993 *The Conquest of Mexico: The Incorporation of Indian Societies into the Western World, 16th–18th Centuries.* Translated by Eileen Corrigan. Cambridge: Polity Press.

2002 *The Mestizo Mind: The Intellectual Dynamics of Colonization and Globalization.* Translated by Deke Dusinberre. New York: Routledge.

Hanke, Lewis

1994 *All Mankind Is One: A Study of the Disputation between Bartolomé de Las Casas and Juan Ginés de Sepúlveda in 1550 on the Intellectual and Religious Capacity of the American Indians.* DeKalb: Northern Illinois University Press.

Hanks, William F.

2010 *Converting Words: Maya in the Age of the Cross.* Berkeley: University of California Press.

Hassig, Ross

1992 *War and Society in Ancient Mesoamerica.* Berkeley: University of California Press.

2001 *Time, History, and Belief in Aztec and Colonial Mexico.* Austin: University of Texas Press.

Heyden, Doris

1981 "Caves, Gods, and Myths: World-View and Planning in Teotihuacan." In *Mesoamerican Sites and World-Views,* edited by Elizabeth Benson, 1–35. Washington, DC: Dumbarton Oaks Research Library.

Hicks, Frederick

1994 "Texcoco 1515–1519: The Ixtlilxochitl Affair." In *Chipping Away on Earth: Studies in Prehispanic and Colonial Mexico in Honor of Arthur J. O. Anderson and Charles E. Dibble,* edited by Eloise Quiñones Keber, 35–239. Lancaster, CA: Labyrinthos.

Hinojosos, Alonso López de

1977 *Suma y recopilación de cirugía con un arte para sangrar muy útil y provechosa.* Mexico City, Academia Nacional de Medicina.

Historia de los mexicanos por sus pinturas

1965 "Historia de los mexicanos por sus pinturas." In *Teogonía e historia de los mexicanos: Tres opúsculos del siglo xvi,* edited by Angel Ma. Garibay, 23–66. Mexico City: Editorial Porrúa.

Hourihane, Colum

2007 *Time in the Medieval World: Occupations of the Months and the Signs of the Zodiac in the Index of Christian Art.* Princeton,

NJ: Princeton University and Penn State University Press.

Kalyuta, Anastasya

2008 "La casa y hacienda de un señor mexica: Un estudio analítico de la 'Información de doña Isabel de Moctezuma.'" *Anuario de Estudios Americanos* 65(2):13–37.

Kirchhoff, Paul

1966 "Civilizing the Chichimecs: A Chapter in the Culture History of Ancient Mexico." In *Ancient Mesoamerica: Selected Readings*, edited by John A. Graham, 273–278. Palo Alto, CA: Peek Publications.

Klapisch-Zuber, Christiane

1991 "The Genesis of the Family Tree." *I Tatti Studies in the Italian Renaissance* 4:105–129.

Klein, Cecelia

2000 "The Devil and the Skirt: An Iconographic Inquiry into the Pre-Hispanic Nature of the Tzitzimime." *Ancient Mesoamerica* 11(1):1–26.

Kobayashi, José María

1974 *La educación como conquista: Empresa franciscana en México*. Mexico City: El Colegio de México.

Kubler, George, and Charles Gibson

1951 *The Tovar Calendar: An Illustrated Mexican Manuscript ca. 1585*. New Haven, CT: Yale University Press.

Laird, Andrew

2016 "Aztec and Roman Gods in Sixteenth-Century Mexico." In *Altera Roma: Art and Empire from Mérida to Mexico*, edited by John M. D. Pohl and Claire L. Lyons, 167–187. Los Angeles: University of California, Cotsen Institute of Archaeology Press.

Lara, Jaime

2008 *Christian Texts for Aztecs: Art and Liturgy in Colonial Mexico*. Notre Dame, IN: University of Notre Dame Press.

Leonard, Irving

1992 *Books of the Brave*. Berkeley: University of California Press.

León-Portilla, Miguel

1963 *Aztec Thought and Culture: A Study of the Ancient Nahuatl Mind*. Norman: University of Oklahoma Press.

1979 *Un catecismo náhuatl en imágenes*. México: Cartón y Papel de México.

Lesbre, Patrick

1999 "Les enjeux d'un mariage chrétien en Nouvelle Espagne: Texcoco, octobre 1526." *Caravelle* 73(1):27–49.

Li, Andrés de

1492 *Repertorio de los tiempos*. Spain: Pablo Hurus.

Litvak King, Jaime

1971 "Las relaciones entre México y Tlatelolco antes de la conquista de Axayácatl." *Estudios de Cultura Nahuatl* 9:17–20.

Lockhart, James

1992 *The Nahuas after the Conquest: A Social and Cultural History of the Indians of Central Mexico, Sixteenth through Eighteenth Centuries*. Stanford, CA: Stanford University Press.

López Austin, Alfredo

1973 "Un reportorio de los tiempos en idioma náhuatl." *Anales de Antropología* 10:285–296.

1988 *The Human Body and Ideology: Concepts of the Ancient Nahuas*. Salt Lake City: University of Utah Press.

López de Meneses, Amada

1960 "Dos hijos de Moctezuma en España." *Cuadernos de Historia de España* 31:188–200.

López Don, Patricia

2008 "The 1539 Inquisition and Trial of Don Carlos of Texcoco in Early Mexico." *Hispanic American Historical Review* 88(4):573–606.

Love, Edgar F.

1967 "Negro Resistance to Spanish Rule in Colonial Mexico." *Journal of Negro History* 52(2):89–103.

Lupher, David

2006 *Romans in a New World: Classical Models in Sixteenth-Century Spanish America.* Ann Arbor: University of Michigan Press.

Magaloni-Kerpel, Diana

2003 "Visualizing the Nahua/Christian Dialogue: Images of the Conquest in Sahagún's Florentine Codex and Their Sources." In *Sahagún at 500: Essays on the Quincentenary of the Birth of Fr. Bernardino de Sahagún*, edited by John Frederick Schwaller, 193–221. Berkeley: Academy of American Franciscan History.

Martínez, Enrico

[1606] *Reportorio de los tiempos y historia natural*
1981 *de Nueva España.* Mexico City: Centro de Estudios de Historia de México.

Martínez, María Elena

2008 *Genealogical Fictions: Limpieza de Sangre, Religion, and Gender in Colonial Mexico.* Stanford, CA: Stanford University Press.

Martínez Baracs, Rodrigo

2006 *La perdida Relación de la Nueva España y su conquista de Juan Cano.* Mexico City: Instituto Nacional de Antropología e Historia.

Mathes, W. Michael

1985 *The America's First Academic Library: Santa Cruz de Tlatelolco.* Sacramento: California State Library Foundation.

1996 "Humanism in Sixteenth- and Seventeenth-Century Libraries of New Spain." *The Catholic Historical Review* 82(3):412–435.

Maya Society, The

1935 *A Planetary Calendar en Lengua Mexicana del Año 1639.* Baltimore: The Maya Society.

McCaa, Robert

1995 "Spanish and Nahuatl Views on Smallpox and Demographic Catastrophe in Mexico." *Journal of Interdisciplinary History* 25(3):397–431.

Mendieta, Fray Geronimo de

1945 *Historia eclesiástica indiana.* 4 vols. Mexico City: Editorial Salvador Chávez Hayhoe.

Mengin, Ernst

1952 "Commentaire du Codex Mexicanus, Nos. 23–24 de la Bibliothèque National de Paris." *Journal de la Société des Américanistes* 41(2):387–498.

Milbrath, Susan

2013 *Heaven and Earth in Ancient Mexico: Astronomy and Seasonal Cycles in the Codex Borgia.* Austin: University of Texas Press.

Miller, Mary Ellen, and Barbara Mundy (editors)

2012 *Painting a Map of Sixteenth-Century Mexico City: Land, Writing, and Native Rule.* New Haven, CT: Yale University Press.

Mota Padilla, Matias de

1870 *Historia de la conquista de la provincia de la Nueva Galicia.* Mexico City: La Sociedad Mexicana de Geografía y Estadística.

Motolinía, Fray Toribio

1951 *Motolinía's History of the Indians of New Spain.* Edited and translated by Francis Borgia Steck. Washington, DC: Academy of American Franciscan History.

Mundy, Barbara

2012 "Crown and Tlatoque: The Iconography of Rulership in the Beinecke Map." In *Painting a Map of Sixteenth-Century Mexico City: Land, Writing, and Native Rule,* edited by Mary Ellen Miller and Barbara Mundy, 31–52. New Haven: Yale University Press.

2015 *The Death of Aztec Tenochtitlan, the Life of Mexico City.* Austin: University of Texas Press.

Muñoz Camargo, Diego

2002 *Historia de Tlaxcala.* Edited by Germán Vázquez Chamorro. Madrid: Dastin.

Navarrete, Federico

2000 "The Path from Aztlan to Mexico: On Visual Narration in Mesoamerican Codices." *Res* 37(Spring):31–48.

Nesvig, Martin Austin

2006 "'Heretical Plagues' and Censorship Cordons: Colonial Mexico and the Transatlantic Book Trade." *Church History* 75(1):1–37

2013 "The Epistemological Politics of Vernacular Scripture in Sixteenth-Century Mexico." *The Americas* 70(2):165–201.

Nicholson, H. B.

1971 "Pre-Hispanic Central Mexican Historiography." In *Investigaciones contemporáneas sobre historia de México,* 38–81. Mexico City: Universidad Nacional Autónoma de México.

Nowotny, Karl Anton

1973 "Die spanischen 'Reportorios de los tiempos.'" In *Festschrift zum 65: Geburtstag vom Helmut Petri,* edited by Kurt Tauchmann, 390–406. Cologne: Böhlau.

2005 *Tlacuilolli: Style and Contents of the Mexican Pictorial Manuscripts with a Catalog of the Borgia Group,* translated and edited by George A. Everett Jr. and Edward B. Sisson. Norman: University of Oklahoma Press.

Nuttall, Zelia

1903 *The Book of the Life of Ancient Mexicans, Containing an Account of Their Rites and Superstitions.* Berkeley: University of California.

O'Boyle, Cornelius

2005 "Astrology and Medicine in Later Medieval England: The Calendars of John Somer and Nicholas Lynn." *Sudhoffs Archive* 89(1):1–22.

O'Daly, Gerald J. P.

1999 *Augustine's City of God: A Reader's Guide.* Oxford and New York: Oxford University Press.

Olko, Justyna

2007 "Genealogías indígenas del centro de México: Raíces prehispánicas de su florecimiento colonial." *Itinerarios* 6:141–162.

2012 "Remembering the Ancestors: Native Pictorial Genealogies of Central Mexico and Their Pre-Hispanic Roots." In *Mesoamerican Memory: Enduring Systems of Remembrance,* edited by Amos Megged and Stephanie Wood, 51–72. Norman: University of Oklahoma Press.

Osowski, Edward W.

2008 "Passion Miracles and Indigenous Historical Memory in New Spain." *Hispanic American Historical Review* 88(4):607–638.

Padden, Robert Charles

1956 "The Ordenanza del Patronazgo, 1574: An Interpretive Essay." *The Americas* 12(4):333–354.

Palerm, Angel

1973 *Obras hidráulicas prehispánicas en el sistema lacustre del Valle de México.* Mexico City: Instituto Nacional de Antropología e Historia.

Peperstraete, Sylvie, and Gabriel Kenrick Kruell

2014 "Determining the Authorship of the Crónica Mexicayotl: Two Hypotheses." *The Americas* 71(2):315–338.

Pérez de Vargas, Bernardo

1563 *La fábrica del universo o repertorio perpetuo.* Toledo.

Pérez-Rocha, Emma

1998 *Privilegios en lucha: La información de doña Isabel de Moctezuma.* Mexico City: Instituto Nacional de Antropología e Historia.

Pérez-Rocha, Emma, and Rafael Tena

2000 *La nobleza indígena del centro de México después de la conquista.* Mexico City: Instituto Nacional de Antropología e Historia.

Peterson, Jeannette Favrot

1993 *The Paradise Garden Murals of Malinalco: Utopia and Empire in Sixteenth-Century Mexico.* Austin: University of Texas Press.

2014 *Visualizing Guadalupe: From Black Madonna to Queen of the Americas.* Austin: University of Texas Press.

Pettas, William

1995 *A Sixteenth-Century Spanish Bookstore: The Inventory of Juan de Junta.* Philadelphia: American Philosophical Society.

Phelan, John Leddy

1970 *The Millennial Kingdom of the Franciscans in the New World.* Berkeley: University of California Press.

Platt, Tristan

2014 "Conclusion." In *Indigenous Intellectuals: Knowledge, Power, and Colonial Culture in Mexico and the Andes,* edited by Gabriela Ramos and Yanna Yannakakis, 261–278. Durham, NC: Duke University Press.

Pohl, John M.D., and Claire L. Lyons (editors)

2016 *Altera Roma: Art and Empire from Mérida to Mexico.* Los Angeles: University of California, Cotsen Institute of Archaeology Press.

Prem, Hanns J.

1978 "Comentario a las partes calendáricas del Codex Mexicanus 23–24." *Estudios de Cultura Náhuatl* 13:267–288.

1991 "Disease Outbreaks in Central Mexico during the Sixteenth Century." In *"Secret Judgments of God": Old World Disease in Colonial Spanish America,* edited by Noble David Cook and W. George Lovell, 20–48. Norman: University of Oklahoma Press.

2008 *Manual de la antigua cronología mexicana.* Mexico City: Centro de Investigaciones y Estudios Superiores en Antropología Social.

Prem, Hanns J., Sabine Dedenbach-Salazar Sáenz, Frauke Saschese, and Frank Seeliger

2015 *Relación de la genealogía y origen de los mexicanos: Dos documentos del Libro de*

Oro. Mexico City: Universidad Nacional Autónoma de México; Bonn: Rheinische Friedrich-Wilhelms-Universität Bonn.

Proceso inquisitorial del cacique de Tetzcoco don Carlos Ometochtzin

1980 *Proceso inquisitorial del cacique de Tetzcoco don Carlos Ometochtzin*. Mexico City: Patrimonio Cultural y Artístico del Estado de México.

Quiñones Keber, Eloise

1995 *Codex Telleriano-Remensis: Ritual, Divination, and History in a Pictorial Aztec Manuscript*. Austin: University of Texas Press.

Ramos, Gabriela, and Yanna Yannakakis

2014 "Introduction." In *Indigenous Intellectuals: Knowledge, Power, and Colonial Culture in Mexico and the Andes*, edited by Gabriela Ramos and Yanna Yannakakis, 1–19. Durham, NC: Duke University Press.

Regiomontanus, Johannes

1512 *Kalender*. Augsburg.

Reyes-Valerio, Constantino

1989 *El pintor de conventos: Los murales del siglo xvi en la Nueva España*. Mexico City: Instituto Nacional de Antropología e Historia.

Ricard, Robert

1966 *The Spiritual Conquest of Mexico: An Essay on the Apostolate and the Evangelizing Methods of the Mendicant Orders in New Spain, 1523–1572*. Translated by Lesley Byrd Simpson. Berkeley: University of California Press.

Robertson, Donald

1954 "A Note on the Last Pages of the Codex Mexicanus." *Journal de la Société des Américanistes* 43:219–221.

1959 *Mexican Manuscript Painting of the Early Colonial Period*. New Haven, CT: Yale University Press.

Rubial García, Antonio

1989 *El Convento Agustino y la Sociedad Novohispana (1533–1630)*. Mexico City: Universidad Nacional Autónoma de México.

Ruiz de Alarcón, Hernando

1984 *Treatise on the Heathen Superstitions that Today Live among the Indians Native to this New Spain, 1629*. Norman: University of Oklahoma Press.

Ruiz Medrano, Ethelia

2006 *Shaping New Spain: Government and Private Interests in the Colonial Bureaucracy, 1535–1550*. Boulder: University Press of Colorado.

2010 *Mexico's Indigenous Communities, Their Lands and Histories, 1500–2010*. Boulder: University Press of Colorado.

2014 "Don Carlos de Tezcoco and the Universal Rights of Emperor Carlos V." In *Texcoco: Prehispanic and Colonial Perspectives*, edited by Jongsoo Lee and Galen Brokaw, 165–182. Boulder: University Press of Colorado.

Rutsch, Mechthild

2004 "Natural History, National Museum and Anthropology in Mexico: Some Reference Points in the Forging and Re-Forging of National Identity." *Perspectivas Latinoamericanas* 1:89–122.

Sahagún, Bernardino de

1950– *Florentine Codex: General History of*
1982 *the Things of New Spain*. Translated and edited by Charles E. Dibble and Arthur J. O. Anderson. 13 vols. Santa Fe School of American Research and University of Utah.

1986 *Coloquios y doctrina cristiana: Los diálogos de 1524 según el texto de fray Bernardino de Sahagún y sus colaboradores indígenas*. Mexico City: Universidad Nacional Autónoma de México and Fundación de Investigaciones Sociales.

1993 *Primeros Memoriales: Facsimile Edition*. Photographed by Ferdinand Anders. Norman: University of Oklahoma Press.

Schroeder, Susan

2011 "The Truth about the Crónica Mexicayotl." *Colonial Latin American Review* 20(2):233–247.

2016 *Tlacaelel Remembered: Mastermind of the Aztec Empire*. Norman: University of Oklahoma Press.

Schwaller, John Frederick

1986 "The Ordenanza del Patronazgo in New Spain, 1574–1600." *The Americas* 42(3):253–274.

1987 *The Church and Clergy in Sixteenth-Century Mexico*. Albuquerque: University of New Mexico Press.

Seed, Patricia

1991 "Colonial and Postcolonial Discourse." *Latin American Research Review* 26(3):181–200.

1993 "More Colonial and Postcolonial Discourses." *Latin American Research Review* 28(3):146–152.

Sharpe, William

1964 "Isidore of Seville: The Medical Writings." *Transactions of the American Philosophical Society* 54(2):1–75.

SilverMoon

2007 "The Imperial College of Tlatelolco and the Emergence of a New Nahua Intellectual Elite in New Spain (1500–1760)." PhD diss., Duke University.

Skaarup, Bjørn Okholm

2016 *Anatomy and Anatomists in Early Modern Spain*. London: Routledge.

Smith, Michael E.

1984 "The Aztlan Migrations of the Nahuatl Chronicles: Myth or History?" *Ethnohistory* 31(3):153–186.

Spitler, Susan

1998 "The Mapa Tlotzin: Preconquest History in Colonial Texcoco." *Journal de la Société des Américanistes* 84(2):71–78.

2005a "Colonial Mexican Calendar Wheels: Cultural Translation and the Problem of 'Authenticity.'" In *Painted Books and Indigenous Knowledge in Mesoamerica*, edited by Elizabeth Hill Boone, 271–288. New Orleans: Middle American Research Institute.

2005b "Nahua Intellectual Responses to the Spanish: The Incorporation of European Ideas into the Central Mexican Calendar." PhD diss., Tulane University.

Tavárez, David

2011 *The Invisible War: Indigenous Devotions, Discipline, and Dissent in Colonial Mexico*. Stanford, CA: Stanford University Press.

Tena, Rafael

1987 *El calendario mexica y la cronografía*. Mexico City: Instituto Nacional de Antropología e Historia.

2012 *Tres crónicas mexicanas: Textos recopilados por Domingo Chimalpáhin*. México: Consejo Nacional para la Cultura y las Artes.

Thebaut, Nancy

n.d. "Cyclical Time and the Timeline: The Prefatory Pages of the Codex Mexicanus." Seminar Paper, University of Chicago.

Torquemada, Juan de

1986 *Monarquía indiana*. 3 vols. Mexico City: Editorial Porrúa.

Torre Rangel, Jesús Antonio de la

1998 *Alonso de la Veracruz: Amparado de los indios, su teoría y práctica juridicial.* Aguascalientes, Mexico: Universidad Autónoma de Aguascalientes.

Townsend, Camilla

2009 "Glimpsing Native American Historiography: The Cellular Principle in Sixteenth-Century Nahuatl Annals." *Ethnohistory* 56(4):625-650.

Trabulse, Elías

1983 *Historia de la ciencia en México, siglo xvi*. Mexico City: Fondo de Cultura Económica.

Trexler, Richard C.

1987 *Church and Community 1200–1600: Studies in the History of Florence and New Spain*. Rome: Edizioni di storia e letteratura.

Umberger, Emily

1981 "The Structure of Aztec History." *Archaeoastronomy* 4(4):10–18.

Vågene, Åshild J., Michael G. Campana, Nelly M. Robles García, Christina Warinner, Maria A. Spyrou, Aida Andrades Valtueña, Daniel Huson, Noreen Tuross, Alexander Herbig, Kirsten I. Bos, Johannes Krause

2017 "*Salmonella enterica* Genomes Recovered from Victims of a Major 16th Century Epidemic in Mexico." *bioRxiv* 106740. doi: dx.doi.org/10.1101/106740.

Valadés, Diego

1579 *Rhetorica Christiana*. Perugia: Apud Petrumiacobum Petrutium.

Viesca, T. Carlos, Andrés Aranda C., and Mariblanca Ramos

1998 "El cuerpo y los signos calendáricos del tonalamatl entre los nahuas." *Estudios de Cultura Nahuatl* 28:143–158.

Villella, Peter

2011 "'Pure and Noble Indians, Untainted by Inferior Idolatrous Races': Native Elites and the Discourse of Blood Purity in Late Colonial Mexico." *Hispanic American Historical Review* 91(4):633–663.

2016 *Indigenous Elites and Creole Identity in Colonial Mexico, 1500–1800*. New York: Cambridge University Press.

von Humboldt, Alexander

2013 *Views of the Cordilleras and Monuments of the Indigenous Peoples of the Americas*. Edited and translated by Vera M. Kutzinksi and Ottmar Ette. Chicago: University Press of Chicago.

Wallis, Faith

1990 "Images of Order in the Medieval *Computus*." In *ACTA XIV: Ideas of Order in the Middle Ages*, edited by Warren Ginsberg, 45–67. Binghamton: State University of New York Press.

Weckmann, Luis

1992 *The Medieval Heritage of Mexico*. New York: Fordham University Press.

Wichmann, Søren, and Ilona Heijnen

2008 "Un manuscrito en náhuatl sobre astrología europea." In *XV Congreso Internacional de AHILA, 1808-2008: Crisis y problemas en el mundo atlántico*, edited by Raymond Buve, Neeske Ruitenbeek, and Marianne Wiesebron, 106–124. Leiden: Universidad de Leiden.

Zaballa Beascoechea, Ana de

2016 "Promises and Deceits: Marriage among Indians in New Spain in the Seventeenth and Eighteenth Centuries." *The Americas* 73(1):59–82.